You see things as they are and ask: why?

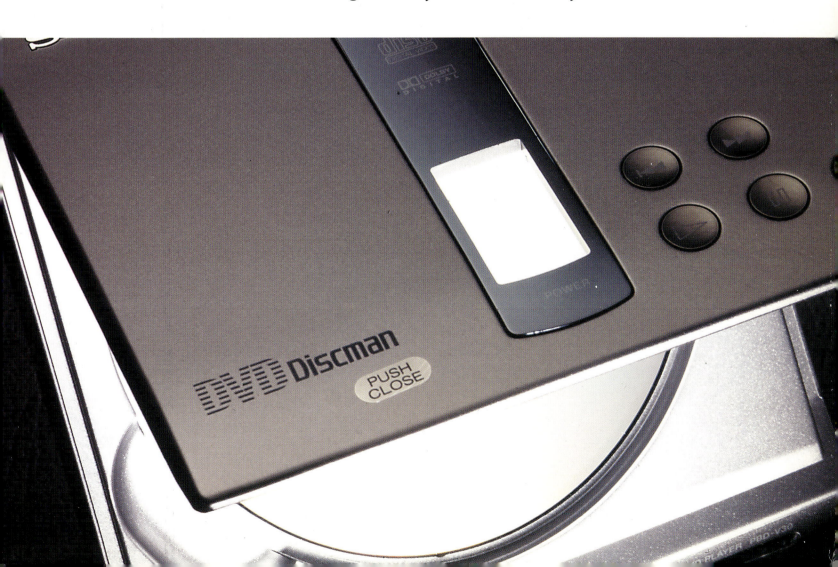

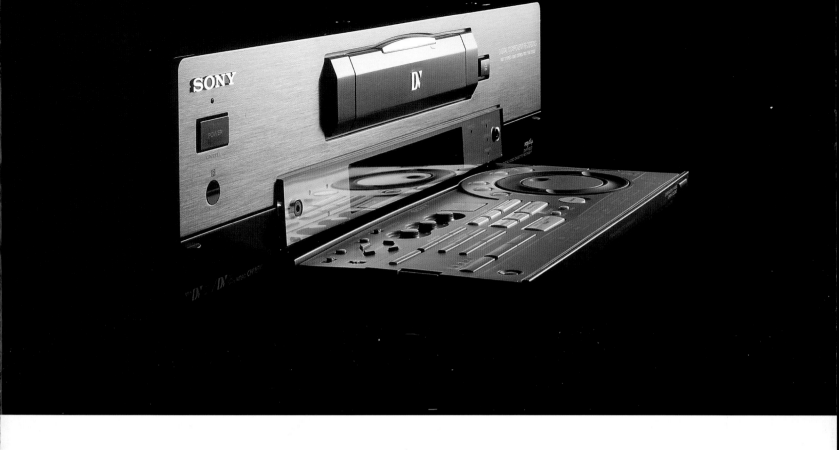

We dream things that never were

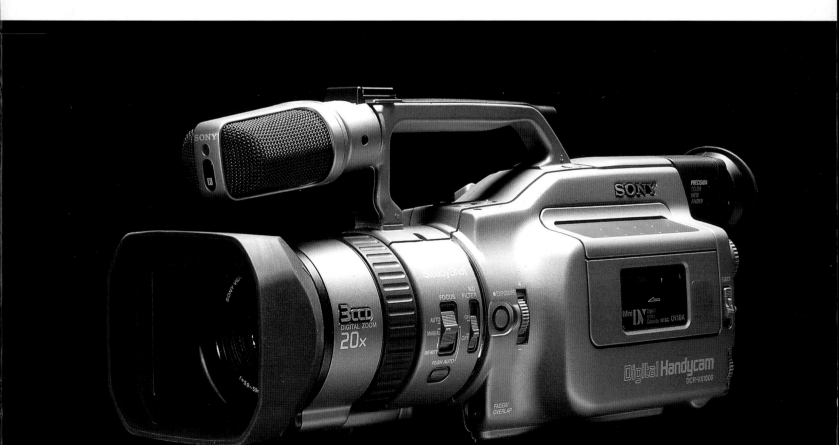

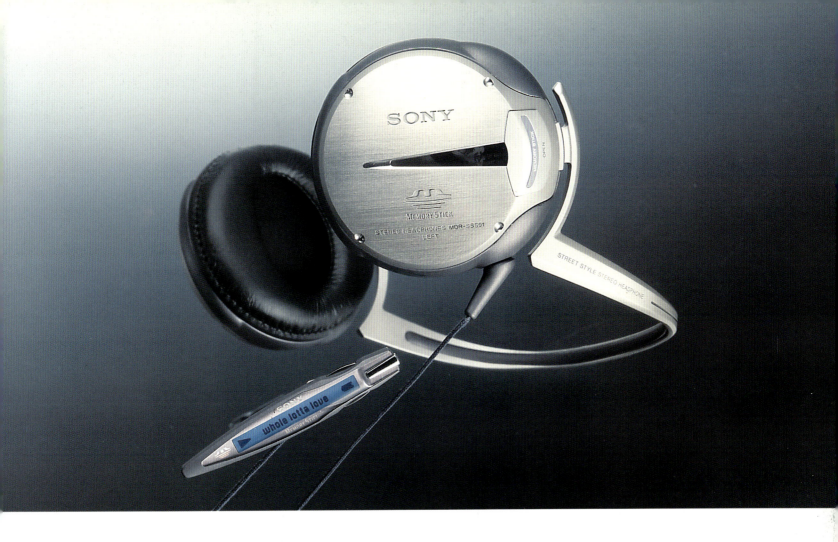

And ask: why not?

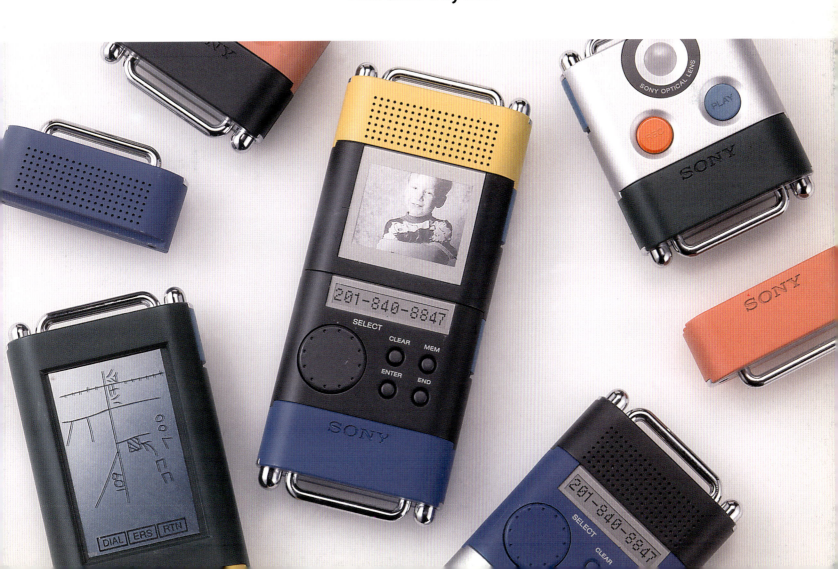

Digital Dreams

THE WORK OF THE SONY DESIGN CENTER

PAUL KUNKEL

UNIVERSE

First published in the United States of America in 1999
by UNIVERSE PUBLISHING
A Division of Rizzoli International Publications, Inc.
300 Park Avenue South
New York, NY 10010

Trademark Information. Beans Walkman, BetaMax, BYOS, CDit, CDit Pro, Cable Mouse, Clear Scan, Compact Series, Community Place, Cybershot (name and logo), Cybershot Pro, DAT, Data Discman, Digital Dreams, Digital Dream Kids, Digital Mavica, Digital Sync, Digital Signal Transfer, Direct Access, Direct Tuning, Discman, Dream Machine, DST, DVDiscman, Dynamic Focus, Dynamic Color, Dynamic Picture, EditStation, eMD, eMotivator, Express Navigator, Express Tuning, ExtraAlloy, Flying Erase, Fontopia, G-Chassis, G-Up, GIG, HandyCam, HandyCam Pro, HandyCam Vision, Hi-Band, Hi8, i.Link, ImageStation, Info-Navi System, Integrated System Commander, Magic Link, Matrix Sound, Mavica, Maximum Television, MaxiTV, MegaBass, MegaStorage, Mega Watchman, Memory Stick, Metal Master, Metal Select, Micro-Beam, Micro-Black, MiniDisc (name and logo), My First Sony, NT Cassette, Outback, PlayStation, Pressman, ProSound, Psyc, Remote Commander, S-Link, SonicFlow Sony, Sony-Matic, Sony (logo), Sony Plaza, Sony Style, Sony Signatures, Sony Wonder, SportsPack, SuperBeta, Slide Case, Street Style, Super Beta, Super Bias, SuperBright, Super Fine Pitch, Syncro Edit, Video Walkman, The Leader in Digital Technology, Trinitron, VAIO, Video Walkman, Voice Boost, Walkman, Watchman, Wega, Whoopee, Widdit, World Band Radio, World Band Receiver and XBR are trademarks or tradenames of Sony. All other trademarks are trademarks of their respective owners.

Library of Congress Cataloging-in-Publication Data
Kunkel, Paul.
 Digital dreams : the work of the Sony Design Center / Paul Kunkel.
 p. cm.
 ISBN 0-7893-0262-4 (pbk. : alk.paper)
 1. Electronic apparatus and appliances—Japan—Design. 2. Sony Kabushiki Kaisha.
 3. Design, Industrial—Japan. 4. Digital electronics. I. Title.
 TK7836.K79 1999
 621.381—dc21 99–10272

01 02 / 10 9 8 7 6 5 4 3

Design by Paul Kunkel

Printed in Hong Kong

Start Dreaming

Contents

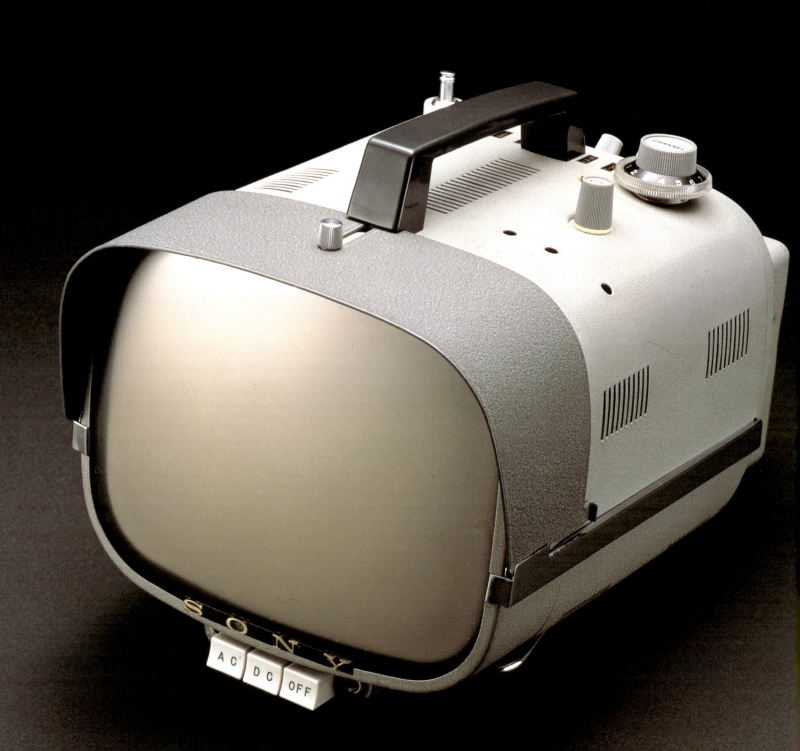

First Principles

FOR ANYONE INTERESTED IN CONSUMER ELECTRONICS, DIGITAL MEDIA, MOVIES, MUSIC AND THE GROWTH OF THE INTERNET, IT IS NEARLY IMPOSSIBLE TO IMAGINE THE WORLD WITHOUT THAT SIMPLE, beautiful four-letter word, Sony. With its unparalleled name recognition, global presence and immense roster of brands, businesses, products and services, Sony is now a household name. Yet half a century ago, such a notion would have seemed absurd. As Japan was beginning its long slow climb from postwar status to wealth and prominence, few could have guessed that the tiny firm called Tokyo Telecommunications Engineering Corporation, founded on May 7, 1946, in a burned-out warehouse by two young visionaries named Masaru Ibuka and Akio Morita, would have evolved from a maker of rice cookers and heating pads into the world's preeminent developer and manufacturer of consumer, professional and broadcast audio/video equipment, recording media, computers, software, motion pictures, recorded music, telecommunications, medical equipment and more.

As the vast array of hardware, software and entertainment that Sony creates each year claims the hearts of millions around the world, in many cases occupying a central location in our living rooms, Sony innovation and vision are changing the way we relate to technology, how we perceive the world and even how we perceive ourselves. And the source of this vision can be seen at a glance. For the heart of the Sony empire, the foundation from which most of the profits are made year in and year out, is the Sony Corporation. And the author of that corporate vision—revealed in the form, functionality, color, content and detailing of hundreds of new products, packaging schemes, graphic and user-interface designs, Web-based communications and media products each year— comes from the largest and most secretive "idea factory" in the world: the Sony Design Center.

Over the past half century, no other group of individuals have had a more profound effect on industrial culture and the world of design than the 200-plus men and women who work inside the modern office building next door to Sony's global headquarters in the Kitashinagawa district of Tokyo. With colleagues working at Sony studios around the world, the Design Center is the quintessential example of an organization that thinks globally but acts locally. Their every move is closely watched by competitors throughout the many industries in which Sony participates. As a result, the code of silence within the Design Center differs from most high-tech organizations. Unlike firms such as Apple, Philips, Nike or BMW, whose design groups receive journalists and visitors as part of their normal course of business, no one simply

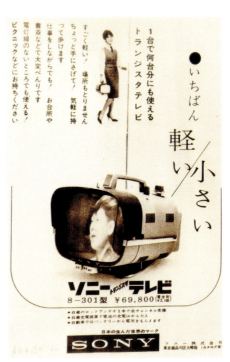

"drops in" for a visit at the Design Center. Indeed, the environment in which Sony designs take shape is so fast-paced and the range of specialties so varied that no single visit can convey what really goes on there. For the Design Center does not only create new products, it provides a vision that all of Sony draws upon, turning industrial and consumer products into the purest form of culture while propelling humanity into an era of change the likes of which we have never seen before.

As such, the work of the Sony Design Center defies easy analysis. It entertains, informs, empowers and thrills us with its imagery, performance, potential and symbolism. The form and functionality of its products improve our lives in a thousand different ways. Yet the Design Center's greatest role may be to help us design our own lives—and, in so doing, to enhance the most precious of all human traits: our individuality. The consumer electronics, media products and imagery that Sony designers create not only give us power over our own lives. They serve as the greatest instruments of freedom ever invented—allowing us to reach out from our homes, from our desks, from our automobiles and from ourselves to grasp and share knowledge with others, allowing us to record the moments of our lives, create our own masterpieces, enjoy the vast array of movies, music and television programming and sample the new worlds of electronic publishing and music on demand that the Internet provides.

As the analog technologies that Sony pioneered give way to an all-new line of digital equipment, the products and services that make up the Sony family will be as different from today's products as today's Sony is from the tiny firm that began it all. Yet the founding principles on which the Sony legend is built, the dreams that live inside the heart of everyone from the chief executive to the first-year employee and the philosophy that serves as the lifeblood of the Design Center remain intact.

It began in the spring of 1946, when company founder Masaru Ibuka put pen to paper and wrote a founding prospectus. Even though his firm had no products, no customers and scant prospects for success, Ibuka wanted his new company to have an ideology that stemmed from his own beliefs and character. First among these principles was to "always do what has never been done before"—setting a tone that has resulted in more "first products" at Sony than at any other consumer electronics company. These include Japan's first tape recorder in 1950, the world's first portable transistor radio in 1955, the world's first transistorized television in 1960, the first Trinitron television in 1968, the first home video system (the Betamax) in 1975, the Walkman in 1979, the first home compact disc player in 1982, the first handheld 8mm video camera in 1985, the first portable compact disc player and MiniDisc player, the first flat-screen

The Sony dream was first symbolized by small innovative products that captured our hearts as they garnered worldwide attention. Early examples include the TV8-301 transistor television, launched in 1960.

The foundation for everything that Sony would become is contained in a simple handwritten document inscribed by Sony's co-founder Masaru Ibuka. An avid radio aficionado, Mr. Ibuka founded the company known as Tokyo Tsushin Kogyo (Tokyo Telecommunications Engineering Corp.) with his partner Akio Morita on May 7, 1946. In the founding prospectus, which still serves as the company's core ideology more than fifty years later, Mr. Ibuka promised "to establish conditions where persons could become united with a firm spirit of teamwork and exercise to their heart's desire their technological capacity . . . to pursue dynamic activities in technology and production for the reconstruction of Japan and the elevation of the nation's culture . . . to apply advanced technology to the life of the general public and thus bring untold pleasures and untold benefits. . . . Those of like minds will naturally come together to embark on these ideals." Mr. Ibuka also promised to "eliminate unfair profit-seeking, persistently emphasize substantial and essential work, and not merely pursue growth. . . . We shall welcome technical difficulties and focus on highly sophisticated technical products that have great usefulness in society regardless of the quantity involved . . . [and] we shall place our main emphasis on ability, performance and personal character so that each individual can show the best in ability and skill." Though refined

and restated by others in later years, this founding statement still expresses the principles that Sony follows today. After developing a few failed products, such as a rice cooker (above), and a marginally successful heating pad, Mr. Ibuka and his team turned their attention to electronics—and soon transformed both Japanese industry and the world at large.

television and other outstanding products, many of which spawned whole new industries, brought untold enjoyment to millions and redefined the way we work, learn and play. Given shape by the men and women at the Design Center, these products have cultural significance that helps to define our existence. Yet most of these achievements, great as they are, represent the past.

As the twentieth century draws to a close and the first chapter of a new millennium takes shape, the Design Center has reinvented itself in order to take advantage of the new technology and changing markets brought about by the phenomenon known as digital convergence. In a program code-named Digital Dreams, the most design-driven organization on earth has looked beyond the standard mission of every corporation (to earn profits, gain market share and protect shareholder value) to create a global culture through the design of Sony's products, and thus give form and meaning to the modern world. The culture of design and the impact that designers and their works have on society at large may be difficult to comprehend because these designed objects are so prevalent in our day-to-day existence. Most people living in industrialized society are in contact with designed objects every moment of their lives. These manufactured products—be they telephones, televisions, cameras, clothing, automobiles or furniture—are "silent persuaders," influencing our thoughts, choreographing our behavior and guiding our decisions in ways that are both obvious and subtle. No phenomenon in modern history has had such a profound effect on human society as the advent of personal electronics. For unlike the personal computer, which has penetrated fewer than half the homes of even the most advanced societies, personal electronics in the form of televisions, radios, Walkman products, camcorders, video tape recorders, game machines, cell phones, and digital still cameras are *everywhere*. Industries such as music, video and television would not be as large and powerful as they are today without an unending supply of top-quality seductively designed hardware that is affordable to all. The role that these designed objects play in shaping our world is enormous. Yet the men and women who design these modern icons and the techniques they use to create them remain a closely guarded secret. In a rare opportunity, the Sony Design Center has agreed to lift the lid on their work, share their philosophy and preview a new family of digital audio/video, computer,

imaging, telecommunications and software products and concepts now under development that will transform the way we live, work, learn and play in the twenty-first century.

Formed in 1961 by Akio Morita and first managed by Norio Ohga, the Design Center has long been the fulcrum on which Sony's reputation for style and innovation is balanced. Everything you need to know about the spirit that built Sony, as well as the energy that drives it today, can be learned by visiting Design Center/Tokyo and examining one of their latest creations. What do we see? High quality, of course. Simplicity, a clear recognizable image, and unmatched reliability, yes. A sense of fun, always. But we also see a vision of perfection, the flawless execution that separates true culture from everything else. In an industrial context, this results when the best engineers work closely with the best designers. But there is more: a sense of spirit, teamwork, camaraderie and a shared vision that is almost contagious. Spend the day there, meet the people who design the products that fill your dreams, and you will never want to leave.

In the Design Center's twelve studios—four in the Tokyo vicinity and one each in Singapore, San Francisco, New York, Park Ridge (New Jersey), London, Sao Paulo, Köln and Amsterdam—the obsession to create the best design is always tempered by the words of Sony's founders Ibuka and Morita, which inform every design move as though the founders were there giving direction.

Innovation—"doing what has never been done before"—is the first goal. The second principle is to always lead and never follow. As Mr. Morita once said, "if you ask the public what they think they will need, you will always be behind in this world. You will never catch up unless you think one to ten years in advance and create a market for the items you think the public will accept at that time." Translating this principle into practice has given the Design Center the freedom to make bold moves, pursue markets with products that no one else had, invent rules rather than follow them and develop a management structure that values talent and initiative and encourages Sony designers to think of themselves as members of an elite group. This makes Sony very different from traditional Japanese businesses.

"Instead of doing market research or asking what kind of products people want," says the Design Center's senior general manager Mitsuru

(a.k.a. John) Inaba, "we use the the best technology to create something that excites us, refine that product and try to create a market for it by educating and communicating with the public." As a result, the Design Center's greatest successes have come from products for which there was no proven demand. The classic example is the Walkman, which many people (even inside Sony) greeted with skepticism when the idea was first floated in 1979. Fortunately, the uncertainty extended to rival companies, giving Sony a one-year head start in what proved to be the most successful product of its generation.

In the past, being first to market and being the most innovative, with high-quality, low-cost products, were enough to succeed. But today, products must entertain on every level and have a spirit and personality that can best be conveyed through design. The success of the Sony image is a testament to the company's keen understanding that design quality and consistency are a top priority. It is from this dedication and careful planning that Sony's image has remained intact, earning great respect and awareness over the years.

With technology now within everyone's grasp and prices dropping every year, consumer electronics would quickly become commodity items if people did not yearn for products with an image, tactile quality, symbolism and story that give the products value and meaning. As Sony chairman Norio Ohga says, "The product itself must be good, but it must also make the customer think, 'I'm glad I bought it,' 'I'm glad I use it,' 'I'm glad I have it.'" Great products and the experience they deliver serve an important, even crucial, role in a world in which mediocrity is the norm.

Building beautiful, high-performance products that have a distinctive flair, are easy-to-use and fun to operate has been the mission of the Design Center since its founding in 1961. In the late 1950s, long before graphic or industrial design was established in Japan, Sony was alone in aggressively pursuing a product design and packaging program inside the company. Unwilling to hire outside designers (few existed in Japan at that time), Sony built its own design organization from the ground up, visiting art schools throughout Japan to find the most talented sculptors, painters and graphic artists to join Sony and create a new kind of art that would give joy not just to a few, but to millions. Over the years, this simple practice of hiring talented young people and teaching them the Sony Way has resulted in the most formidable design group in the

world. Yet today, as the company that invented consumer electronics begins its second half century, Sony faces many challenges.

As technologies change, markets divide into new niches and consumer tastes evolve in ways that few can predict. The comforting past and knowable present will soon give way to a brave new world populated by a new breed of individuals raised not by television but by the Internet, having no allegiance to the analog technology of the past, to the Sony name or anything else. For these new consumers, who represent the future just as surely as their parents and grandparents occupied the past, the old rules that governed society no longer apply. Indeed, every rule written in the age of analog must be reexamined, and some turned inside out, to accommodate the digital age that is now upon us.

Sony innovation and vision are changing the way we relate to technology, how we perceive the world and how we perceive ourselves.

As the end of the second millennium draws near, we stand at the edge of a new culture—one that is skeptical, questioning, connected with the world, yet strangely disconnected, hungry for information and change, yet distrustful of any change that comes its way. With technology driving society at a speed unparalleled in history, a new consumer is emerging: suspicious of traditional solutions, unmoved by advertising and contemptuous of mass media. Persuading this new consumer is possible only for those who understand this new reality and boldly embrace it.

To meet this challenge, the Design Center has reinvented itself, discarding practices that worked in the past and inventing new techniques to make Sony the world leader in entertainment digital convergence in the next century. With a newly expanded role at Sony, the three hundred men and women who make up the Design Center are rethinking how people will choose, receive and experience technol-

ogy and entertainment. After a dramatic reorganization, combining Sony's huge expertise in software (motion pictures, television programs, music, electronic publishing and computer games) with its world-famous hardware (personal and home audio/video products, computers, digital video and still cameras, cellular telephones, professional and broadcast equipment and recording media), the line between electronics and entertainment has begun to disappear. Likewise, our old view of products as stand-alone items will soon give way to a new relationship in which all products, even those such as voice recorders and digital cameras, which may seem unrelated, will use the same form of digital information—speaking the same language and working together in ways that allow each product to join a seamless media landscape. At the Design Center, this idea is called VAIO (short for Video Audio Integrated Operation) and has driven not only Sony's entry into the personal computer market, but its entire consumer electronics strategy.

The architect of this strategy and the agent of change is Sony's digital dreamer, former head of the Design Center, now company president and co-CEO, Nobuyuki Idei. Mr. Idei and the Design Center's senior general manager, John Inaba, are spearheading the most dramatic shift in design philosophy that Sony has ever seen—casting off the "analog thinking" that propelled Sony to international prominence in the past and replacing it with "digital thinking" and a new all-digital product line that will establish a new dialog with users, seeing them as individuals rather than members of a single mass market.

Unlike the past with its many rules, the key to creativity in the future will be to turn convention inside out: to explore progressive design ideas, discard the norm, embrace the unknown, cultivate fantasy, respect ritual, use chaos to advantage, be fearless and, above all, to distrust your own success. For nothing is more vulnerable than a company entrenched in its own success.

In a networked world, all power migrates from the center (the state, the church, the corporation) to the individual, forcing old power structures to crumble, markets to fragment and the old logic of product development to disappear. What remains are the eternal qualities: craftsmanship, the need to innovate, a respect for the classical roots of design and a recognition that every user is unique. This shift in society, which has only just begun, recalls a similar upheaval that occurred just ten years ago.

Riven by a worldwide economic decline, a slowing of technological evolution, the rapid growth of personal computers at the expense of Sony's analog technology and relentless competition in the consumer electronics industry resulting in rampant copying, a dark shadow had fallen over the Design Center. Exhausted by the endless demand for new products that would be knocked off the moment they appeared on the market, designers within Sony's Audio group were disillusioned.

Convinced that their work no longer lived up to

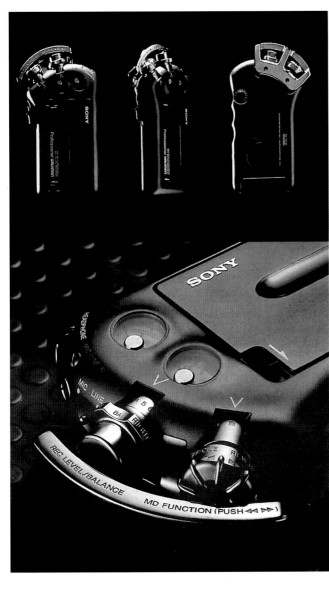

the Sony ideal, they broke from their normal routine during the winter of 1988–89 and spent several weeks creating a series of concepts, code-named Spirit, that would exhibit the highest levels of craftsmanship, individuality, performance, function and symbolism that Sony had ever offered.

Published here for the first time, these concepts are not only profound in themselves, they contain the genetic code on which most of Sony's current

designs are based, providing seeds that would take root in the early 1990s and reach full flower in today's product line.

Always a hotbed of activity, the General Audio (GA) group has been responsible for the design of all Sony radios, the Walkman, Discman and MD Walkman, consumer video cameras, digital still-frame cameras and all manner of voice recording equipment that form the bedrock of Sony's consumer product family.

With such a vast product line to address and a small army of designers to keep happy, the mood within GA is always changing. Even in the best of times, the atmosphere at GA is always a bit tense. But in the worst of times, such as the years 1988–89, when Sony's success was being undercut by legions of copycat products just as the market was entering a slump, the designers at GA found themselves working at top speed just to stay in place. With no time to reflect or generate the breakthrough ideas that had made the company great, the quality of GA's work was beginning to slip. Walkman products were all starting to look alike. The first several Discman products, though marvels of technical precision, were aesthetically stillborn. And classic products such as radios and voice recorders were not evolving as dramatically as they once had.

As Audio Group designer Keiichi Totsuka recalls, "We were feeling a bit depressed. The company was demanding more from us. Everything was getting cheaper. And profits were disappearing." It was as though the consumer electronics industry had become a giant merry-go-round that was spinning faster and faster.

"In 1988," Mr. Totsuka recalls, "the designers agreed that something was not right. We were supposed to be enjoying our work. We wanted to do great work, but had lost our spirit. We were tired, for sure. But we also had lost touch with the older values on which Sony design and Japanese design in general had been based. The sense of craftsmanship, integrity, simplicity and mystery found in great design was in our hearts. But it was not in our work. We wanted to change that."

They not only wanted to create the finest designs they were capable of producing, they wanted to do it in a strategic fashion: making a series of concepts in the home audio and Walkman category that would inspire the next generation of Sony products and provide a touchstone for generations of products to come. Management agreed with this proposal and allowed six of GA's best designers—Keiichi Totsuka, Joe Wada, Akira Yamazaki, Atsushi Kawase, Shinichi Ogasawara and Fumitaka Kikutani—to create a series of visionary concepts that would be displayed as a group within the Tokyo Design Center.

Known as Spirit, these concepts summarize the key ideas and concerns that Sony designers were grappling with ten years ago, many of which designers still think about today. Most important among those concerns is how to give mass-produced consumer electronics greater quality and value, a sense of integrity and exclusivity, and the high degree of craftsmanship that was sorely lacking in most products at the time.

Though created by a Japanese team, the style of the work and inspirations the designers drew upon reflected an international outlook, with an equal mixture of Asian, American and European aesthetics. Images of French restaurants, high-priced leather goods, Mercedes-Benz cars and English country houses were photographed for the portfolio that the Design Center later created to showcase the work. Their motto was "to appeal not only to the factory, but also to humanity."

Here we see the genetic blueprint from which all later Sony designs are based. The visual, functional and spiritual cues contained in these designs would filter throughout the Design Center and the company as a whole, representing the highest achievement in the field of industrial design at that time. From these concepts a dynasty was born that still exists to this day, its Spirit intact.

Professional, a cassette Walkman concept, designed by Joe Wada, DC/Tokyo, 1989, is made of die-cast magnesium with chrome-plated corner-mounted controls.

Elegance

In 1989, the most important product within the General Audio Group was, and remains, the Walkman—a design idea that has already swept the world and fostered so many expressions and permutations that it almost defies categorization. No less than six different concepts for the Walkman were proposed by the Spirit design team. But the best and most influential of them all were two models designed by the enigmatic designer Joe Wada, a superstar within Sony at the time and now a living legend whose best works have become a permanent part of our world. The two Walkman concepts that Mr. Wada created for Spirit are both extreme statements reflecting not only the two sides of the designer's personality, but the two principal directions that all Walkman products have followed in the decade since.

The first concept, known as Professional, (pages 16–17) is a large heavy brute. Its solid black case has the texture of iron with delicate silver controls on top that evoke the whimsical over-the-top aesthetics of the 1920s and 1930s. The weight and precision of Wada's controls might be better suited to a diving bell or a submarine than a personal audio product. But that is exactly the point. Rather than create an ordinary or subtle vision of the future, the Spirit designers wanted to discover the essence of a product by making an extreme statement that no one could ignore. One functional detail that would later enter the product line was the placement of controls in the corner of the product, where the user's thumb naturally falls when grasping the product. The bluntness of Mr. Wada's Professional design raised more than a few eyebrows when it was shown to Sony management months later. Some wondered: "How could *this* reflect Sony design?" But his fellow designers understood, and nothing else mattered.

Mr. Wada's second concept, known as Elegance, takes a more sophisticated and feminine approach to the Walkman. Shaped like a slim cigarette case with tight corners and a crisply detailed door that fits flush with the top surface, the Elegance concept was finished in two-toned silver with a tobacco brown flourish across the front (reminiscent of Japanese brush painting)—taking the opposite approach to the heavy black Professional design. Like the earlier concept, the Elegance Walkman was designed as a left-handed product with the main controls set at an angle and positioned in the corner of the product for easy thumb access. With its trim dimensions and luxurious materials, Mr. Wada's second concept assumes the role of a personal accessory rather than a machine, a direction that all later Walkman designs would follow.

This Janus-faced definition of the Walkman —half masculine, half feminine . . . at times exuding power and prestige and at other times a sense of personality, luxury or fun— stills moves us as completely today as it did the GA group designers ten years ago. It's remarkable that after such a long period, in which the Walkman has undergone at least twenty product cycles and has been redefined again and again, Mr. Wada's Spirit concepts still seem as fresh as the day they were born. It's conceivable that if Sony were to put these two designs into production as limited-edition products, they would quickly sell out.

The ideal companion to Mr. Wada's Spirit Walkman was Akira Yamazaki's elegant headphones, which offer a number of unique features. To accommodate different kinds of music and varying tastes among listeners, Mr. Yamazaki designed the headphones to accommodate three different condenser elements for different types of music: one set to reproduce the high frequencies and spaciousness required for classical music; a second set that could handle deep bass and loud volume for pop and rock music; and a third set that offered more balanced sound. This concern for individual taste stemmed from the belief among Sony's designers that by developing mass-market products designed to satisfy everyone to some degree, the products ended up satisfying no one completely. "Customization was our answer to the one-size-fits-no-one problem," says the designer.

Beautiful both to look at and to touch, the oval earpieces on Mr. Yamasaki's headphones were made of cast metal and attached to a pivoting mechanism that fit closely to the head with a fine leather headband on the top. Form and feel are superb.

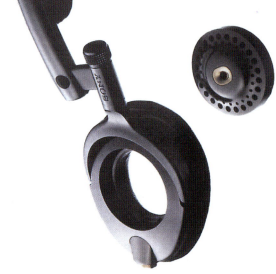

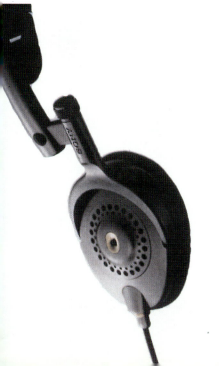

Enigma

Enigma, a concept for a bookshelf reference speaker, made of mold-blown thermo-plastic, designed by Akira Yamazaki (DC/Tokyo), 1989.

"Because of their dynamic function," says designer Akira Yamazaki, "loudspeakers should be the most expressive of all audio components. But that is rarely the case." With Enigma, Mr. Yamazaki set about to redefine the loudspeaker by giving it a fluid shape with bold curves that convey the idea of sound distorting the box as it pushes its way out. Made of white molded polymer, the two-way speaker is of bass reflex design with organic curves that express the bass and treble components. Unlike conventional speakers, which have a device-like appearance or no discernable image, Mr. Yamazaki's design shows how it's possible to breathe life into an object that is often ignored by manufacturers. Years later, Sony designer Takuya Niitsu would build expression into a speaker by treating his design in a similar, if less overt, way. Because the GA designers considered 1989 a difficult and pivotal time for Sony, designers such as Mr. Yamazaki made their Spirit concepts bolder and more exaggerated than they would today. But overstated gestures such as the Enigma loudspeaker are still useful, even if they show a designer what not to do.

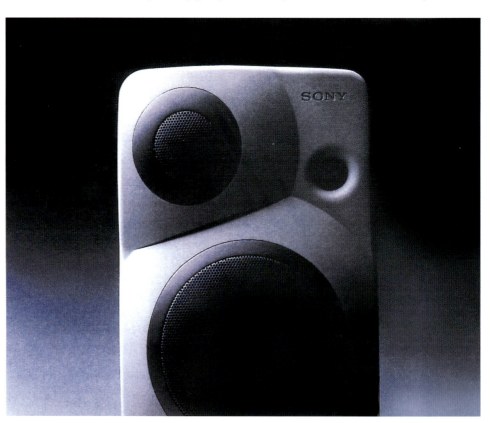

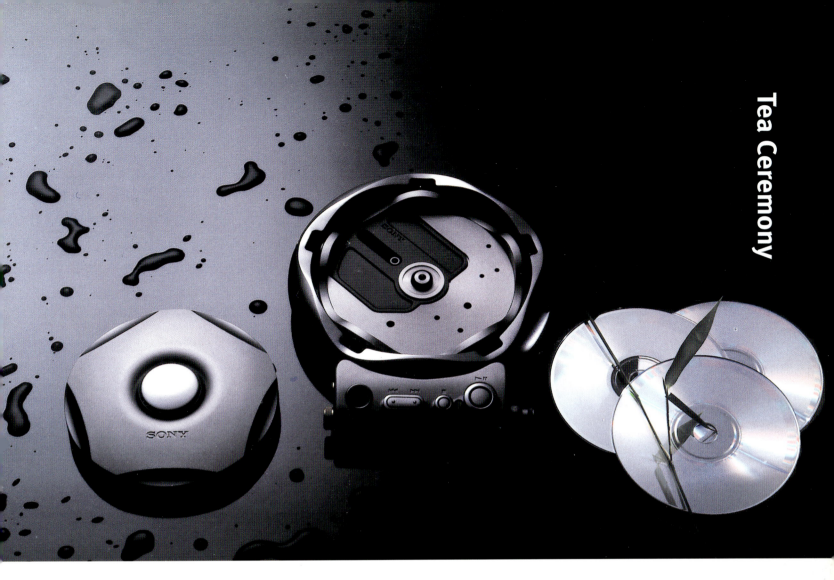

Sony has long prided itself on the design of its electronic components, but not always its speakers. The reason is that electronics are the product of technology whose performance can be measured and incrementally improved until the desired result is achieved. By contrast, loudspeakers are considered a product of art rather than technology: a great loudspeaker is more like a fine musical instrument than an electronic component. But Enigma suggests that perhaps Sony design can make a difference. It would be intriguing for Sony to develop a commercial version of Yamazaki's design. For, like Joe Wada's Professional and Elegance Walkman designs, a molded plastic speaker with this much personality would surely find an audience in a market where most speakers have no character at all.

Another Yamazaki Discman concept draws its inspiration from the Japanese tea ceremony. The connection between the two is obvious. As everyone who has ever experienced the tea ceremony knows, it's not about tea. It's about ritual, tradition and a reverence for things that the modern world has left behind but still needs. When properly understood, the tea ceremony is a meditative experience. The same is true when using a superb piece of technology. The act of enjoying the round shape and gentle contours of the Discman's exterior, opening the stainless steel lid, admiring the foliate shape inside, gently dropping the disk into place and carefully touching the buttons is not only about enjoying music. It is a ritual that both audiophiles and casual music lovers understand and enjoy. The essence of a fine piece of equipment isn't its function alone. It's also the style and grace that the equipment exhibits as we touch it. It's the power that the products impart when we realize that regardless of its perfection, we are its master, and it is there to serve. This philosophy of ritual and quiet service will be explored by other Sony designers on a range of products in the years to come, from DVD players to boom boxes. But the source of their work is this simple disc-shaped piece of metal whose power is both cerebral and physical.

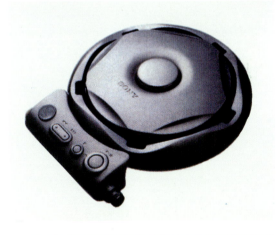

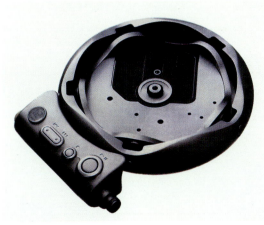

Tea Ceremony, a concept for a portable compact disc player made of die-cast and brushed aluminum, designed by Akira Yamazaki (DC/Tokyo), 1989.

Reference

Vault-like solidity and chilly precision are imbued with an air of mystery in this concept for a tabletop compact disc player by Atsushi Kawase. With radial forms that emphasize the circular CD medium set within a blunt square made of cast aluminum, the design known as Reference is the most monumental of all the Spirit concepts.

Despite its bold personality, the actual object measures less than six inches across and a mere two-and-a-half inches high. Yet the relationship of forms to details almost fools the eye into believing that the cold metal object in these photographs is immense: a spaceship perhaps? Or an enigmatic object left behind by long-departed space aliens?

Mr. Kawase's imagery is clearly excessive, but not totally out of line in the spring of 1989. At that time, the compact disc had not yet achieved market saturation and was not the commodity item that it is today. Ten years ago, many people still thought of the CD as "special." The sound it delivered could be room shattering. Yet the disc itself was thin and almost feather light. The tiny pits embedded in

its mirrored surface were too tiny to see with the unaided eye, and the ones and zeroes contained on the disc were a mystery to most people. So it seemed only natural that Mr. Kawase would invest his design with similar qualities.

The craftsmanship required to cast the solid aluminum block, balance it on four massive conical feet (which narrow into points where the feet meet the CD player's base) and install the motorized mechanism that elevates and lowers the heavy aluminum cover is impressive to say the least. But does the concept mean anything outside of itself? Later Sony designers would

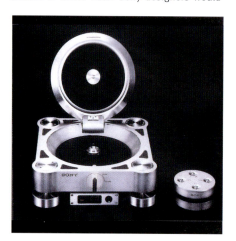

clearly say yes and give all their products some form of spiritual, functional or cultural meaning. Shigemitsu Kizawa gave a similar expression to his high-end compact disc player designed in 1996 (see page 96), and Yasuo Yuyama's Rugged Street Style Discman, designed in 1999 (see page 51) continued the trend. The idea of treating the CD player as a precious and mysterious object began with the Reference concept.

"I wanted to express a sense of the unknown," says Mr. Kawase, "something powerful yet also very precise. A strong image was important. The design also had to look as heavy as possible. I wanted it to express no particular place, time or nationality. The lines could almost have been drawn by a machine." There is no warmth, no clothing on the product, just smooth polished metal, with a brushed surface that is almost too perfect to be from this Earth. "Perhaps it came from outer space," says Mr. Kawase with a wink. "Or from a dream."

Something more powerful than us has landed. It will remain here for only a short time. Then, as mysteriously as it arrived, it will vanish. Never to return.

Reference, a concept for a high-fidelity tabletop compact disc player, designed by Atsushi Kawase (DC/Tokyo), 1989.

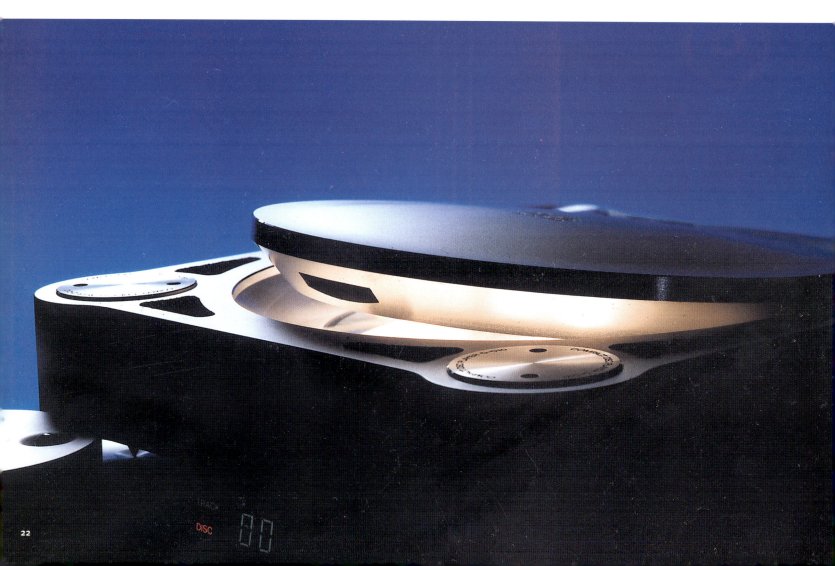

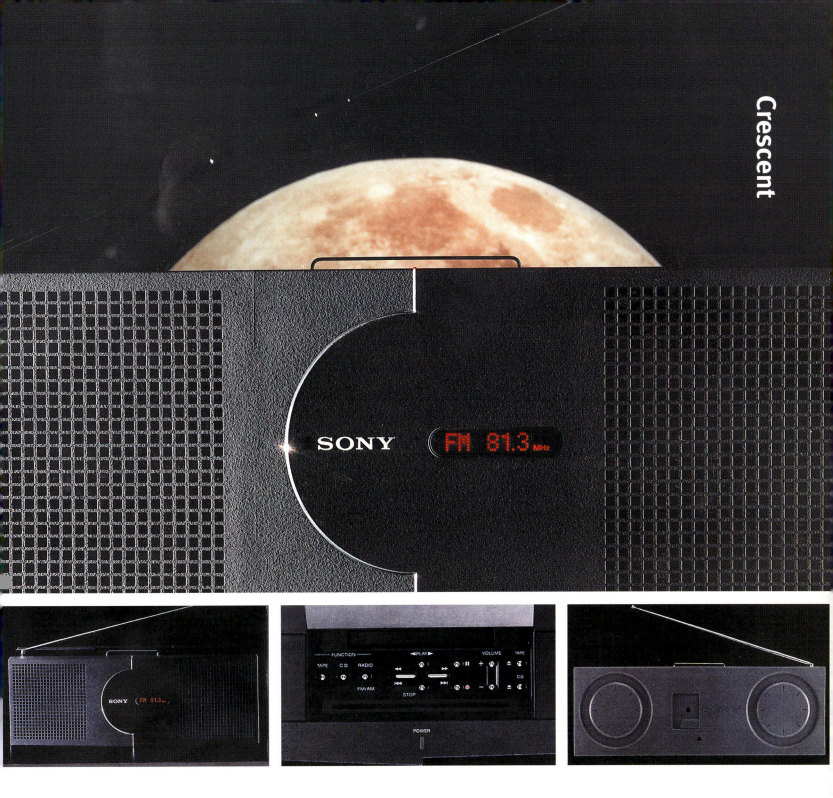

At the opposite end of the aesthetic and emotional spectrum from Mr. Kawase's cast aluminum concept is this elegant black boom box designed by Keiichi Totsuka. Called Crescent, the design marries an Eastern fascination with subtle lines and shapes with a European love of detail in the latticework that overlays the speakers (echoing the work of turn-of-the-century designer Charles Rennie Macintosh). The bold moon-shaped crescent on the front joins two connecting planes that meet at a three-degree angle, a detail best noticed by looking straight down at the concept (see the middle picture above). In an otherwise calm and visually quiet design, the point at which

these two planes connect form a slight overlap, creating a subtle yet interesting area of tension that punctuates the entire composition.

Mr. Totsuka gave his concept a sense of elegance and reserve that draws inspiration from the Black and Silver Sony designs of the 1960s and has been adopted in several later Sony products, notably a 1997 boom box (see pages 100–101) by the same Mr. Kawase who authored the tiny aluminum vault on the opposite page. Despite its obvious Black and Silver reference, the simple modernist lines and restricted palette of Mr. Totsuka's Crescent make their own unique statement that contrasts to the rest of

the Spirit concepts. We see no color, except a bit of red on the front. And no curves except the moon shape on the front and the two circles on the back, which echo the loudspeakers inside.

All designers know that the most difficult expression of all is simplicity, in which elements are removed one by one until the essence of the product has been revealed. Nothing can be added or removed without diminishment. And remember—Cresent was designed ten years ago. The fact that it looks so fresh today tells us that the design is timeless. It has escaped the boundaries of time and fashion. It exists in its own realm.

Crescent, a concept for an AM/FM cassette boom box, designed by Keiichi Totsuka (DC/Tokyo), 1989.

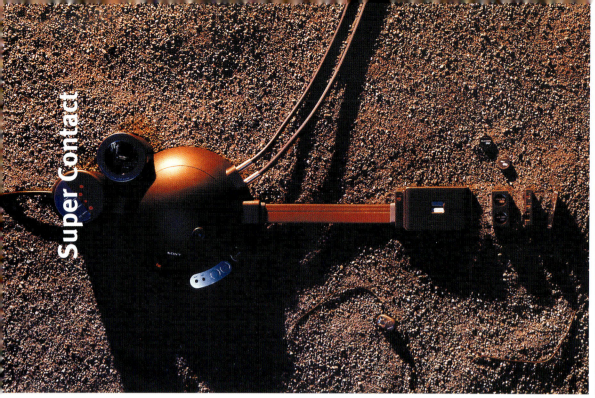

Super Contact

Combining simple parts to create complex products is a common tactic in the consumer electronics industry. If you take a radio, add two speakers, then add a tape player, headphones and a clock, the product's value is much greater than the sum of its parts. But taking a complex piece of equipment, dividing it into its constituent elements, then joining the separate parts in various ways has long been a fascination for Sony designers. Once divided into separate functions, the individual elements can be put together in any number of ways, performing the precise function needed at any particular moment. This assembly/disassembly idea was explored by Shinichi Ogasawara in this Spirit concept known

Super Contact GA Connection, Essence of Supreme (above), designed by Shinichi Ogasawara (DC/Tokyo), 1989, includes a compact disc player, cassette player and other components connected in a modular fashion.

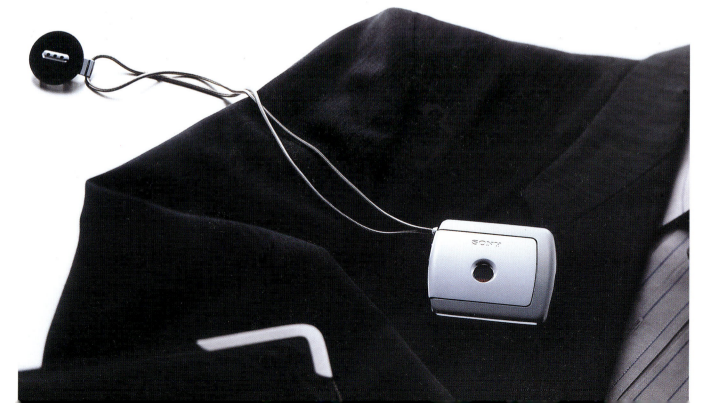

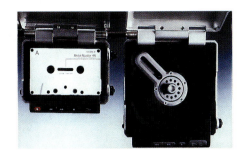

as Super Contact GA Connection. Combining a dome-shaped compact disk player, cassette Walkman and headphones with various other components, Mr. Ogasawara's design was startling for its time and later served as inspiration for a concept known as Digital Block (see page 184), which also takes a modular approach to product formation.

Taking a similar approach to assembly and disassembly, Fumitaka Kikutani created a series of components that included cassette Walkman and Discman units, a black lunchbox-shaped amplifier with integrated subwoofer and satellite speakers. When wired together, this ensemble makes an efficient and visually compelling home audio system. But when broken down, the individual elements work well on their own—offering a vision of flexible systems that has been carried forward to today's product line and will form the backbone of systems in the future.

The inspiration that the Spirit concepts gave to the Design Center was incalculable. When put on display during the summer of 1989, the concepts inspired legions of younger designers who would spend hours studying their every detail.

Many of the forms, aesthetic gestures and functional details in the Spirit concepts were transposed to other Sony products, giving spice to the larger idea that guides the evolution of Sony's product development, known at the Design Center as Sunrise/Sunset.

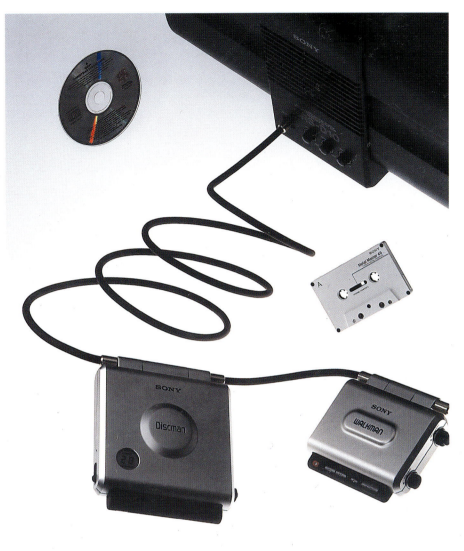

The **Hyper Micro** ensemble, designed by **Fumitaka Kikutani** (DC/Tokyo), 1989, consists of portable compact disc and cassette players that can be used alone or attached to a subwoofer/ amplifier with satellite speakers.

What Time Is It?

Target Audience(s)
Opinion/fashion leaders
and professionals, more
mainstream customers

Market Penetration

Target Audience(s)
Early adopters,
opinion leaders,
technology junkies

Late Morning
Third generation often coincides with the first peak in
design expression as an inspired designer captures the
"essence" of the product. The "icon" phase occurs
when a technology is new but already known, drawing
further attention to the technology and inspiring the
"ultimate" design to come.

Early Morning
An important phase of the product cycle, the design of the second-generation product largely
determines whether the product line as a whole will succeed. As engineers perfect the
underlying mechanism, the design of an early-morning product helps establish the goal(s)
that will be achieved in the "icon" product (late morning) and the "high noon"
design that will appear in the months or years to come.

Sunrise
As a new technology is developed, the race to be "first to market" forces engineers and designers to
release a product quickly, even if it is not optimized, too large and too expensive to attract any but the
most curious (and well-heeled) customers—known as "early adopters." Like the first moments of day-
light, the sunrise product is fresh and new . . . and fleeting. Thus no more than a few thousand first-
generation products are made as attention turns to the all-important second iteration. The race for
market leadership has begun.

Market Creation

"TO COMMUNICATE THE SHIFT FROM ANALOG TECHNOLOGY TO DIGITAL CONVERGENCE," SAYS MR. IDEI, "PRODUCTS MUST DO MORE THAN THEY DID IN THE PAST. THEY MUST NOT ONLY

function beautifully, they must also have a human side, allowing us to use the product in a playful manner and enjoy it even when it is at rest. In the past, when we looked at a Sony product, we saw something that was innovative, technically strong, physically beautiful and new. But today, we must see with more than our eyes. The design should also draw our hand, create a fire in our mind and make us smile as we pick it up. And follow-up products should constantly evolve to ensure that we never grow tired of them." This last ingredient is the most difficult to achieve, because it forces the designer to never make the same statement twice. With no design language to fall back on, developing a new identity and image for each product and fitting those statements into a larger context is extremely difficult. At Sony, where product lines are numerous and the items within each family large, no design language can encompass so many products and still be recognizable and interesting enough to satisfy the demands of Sony customers.

Take a close look at Sony's product line, and you will discover that no two products follow the same design language in more than a peripheral way. They all use the same logo, and many products, such as audiocassette players and recorders, use the same mechanisms, sub-assemblies and controls. But the external design of each unit is unique. At times, the

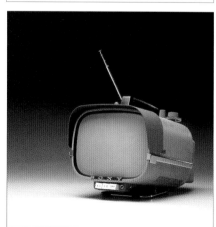

Good morning

look and feel of two products in the same family can even be antithetical—something you would never find in design at Mercedes, Philips, Apple or IBM.

On the surface, it would appear that the Design Center prefers chaos. Or perhaps they have no strategy and merely come up with as many designs as they can, release them all, and let the customers pick the winner. Yet neither is true. For beneath the apparent chaos in Sony's design is a secret strategy, a paradigm that has guided the evolution of every Sony product line from 1955 to the present. This strategy plays out over such a long period of time that most observers fail to see the pattern. Yet it does exist. There are no style manuals that describe this strategy and no chalkboard diagrams at the Design Center outlining its purpose or implementation. Instead, the method is conveyed in the designs themselves. The young observe and learn from their elders. And the eternal pattern that guides the evolution of every Sony design as predictably as the hours of the day, passes from one generation to the next, in a continuous, uninterrupted flow. The method is internalized, allowing each designer to work in an atmosphere that is not bound by rules. Instead, the designer creates the spirit that allows all good products to come to life, achieve icon status and evolve in a necessary fashion. Only when taking

Noon

The "ultimate" version of a product achieves the essential goals in terms of product size, performance, price, product statement, functionality, relationship of the product to the media it contains, etc. Later versions may be finer, smaller, more expressive or elaborate, but when the day is done, the high noon design is often seen as the best.

Target Audience(s)
Mass audience, which divides into professional, mainstream and youth/sports audiences

Market Expansion

Early Afternoon
Differentiation begins as the product line splits into niche groups that represent sophisticated users, conservative "middle of the road" types, the fashion-conscious and youth/sports markets.

Target Audience(s)
Audience division increases, "tribes" emerge as total audience size peaks just prior to sunset

Late Afternoon
Differentiation continues as the product line evolves to more extreme expressions: sophisticated lines become more rarified and extreme; "middle-of-the-road" designs lose their expression and become purely functional; and expressive items grow wings and begin to take off. Color, materials, differences in shape, cultural/generational/sexual distinctions become valid reasons for developing new products as engineers further simplify mechanisms and manufacturing processes and design pursues customers into ever smaller niches.

Sunset
As the market becomes saturated and reaches its maximum size, differentiation approaches its logical end: as the number of product expressions increase, as internal mechanisms reach the ultimate in performance and low cost, the rate change from one iteration to the next slows; "product inflation" causes each new design to mean less than the one that came before, which forces the designer to "create fireworks" in order to gain attention. Sophisticated products become useless marvels; "middle-of-the-road" search for innovative tricks; youth-, fashion- and sports-related lines metastisize into ever more elaborate and culturally-specific expressions. Design is replaced by myth-making. Image overtakes reality.

Perpetual Sunset
Continually feeding a market that has grown huge but is shrinking at a measurable rate, designers recycle old ideas, and continually throw minute extensions of last year's models onto the market. With the core technology fully amortized, the goal is to push as many products as possible into users' hands before the technology becomes obsolete. The quest for image and myth results in product s that function as "eye candy" and "visual jokes"—the final burst of fireworks before the sun goes down. The product line dies when designers can no longer hide the fact that the underlying technology is obsolete.

Market Saturation

Market Exhaustion

Target Audience(s)
Extremely diverse, with total numbers beginning to decline

a longer view—from a technology's inception to its final expression ten or twenty years later—does the pattern become clear, evolving not as a conscious strategy, but in a natural way, as a living organism, capable of changing at any moment and in any way that conditions require.

This strategy, called Sunrise/Sunset, is an eight-step process that guides the design and development of virtually all products. This includes the design of hardware, software, packaging, media and even the Sony logo itself. Since markets, like society, change in often unpredictable ways, the Sunrise/Sunset strategy allows the Design Center to manage the evolution of products with designs that always stay one step ahead of the public's imagination. By following this pattern in a creative way, Sony can introduce a new product, build the market for it as the design and technology evolve, dominate that market as the design reaches icon status, expand the market with variations on the icon as the audience grows in number and divides into distinct groups, and saturate the market with multiple expressions, each new design being more "pure" or "extreme" than the one it replaces. As the underlying technology ages and nears obsolescence at Sunset or just beyond, the design reaches the point of absolute expression, when the fireworks begin. This

Good evening

explains why Sony designers consider Sunset the most beautiful time of day.

Just as the hours of the clock follow the same pattern every day, allowing us to look at the sun and judge the approximate time at any moment of the day, the Sunrise/Sunset paradigm allows the Design Center to analyze a product at any point in its evolution, ask "What time is it?" and make a design that will excite customers and confound the competition by advancing the clock.

To understand the concept, imagine that an entire product line evolves, from first appearance to final design, within a single day. Divide that day into seven phases: sunrise, early morning, late morning, noon, early afternoon, late afternoon, and sunset. If the product line (and its audience) is large—such as the radio or cassette Walkman—an eighth phase can be added that extends beyond Sunset, called Perpetual Sunset. Don't assign products to each time of day too quickly. Instead, decide what qualities a product would need to succeed at any particular moment. Take into account that first products are often experimental and too expensive,

Radio

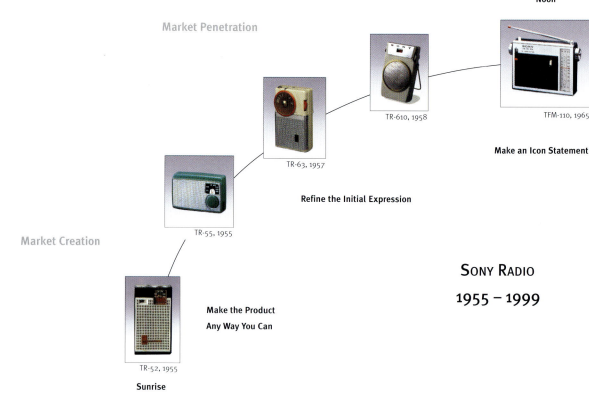

Market Domination
Noon

Market Penetration

TR-610, 1958

TFM-110, 1965

Make an Icon Statement

TR-63, 1957

Refine the Initial Expression

TR-55, 1955

Market Creation

**SONY RADIO
1955 – 1999**

**Make the Product
Any Way You Can**

TR-52, 1955

Sunrise

with more attention given to the engineering than to the design, and thus bear little resemblance to the "ultimate" design that will appear in the months to come. As competition increases, the urge to create a "knockout" version of the product will result in a design that is later seen as the "icon" from which all succeeding versions will flow. As product volumes grow, the multiplicity of tastes that exist in society will require that the design and feature set appeal to many different audiences at once, causing the product line to split into two or more families. Rising sales and falling unit prices accelerate as the turnover from one design to the next grows faster and faster. Gradually, cosmetic issues, image and fashion become more important than technology or features. Then, as the shadows of afternoon grow longer and Sunset approaches, the most beautiful moment arrives. As new designs appear, they adopt multiple personalities as they pursue ever smaller and more particular niche groups. Elegance, expression and personality become so strong that they often ignore reason and become as unique as the people who buy them—which makes Sunset the most interesting phase in the life of a product. Finally, with the market still strong, Sunset becomes perpetual, allowing product evolution to slowly decelerate and product styles to coalesce into a few distinct statements. High-end elegant designs become rarified, a bit too small for comfort and so complex they force the user to work in order to use the product. Yet we worship these products and almost welcome the inconvenience. Youth and sports versions

evolve from fashion to eye candy. Visual jokes and cartoon-like imagery abounds. Sexual references become explicit. Conservative designs adopt mixed functionality in order to stay relevant. And more products for older users gradually appear (as a product line ages, so do its users).

Occasionally, while searching for a unique concept or image at or beyond sunset, a designer will achieve a breakthrough. Otherwise, the task at sunset is to create a story for the product that allows it to transcend its everyday existence and achieve mythic status. Just as engineering overshadows design in the morning of a product's life, at the end of the day, the design is king. The result is that sunset products often mean more to the mind than they do in fact. Imagery, fashion, symbolism and storytelling are more apparent than technology, and sometimes more important than function. This condition remains fixed until the last customer purchases the last product. For in the life of Sony products, all sunsets are perpetual until the market is exhausted.

To see the evolution in full, one need only look at the first (and therefore the oldest) product line in the Sony family: the radio. As the first mass-produced Japanese design to achieve international status and the first product to carry the Sony name, the transistor radio was the engine that powered Sony during its early years and provided profits that were later invested in a broad range of products and technologies that, in turn, fed its continued growth.

The radio is central to any understanding of Sony design, for all the maneuvers and tricks injected into

later products can be found in the radio's evolution. Though the original radio designers didn't know it at the time, their instincts would set a pattern that would be repeated in infinite variety in more than a dozen different product lines to come.

Old yet ageless, radio technology reached Perpetual Sunset years ago, yet remains so durable that we can only marvel at the variations that now exist. The origins of the Sony radio date back to March 1925, when the first pirate radio station in Japan emitted a weak signal from a rooftop in the Shibaura section of Tokyo (the same district in which Sony's team of radio designers work today). Among the handful of listeners of that first Japanese broadcast was Masaru Ibuka, who used a handbuilt three-tube radio and a pair of rudimentary headphones to pull in the scratchy signal. After founding his own company, Mr. Ibuka wanted to produce the first pocket-sized transistor radio in Japan, which was released to the market as the TR-55 in 1955 (see sidebar). After two years of development came the TR-63, the first product to carry the Sony name and the first radio of any kind to have a fully resolved case design with a silver perforated speaker in the lower section, a nifty beltline around the middle and a bright red rotary dial set against a canary yellow body. Evolving the form another step, Ibuka's radio team slimmed the underlying mechanism, reduced the case to minimum size, transferred the round element from the dial to the speaker and gave the next model, the TR-610, a support strut on the back, allowing the radio to lean back in a now-classic gesture.

28

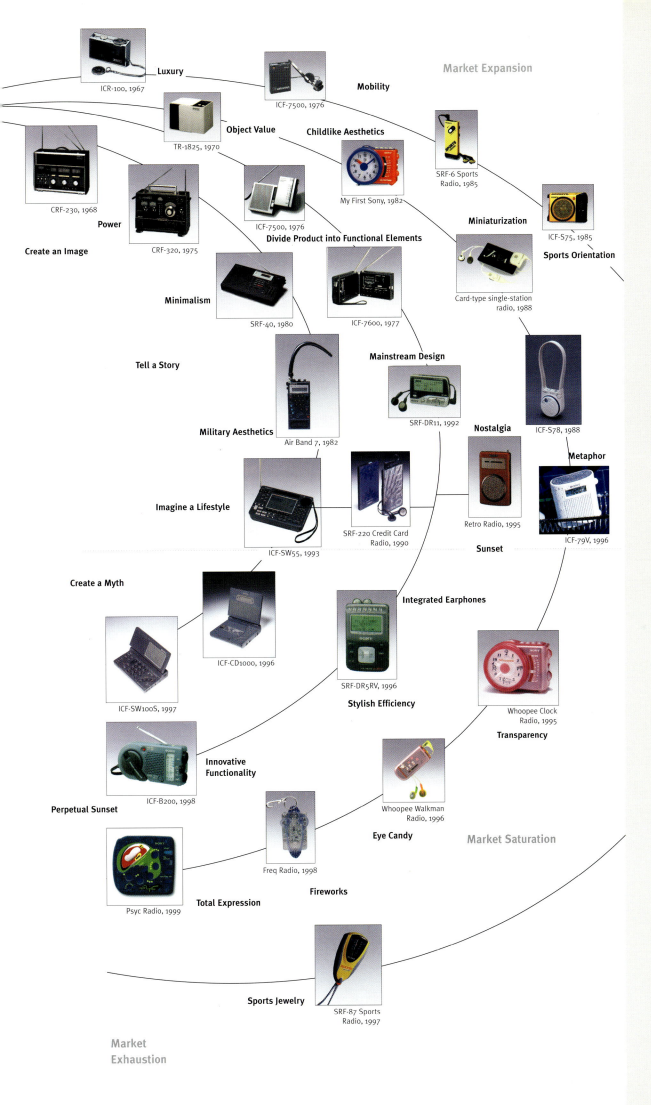

Luxury
ICR-100, 1967

Mobility
ICF-7500, 1976

Market Expansion

Object Value
TR-1825, 1970

Childlike Aesthetics

SRF-6 Sports
Radio, 1985

CRF-230, 1968

Power

Create an Image

CRF-320, 1975

Divide Product into Functional Elements

My First Sony, 1982

Miniaturization

ICF-7500, 1976

ICF-S75, 1985

Sports Orientation

Minimalism

SRF-40, 1980

ICF-7600, 1977

Card-type single-station
radio, 1988

Tell a Story

Mainstream Design

Nostalgia

ICF-S78, 1988

Military Aesthetics

Air Band 7, 1982

SRF-DR11, 1992

Metaphor

Retro Radio, 1995

ICF-79V, 1996

Imagine a Lifestyle

SRF-220 Credit Card
Radio, 1990

Sunset

ICF-SW55, 1993

Create a Myth

Integrated Earphones

ICF-CD1000, 1996

ICF-SW100S, 1997

SRF-DR5RV, 1996

Stylish Efficiency

Whoopee Clock
Radio, 1995

Transparency

Innovative
Functionality

ICF-B200, 1998

Perpetual Sunset

Whoopee Walkman
Radio, 1996

Eye Candy

Market Saturation

Freq Radio, 1998

Fireworks

Total Expression

Psyc Radio, 1999

Sports Jewelry

SRF-87 Sports
Radio, 1997

Market
Exhaustion

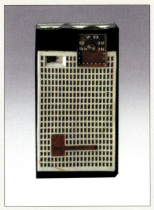

The Radio No One Ever Saw

After months of effort to produce the world's first transistor radio in 1954, Sony researchers were dismayed to learn that a now-defunct American firm named Regency had won the title with their TR-1 model, released in December of that year. Undaunted, the Sony engineers completed the prototype for their first radio, the TR-52, a few weeks later, and soon received an order of 100,000 units from the American watchmaker Bulova—but only with the condition that the radio *not* carry the Sony name. After lengthy discussions, company founders agreed to reject Bulova's demand and distribute the product themselves. Nicknamed the "UN Building Radio"—in reference to the white latticework on the front, which resembles the grid on the front of the UN headquarters in New York—the cute little product was supposed to be the first consumer electronic to carry the Sony name. Instead, disaster struck. The problem occurred in May 1955. As summer temperatures inside the Sony factory rose, the front lattice section on many TR-52s began to peel away, making the radios unsalable. Eventually, the entire product was scrapped and redesigned. But the cabinet incident served as a good lesson. Instead of designing for appearance alone, Sony designers agreed to emphasize quality and performance as well. In August 1955 the remodeled TR-55 succeeded on both counts and became Japan's first pocket-sized transistor radio.

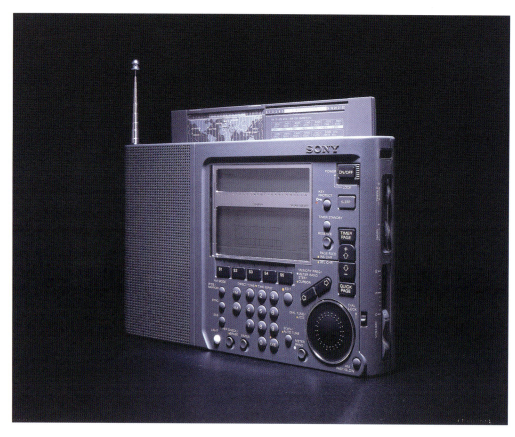

This page, above: ICF-SW77 World Band Radio. Design: Shuhei Taniguchi (DC/Tokyo), 1994. Below left: Air Band 7 Radio Frequency Scanner. Design: Shuhei Taniguchi (DC/Tokyo), 1982. Below middle: Credit card AM/FM radios ICR-520 and SRF-220. Design: PAV Design Center, 1990. Below right: ICF-SW100S World Band Radio. Design: Keisuke Tejima (DC/Tokyo), 1997. Opposite page: ICF-SW55 World Band Receiver. Design: Atsushi Kawase (DC/Tokyo), 1993.

Sony's radio designers gradually simplified their approach, stripped the products of their color and excess decoration, retaining enough detail and texture to give the design good hand-feel, formalized functional details and completed the package by clothing the design in black and silver plastic, which no one else was using at the time. First implemented in the TFM-110 radio, released in 1965, the Black and Silver Design Language quickly spread to every product in the Sony family.

As Shuhei Taniguchi recalls, "Black and Silver reflected Sony's corporate philosophy by being simple and easy to recognize, with a personality that speaks to every country in a voice that is neither masculine nor feminine." By unifying Sony's design at a key moment in the radio's evolution, the TFM-110 became the icon in Sony's radio family—the form that all later radios, from $20 throwaways to $500 world band receivers, would follow.

Each of Sony's early radios were stand-alone designs that existed in a step-by-step progression, with each design more distinctive than the last. But by the mid-1960s, Sony's product line had grown far beyond the radio. With tape recorders, portable televisions and other electronics now bearing the Sony name and selling in markets around the world, the Design Center's first director, Norio Ohga, encouraged the form-givers to invest their designs with a more unified approach. Although the term "design language" had not yet been coined and few international firms were using design in a strategic way, Mr. Ohga wanted all of Sony's products to have

the same visual language. But he didn't know what that language would be or how it would be developed. In his weekly meetings at the Design Center, he conducted a Socratic dialogue with his designers, says Shuhei Taniguchi, who crafted many of Sony's early product icons. "Mr. Ohga never told us what we should do. Nor did he have a clear idea of what kind of image we should create. Instead, he asked us questions and made observations that we would respond to. Over the course of a few months, we would react to each meeting by creating a new set of concepts that evolved over time." Eschewing the playful character found in the TR-63 and TR-610,

Though no one at the Design Center was aware of it at the time, the decisions that radio designers would make in the 1960s would establish a pattern for Sony's product evolution that later designers would treat as a golden rule. First, you create the market with bold, innovative products. Refine that approach. Create the icon that everyone recognizes as the "best of the best." Then split that icon statement into two or more families. Allow each family to evolve along its own trajectory as the market broadens. Ride the tiger until the market is saturated.

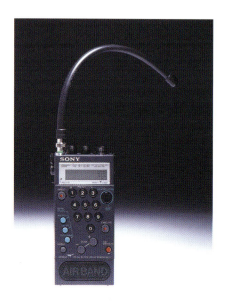

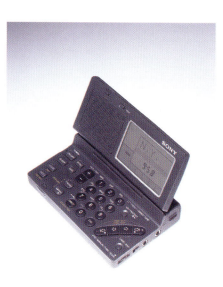

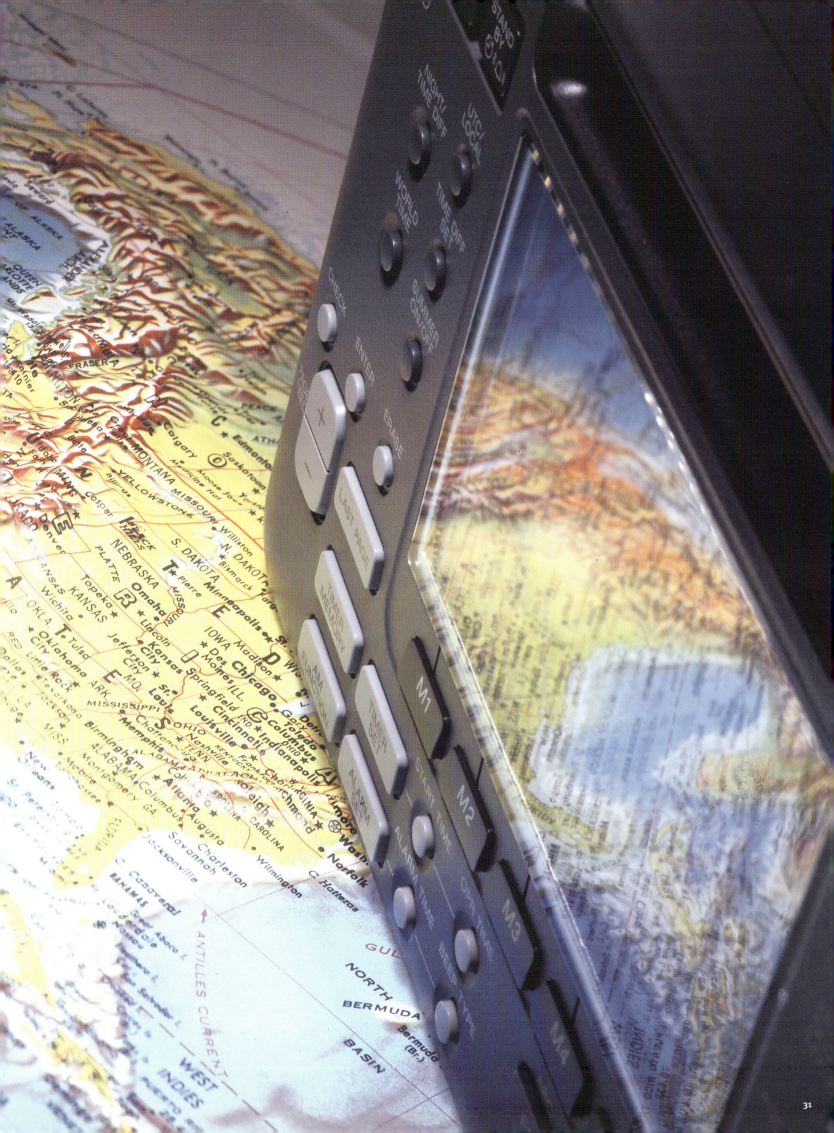

Above: The ICF-B200 Portable Emergency Radio highlights the hand-cranked battery recharger in a form that fits comfortably in the hand and has a sturdy look and feel. Design: Katsuhisa Hakoda (DC/Tokyo). Below: Sony's perpetual sunset portable radios explore a never-ending series of variations on a now-common theme. Opposite page: The Whoopee Clock radio comes in new eye-popping colors developed by the DC's graphic design department. Design: Miwako Tsukada (DC/Tokyo), 1997.

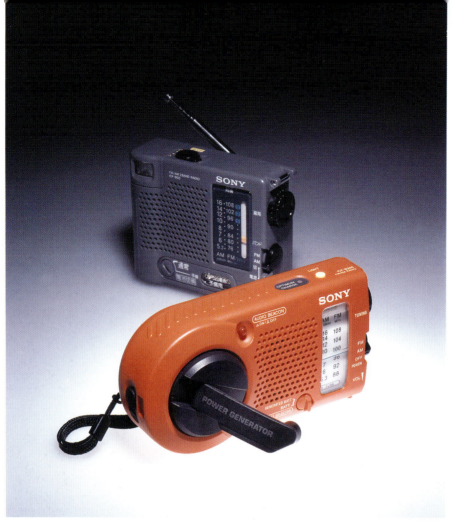

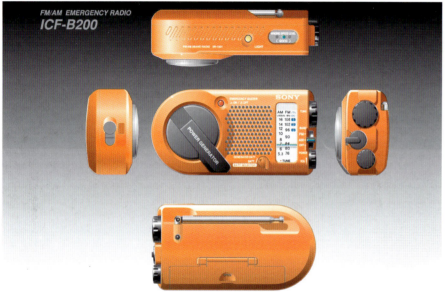

FM/AM EMERGENCY RADIO
ICF-B200

Then narrow your design statements into a few distinct expressions.

In the evolution of the Sony radio, the success of the TFM-110 caused the design to split into four expressions: a hard-edged, high-tech version with world band tuning that evolved into ever more powerful, elegant and sophisticated forms; a mass-market, middle-of-the-road line that offered inventive yet predictable forms and details for the average radio listener; portable units that offered greater expression and personality; and a sports line that turned radio listening into a lifestyle activity. Once Sony designers had departed from the icon statement, the powerful, minimalist, even militaristic look of the world band radio line (epitomized by the CRF-320 and the Air Band 7, both designed by Shuhei Taniguchi in Tokyo) bore no resemblance to the design of mainstream products, such as ICF-7500, which split the radio's functionality into separate tuner and speaker elements, or the My First Sony clock/radio, which gave the technology a bold candy-color exterior.

As radio circuitry becomes denser and the size of the receiver shrinks, the sunset expression in the elegant/sophisticated line combines maximum functionality in a product that is just large enough for human fingers to manipulate. The prime example is the ICF-SW100S, which is small enough to fit into palm of your hand, yet can pull in any radio signal available to the general public. The size/sensitivity ratio of the SW100S is truly amazing. Yet the drawback is the internal speaker, which is so small it will make you reach for your earphone as soon as you turn the unit on. Like all sunset products, the SW100S's perfection exists more in the user's mind than it does in reality. It's about the *idea* of radio listening, not the fact of it.

The natural desire to miniaturize the radio, an urge inherent in all Sony design, has resulted in the radio's shrinking to the size of a credit card. First released as single-station receivers, the credit-card radio came about in the 1970s, when even the largest Japanese cities, such as Tokyo and Yokahama, had only a few radio stations. In order to dominate their markets, these radio stations would order single-station credit-card receivers by the thousand, decorate the tiny units with graphics that made them look like advertising cards, and sell them cheaply or, on occasion, give them away. Though it's hard to believe today, ten years ago there were only two FM radio stations in the entire Tokyo region. When a third station, FM

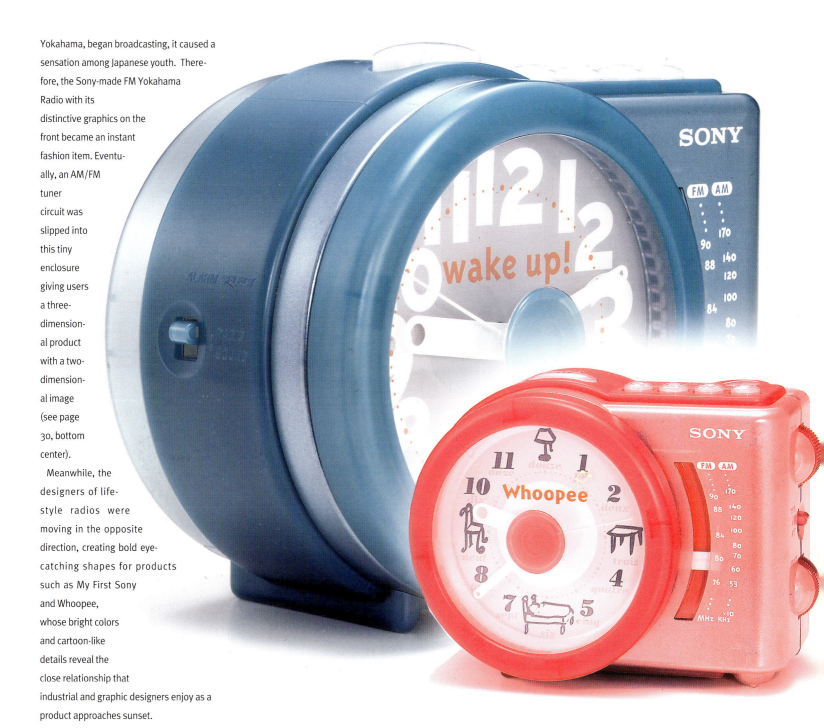

Yokahama, began broadcasting, it caused a sensation among Japanese youth. Therefore, the Sony-made FM Yokahama Radio with its distinctive graphics on the front became an instant fashion item. Eventually, an AM/FM tuner circuit was slipped into this tiny enclosure giving users a three-dimensional product with a two-dimensional image (see page 30, bottom center).

Meanwhile, the designers of life-style radios were moving in the opposite direction, creating bold eye-catching shapes for products such as My First Sony and Whoopee, whose bright colors and cartoon-like details reveal the close relationship that industrial and graphic designers enjoy as a product approaches sunset.

As audiences divide into smaller niches during the afternoon and evening, sunset signals the time when Sony designs reach their purest and most extreme state. Visual fireworks, eye-candy designs, humor, functional gymnastics and sophistication bordering on absurdity are all possible when a product nears the end of its life cycle. Indeed, anything a designer can do to keep a Perpetual Sunset product fresh, if only for a few months, is permissible.

Once the most extreme design statements are recorded, the pace of change begins to slow. Yet even in the dimmest light, a breakthrough can occur that can make a product young again. A classic example is the Sony ICF-B200 Emergency Radio, which features a hand-operated crank on the front

and a generator and rechargeable battery inside that keeps the radio playing even when conventional batteries wear out. For the middle-of-the-road family, typified by the all-in-one, metal-jacketed pocket radio, which Sony churns out by the thousands every month, the goal is to maintain an air of stylish efficiency that thrills no one and offends no one. Minor function improvements such as integrated earphones, oversized buttons or an enlarged LCD screen to make tuning the product easier for weak eyes and arthritic fingers keep the product fresh in the buyer's mind. Otherwise the middle-of-the-road design functions in a consistent way, reminding us

that sometimes the best surprise is no surprise.

The evolution of the radio from the first Sunrise design half a century ago to today's exuberant Sunset models illustrates the range of product types and design expressions that are possible in a product whose underlying technology has not changed.

Even more startling is the progression when a product experiences a sudden shift in technology. The second oldest of Sony's product lines, the voice recorder, demonstrates this phenomenon. From complex machine to solid state device, the voice recorder shows that as the technology simplifies, the design challenge grows ever more difficult.

Market Penetration

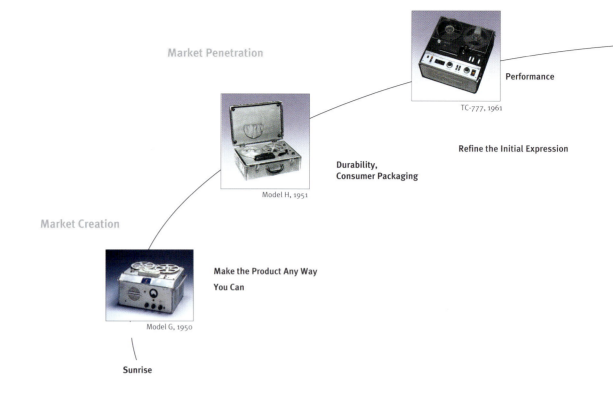

Performance

TC-777, 1961

Refine the Initial Expression

Durability,
Consumer Packaging

Model H, 1951

Market Creation

Make the Product Any Way
You Can

Model G, 1950

Sunrise

With its cool metallic skin, gorgeous details and over-the-top digital tape technology, the NT-2 handheld recorder embodies everything we expect in a Sunset product. Design: Takahiro Tsuge and Mitsuhiro Nakamura (DC/Tokyo), 1995.

Like the radio, the evolution of the magnetic tape recorder dates back to Sony's earliest days. Such machines were rare in Japan in the late 1940s and mostly reserved for military use. Yet Ibuka and Morita got a close look at one at NHK Studios in 1947 and immediately decided to make one for consumer use. After many trials and errors, Sony's engineers developed the metal oxide formula that allowed them to produce magnetic paper tape in 1949, built a prototype "talking paper" tape recorder in September of that year and released the Model G (for institutional use—G was short for government) with "Soni-Tape" magnetic media in 1950, the Model H (for home use) in 1951 and later models with stereophonic sound and transistor technology. In the 1960s Norio Ohga, section manager of the Tape Recorder Division, began the push to make reel-to-reel tape recorders easier to use with the TC-357, known as the SONY-O-MATIC Seven, which offered automatic recording, and the TC-777 in 1961, which delivered superb sound reproduction and a refined design. At the same time, Mr. Ohga began to recognize the limitations of reel-to-reel recording.

Mr. Ohga realized that before easy-to-use tape recorders could become a reality, Sony would have to create a worldwide standard for magnetic tape cartridges that eliminated threading tape. Even though Sony was Japan's leading tape

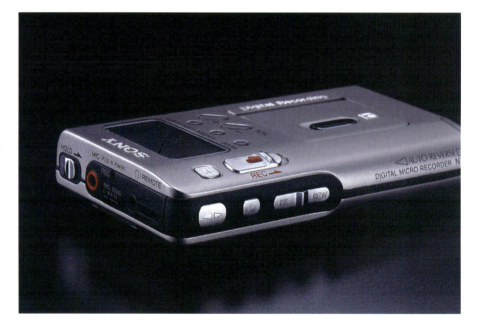

recorder manufacturer, they could not create a worldwide standard alone. So Mr. Ohga struck a deal with the Dutch giant Philips, N.V. to co-develop a compact tape cassette and in 1961 launched the TC-100 "Magazine-matic" cassette tape recorder, which used the new compact cassette standard. Weighing seven pounds, the TC-100 was less than half the weight of the lightest reel-to-reel tape recorder. Yet it was still too large for mass consumption and could not match the sound quality of a reel-to-reel machine. Seven years later, both problems were solved with the release of the TC-50,

which produced high-quality recordings with its built-in microphone, yet was no larger than a paperback book—a feat of miniaturization that was considerable even for Sony. Like the Sony radios at this time, the TC-50 was clothed in the Black and Silver Design Language. Yet because of its slim dimensions, the product was more silver than black. "The TC-50 was small in size, but it was not particularly light. So we minimized the use of black on the case," explains Mr. Ohga.

Because the voice recorder is often held in the hand close to the face when in use, their design is

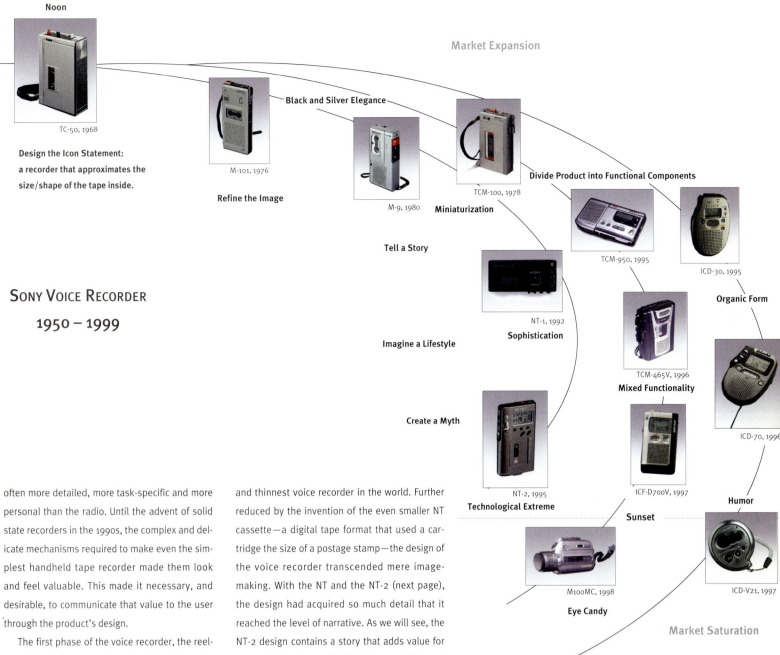

Noon

TC-50, 1968

Design the Icon Statement:
a recorder that approximates the
size/shape of the tape inside.

Market Expansion

Black and Silver Elegance

M-101, 1976

Refine the Image

TCM-100, 1978

M-9, 1980 Miniaturization

Divide Product into Functional Components

TCM-950, 1995

ICD-30, 1995

Tell a Story

Organic Form

NT-1, 1992 Sophistication

Imagine a Lifestyle

TCM-465V, 1996

Mixed Functionality

ICD-70, 1996

Create a Myth

NT-2, 1995
Technological Extreme

ICF-D700V, 1997

Sunset

Humor

ICD-V21, 1997

M100MC, 1998

Eye Candy

Market Saturation

SONY VOICE RECORDER
1950 – 1999

often more detailed, more task-specific and more personal than the radio. Until the advent of solid state recorders in the 1990s, the complex and delicate mechanisms required to make even the simplest handheld tape recorder made them look and feel valuable. This made it necessary, and desirable, to communicate that value to the user through the product's design.

The first phase of the voice recorder, the reel-to-reel period, was engineering-driven. Its main preoccupations were getting the first models out the door, perfecting the mechanism and providing the best possible sound. The second phase was design-driven. Its goal was to create an icon, the TC-50, that would forever change the way we see and use the voice recorder. Since all later products stem from the icon, the third phase of design evolution involves giving the icon statement the right image, or, in the case of the voice recorder, a range of images that are infused with narrative, lifestyle references and the strongest pull a design can exert: pure desire.

Like the radio, the evolution of the voice recorder falls into several distinct families. The first of these, the Elegant/Sophisticated line, gave rise to another round of miniaturization, which yielded the microcassette, a matchbook-sized tape cartridge that made the M-101 microcassette recorder, released in 1976, the smallest

and thinnest voice recorder in the world. Further reduced by the invention of the even smaller NT cassette—a digital tape format that used a cartridge the size of a postage stamp—the design of the voice recorder transcended mere image-making. With the NT and the NT-2 (next page), the design had acquired so much detail that it reached the level of narrative. As we will see, the NT-2 design contains a story that adds value for users who push a product's buttons and demand that the product push their buttons as well.

The mass-market line of voice recorders achieved optimum size (as close to the size of a cassette as conventional mechanisms will allow) with the TCM-100, split the product into recorder and speaker elements with the TCM-950, added functionality to keep up with middle-class expectations and achieved expression in recent models (such as the M100MC) as tape technology approaches obsolescence.

Pushing tape technology to an early grave is the task of the third, and most interesting, family of voice recorder, which uses IC memory chips to store sounds rather than magnetic media. With no mechanical elements inside, the IC recorder can be any size or shape. The functional and expressive possibilities of IC recorder designs have given this "ancient" product line a new life, which the Design Center is sure to exploit.

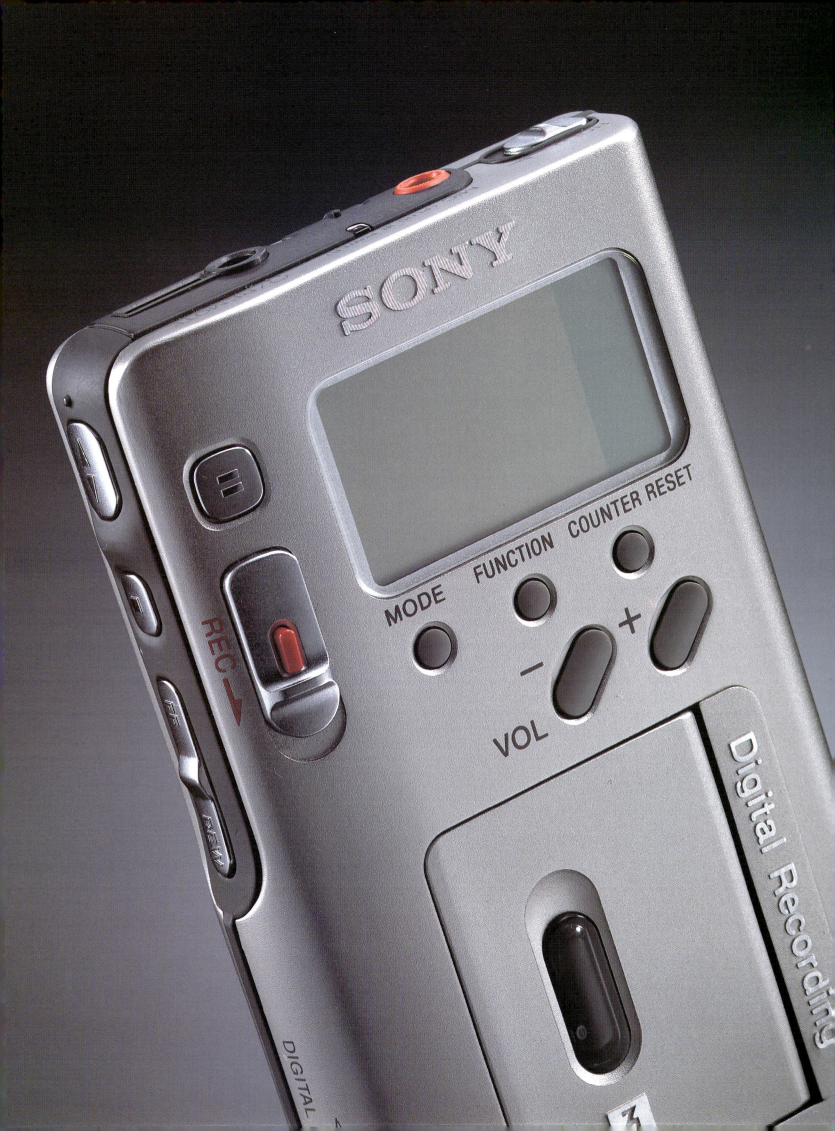

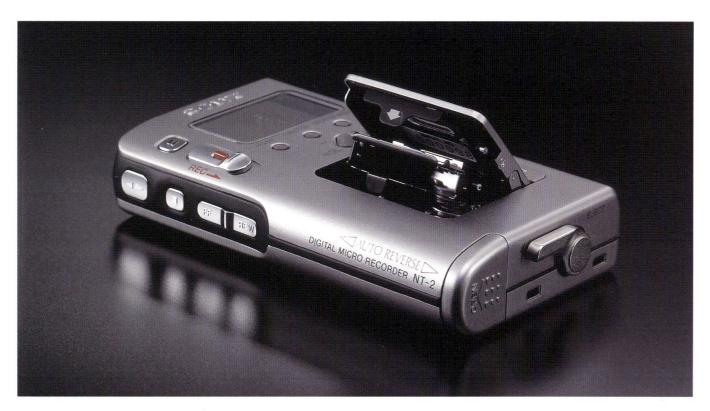

Once a product icon has been established, the most enjoyable experience for a designer is to craft a "pure" interpretation of the icon using technology that ensures the product will stand alone. No one will ever exceed the level of difficulty or technical refinement found in the NT-2 Digital Recorder. Rather than use a standard analog tape mechanism, a DAT device of an MD recorder, the NT-2 incorporates the same digital tape transport found in Sony's finest digital video camcorders—making it the most exotic voice capturing device on the planet. The design, by Takahiro Tsuge and Mitsuhiro Nakamura of DC/Tokyo, carries this idea to its logical extreme by giving the NT-2 a closed form, quiet strength, cool metallic feel and an almost hermetic expression that speaks in a very soft, controlled tone of voice.

Everything about the NT-2 speaks of excess and luxury: from the postage stamp-sized tape cassette, which is so small it sometimes difficult to insert in the tiny opening, to the beautiful flush-mounted LCD on top, the jewel-like brushed titanium finish, the feather-soft buttons to the marvelous mechanical action when you set the tape in motion. It doesn't have to shout to draw attention. Everything we see, even the tiny embossed product graphics on the top surface, speaks of perfection. It is a true power object.

As a replacement for the earlier black box NT, the NT-2 shows how much can be accomplished with the simplest of means. Perfect proportions, soft

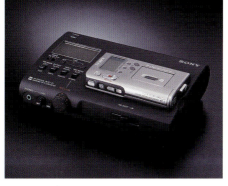

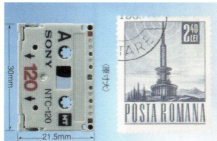

corner treatments, an incredibly solid case with a black elastomer belt around its perimeter and a flush-mounted cassette door on top that is accessed using a nifty camera-style release lever on the end (a detail suggested by PAV manager Kazuo Ichikawa), give the NT-2 a level of quality that few Sony products can match. Fitted to a recording deck (above), it can make CD-quality recordings and play them back with astonishing quality. According to Mr. Tsuge, "products such as NT-2 are not meant to sell in large numbers. They are designed to fulfill Sony's original mission,

which is to never be satisfied, to always use technology in unique ways and to push the outer boundaries of human experience."

If you don't believe Mr. Tsuge, just pick up the NT-2, cradle it in your hands, listen to the mechanism purr, watch the images on the LCD dance as you record a brief message, and you will be hooked. For this is not design in the normal sense. This is the most rarefied form of industrial sculpture: a product that generates pure desire. "At the top of the product scale, users appreciate a product that is so capable we have to learn its secrets," says Mr. Tsuge. "Just using a product such as NT-2 confers a sense of power to the user. The shape and mechanical action exude a sense of quality and exclusivity. You feel better about yourself just by holding it." Yet, for all its power and prestige, the NT-2 falls behind the newest digital recorders in one key respect: By using tape technology, which records data in a linear format, it does not offer random access. As such, the NT-2 does not fit with Sony's convergence strategy, in which all digital products—from computers, AV equipment and cameras to telephones and voice recorders—will communicate and exchange information seamlessly.

Despite its lapidary quality, its air of mystery and over-the-top technology, the NT-2 belongs to the past—a past in which products conferred power on the user and demanded worship in return. But that old relationship between product and user is changing.

The NT-2 Digital Recorder (opposite and above) and NT-2 Desktop Recording Deck (this page, center) represents the ultimate in tape-based voice recording technology, making it a true sunset expression. The NT digital tape cassette (this page, below) is no larger than a postage stamp. Design: Takahiro Tsuge and Mitsuhiro Nakamura (DC/Tokyo), 1995.

The ICD-30 and ICD-70 IC Recorder uses memory chips instead of tape to record sounds allowing the product to fit the hand rather than conform to the mechanism inside. Design: Satoshi Masamitsu (DC/Tokyo), 1996.

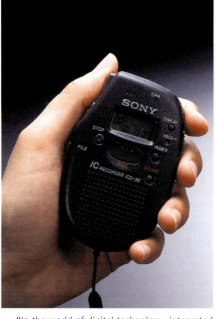

"In the world of digital technology, integrated circuits have replaced mechanical systems and have cast away their limitations in the bargain," says DC/Tokyo's senior general manager John Inaba. "Since the internal mechanism inside a voice recorder has been replaced by computer chips, the design does not have to accommodate that bulky mechanism. Today, nearly any form is possible. Thus, we are developing a completely new design paradigm, allowing us to design products that are dictated not by the cold requirements of technology, but the more human values of culture and tradition."

The transformation from mechanical to IC (integrated chip) recording devices has liberated form from function and spawned a new style of user interaction. Ideally, when we push the product's buttons, the product should push our buttons.

While crafting this new relationship, DC/Tokyo designer Satoshi Masamitsu realized that an IC recorder would offer a very different tactile experience than a mechanical product. "All our lives, we've picked up the tape recorder, felt that slight resistance as we press the record button and felt good about the smoothness of that experience."

The interaction between our hand and a well-designed mechanical product gives value to the product. Since the IC recorder has no motor or tape, and thus no mechanism, Mr. Masamitsu could give it a form and interface that are totally natural. Echoing the corner-mounted controls on Joe Wada's Spirit concepts (pages 16–19), he grouped the controls for his recorder in the upper left-hand corner, where the thumb of the user's left hand naturally falls, and married this idea to an organic shape that resembles a flattened pebble— the kind you would skip across a pond. The LCD readout and speaker mirror the eyes and mouth on a human face, with sight elements on top and sound elements below.

Like the Sports Walkman, the IC recorder is task-specific and meant to be used on the go. Thus the form and details are designed for two-handed activity, encouraging the user to hold the product in the left hand and control it with the thumb while using the telephone, holding a briefcase or driving a car with the right hand. "People often record voice notes while doing something else," says the designer. "It's not a primary activity. It's something you do 'in addition' . . . so designing for left-handed operation made sense for the vast majority of users who are right-handed. With a new technology and a new design we expect a new form of interaction."

The ICD-30 and ICD-70, which incorporate this

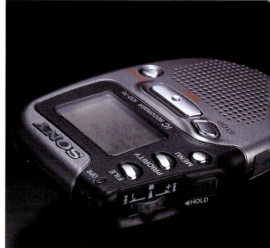

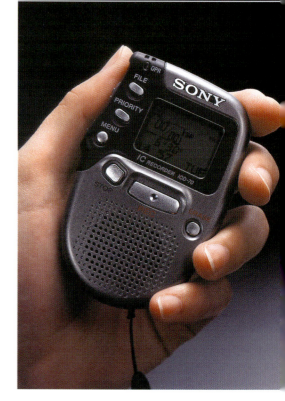

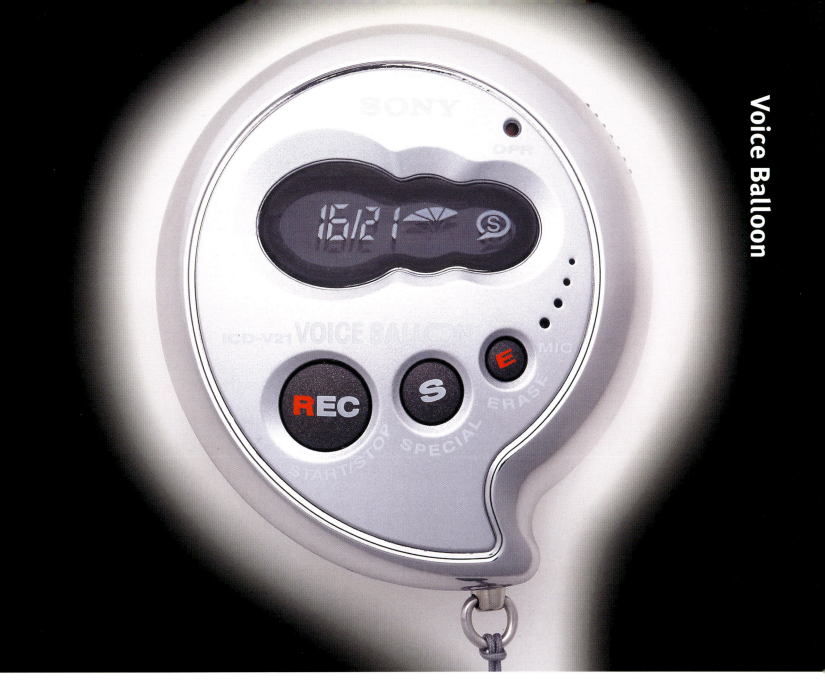

new design, represent a breakthrough in voice recording in other ways as well. Since voice notes are captured in a memory chip instead of on tape, it's easy to download your thoughts to a VAIO computer and store them as sound files. Using voice recognition software, the computer can transcribe your words into typed text. Or you can attach your voice to an e-mail message. This convergence of voice recording with computing and the Internet is the most profound shift in the fifty-year evolution that began with that first enormous Model G recorder in 1950.

Yet as afternoon designs, the ICD-30 and ICD-70 do not give us a "pure" expression. Their technology may be forward-looking, but their surface detailing focuses on the mundane task of differentiating one model from another. As an inexpensive product, the ICD-30 is given additional weight and value by cloaking it in a black exterior. For the ICD-70, a higher price point allows the designer to

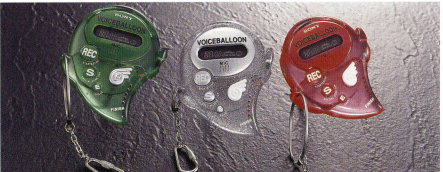

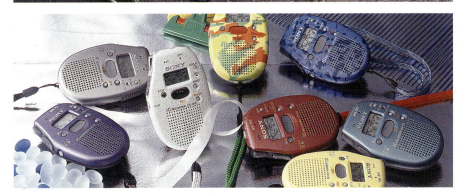

Above: The design for Voice Balloon transforms the IC Recorder with a heavy dose of humor. Design: Rumi Nakano (DC/Tokyo), 1998. Center and below: Future IC recorders will push form and color to the limit.

Above: The design for the M-950 Microcassette Recorder splits the product along functional lines, allowing the user to take only the recorder on trips and leave the speaker at home. Design: Shinichi Ogasawara (DC/Tokyo), 1996. Below: The mainstream TCM-465V design encloses the familiar side-control mechanism in a black and silver case with a pop-up omnidirectional microphone. Design: Shinichi Obata (DC/Tokyo), 1996.

use expressive chrome-capped buttons and a two-toned black and silver case, which reassures the user that no matter how new or unfamiliar the product, its values are rock-solid.

Of course, not every customer needs reassurance. For those who see IC recorders as liberation, a totally different design treatment is possible. Youth markets, in particular, demand that products excite the mind as well as perform a function.

"These days emotional and symbolic content are important to a product's function," says Rumi Nakano of DC/Tokyo, designer of the ICD-V21 memory chip recorder. For a generation raised on comic books (which in Japan appeal to adults as well as youngsters), the Voice Balloon IC recorder may be the ideal shape. Small and pebble-smooth like its cousins the ICD-30 and ICD-70, the Voice Balloon's detailing continues the theme by centering the LCD in a balloon-shaped recess and grouping the main controls in a series of buttons that start out large at the bottom, grow smaller as they travel up the product's face and trail off in a series of graduated holes that serve as a speaker grill. It's no surprise to learn that Ms. Nakano consulted with the Design Center graphic design department when designing the Voice Balloon.

The success of Voice Balloon has not only advanced the clock for the digital voice recorder, it has spurred the development of analog recorders as well. Like the radio family, the voice recorder entered the afternoon in three families, the largest being the mainstream line, which consists of both standard and microcassette products. Because microcassettes are smaller and more

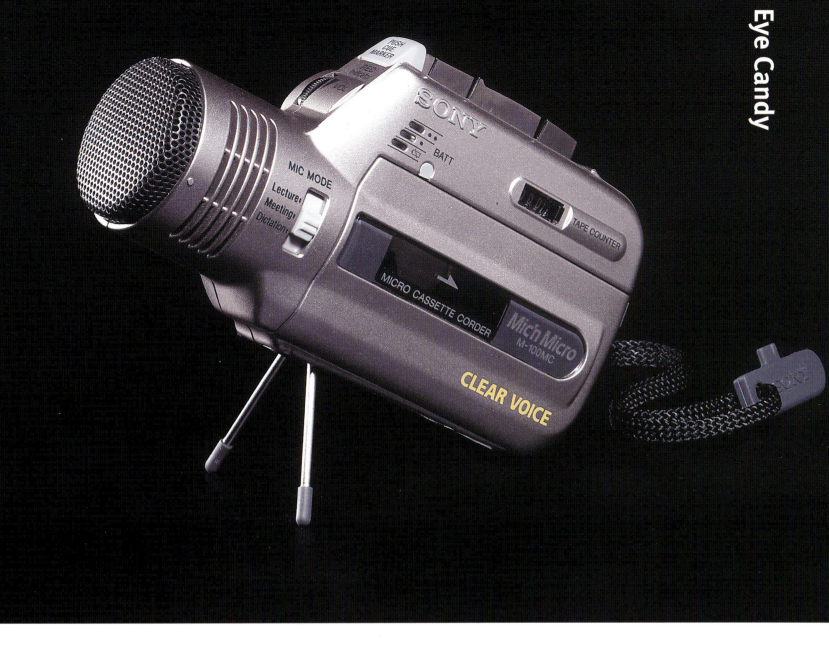

valuable than standard cassettes, an extra dose of expression and product variation is possible in their design. At Sony, all products that use removable media must evolve and shrink in size until they approximate the size of the media itself. Since recorders needed a speaker in order to function, this proved impossible for the microcassette until Shinichi Ogasawara designed the M-950 in 1995. By following a move made twenty years earlier in the radio line (the ICF-7500, page 29), Mr. Ogasawara split the product into separate speaker and recorder elements, allowing the user to slip the recorder section into a pocket without creating a bulge.

Compare this to the conventional cassette recorder, which has become the most difficult voice machine to design. Why? "Because it is so well known, and we've already performed every trick imaginable. There's very little left to discover," says PAV senior general manager Kazuo Ichikawa. "Since we've stopped designing new mechanisms for this kind of product and use the standard side-control assembly for most models, all we can do is change the surface treatment and add the occasional new feature. For the TCM-465V (shown opposite), that means adding a tiny pop-up microphone that allows the machine to gather sounds from all directions.

As the sun settles over the analog voice recorder, ideas that have been collected over the years and reserved for this moment finally come into play. Like fireworks shot into the air, these 3-D rockets burn bright for a season, then fall back to earth. The first, and most startling, of these confections is the M100MC "Mic 'n Micro" recorder, which encloses a microcassette mechanism in a body shaped like a tiny camcorder with a microphone on the front instead of a lens. But look again: When you flip down the integrated stand, the camera/voice recorder sits on its hindquarters, the lens on the front becomes a nose and the curly strap on the back becomes a tail. Is this a tiny camcorder or the smallest, cutest pot-bellied pig we've ever seen? Its designer, Akinari Mohri, isn't talking.

As we can see, today's voice recorder bears little resemblance to the product that existed only a few years ago. With other powerful cassette-based products, like the Walkman, rocketing forward with no signs of fatigue, the voice recorder cannot afford to lag behind.

Voice recorder, miniature camcorder or tiny pot-bellied pig? The M100MC is the most expressive analog voice recorder that Sony has ever produced. Design: Akinari Mohri (DC/Tokyo), 1997–98.

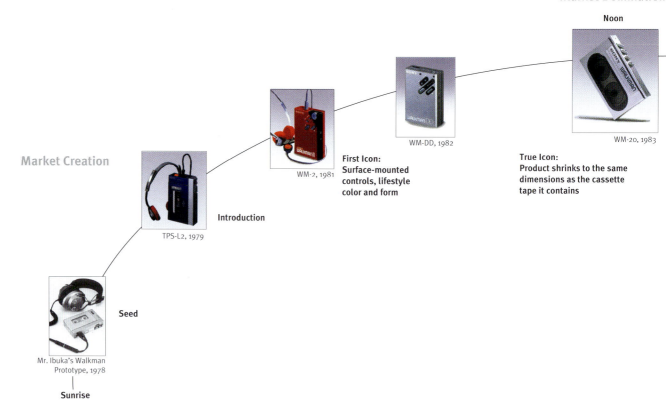

Noon

WM-20, 1983

True Icon:
Product shrinks to the same
dimensions as the cassette
tape it contains

WM-DD, 1982

First Icon:
Surface-mounted
controls, lifestyle
color and form

WM-2, 1981

Market Creation

Introduction

TPS-L2, 1979

Seed

Mr. Ibuka's Walkman
Prototype, 1978

Sunrise

**This page:
the majestic
WM-DD
Quartz may
be the most
seductive
portable tape
player ever
created.
It is now
considered a
collector's
item.
Design:
Joe Wada
(DC/Tokyo),
1988.**

By the end of the 1970s, stereo cassette tape machines were a cherished fixture in many homes and automobiles. Yet truly portable units were limited to monaural sound. In 1978, Sony added the small TC-DS stereo model, which was very popular among audiophiles, but was too heavy to be truly portable. Mr. Ibuka (then honorary chairman) was a regular user of the TC-DS, and would take one with a set of headphones virtually everywhere. Yet, eventually, even he considered it too heavy. One day, he asked Norio Ohga (then executive deputy president) to solve the problem. Mr. Ohga ordered his staff to alter a handheld Pressman recorder, removing the record function and converting the machine to produce stereo sound and attached a pair of large headphones. The sound was so good that Ohga quickly presented the unit to Ibuka, who then showed it to Morita (then chairman) and said, "Don't you think a stereo cassette player that you can listen to while walking around is a good idea?" Mr. Morita was excited by the fact that the device could be carried around easily, creating a personal listening experience. In February 1979, Morita called his staff together, held up the modified Pressman that Ibuka had given him and declared, "This is the product that will satisfy those young people who want to listen to music all day. They'll take it everywhere, and won't care about not being able to record. It will be a hit." The target market would be students and other young people, so the product must be launched before the start of summer vacation—just four months away.

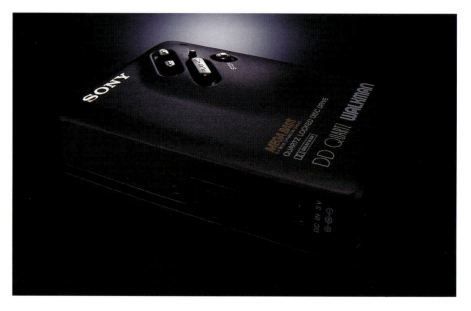

It was obvious to Morita that young people would fall in love with the new product. The only problem was that the headphones on Ibuka's prototype were bigger than the playback unit. Fortunately, Sony R&D had just finished the development of a fine-sounding over-the-ear headphone, called H•AIR, that weighed just fifty grams.

Given the tight time schedule, Morita told the team not to worry about the appearance of the first model. Using the same mechanism as the Pressman, half a million of which had already been manufactured, the first production run went slowly to ensure that the product was totally reliable. Toru Kohno and his young publicity department chose the name "Walkman" for the product. Advance units were sent to the Sony sales force and were greeted with skepticism from retailers, who did not believe that a cassette machine without recording function would sell. Yet, as sunrise for the Walkman approached, Morita and the entire Walkman team staked everything on its success.

The launch date of the TPS-L2—July 1, 1979—was a turning point for Sony. Never before had a product that was so new and different been developed so quickly and released with such success and with no competition. Soon, a worldwide market for personal audio that hadn't existed before, and was now synonymous with the name Walkman, which belonged to Sony. By the time competing models reached the market, the Walkman name was firmly established, and a follow-up model, the WM-2, the first Walkman icon, had been released.

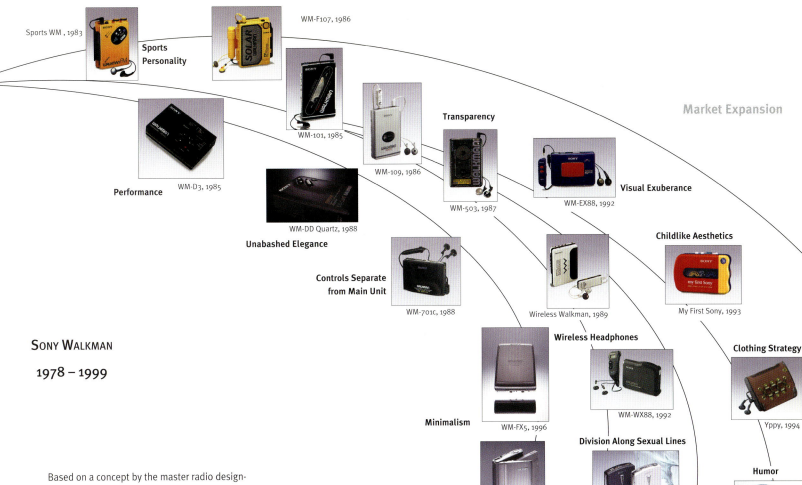

Sports WM , 1983

Sports Personality

WM-F107, 1986

Performance

WM-D3, 1985

WM-101, 1985

WM-109, 1986

Transparency

WM-503, 1987

Visual Exuberance

WM-EX88, 1992

Unabashed Elegance

WM-DD Quartz, 1988

Controls Separate from Main Unit

WM-701c, 1988

Wireless Walkman, 1989

Childlike Aesthetics

My First Sony, 1993

Wireless Headphones

WM-WX88, 1992

Clothing Strategy

Yppy, 1994

SONY WALKMAN

1978 – 1999

Minimalism

WM-FX5, 1996

Division Along Sexual Lines

WM-EX7, 1996

WM-WE7, 1996

Humor

WM-EQ series (aka "Beans"), 1997

Sunset

Based on a concept by the master radio design-er Shuhei Taniguchi for a product with surface-mounted controls, the WM-2 was developed under Mr. Morita's personal supervision and designed by the young master Kaoru Sumita, who acknowl-edges his debt to Mr. Taniguchi by calling him "the *real* father of the Walkman two." Yet others aren't so sure. By reducing the length, width and thick-ness of the first Walkman, Mr. Sumita made the WM-2 a unique product even before he decided to wrap it in bright red plastic—making the Walkman a "lifestyle" product long before that term had been invented.

Because the Walkman is a playback-only prod-uct with few internal parts, achieving the smallest possible size became an obsession—the goal being a product that was no larger than the plastic case that contains the tape cassette. After many sleepless nights, this impossible goal was achieved in 1983 with the WM-20—the true high-noon icon that signaled the division of the Walkman family. Even though there are more than 350 individual Walkman designs now in circulation, nearly all of them fall into the same basic categories as the Sony radio. These include: a sophisticated/ele-gant line emphasizing performance and high-value aesthetics; a mainstream line that empha-sizes functionality and convenience and later divides into products designed for male and female users; an expressive line that pursues image-mak-ing fashion and lifestyle objectives; and a Sports line, which is among the most popular of all.

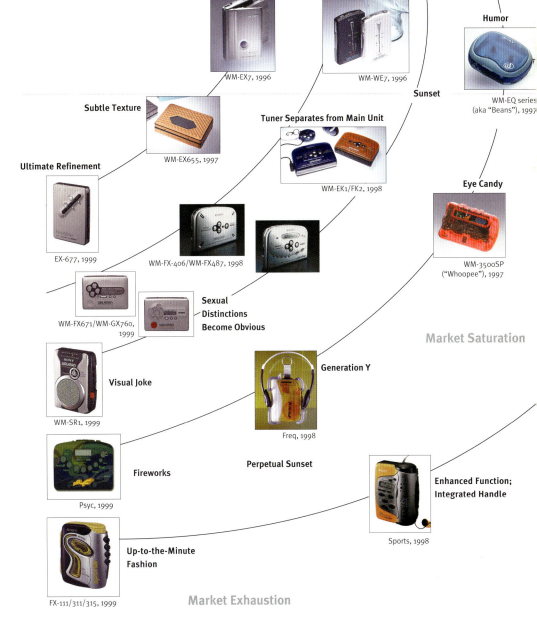

Subtle Texture

WM-EX655, 1997

Tuner Separates from Main Unit

WM-EK1/FK2, 1998

Eye Candy

WM-3500SP ("Whoopee"), 1997

Ultimate Refinement

EX-677, 1999

WM-FX-406/WM-FX487, 1998

WM-FX671/WM-GX760, 1999

Sexual Distinctions Become Obvious

Generation Y

Freq, 1998

Market Saturation

Visual Joke

WM-SR1, 1999

Perpetual Sunset

Enhanced Function; Integrated Handle

Sports, 1998

Fireworks

Psyc, 1999

Up-to-the-Minute Fashion

FX-111/311/315, 1999

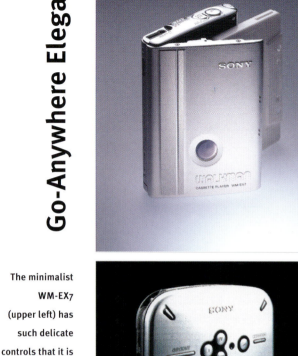

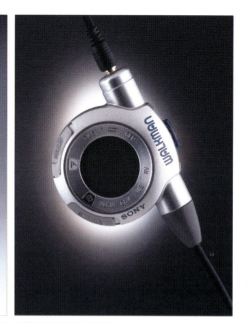

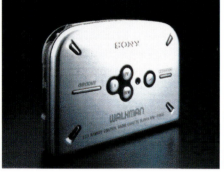

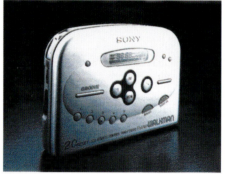

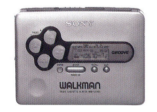

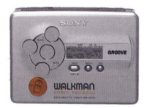

Go-Anywhere Elegance

The minimalist WM-EX7 (upper left) has such delicate controls that it is often paired with a watch-style remote commander (upper right). Design: Haruo Hayashi (DC/Tokyo), 1996. Remote commander design: Haruo Hayashi (DC/Tokyo), 1996. Center and bottom row: The slight male/female distinction in the WM-EX406/FX487 (center) became more apparent in the WM-FX671/GX670 (bottom). Design: Daisuke Ishii (EX406/FX487) and Tetsu Kataoka (FX671/GX670) (DC/Tokyo), 1997–98.

If we start from the high-noon icon, the WM-20 in 1983, the sophisticated/elegant family begins in the early afternoon with the WM-D3 (1985), evolves to the WM-DD Quartz (1988), which updated the WM-2 in an anodized metal body with a soft bulge on the top, evolves further to the WM-701C (1988) in midafternoon, a minimalist expression that separates the controls from the main unit by introducing a pen-shaped controller, then evolves to the simplest, most austere examples of Walkman design to date, the WM-EX5 (1995) and the WM-FX6 (1996), which signal the beginning of sunset. The Ex5's razor-thin shell has surface-mounted controls at the end; the equally thin FX6 has a mirror-smooth top cover and feather-touch controls on the underside. These feminine designs are so precious and delicate, you almost hate to use

them. Eventually, preciousness reaches an endpoint with the WM-EX655 (1997), which sports a Fabergé-like square box of minimal size with a quilted surface and ends with today's minimalist design, the EX670, which is little more than a box with raised controls mounted diagonally on top.

The mainstream Walkman line evolves from the WM-20 in a completely different way: first with stylistic and sexual variations such as the black WM-101 for men (1985) and the white WM-109 for women (1986), a product with a transparent cover, the WM-503 (1987) and the Wireless Walkman (1989) which eliminated the cord between the player and headphones by using a low-power transmitter (which sometimes created fun if more than one Wireless user happened to be listening in the same Tokyo subway car). That first Wireless Walkman

was intended for women; the follow-up model WX88 Wireless (1992) was for men. Thereafter, male and female versions of the same design were released simultaneously: first the WE7 Wireless (1996); then, the EK1/FK2, (1997), which separates the radio unit from the tape player and introduced a newly designed button treatment that would take on a male/female connotation in the follow-up his/hers model, which offers delicate crevices on the female version. Pushing that button as hard as possible, the current boy/girl model WM-FX671 (1999), emphasizes the male product in an overtly sexual reference that all users will notice. Moving forward, Sony designers have since turned the mainstream Walkman into a visual joke with the WM-SR1, (1999), which looks like a tiny loudspeaker with a simulated woofer and tweeter. Remember, it's sunset. Anything is possible.

As competition in the personal audio market intensified in the early 1990s, a new expressive family grew out of the mainstream Walkman line, the first being a candy-colored version of the WM-EX88 called the WM-EX77 (1992) with a separate controller as well as feather-touch controls on the player hidden behind a thin sliding door. But merely changing the Walkman's color wasn't enough. As markets and audiences were changing, true differentiation was needed to target consumers in a more specific way.

For years, the Design Center had wanted to give four- to eight-year-olds their own line of products. They got the chance in 1987 with My First Sony, conceived at the Park Ridge Design Center, with a newly designed Walkman whose body would return in new disguises for years to come. The success of My First Sony inspired a blizzard of new shapes, colors, surface treatments and names: such as Yppy (pronounced "Ip•pee") in 1994, designed for adults, which clothed the Walkman in canvas and leather-like materials whose color and texture had seasonal variation (bright greens for spring, somber colors for fall) and Whoopee (1997), which targeted the eight- to twelve-year-old segment with an exaggerated shape (based on My First Sony) dressed up in translucent candy colors.

While creating ever more specific models for various age and socio-economic groups, the most obvious differentiator of all—the difference between boys and girls—loomed large in the minds of many Sony designers. By the mid-1990s, the Design Center's packaging and graphic designers knew that sales of tape cassettes increase when

44

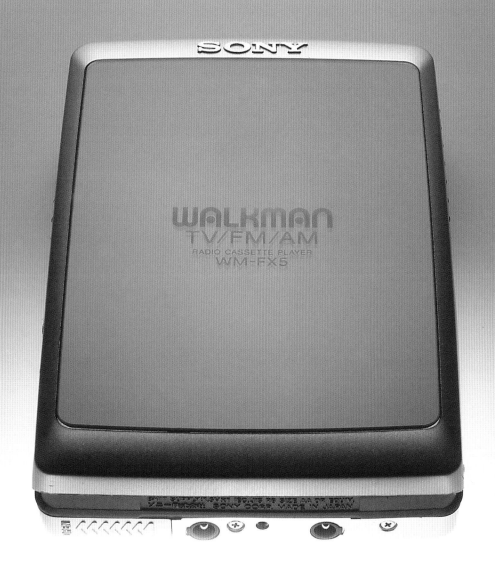

The 50th
Anniversary
Walkman,
WM-FX5, is the
ultimate in
elegant late-
afternoon
expression.
Design:
Takashi
Sogabe
(DC/Tokyo),
1996.

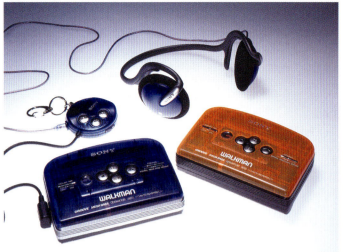

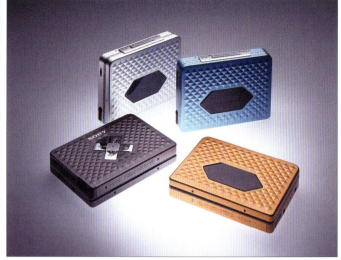

separate packaging schemes are designed for young boys and young girls (see page 120). Adolescent girls are particularly important, because in a male-dominated world, girls respond strongly to products designed specifically for them. This discovery inspired the design called Beans—the most intriguing of all 300-plus Walkman models. Given out as a routine project to Rie Isono, one of PAV's youngest and most accomplished female industrial designers, Beans was not considered an important job by PAV manager Kazuo Ichikawa. "In our minds, the Beans design would be targeted to high school girls, which meant it would have soft colors and a gentle shape. But Rie gave us much more."

With high school years still fresh in her memory, Ms. Isono instinctively knew what the product should be. But she did not begin with a specific image. It was important not to make the product seem obvious or cliched. To appeal to young girls, it had to be clever, yet honest. "I wanted to realize a breakthrough from conventional Walkman aesthetics, such as minimum size and the old-fashioned square-box-look," she recalls. "At the same time, I wanted to develop a characteristic form that could evolve into a series of products growing from the same basic form. For years, Sony has been successful designing high-tech products with a typical high-tech aesthetic. But I've always wanted to create products that could attract people with their emotional value." Her first foam model looked like a giant pebble, But when Ms. Isono applied different colors—apple red, royal blue and deep green—a colleague who peeked into Ms. Isono's cubicle said, "They look like jelly beans!" That off-hand remark not only gave the product its name, it helped focus Isono's thinking to make the product great.

Today, the Beans Walkman has sprouted an

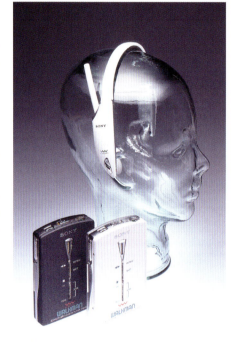

entire family of products—from the original single-colored plastic to multicolored, translucent and fluorescent models, a version covered in soft-feel plastic (with a quirky blue and orange skin), two glow-in-the-dark versions (with glowing earphones), and soon, a model that glows continually (drawing power from the product's internal battery). Beans's eye-catching shape and warm personality have redefined the Walkman icon, drawing it away from its boy-toy origins at precisely the moment when society was embracing products with a more feminine mien. The biggest surprise is that Beans—unlike most products targeted to girls—has crossed the sexual divide, appealing to young boys in a way that Ms. Isono never anticipated, thus influencing the approach that Sony designers give to a broad range of products. "The values reflected in our

work must change with the times," says DC/Tokyo senior general manager John Inaba. "The task we face is to carry forward the proven values of the past while always introducing new ones. For many products, that means effecting a transition away from technology-driven design toward a warmer, people-friendly approach."

Transplanting feminine virtues into a male-oriented product can be seen in the 1997 redesign of the Sports Walkman conducted by PAV designer Tetsu Kataoka. An inveterate outdoorsman and snowboard enthusiast, Mr. Kataoka embodies the sporting life not only in his choice of dress (cable knit sweaters, hiking boots and fur-trimmed parka) but in the intelligence and care he gives to products intended for people in motion. Think back to the first Sports Walkman (designed in 1983 by Ichiro Hino as an intern product just after he joined Sony). Beyond its scuba-inspired bright yellow color, shock-absorbing mechanisms and thin rubber gasket that sealed the lid to the body, its form was an exercise in packaging—more about the idea of athletics than the reality that taking such a product to the beach or ski slope presents. By the mid-1990s, every one of Sony's competitors had their own Sports models, all delivering the same middling performance. "For Sony to stand out," says Mr. Kataoka, "the Sports model had to mold itself to the user's body. It had to fit the hand like a glove with every control a short finger's distance away." Since most users are right-handed (which means they tend to catch themselves with their right hand when taking a spill), Mr. Kataoka designed the new Sports model as a left-handed product, giving it a contoured cylindrical form that begs the hand to touch it, echoing a feature from Joe Wada's 1989 Spirit Walkman by placing the

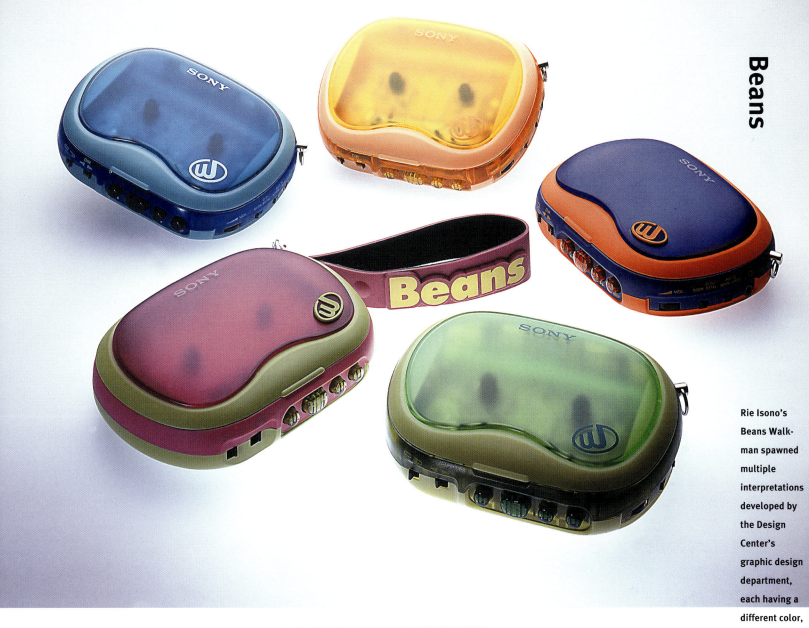

Rie Isono's Beans Walkman spawned multiple interpretations developed by the Design Center's graphic design department, each having a different color, texture or level of detail. The thermoluminescent model (below) gives the product what Sony designers term "necessary luxury." Design: Miwako Tsukada, Yoko Uzawa, Hiroshige Fukuhara (DC/Tokyo), 1998.

main control at the corner of the product (where the user's thumb comes to rest), angled the LCD screen for easy viewing when holding it in the left hand and placed other controls on the top surface near the user's forefinger and ring finger. He even designed a pulsemeter that would attach to the left forefinger, but that feature was dropped.

"Experience told me that users grip the product with their palm, thumb and middle finger, leaving the others relatively free," he explains. But convincing PAV's engineers to redesign the underlying mechanism and re-locate the buttons was a challenge. After several rounds of negotiation, Kataoka's original sketches (see page 48, top left) evolved into a "finished" concept (page 48, top right), which evolved again (page 48, below left) and was refined yet again by Daisuke Ishii (page 48, below center) and Yasuo Yuyama (page 48, below right), resulting in a form that preserves Kataoka's original idea without forcing the engineers to create a new button array. For those who

think that buttons are a minor issue, think again: Once the costs of engineering, testing and tooling come in, the price tag for moving buttons on a Walkman can exceed $200,000. Since Walkman profit margins are often slim due to relentless competition, amortizing that cost would have required PAV to use the same button arrangement on other models as well, thus removing the "unique advantage" of Kataoka's design. "The Walkman is a commodity product, so it's hard to design variations that stray too far from the basic form," says Ichikawa.

That first Walkman wasn't merely a product. It was a phenomenon—a stone cast into an immense and perfectly still pond. Twenty years later, the ripples continue to widen, with more than 160 million units with more than 350 unique designs now in existence. It's not surprising that Sony would reclothe such a venerable product again and again. Indeed, variations will continue until the last customer graduates from analog to digital options. As the Walkman enters perpetual sunset, this means that future models will work variations on a few well-accepted forms. One example is the new Whoopee model (see page 49), which uses the same molding as the original My First Sony Walkman but is now clothed in a tinted translucent shell with powdered metal added to the plastic to make it sparkle. For 1999, the WM-FX111/311/315 Sports models give Tetsu Kataoka's 1997 case design a head-turning twist by melting the surface details into a psychedelic melange. The ultra-slim EX670, a perpetual sunset model, offers the ultimate in ele-

The Sporting Life

Tetsu Kataoka's first concept for the Sports Walkman included a pulsemeter that attached to the user's finger and a new shape that made the product easy to grip. The first grip mockup (below left) evolved into the final design concept (above right) and was changed for the final product (below middle left) and modified again by Daisuke Ishii (below, middle right) and Yasuo Yuyama (below, far right). Opposite page: The redesigned Whoopee model WM-3500SP has a translucent metal-impregnated shell. Design: Hiroshi Yasutomi (DC/Tokyo), 1997-98.

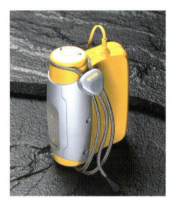
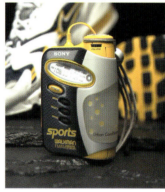
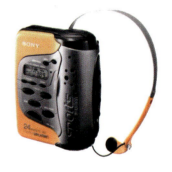
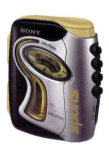

gance and simplicity. The sexually charged FX-271 and funny SR-1 (with a tiny built-in two-way speaker) take a more blunt approach. And as the sun goes down and darkness gathers over the Walkman, future models will revisit old territory.

One concept, now in the works, calls for a product that is the same size as a cassette box—just like the icon-making WM-20—with a slide-case mechanism similar to the slide-case cassette packaging that is now sweeping the market, allowing the user to insert and remove the cassette with a simple thumb motion (see page 120).

Virtually anything that keeps such a venerable product fresh is permissible, because all Walkman designs speak the same language. Individual accents or tone of voice may differ. Yet the product's core remains the same. For the past quarter century, the Walkman design has demonstrated the profound effect that shape, color, texture and

detailing has on the human hand and mind. The moment you pick up a Walkman, hold it in your hand, insert or remove a cassette and fiddle with the controls, the connection between user and designer is instantaneous. It comes to life the moment you touch it. Yet once you turn it on, the design assumes a new identity and recedes into the background, never competing with the music for our attention. The rightness that we experience whenever we use one of these products is no small matter. Indeed, the culture of music itself would not be the same without the close connection that exists between our hands and ears and the devices that deliver the music. The role of the design is to make that connection, to create interest in our minds, draw our hands, persuade us to listen, ease the transition from silence to experience, then gently draw the experience to a close, reminding us that the next pleasure is just

a push button away, anytime, anywhere. That is the beauty of the Walkman.

As technology advanced from analog cassette in the 1970s and 1980s to the compact disc in the 1980s and 1990s, the Walkman would be joined by the Discman—a marvel of miniaturization that presented a completely different set of challenges to those given the task of designing it.

On October 1, 1982, after years of collaboration with the Dutch electronics giant Philips, N.V., Sony introduced the world's first compact disc player, the CDP-101, which featured fully digital audio with breathtaking fidelity. To gain acceptance for the new medium, Sony mounted a full-scale effort to reduce the size and cost of the player. Led by Nobuyuki Idei, the program (called CD/CD, short for "Compact Disc/Cost Down") reduced the size and complexity of the optical

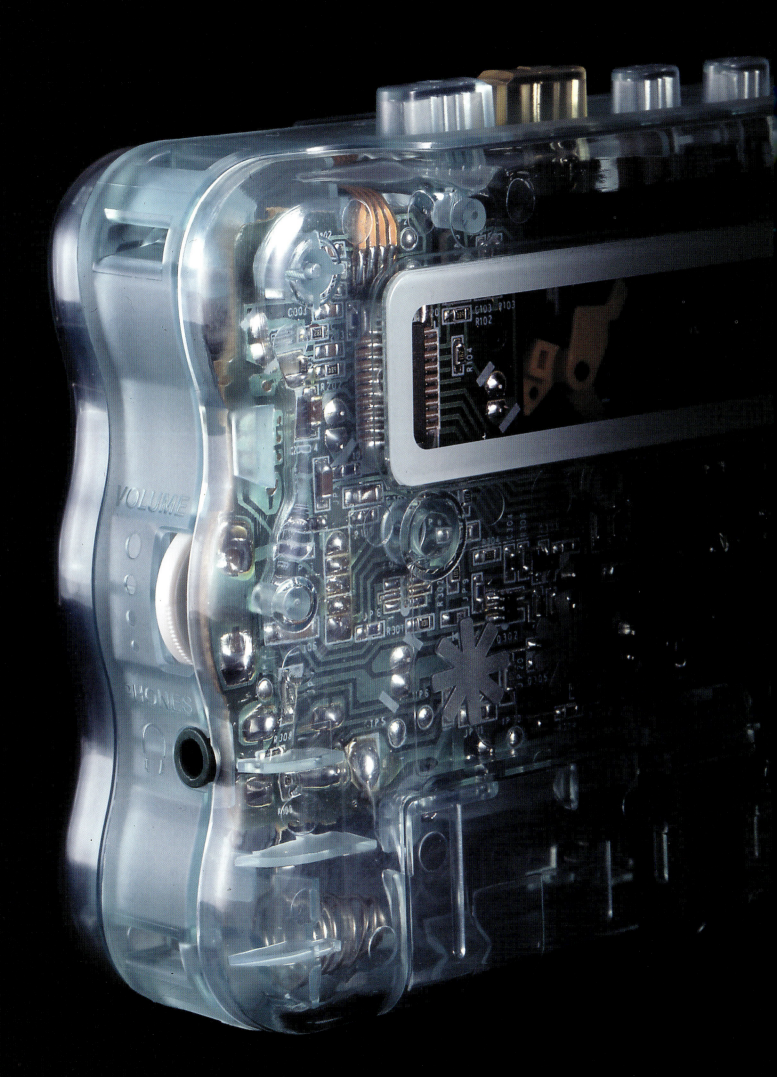

VOLUME

PHONES

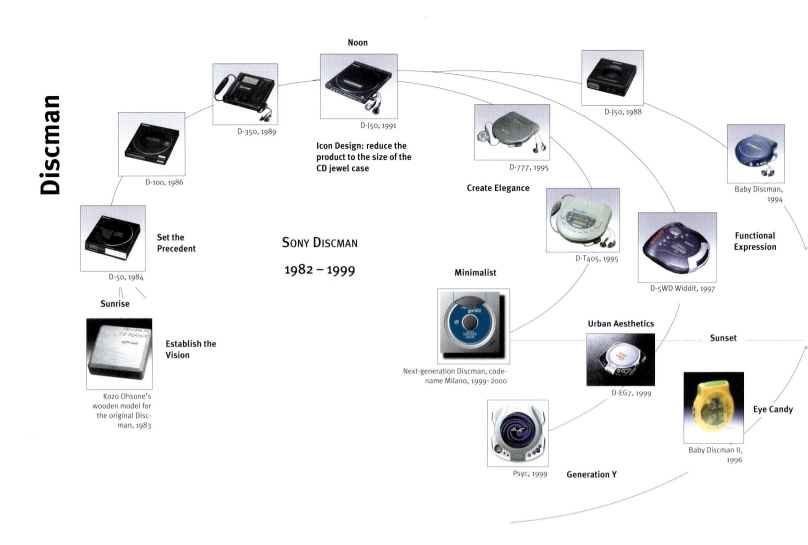

Discman

SONY DISCMAN

1982 – 1999

Noon

D-J50, 1991

Icon Design: reduce the product to the size of the CD jewel case

D-350, 1989

D-100, 1986

D-J50, 1988

Set the Precedent

D-50, 1984

Sunrise

Establish the Vision

Kozo Ohsone's wooden model for the original Discman, 1983

D-777, 1995

Create Elegance

Baby Discman, 1994

D-T405, 1995

Minimalist

Functional Expression

D-5WD Widdit, 1997

Next-generation Discman, code-name Milano, 1999–2000

Urban Aesthetics

Sunset

D-EG7, 1999

Eye Candy

Baby Discman II, 1996

Psyc, 1999

Generation Y

The candy-colored Baby Discman II made personal audio a lifestyle experience. Design: Masakazu Kanatani (DC/Tokyo), 1996.

pickup and minimized the number of parts used in the basic CD mechanism. By 1983, Sony had the technology to build a CD player that was one-tenth the size of the first player, which inspired the GA group to develop a handheld CD player, known as the Discman, that could compete with the cassette Walkman.

The design effort began in November 1983 as a simple block of wood measuring 13.4cm across and 4cm thick, carved by GA manager Kozo Ohsone to show his engineers the correct size for a portable product. The wood block was just slightly larger and thicker than the CD itself. Using this as a goal, the PAV group developed the first pocket-sized Discman—the model D-50 with its simple black and silver case—in a matter of months and stunned the audio world with its release in 1984. Since the D-50, the Discman design has become smaller and thinner, replicating on a portable scale the black box treatment of Sony's mainstream consumer audio systems. Unlike the Walkman, which metastisized into hundreds of different expressions, the Discman line adhered to the D-50 aesthetic for several years—giving us a clean, vacuum-formed look that does not excite and does not offend.

This began to change in 1994, when DC/Tokyo designer Masakazu Kanatani collaborated with the Design Center's graphic design group to create Baby Discman, an oh-so-cute candy-colored confection that played the 8-centimeter CD singles that are popular among Japanese youth. "Since CD players were considered 'serious,' introducing expression to the Discman line could only happen by catering to youth first and working toward adults later on," says Kanatani. This was followed in 1997 by the intro-

duction of Tetsu Kataoka's Sports Discman, which featured a rounded integrated handle and ergonomically correct corner-mounted controls designed for left-handed use (just like Kataoka's new Sports Walkman). This opened the flood gates.

As stylistic variations on the Sports Discman merged with the world of fashion, DC/Tokyo designers Mitsuhiro Nakamura and Daisuke Ishii proposed a pumped-up Street Style Discman concept that pushed image-making to a new level. "Until recently, the most characteristic feature of all PAV products has been their small size and thin profile," he says. "The ruling principle has been to make the next Discman smaller and lighter than the last one. But Tetsu's Sports model changed all that." With the arrival of the new Street Style headphones (see page 61), Mr. Nakamura saw an opportunity to create a third category of Discman that discards the thinner/smaller/lighter formula. "The Street Style headphone design is so new, it inspired us to write a totally new story for the Discman that is different from the Sports genre," he says. "When we talk about the Sports model, which emphasizes mobility, durability and water resis-

tance, the concept is easy to understand. But the Street Style concept is not performance-driven. It's inspired by urban lifestyle. Even though its form and details, such as the rubber gasket between the top cover and base, are like the Sports model, the product's image is very different. It speaks in a new language to a new group of music listeners who play in the street rather than on the tennis court or the beach." To visualize the product, Mr. Nakamura imagined young people hanging out in urban America wearing fashionably torn T-shirts and expensive sneakers, their eyes shielded by Oakley sunglasses, using a new personal audio product that is not small, thin and silver and definitely not yellow with a happy Sports logo. "The Street Style user is hanging out, not working out," says Mr. Nakamura with a wink.

Wrapped in dark colors with a contrasting silver clasp that secures the top cover to the base, the Street Style Discman uses the same round grip architecture as the Sports model yet is skinned in a tight interlocking pattern that clings to the 3-D curves like urban camouflage. This coating will soon become a common feature on youth-oriented Walkman, Discman and headphone products.

"I enjoy taking an existing concept and repackaging it," says Nakamura. "It forces me to limit the number of changes and squeeze as much meaning from it as I can by writing a new story." The storytelling reference is no joke: For years, Sony designers have preceded their design with a lengthy written description of the product, audience and symbolism the new design will achieve. This effort underscores the quest within Sony to derive new meaning from existing products to keep pace with an ever changing society.

An updated Street Style Discman, by DC/Tokyo designer Yasuo Yuyama, departs from the handgrip Sports architecture and eliminates the water resistant gasket, which urban users no longer need. The new design, called Rugged Discman, retains the circular image of earlier products and adds four shock-absorbing bumpers to the corners, visually expressing the new ESP2 shock resistance technology inside. Linking the design to the sneaker set, Yuyama applied a rubberized sneaker tread to the bottom of the product and suspension hardware on the side, allowing Rugged to be hung from a backpack or belt.

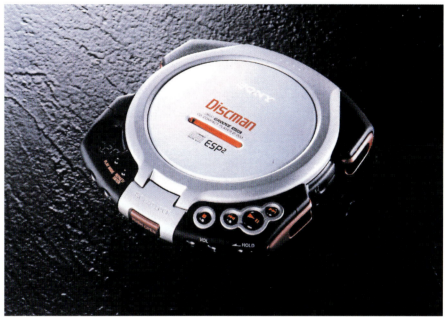

Top: The D-5WD Widdit Street Style Discman. Design: Daisuke Ishii (DC/Tokyo), 1997. Below: This Mockup for the D-EG7 Rugged Street-Style Discman has a hinged circular top reminiscent of Atsushi Kawase's Enigma concept (page 22) and a rubberized sneaker tread on the bottom. Design: Yasuo Yuyama (DC/Tokyo), 1999.

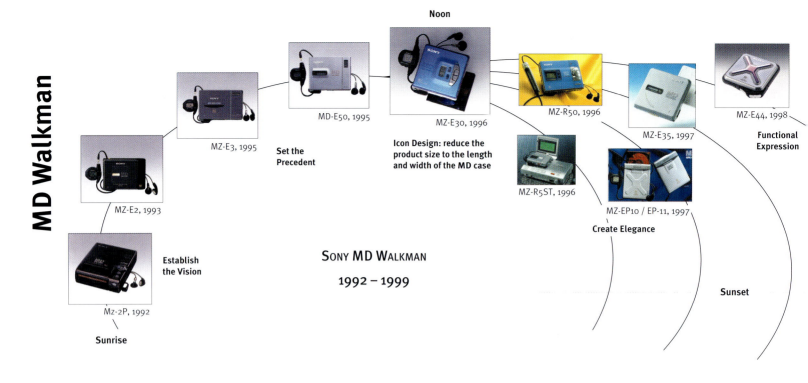

Noon

MD-E50, 1995

MZ-E3, 1995

Set the
Precedent

MZ-E30, 1996

Icon Design: reduce the
product size to the length
and width of the MD case

MZ-R50, 1996

MZ-E35, 1997

MZ-E44, 1998

Functional
Expression

MZ-E2, 1993

MZ-R5ST, 1996

MZ-EP10 / EP-11, 1997

Create Elegance

Establish
the Vision

Mz-2P, 1992

Sunrise

SONY MD WALKMAN

1992 – 1999

Sunset

The MZ-E50 was the lightest and thinnest MD Walkman on the market when it appeared in 1995. Using molded magnesium for the top made the delicate curve on the top cover possible. Design: Daisuke Ishii and Takahiro Tsuge (DC/Tokyo), 1995.

The most recent member of the Walkman family has also been the most important new recording technology of the past half decade, the MiniDisc. Combining the best features of the magnetic cassette (portability, reliability and shock resistance) with the compact disc (durability, random access and full-spectrum digital sound) the MiniDisc functions like a miniature computer floppy disc, storing compressed digital information on a magnetic disc surface that uses an optical pickup to guide the record and playback heads to precisely the right track. After the technology was perfected, an intense push to shrink the MD mechanism resulted in a series of small tabletop and handheld units (beginning with the MZ-2 in 1992) that culminated in the ultraslim MZ-E50, designed by Takahiro Tsuge in 1995 for Sony's fiftieth anniversary and updated by Daisuke Ishii the following year as a consumer product.

Extreme in its quest to downsize the MD player, the E50 is so thin and lightweight that it looks and feels more like a credit card than a Walkman. "A key design point is the use of molded magnesium alloy," says Mr. Ishii. "This made it possible to give the surface around the media window a delicate curve that we could not do with an aluminum case."

As the MD Walkman gradually shrunk in size, allowing it to fit easily in a pocket, Sony decided to give the product a remote commander that could control the disc mechanism without touching the unit itself. Yet unlike the watch-style cassette Walkman controller, which has simple forward, reverse, pause and stop buttons, the MD commander needed a wide LCD (to display track titles) and a feather-touch jog-shuttle control (to provide the

appropriate response when playing the music or skipping from one track to another). The design of this stick-type controller, by Daisuke Ishii, Masakazu Kanatani and Katsuhisa Hakoda (DC/Tokyo), is purposeful, elegant and functionally distinct from the watch-shaped Walkman controller. The secret to the design is what Mr. Ishii calls "blind interaction." With the MD Walkman tucked into a pocket and the controller held in the hand or clipped to the user's shirt, it's easy to start a disc, change tracks, or stop the Walkman with a slight twist of the jog-shuttle wheel at the end of the stick. The finger action is so intuitive, you never even have to look at the controller.

Working in a corner of PAV's Shibaura Design Center, a fast-rising design star named Masakazu Kanatani felt that the MZ-E50 would fall behind the curve unless Sony admitted its other drawback: by making the E50 so thin, it could never be reduced to the optimum size—which Kanatani defined as

the same length and width as the MiniDisc itself.

A graduate of the Kanazawa College of Art, Mr. Kanatani worked at GK Design, the largest ID consultancy in Japan, before joining Sony in 1986, and collaborated in the design of My First Sony products at Park Ridge and Discman products in Tokyo before turning his attention to the MD Walkman. Philosophically, Mr. Kanatani sees design as the result of two conflicting impulses: the need to work for the benefit of society and the desire to work as an artist and please himself. Thus he takes a purist approach, designing personal entertainment products that he alone wants, while challenging the status quo within Sony to take products to new levels of expression.

Since the MD Walkman was still an emerging product in 1995, Mr. Kanatani wanted Sony to move beyond the E50 to develop a product that was only slightly larger than the MD media that fits inside. In 1996, he began work on such a concept, consulting with Sony engineers to determine the absolute minimum length and width that an MD Walkman could assume. By rearranging the interior mechanism, it was possible to make the product small and square. But it would be nearly twice as thick as the E50. Undeterred, Kanatani carved three versions of this initial concept with the LCD and controls on top and proposed that PAV follow his path. But when Sony Marketing saw Kanatani's first concept, they predicted it would fail, because it was "too square"—even though Design Center philosophy prefers that portable products resemble the size and shape of the media they contain. "Since the MiniDisc is square, the MD player should be square as well," says Mr.

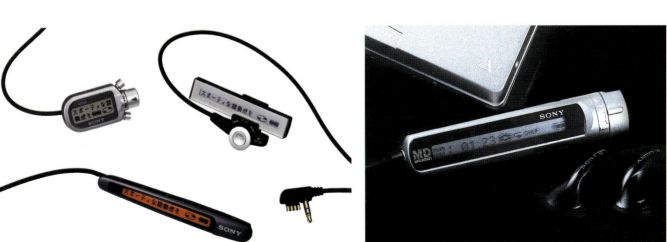

Kanatani. But the more important issue was thickness. To make the design the same length and width as the MD disc, Kanatani could not place the controls at the side of the case, as Tsuge and Ishii had done with the E50. Instead, the LCD and controls had to go on top, adding to the thickness of the product by only a few millimeters. "But in small products, every millimeter is considered important," says the designer. At first, Kanatani set the LCD and controls at an angle to make the product seem less square. He then designed a second version with the LCD and controls on a raised flat area in the center of the product, where it resembled the sliding shutter on the MD disc,

reinforcing the idea that the player be the same size and proportions as the media it contains. He gave this concept a beveled edge around the top, which made it appear thinner, and applied a gentle curve that extends from the flat surface on top (where the LCD and controls reside) to the surrounding top surface, giving it a wonderfully delicate feel. "When you have a problem in a design, you must turn the negative into a positive," says Kanatani. "You know the new product is thicker than the old one, but the surfaces are so interesting, you are almost glad for the increased mass. This way, the thickness is not a flaw, it's a feature." In this way, the MZ-E30 was born—and

soon became the icon design for the entire MD Walkman family.

When designing the E30, Mr. Kanatani already had in mind the image for his second-, third- and fourth-generation versions, which would extend the MD Walkman for the next three years, from noon to midafternoon. The next model, MZ-E35, is a broad-based consumer version of the E30, slightly thinner than its predecessor with a flatter bottom (benefiting from a more compact internal mechanism) and a plain vanilla case. Instead of the E30's raised control panel, which echoes the shutter on the MD disc, the E35 references the disc inside with a simple curved line on the top

Above: The evolution of the MZ-E30, which reduced the MD Walkman to the same size and proportions as the MD jacket itself. Design: Masakazu Kanatani, Yoshinobu Yamagishi (DC/Tokyo). Below left: Preliminary exploration for the MD Remote Commander. Below right: Second-generation RM-Z35K Remote Commander for use with the portable MD Walkman. Design: Daisuke Ishii, Masakazu Kanatani, Katsuhisa Hakoda (DC/ Tokyo), 1995.

53

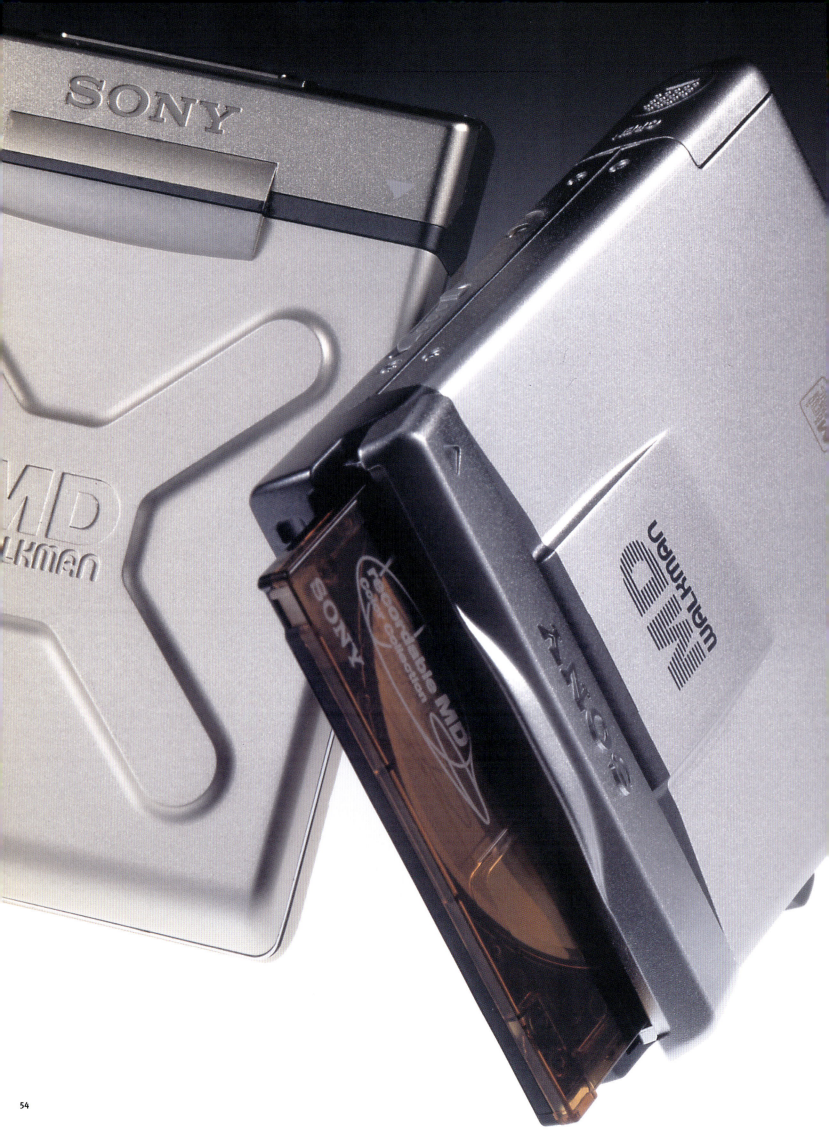

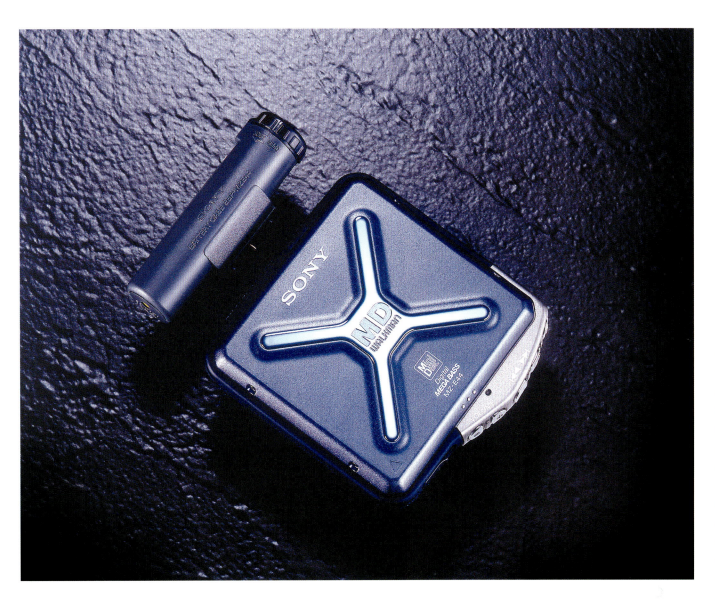

and a small window on top that invites the user to peer inside the product and marvel at the tiny spinning disc inside. For years, second- and third-generation cassette Walkman and Discman designs have exposed their spinning mechanisms in this way. It was only natural that Kanatani would steer the MD Walkman down the same path. The E30 is for those who crave style and performance; the E35 is a middle-of-the-road design that targets the undecided masses. Maintaining this distinction between products within a family while advancing the clock for the family as a whole, Mr. Kanatani then designed two additional versions, which pushed the MD Walkman toward midafternoon. First came the MZ-EP10 and MZ-EP11, which share a unique "pop top" head-loading mechanism. Instead of a door covering the entire face of the product, the EP10/EP11 have a "mouth" at the end that ejects the disc by spitting it out, or gobbling it up as you insert a new one— similar to the floppy disk drive on a computer. This

sophisticated yet animated interactive loading system makes the product "Sony unique" and gives the EP10/EP11 an elite quality that other versions in future years will surely build upon. "The engineers were so excited when Ichikawa and I showed them the head-loading feature," Mr. Kanatani recalls. That meeting took place in February 1997. By September, the mechanism was perfected and the EP10/EP11 was already on the market.

The more expressive midafternoon design, the MZ-E44, is a tour-de-force. Resembling the icon E30 in its small size and square shape, the E44 exhibits an entirely different personality in its

wide, hard rubber bumper around the belt-line, which encourages the user to carry the product in the hand rather than stuff it into a pocket. Borrowing a detail from Joe Wada's 1989 Spirit concepts, controls on the E44 are now at the corner of the product, where the thumb naturally falls when holding the unit. On earlier models, many people controlled the MD Walkman by storing the product in their pocket and controlling it with a stick-type remote commander. But Kanatani wanted to ensure that users hold the E44 in their hand, so he applied an eye-catching X-shape on top with an iridescent coating that radiates energy and potential.

Opposite: The MZ-EP10 and MZ-EP11 Portable MD Players offer an early afternoon expression in the improved disc loading mechanism with a "slot in" design that makes the top cover an integral part of the design, doing more than hiding the internal components. This page: The handheld MZ-E44 features a thumb-actuated corner-mounted control. Design: Masakazu Kanatani (DC/Tokyo), 1998.

Technology into Art

engineering miniature speaker components that are accurate and durable and can be manufactured in unlimited quantity. Then a designer had to create an ergonomically correct headphone that can accommodate the largest possible audience yet fit each member of that audience as though it were designed for them alone.

Since the advent of the Walkman in 1979, Sony has explored a broad range of portable headphone designs, drawing inspiration from the high-quality professional headphones that the General Audio and Broadcast & Professional Groups have supplied to audiophiles and music professionals, as well as the rough-and-ready approach favored by the PAV group. When the Walkman was first released, its sound quality was a perfect match for the first-generation H•AIR headphones, whose soft, foam-covered speaker elements joined by a simple metal band that fits over the head is famous around the world. But as the Walkman's performance improved, the need for better headphones never ceased. Crafting a new headphone and downsizing these delicate components was but one part of the challenge. The more difficult part of the problem was designing a headphone that was lightweight, fit naturally around the head and over the ears, provided the best possible sound and was comfortable enough to use for an extended period.

Among the many classic headphones that have emanated from Sony, the most enduring is the 1990 Joe Wada design known as Eggo (MDR-D33, D55, D77)—comprising a simple, elegant pair of egg-shaped cups held together by a wide, two-pronged headband. According to Wada, the design came together so quickly that he was not even conscious of having designed it. "The Eggo idea virtually designed itself," he recalls.

The best ideas are often the most obvious. In the case of the ever-popular in-the-ear design—called N.U.D.E.—the challenge was to develop a product that feeds sound directly to the user yet remains inconspicuous. Since the concept called for the most minimal design possible, emphasis is given to quality components and an earpiece that fits snugly and naturally in the ear. Entry-level versions of the N.U.D.E. design are now included with

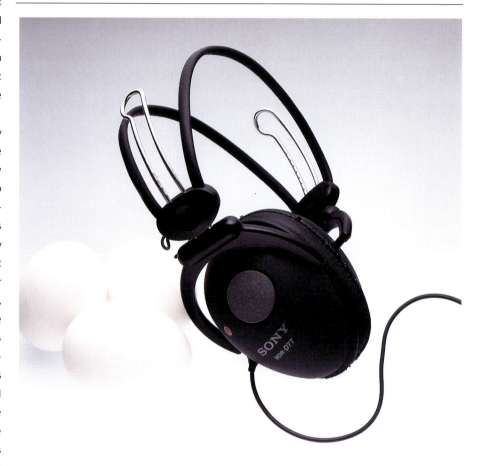

many moderately priced Walkman products and portable radios, while top-of-the-line models are coveted by those who value the superlative sound reproduction and near-total isolation that this design provides. Yet not everyone enjoys inserting a stereo component directly into their body, nor does an in-the-ear headphone express the *idea* of music to the same degree as a product that fits around the head and over the ears.

If there were a way to safely and permanently implant a Walkman or Discman inside the human body, port the sound directly to your inner ear and harness the electrical charge inside the body as a power source, many people would quickly sign up for an implant. Yet many others would be disturbed by a product that offered sonic enjoyment without a corresponding image. For music, and the components that deliver it, is more than a sound experience. It exists in the world of three dimensions.

After years of experience relating the physical

part of the music experience to the sonic—gently laying a record needle on the first track of an LP, pushing a cassette tape into a Walkman, watching a CD or MiniDisc slide into a player or wrapping a pair of headphones around your shaggy dome before hearing those first beautiful sounds—you would miss the physicality that hardware provides if it were suddenly taken away.

Without a physical object to play with, hold to our breast and remember in our dreams, our relationship to music would be very different than it is today. For the most intimate relationship we have with music takes place in that fraction of an inch that separates the headphone from our ears.

For years, PAV design manager Kazuo Ichikawa has wanted to design the "perfect" headphones. Under his aegis, PAV developed a wide range of sound-dampening and reference model headphones, including the WARP Noise Cancellation Headphones, which use an electronic circuit to

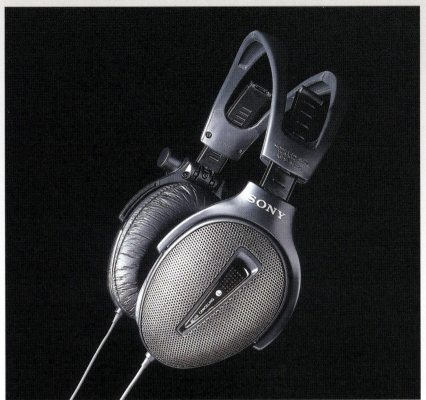

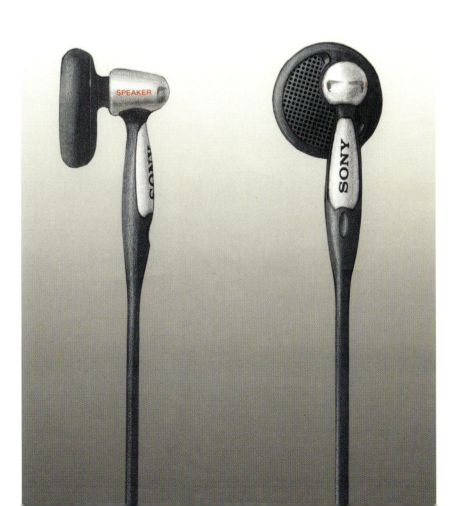

Top: WARP Noise Cancellation Headphones provide near-total isolation by electronically negating sound from the listener's environment. Design: Haruo Hayashi (DC/Tokyo). Middle row (left to right): MDR-F1 Open Air Headphones offer a more natural feel through the use of lightweight materials such as magnesium alloy, and earpads and headband made of exene, a high-quality material that feels good against the skin. Design: Akinari Mohri (DC/Tokyo), 1997; The unique shoulder design of the SRS-GS70 conveys the vibrations of a video game, movie or music as well as the sound. Design: Satoshi Suzuki (DC/Tokyo); The high-end MDR-R10 headphone is so exclusive, fewer than a dozen units have been sold worldwide. Design: Kazuo Ichikawa (DC/Tokyo), 1994. Sony's N.U.D.E. style in-the-ear phone, developed in the late 1980s, has become an industry standard.

detect sound waves coming from the outside environment and generate the opposite sound wave, resulting in a total absence of background noise. He also led development of the ultra-high-end MDR-R10 headphones, which incorporate the most precious condenser elements ever put into a head-mounted sound device, beautifully carved rosewood earpieces and a thick leather head-band. With a retail price of more than $2,000, only a handful of MDR-R10 units have been sold since it was introduced in 1992. Yet the purpose of such products is not to generate profits. It is to gain knowledge and to develop the necessary tools and insight to make the finest products possible. The most interesting of these tools is the computer-aided design program called Fresdam, developed within Sony during the late 1980s.

Sony designers began to use desktop computers to generate their designs in 1982. At that time, the only computer-aided design programs were simple 2-D drawing programs. "For five years, the Design Center used these 2-D applications for their general work." says designer Tad Kitsukawa. "Yet what we needed was a good three-dimensional CAD system. Most of the parts we create for products require extreme precision, far greater than those early CAD systems could provide."

Unwilling to compromise, the Design Center's Mitsuhiro Nakamura and Tad Kitsukawa created Sony's own CAD/CAM system in 1987, known as Fresdam. Starting from scratch, they interviewed designers, engineers and manufacturing specialists to determine their needs and designed the system's user interface using computer code written by Dr. Tetsuzo Kuragano, a project manager at the Information Processing Lab at Sony's Atsugi facility. "At Sony, we prefer not to use off-the-shelf solutions," says Mr. Kitsukawa. "Our core belief is to do everything in the best possible way, which usually means doing it ourselves. That way, every product we design and every tool we use to create those products reflect the Sony ideal."*

The first project to make use of Fresdam was Kazuo Ichikawa's $2,000 carved rosewood headphones. "The first mockup had been made by hand," recalls Mr. Kitsukawa. "Kazuo Ichikawa and Katsu-mi Yamatogi [now a creative producer at DC's Broadcast and Professional group] had carved and assembled the first version by hand. I then translated the details into Fresdam so that the same shape could be replicated at the factory." The entire project took six months to complete.

As the MDR-R10 took shape, Kazuo Ichikawa began to focus on a newer, more casual style of headphone that would fit behind the

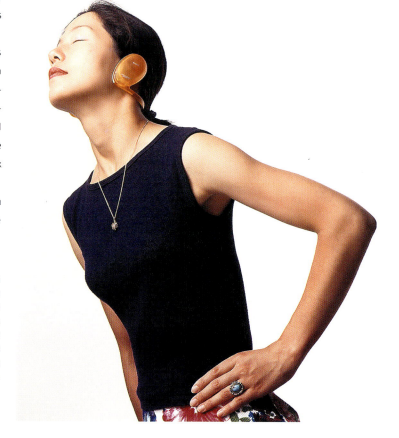

Above: Kazuo Ichikawa's original concept for Street Style Headphones, 1990, was inspired by urban fashion and behavior and a more specific source, the harmonica brace made popular by Bob Dylan in the 1960s. Below: Haruo Hayashi's second concept for Street Style Headphones, 1992.

*The most interesting example of this practice was Sony's choice of typeface for its products. In the early 1960s, the decision was made to use Helvetica for all product graphics except for the Sony logo and any sub-brand that might apply. Yet rather than use a standard Helvetica typeface such as ITC Helvetica, Sony's graphic designers studied the ITC version, made minute changes to certain letterforms, altered the letter spacing and kerning values to work better on 3-D products using silk-screen ink, and called the redesigned typeface "Sony ID Type." Except for these minute changes, it's the same as the standard Helvetica that comes in your Macintosh or Windows computer.

neck rather than over the head or directly in the ear. "The goal was to design a headphone/radio that contained the radio circuitry in the headband," he says. "But rather than placing the circuits and battery on top of the head, where it could easily slip down, I thought about placing the headband behind the neck." His inspiration came from the way people use conventional headphones in the street (allowing them to drop behind the neck), how people wear baseball caps (often with the visor pointing backwards), and the apparatus that folksinger Bob Dylan used to support his harmonica while performing in concert.

"A critical issue when designing headphones is to make them fit properly," says Mr. Ichikawa. "Yet there is a huge difference from one person to another in the distance from one ear, over the top of the head to the other ear. When you factor in hair styles and the possibility of a cap or hat, you realize that the traditional headphone is not so good. We needed a design that fits everyone better."

While researching the problem, Mr. Ichikawa discovered that the distance from one ear to the other when measured around the back of the head was much more consistent among most people. Turning the headband into a neckband also solved the biggest problem of his radio/headphone concept— keeping the heaviest components as low as possible for maximum stability.

"With a neckband design, the headphone cannot slip down when you're on-the-go," says Mr. Ichikawa, "because it's already slipped down and can't slip any farther." The design also looked incredibly cool. Quickly, he assembled a mockup using a fixed neckband and in-the-ear speaker components. He then handed the project to Haruo Hayashi in 1992, who gave the concept cup-shaped earpieces and a tighter-fitting, adjustable neckband. "The Hayashi model was a turning point in the project," says Mr. Ichikawa. "But in testing it, we realized that the design should not grip the head from behind the neck. It should rest on the ears gently, just touch the back of the neck and be balanced so well that you hardly feel it." Like music itself, the headphones should be as light as air and have a poetic shape that visually expresses the sounds that transform our lives.

No product at a firm like Sony evolves in an uninterrupted flow, and Mr. Ichikawa's headphone was no exception. As soon as the Hayashi concept was finished, market conditions changed, causing resources to be deployed in a different direction. Three years later, attention returned to the behind-the-neck concept. Since Mr. Hayashi had transferred out of headphone

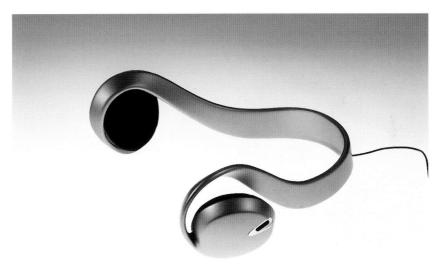

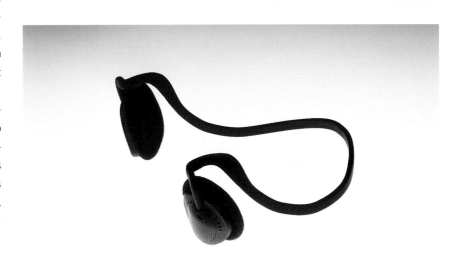

In 1996, Hiroshi Yasutomi revived the Street Style concept in a series of sketches (above) and concept models (below), developed with Ken Yano (DC/Tokyo), that took the design in an interesting new direction.

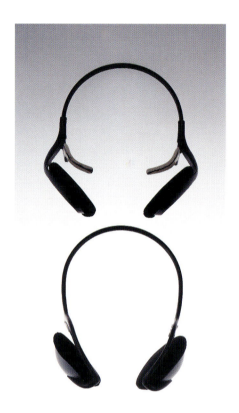

Product as Metaphor

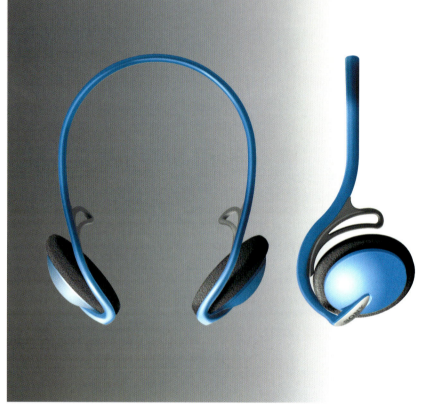

design, the task of realizing Mr. Ichikawa's concept fell to a young designer named Hiroshi Yasutomi, who had never tackled a headphone project before. Yet Mr. Yasutomi demonstrated that his artistic sensibility can meet any challenge.

The final design phase called for attenuating and tightening the behind-the-neck brace, which keeps the speaker elements in position, and refining the elastomer part near the condensers, which allow the headphones to fit gently around the ears.

After reading Ichikawa's research and studying the two previous concepts, Mr. Yasutomi made a series of sketches to get into the project quickly and worked out the basic form before immersing himself in the details. "When beginning a design, it's important to dive into the project and achieve a vision without focusing on specifics too quickly," he says. His drawings during this early phase have such verve and passion, they could be displayed in a design museum. The first hard model, designed by Yasutomi's colleague Ken Yano, flowed from these sketches, with the same curling gesture where the neckband met the earpiece. But the neckband in this first model was too thick. Model number two was thinner and lighter with a curve around the ear pieces that fit the anatomy of the ear better than the earlier model. But an even tighter fit around the ear was needed—a way to gently grip the outer ear without creating unnecessary pressure.

In his third and fourth models, Mr. Yasutomi tried two different approaches. One offered elastomer pieces that fit behind the ear and thus kept the speaker elements correctly positioned over the ear. But this design was not comfortable

and pushed the headphone's balance forward—toward the ears and away from the neck. The final model widened and softened the behind-the-ear elastomer part and lightened the neckband to provide perfect balance. Space for the Sony logo was found on the tiny part that joins the earpiece to the neckband—one of the few instances in which the all-important logo is given secondary status to the product's design.

Voted as one of the best designs of 1997 by Sony's own designers, the Street Style Headphones have become wildly successful and are now standard equipment with many Walkman and

Discman products. Like the greatest designs, the headphones are both product and metaphor—beautiful and functional, yet also symbolic.

Like music itself, the product has a sinuous shape that surrounds the head with sound. It is lightweight yet always firmly in place. It is evanescent, and may be the greatest of all Sony designs from recent years.

"It's remarkable when a design creates a whole new lifestyle," says Ichikawa. "Achieving so much with such minimal, delicate materials should inspire all designers to focus themselves in a new way to deliver the most, using the least of means."

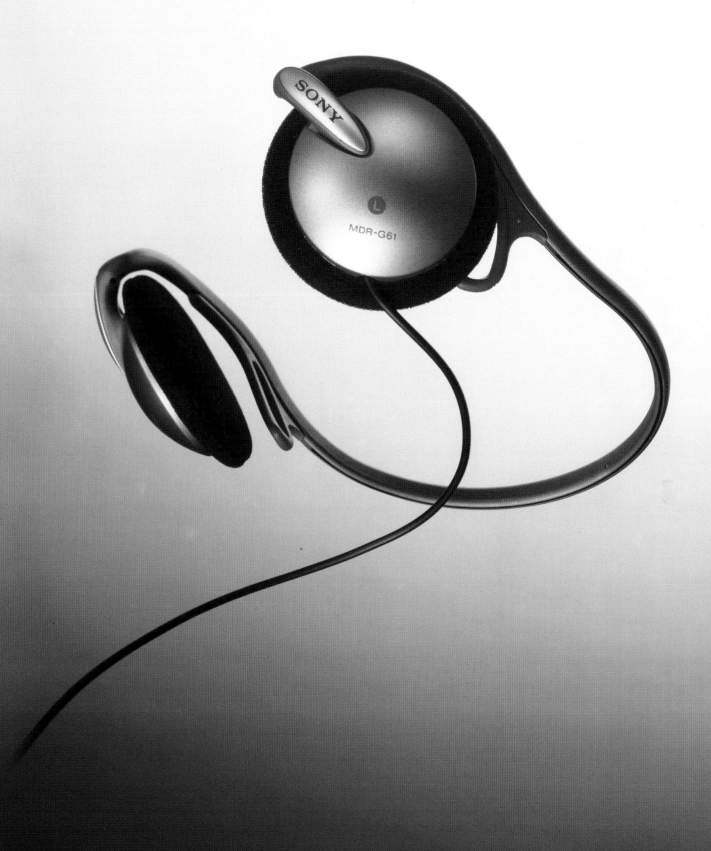

MDR-G61
Street Style
Headphones.
Initial Con-
cept: Kazuo
Ichikawa.
Interim
design:
Haruo
Hayashi.
Final Design:
Hiroshi
Yasutomi,
Mitsuhiro
Nakamura
and Ken
Yano
(DC/Tokyo),
1996.

KV-1310, 1968

Technology Breakthrou

KV-1375, 1966

Market Creation

TV5-303, 1962

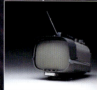

TV8-301, 1959

Sunrise

Noon

ProFeel, 1972

Product Icon

KV-27XBR-1, 1984

Market Expansion

Elegant

KX-27HV1 ProFeel Pro, 1986

Portable

KV-4P1, 1980

KV-41EXR Projection, 1993

Stylish

FD-200, 1982

XBR Square, 1995

Mass-Market Expressions

Eye Candy

Vangee, 1997

KV-20M20, 1997

KX-32HV50, 1995

Wearable Technology

Glasstron, 1997

Sunset

PZ-2500 Plasmatron, 1997

Market Saturation

Transitional Statement

KV-28SF5, 1997

SONY TELEVISION: FROM BLACK AND WHITE TO WEGA
1959 – 1999

If we examine the design evolution of the Sony television stretching back over the past forty years—from the first fragile attempts in the late 1950s to today's bold yet minimal designs—we notice that the TV does not follow the same evolution as the radio, the voice recorder or the Walkman. Rather than begin with a product that is too large with minimal expression and end with fireworks, as we've seen with smaller products, the television evolved in the opposite direction. It all began with the tiny, almost pet-like model known as TV8-301—a product that was so small and adorably shaped that it didn't seem to matter whether it was on or off.

At a time when television reception was awful, with a picture that was often out of focus and sound that was poor on even the best TV, when even the smallest black and white set cost a month's salary, it was necessary for manufacturers to design televisions with a sense of verve and expression, if only to encourage potential viewers to buy one.

In the early days, the television had to be "hot," since what you saw on the screen was often "cold." Yet year after year, as technology advanced and programming improved, the content became hotter as the set that enclosed it

grew cooler in response. It's no coincidence that as television made the jump from black and white to color, from monaural sound to stereo, from narrow- to widescreen, and from standard to high definition, the television has evolved into a minimal object with very little expression of its own. No less effort goes into designing the muted television of today than was given to the sprightly portables of yesteryear. But the creative effort also extends inside the product: into the design of the user interface; the design of on-screen controls such as electronic programming guides, which allow the television to navigate cable and satellite systems; and the design of digital set-top boxes that will soon allow the TV to serve as a portal to the Internet and the infinite world of digital content that exists just over the horizon.

For the past forty years, as the television has evolved from an oddity into our principal source of information and entertainment, Sony has led the way from the curved screens of the past to the flat screens of today. Beginning with their unique aperture grill and electron gun technology, first introduced on the Trinitron in 1968, Sony designers have consistently pushed the Trinitron to higher levels of performance, the ultimate goal being a picture surface that is flat and sharp from corner to corner.

21st-Century Icon

KV-32XBR200 Wega, 1998

Sunrise

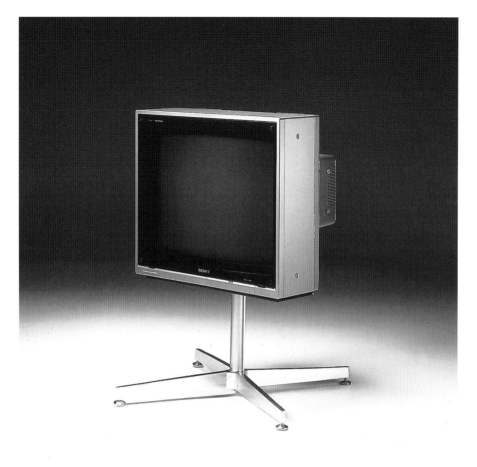

With the era of digital television now upon us, TV designers at the Design Centers in Tokyo, Park Ridge and London, led by the quiet, tightly-wound design star Kiyoshi Ohta, have been working day and night to produce a flat-screen television, called Wega, that makes most of today's TV sets seem old by comparison. Before examining this radical new design, let's first review why so much effort has been devoted to making a flat TV.

Unlike previous TV sets, which appear to be flat and promise horizontal and vertical lines that are straight (but usually are not), the new Wega screen is as flat as a tabletop and displays lines that are absolutely straight, making everything on the screen appear more real and lifelike. The flat screen not only minimizes reflections, making everything look brighter, it allows the viewer to look *through* the glass, *into* the imaginary space behind the screen, and thus experience the picture in considerable depth. With no screen bulge to obscure parts of the picture, the wide, flat Wega screen offers nearly a full 180 degrees of viewing with no loss of picture information, even when viewing at an extreme angle. When you factor in the wide 16:9 aspect ratio (considerably wider than the standard 4:3 aspect ratio we've known for dec-

ades), the effect is so real, it is like looking out a window.

Packaging this astonishing new technology should have been no problem, except for one small but critical matter: a large flat screen can easily

result in a plain (even boring) object when the set is turned off unless the entire product is designed with care. The challenge for Mr. Ohta and his Wega design team was to create a product that was flat and pure but not a box—a goal that Sony designers have worked toward for more than two decades.

Ever since 1972, when Kaoru Sumita designed the icon of all Sony televisions—the ProFeel—the dream has been to create a receiver that offered a true (and flat) window on the world. On the ProFeel, the illusion of flatness was created by mounting a sheet of smoked glass in front of a curved Trinitron screen. Today, such artifice is not necessary. But as the screen has been flattened, the desire to make the TV an interesting object has increased. Throughout the 1980s and early 1990s, the goal at Sony was to integrate a screen that was as flat as possible with a cabinet of interesting shape.

Meanwhile, half a world away, a young designer named John Tree sent the Wega project in a bold new direction. Responding to a request from Tokyo for Wega concepts, Tree delivered a model that had a headlike display, a squat articulated body and a four-sided splayed foot that made the design seem light yet grounded. Sitting two desks away, Mr. Tree's London colleague Yoshinori Yamada evolved a similar concept that was blunt yet still inviting.

Back in Tokyo, manager of television design Masayoshi Tsuchiya consulted his lieutenants Shigeyuki Kazama, Kiyoshi Ohta and Yuji Morimiya. All agreed that merging the Tree and Yamada concepts would provide the best final result.

Since Wega begins a new era in television design, the name was an important issue. Those with a long memory still remember the small German electronics manufacturer called Wega. Known for its high-style products, the firm was sold to Sony in 1981. Ever since, Sony chairman Norio Ohga has wanted to use the Wega name (pronounced VAY•ga and spelled with two intersecting Vs rather than a W) for Sony's next high-profile product. But with competition in the flat-screen TV market heating up in 1996, Sony could not wait to release its first flat TV with the Wega name. In order to be first to market, DC/Tokyo enlisted Takuya Niitsu (a veteran Sony designer) to craft a flat-screen design (known as the KV-28SF5) in just three days—fast even by Sony standards.

As Mr. Niitsu's three-day design hit the market, John Tree's Wega concept was given to his colleague, Yoshinori Yamada, who softened the overall design and applied larger corner radii around the screen, thus preventing the design from appearing too tight.

According to Mr. Tree, "the goal with the first Wega was to create a design that is pure and strong but not too simple or extreme." This was accomplished by giving the back a graceful yet

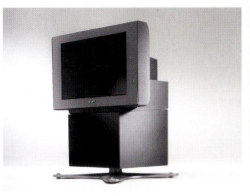

Above (left and right): John Tree's initial concept for Wega (DC/London), 1997; Yoshinori Yamada's interpretation of the Wega design for the European market. Below: KW-32HDF9 Wega High Definition Television, a modified version of the European model made for the world market. Design: Shigeyuki Kazama (DC/Tokyo) and John Tree/ Yoshinori Yamada (DC/London), 1997–98.

subdued shape while treating the front in a more deliberate manner. With tight corners and a descending pattern of perforated dots on either side of the screen to accentuate the angular shape, the front of the new design has two concentric rectangles that frame the screen, with a slight edge around the picture that is perceptible yet not distracting. Indeed nothing draws the eye toward the product but the screen itself. Sounding like a bartender, Mr. Kazama says, "with the first Wega design, we've created gin, a strong liquid that is transparent with a very slight odor and flavor. It's not merely good gin. It's the best in the world. And with this superb liquid we can mix a number of interesting cocktails."

The first Wega design ranks as one of the great achievements of modern industrial culture, not only because of its technology, its physical beauty and social significance, but because it gives the television something that has been missing for many years: expression and symbolism. With a simple series of lines, a precise juxtaposition of color and texture and careful attention to details, the Wega design team has restored the physicality and sense of wonder that once resided in the television. As the glowing hearth that delivers content and contradiction in equal measure, it must have an identity that is both powerful and unique.

The meaning that we invest in the television as an object demands that it be treated by designers who understand not only the form of the product but the relationship of the screen to the viewer. Enhancing

this relationship will be the task of the Wega team in the years to come. A glimpse at this future and the wonders that digital television will bring are contained on the following pages.

CONSTRUCTION · INTERIOR · MATERIAL

ALTERNATE SOUND/Arie · LCD SHUTTER/Kataoka · SLIDING SPEAKER/Cris · DIGITAL PERFORMANCE/Ohta · NEW BEZNET/Nara · GLASS STORAGE/Morimiya · FLOATING EMOTION/Ogura · COMPOSITION/Suzuki · PROFEEL DIGITAL/Sawai · METALLINE/F.Matsuoka · FLAT TOP/Nakayama · THEATER/Y.Matsuoka · BALANCED!/Kazama · GLASS/TREE · ALUMI FRAME/Wiege · DIGITAL FURNITURE/Jan · CLOTH&TENSION/Takagi

This page: the Wega design team at DC/Tokyo drew this roadmap to kick off their 1997–98 second-generation Wega project. Opposite page: DC/San Francisco designer Christopher Frank gave his Digiplane concept a bold theatrical appearance with doors that slide out to reveal twin speakers, a built-in DVD player and removable keyboard for Web browsing.

While engineers and user interface designers are busy transforming what we see on the screen, the Wega design teams in Tokyo, Singapore, San Francisco, Park Ridge and London are enhancing the design that encloses that wonderful screen. Because of its new flat-screen technology, the Wega design exists at the end of one product line and the beginning of another. As both a sunset design and a sunrise expression, the first Wega model provides the raw materials from which many new designs can flow. In touch with the requirements of Sunrise/Sunset design, the Wega team purposely gave their first design a quiet, even spare, personality. As Mr. Kazama explained, the first design was like gin—simple and pure, a foundation on which future products could be built.

Wasting no time, the Wega team began creating these cocktails even before the first Wega product went into product. During the summer of 1997, DC/Tokyo launched a worldwide design effort to come up with their midmorning Wega by emphasizing the preoccupations of all television design: construction, materials and the qualities that allow such a product to fit into a domestic interior. Led by Wega team captain Yuji Morimiya in Tokyo, more than a dozen designers working in Asia, Tokyo, San Francisco, Park Ridge and London came up with various expressions ranging from sober constructions that were as hermetic as the original Wega to provocative concepts that forced the rest of the team to rethink what a twenty-first-century television could become.

Designing the concepts wasn't easy. Indeed, television design can be a mind-bending activity. "If you imagine how many eyes will be judging your work, when you think about how much money is at stake in a new design, and when you realize how culturally significant the television has become, the pressure is almost crippling when you try to develop a new product," says DC/San Francisco designer Christopher Frank, who took part in the 1997 Wega project. Since television is Sony's number-one business, the first in sales volume and second only to PlayStation in its profit potential, the design of each new product assumes an almost surreal importance. As a result, DC/Tokyo designers conducted the Wega/2 project with an intensity that is difficult for outsiders to imagine.

Even though the most efficient way to enclose a fifty-pound video tube with twenty pounds of electronics is to mount it within a six-sided enclosure with a recognizable front, top and sides, a box is probably the most uninteresting form you can imagine in a home. "If you look at a home interior in a magazine, you never see the television, because the photographer removes it before taking the picture," says Wega team leader Yuji Morimiya. "For the second Wega, we wanted to give it a unique shape, color and texture that would look great in any interior."

Concepts for the second-generation Wega designed during the summer and fall of 1997 ran the gamut from room-filling sets to compact forms that had a quiet, closed appearance. Yet all shared one quality: Unlike the first Wega, there were few flat surfaces with straight lines and right angles limited to those around the perimeter of the screen.

In San Francisco, Chris Frank envisioned the product as a giant slab that faced the viewer with a tidy support structure with horizontal lines on the back. Called Digiplane, the design featured twin doors on the front with flat panel speakers mounted on a track that allow the doors inside to slide horizontally (like shoji screens) to reveal the screen. When the doors are open, Frank's design has magnificent presence and superb sound quality. The sliding doors also gave Digiplane a dual personality: one that is active when the doors are open and the screen exposed; and a quieter, more demure appearance when the doors are closed. With a DVD player mounted inside the product capable of playing audio CDs, and a removable keyboard, Digiplane could also function as a home audio system and Web browser terminal for a home-based PC.

While it is tempting for a designer to make a bold statement, the real challenge in television design is to make small, yet meaningful changes that allow the product to evolve in an interesting direction over time. One way to effect this transition would be to start with the first Wega design and give it a more compelling shape by slicing off the corners at the back, front or sides in an expressive way. On a conceptual level, this "cutting strategy" was based on the initial Wega design, in which the designers sliced off the curved screen and made it flat. Creating beveled edges has always been an effective way to reduce mass on a bulky object, and the first-generation Wega design left plenty of opportunity. Two of the most interesting second-generation Wega concepts adopted this approach.

"Slicing off the back of the TV reduces the product's mass, allowing the exterior to conform to the tube inside; cutting the surface also results in a more visually interesting shape. And a shape that is visually interesting deserves to be covered in more appealing colors and textures," says DC/Tokyo designer Noriaki Takagi, who wrapped his second-generation Wega concept in a series of beveled edges and clothed the result in royal blue fabric, giving it a distinctly non-TV appearance. Viewed from above, Takagi's design looks almost like a lamp shade. Viewed from the front, back or side, the design looks impressive from all sides, with magnificent curves in the upper section that meld into a less violent grey curved base.

Working in Singapore, Fumiya Matsuoka took a more nuanced approach with his Metalline concept, mixing the exuberance of Mr. Takagi's design with the more stoical attitude found in earlier Sony TVs. Keeping the front of his concept flat and severe, Matsuoka cut the back of his TV into an emphatic V shape and clad the exterior in brushed aluminum with a triangular vent on top.

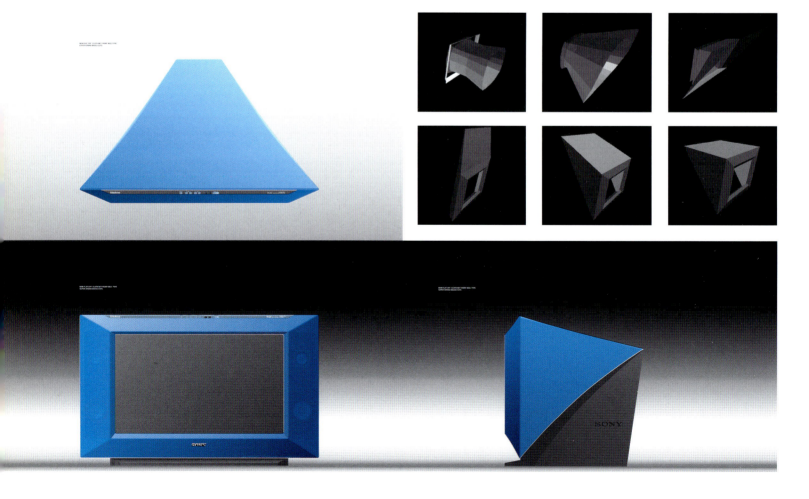

CONCEPT

ギシギシ、ベコベコ、グニャグニャ
チューブを支える樹脂の悲鳴が聞こえる.

金属をベースとした、剛質感が高く
たたずまいに緊張感のあるTVの提案.

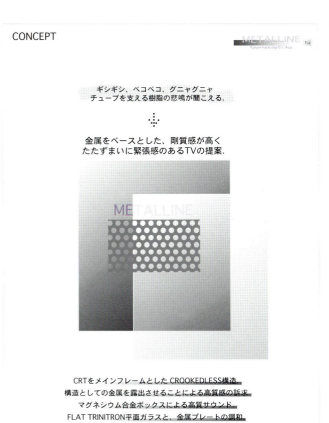

CRTをメインフレームとした CROOKEDLESS構造.
構造としての金属を露出させることによる高質感の訴求.
マグネシウム合金ボックスによる高質サウンド.
FLAT TRINITRON平面ガラスと、金属プレートの調和.

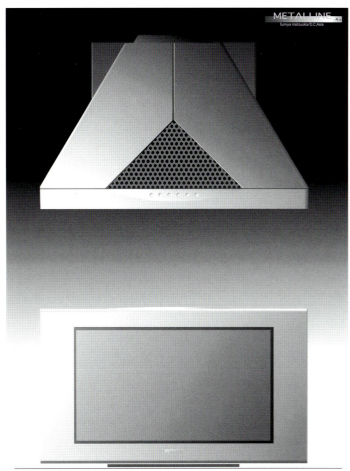

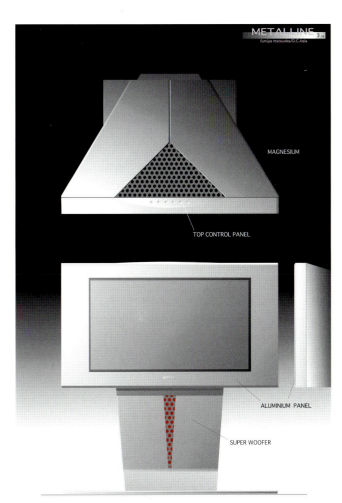

MAGNESIUM

TOP CONTROL PANEL

ALUMINIUM PANEL

SUPER WOOFER

CONSTRUCTION

CRTを構造体のメインフレームとして考え、
マグネシウム合金成型によるリアカバーL.R.を固定する.
それは 高剛性スピーカボックスも兼ねる.

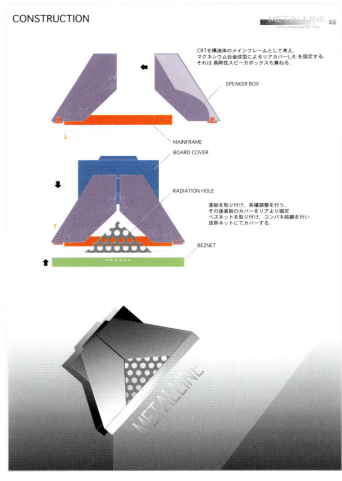

SPEAKER BOX

MAINFRAME

BOARD COVER

RADIATION HOLE

基板を取り付け、各種調整を行う.
その後基板のカバーをリアより固定
ベズネットを取り付け、コンバネ結線を行い
放熱ネットにてカバーする.

BEZNET

DC/Tokyo's Fumiya Matsuoka created a second-generation Wega concept with a deeply cut V-shaped back, quiet front and brushed aluminum surface.

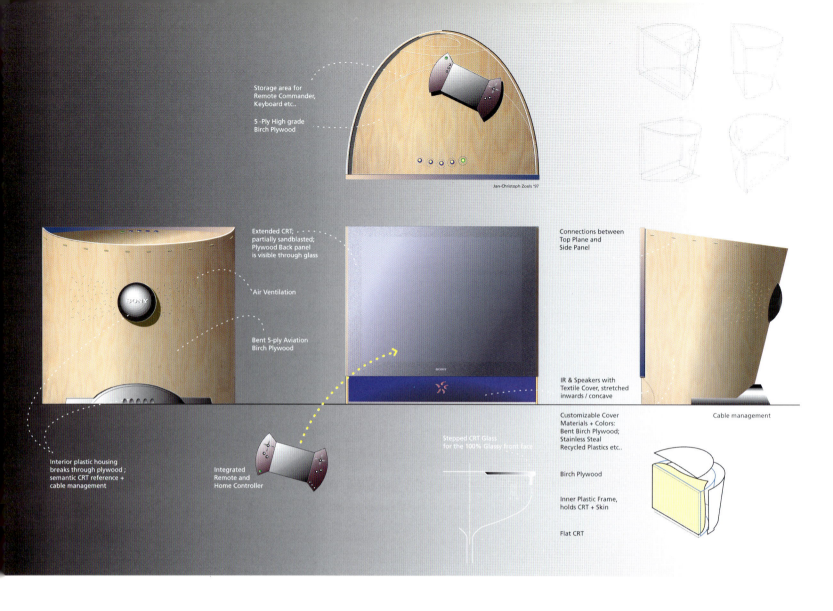

Storage area for
Remote Commander,
Keyboard etc..

5 -Ply High grade
Birch Plywood

Jan-Christoph Zoels '97

Extended CRT;
partially sandblasted;
Plywood Back panel
is visible through glass

Connections between
Top Plane and
Side Panel

Air Ventilation

Bent 5-ply Aviation
Birch Plywood

IR & Speakers with
Textile Cover, stretched
inwards / concave

Cable management

Interior plastic housing
breaks through plywood ;
semantic CRT reference +
cable management

Integrated
Remote and
Home Controller

Stepped CRT Glass
for the 100% Glassy front face

Customizable Cover
Materials + Colors:
Bent Birch Plywood;
Stainless Steal
Recycled Plastics etc..

Birch Plywood

Inner Plastic Frame,
holds CRT + Skin

Flat CRT

Jan-
Christoph
Zoels
imagined
the second-
generation
Wega as a
social entity
whose
shape and
materials
would
confirm the
user's
identity and
aspirations.

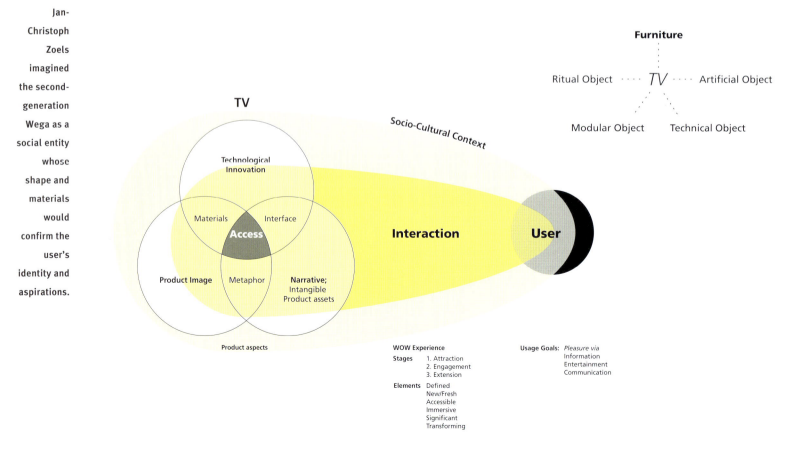

Furniture

Ritual Object ···· *TV* ···· Artificial Object

Modular Object Technical Object

TV

Socio-Cultural Context

Technological
Innovation

Materials Interface

Access

Product Image Metaphor **Narrative;**
*Intangible
Product assets*

Interaction

User

Product aspects

WOW Experience
Stages 1. Attraction
 2. Engagement
 3. Extension
Elements Defined
 New/Fresh
 Accessible
 Immersive
 Significant
 Transforming

Usage Goals: *Pleasure via*
 Information
 Entertainment
 Communication

Depending on the size of the television and its anticipated use, deep cuts allow the back of the TV to fit into the corner of a room. Yet Mr. Matsuoka did not want to hide the back of his concept. With its intricate detailing and brushed aluminum finish, the Metalline design would function best in the center of a room.

Meanwhile, at the Park Ridge studio, German-born designer Jan-Christoph Zoels considered Tokyo's designs a bit conservative. With television technology becoming digital and all aspects of traditional television viewing and design coming into question, Zoels used the Wega/2 project as an opportunity to rethink what the television could be. As an object, the television is many things at once: it is furniture; an object of ritual; an artificial object; a technological wonder; and a modular component, usually part of a larger audio/video system. The TV has a specific product image. It projects a slightly different metaphor and meaning on everyone who uses it. Its interface is essential to understanding the product.

And its shape and materials are equally important, since we live with it every day. In Zoels's mind, the television is more than the sum of its parts. It is a social entity and an expression of the user's identity and aspirations. The interaction between the television and the viewer is so complex that Zoels gave it a shapely, interactive mien with expressive details on every surface.

Eschewing the traditional square-corner look, Zoels gave his design a bent plywood horseshoe-shaped curve on the back, comma-shaped vents on top, a TV stand with a rounded skirt at the bottom and other details that made his concept the most visually active of all the Wega/2 designs. "Using an organic shape and organic materials was an intentional decision, because it is so different from what Sony normally does," says Zoels. "When designing concepts, it's important not to restrict your thinking too much. The concept phase is the time to push possibilities to the limit and hope that the company can see your direction."

Minimizing the visual weight of the Wega design was the goal of DC/Tokyo designer Hajime Ogura, who proposed his Floating Emotion concept by visualizing the television as a heavenly object, floating on a surface of a pool. Challenging the laws of physics, Mr. Ogura pivots his Wega enclosure on a slender stand that allows the bulky product to appear lighter than air. Unlike the bold faceted appearance of the Matsuoka and Takagi concepts, Mr. Ogura's design reduced the volume of the set through a series of three-dimensional curves on the back.

While keeping the front of the product flat and square, many variations on the Wega design are possible by removing mass from the back of the set, supporting the TV on a stand or hanging it from a wall, creating what Fumiya Matsuoka calls a "devicelike" product. Ultimately, as the Wega TV has its backside cut away, it will end the way it started: as a spare, flat, yet graceful object whose design will gain in importance as it diminishes in appearance.

FLOATING EMOTION

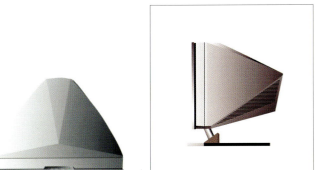

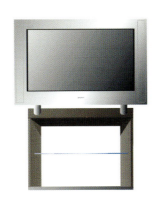

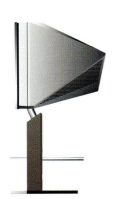

The subtle curves in Hajime Ogura's Floating Emotion concept take a more heartfelt approach to television design. Design: Summer–Fall, 1997.

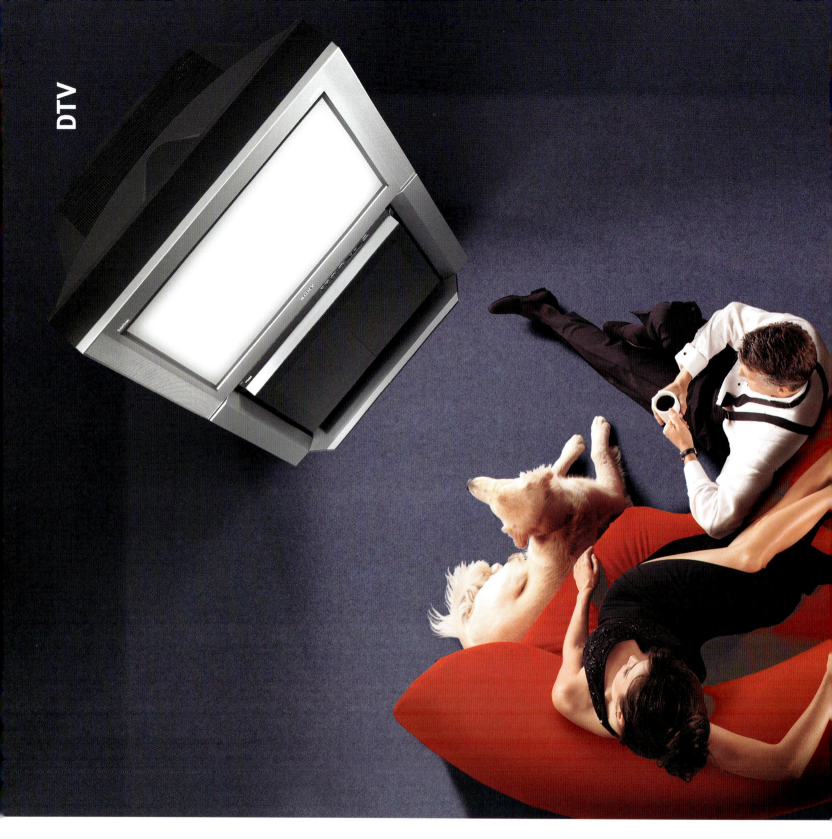

As we mark the end of the analog generation, television stands at the dawn of a new era with digital television—offering unlimited choices of entertainment, education and information. By delivering high-definiton video and CD-quality audio, as well as new and faster digital services to the home, DTV will give us opportunities that are so wide they are almost infinite. Involved in every aspect of DTV—from broadcasting and content creation to design and manufacture of DTV sets and professional/consumer digital camcorders— Sony occupies a vantage point from which to influence the future of Digital Television—with the Design Center pushing on several fronts.

Technically, DTV is like nothing you've seen before. Unlike an analog signal, which uses a system of varying voltages to represent picture elements, DTV converts each picture element into binary code, the ones and zeroes used by computers. This information is then sent through a "bit stream," which is compressed using a technique called MPEG-2, sent to your home, then decompressed and shown on your DTV set. As a result, the ghosting, fussiness, noise and static that you often see in analog broadcasting will be replaced by a rock-solid signal with vibrant colors that will leap off the screen, the result of component video technology that separates the black and white signal from the color signal, which results in better color resolution and no fuzzy edges around picture elements.

The DTV signal provides a crystal clear picture whether you are ten inches from the screen or ten feet. With a 16:9 screen format, DTV viewers will enjoy a nearly cinematic experience. And DTV offers not just a single experience, but three pos-

mercial, such as directions to a local store or discount coupons.

Effecting the transition from analog television to DTV, the Design Center has fed the market for "early adopters" by developing HDCAM recorders, editing suites and cameras for content providers, flat-screen Wega televisions for commercial and consumer applications and set-top box/software solutions that will make accessing the vast range of DTV content much easier than today's analog sets. As we have seen, the emphasis in television design has traveled from the outside of the set to the inside. In response to DTV, as much or more effort is now given to designing the on-screen controls, electronic programming guide and set-top box interface and software as is devoted to designing the DTV set. As manufacturers and content providers battle for DTV market share, success will go to anyone who can design a set-top box with a truly useful and intuitive interface . . . one that guides viewers to broadcast, cable, satellite and Web content as well as work with their audio system, personal computer, digital cameras and other AV products. Moving beyond the standard button-style controller (page 105) and *TV Guide*–style interface now used in the PerfecTV electronic programming guide (EPG) (pages 108–9), the Design Center is now developing a new style of interaction with a fluid on-screen interface. One version includes a dial metaphor that appears on the screen (see sidebar). Another version features on-screen content

sibilities in one. With compressed high-definition television (HDTV), you can enjoy the best possible picture and surround sound. With compressed standard-definition television (SDTV), you get better quality than today's analog broadcasting and digital satellite systems—about the same as today's DVD-digital video disk—but with more than five times as many programming choices in the same bandwidth as today's analog signal. With DTV data broadcasting, you can access a Web site, download a newspaper or select options on a television program or com-

that "zooms" in and out of view (see pages 162–65) and a personal EPG that learns your preferences and preselects the content that *you* want to watch. With so much effort being expended inside the set, a massive effort is also under way at Sony to design the form and detailing of the second-generation Wega TV due out in the year 2000.

The on-screen display for Sony's high-end televisions, designed by Miwako Yoritate and Kiyoshi Ohta, uses transparent imagery to allow viewers to see the television picture through and around the channel information and a unique pressure-sensitive control pad that allows the user to operate the controls by dragging a finger up and down. Menus are displayed on the right-hand side of the screen, providing ease of use while achieving a significant reduction in size. Achieving the correct size and prominence for this on-screen information is the result of simple intuition on the part of the designer followed by extensive user testing both in Japan and the U.S., where the average distance between the user and the product differs considerably, which prevents the Design Center from offering a single worldwide solution. From this simple character-generator approach, Sony designers are working on advanced control systems for DTV, removing as many functions from the surface of the TV and the hand-held controller as possible, and putting them on the screen, where they can be seen from across the room and accessed with a single click. Using a simple handheld device with a dial or jog-shuttle control, it may soon be possible to control the TV set, tune into cable or satellite broadcasts and navigate the Web using a screen-based dial-shaped interface. Get ready, it's coming.

The PZ-2500 Plasmatron Flat Panel Color Television and Stand, 1996, has changed the relationship of the television with the interior decor. Design: Yuji Morimiya (DC/Tokyo). Below: Two of Mr. Morimiya's foam concepts for Plasmatron, 1995.

One of the central tenets of Sony's design philosophy is to define not only the mainstream, but to explore the extremes that technology makes possible. In the television arena, this go-for-broke attitude has led the Tokyo design team to develop one of the largest and thinnest home televisions in the world, as well as the smallest and lightest. Each design probes the outer limits of the designer's imagination.

By any definition, the Plasmatron (PZ-2500) is the most awe-inspiring Sony consumer product of recent history. Using a similar active matrix LCD technology as that found on modern laptop computers, Sony researchers increased the screen size to thirty-six inches (with more than one million pixels), while reducing the depth of the product to less than five inches. The simplest way to display this kind of product would be to hang it from the wall. But the Design Center's Yuji Morimiya had a better idea. "Rather than treat the Plasmatron as an object," he says, "I proposed giving it a symbolic dimension that allows the product to function in a domestic environment and not be

stuck in the corner of a room."

As a specialist in TV design, Mr. Morimiya had noticed that most architecture magazines avoid showing a television in a domestic setting, "because the TV did not fit into the home. That's

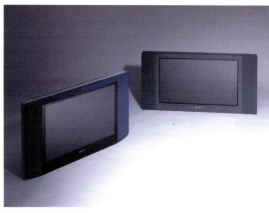

what makes the Plasmatron so exciting. Its unique proportions allowed me to make a new cultural statement by redefining the relationship between people, objects and the space they occupy." Morimiya accentuated the thinness of the product in his first prototype, which inspired the engineers to give the next prototype larger speakers around the screen. The flatness of the screen and the framing effect of the speakers caused

Morimiya to think of the design as an abstract painting. After looking at the work of the 1960s American color field painter Ellsworth Kelly, Mr. Morimiya adopted a more graphic approach, giving the panel a brightly colored beveled edge on the top and sides. "Because the product is thin, it tended to disappear when viewing it from a distance," he explains.

"Framing the screen with a bevel gives it more visual weight," while inserting a plinth beneath the panel allows the product to float above the floor. As a result, the Plasmatron looks thicker than it actually is. The first concept was completed in late 1995. The second (and final) design was finished in the spring of 1996 for release in the summer of 1997.

Since color plays an important role in the Plasmatron design, Morimiya found that changing the color (from Sony blue to russet red to forest green) gave the TV a different personality, allowing its image to change with the seasons. "The traditional TV ignores the world around it. In contrast, the Plasmatron is aesthetically forgiving. It blends into its surroundings and functions

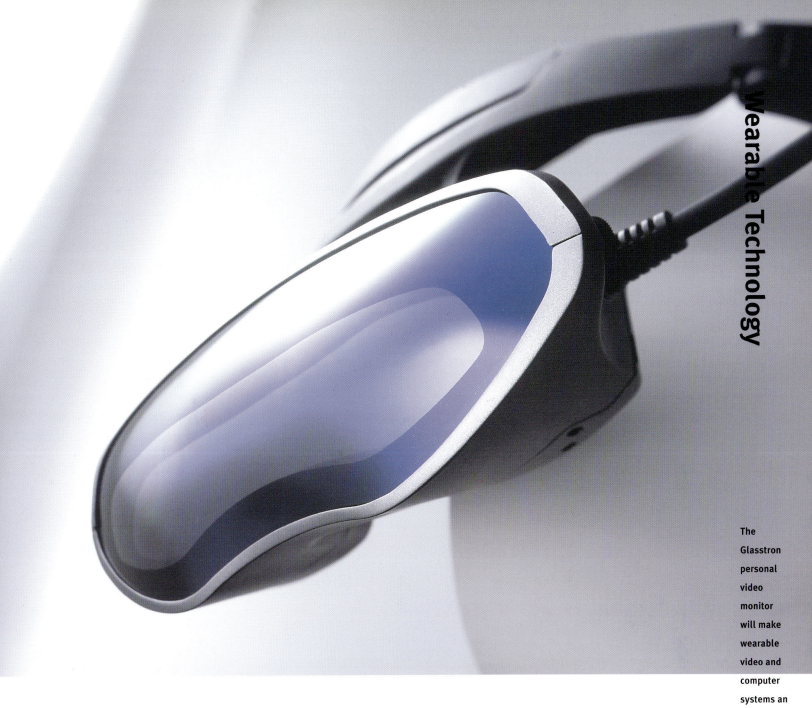

The Glasstron personal video monitor will make wearable video and computer systems an everyday reality. The current model, PLM-S700, offers a virtual experience of watching a 30-inch screen viewed from 1.2 meters away. Design: Daisuke Ishii (DC/Tokyo), 1996–97.

well almost anywhere. By simplifying the panels as much as possible, the power and energy inside the product can emerge. It's a true icon." Future concepts explore the Plasmatron in a variety of ways: suspended from the ceiling, used with a touch-screen overlay as an electronic drawing board, and even as a table top in a French bistro, where the $8,000 screen serves as the world's largest and most expensive restaurant menu.

By combining the miniaturization and computer power brought about by digital technology with the small high-resolution LCD screens now available in limited quantities, it is now possible to design products that serve as an extension of the human body. Lightweight and tailored to the contours of nearly every physique, these "cyborglike" products, such as wearable computers, and televisions with specially designed head-mounted dis-

plays, will one day be as commonplace as the Walkman is today. Indeed, that day has arrived. For the past eight years, Sony engineers have gradually downsized the components used to receive and display television signals, connected this circuitry to tiny high-resolution flat panel color displays and mounted the LCDs inside a headpiece that resembles a pair of ski goggles and attached headphone—to create the world's first self-contained personal viewing system, called Glasstron.

The work of Daisuke Ishii at DC/Tokyo began

as an experiment to make the "ultimate" in portable video pleasure. When imitators appeared, Mr. Ishii developed a new model, PLM-S700, made of magnesium alloy, which resembles a pair of high-tech ski goggles. The lightweight design provides an easy fit and ensures comfort even for those who wear eyeglasses. The PLM-S700 displays 1.5 million pixels in each 0.7-inch screen with a "see-through" mode that allows users to view the surrounding environment by adjusting the transparency of the screen.

The history of video camera design at Sony, as well as its future, is embodied in the mind and spirit of one man. His name is Shin Miyashita, chief designer and manager of the video camera section of DC's Personal Audio Video Group. A veteran designer and manager, Mr. Miyashita has overseen nearly every step in the evolution of handheld video camera design, from the ungainly semiprofessional and heavy boxlike models of the early 1980s to the slim high-resolution cameras that we know today. Looking back over this twenty-year evolution, the video camera has become not only smaller and more sophisticated in its performance but more natural to hold and use. The basic gesture of holding the video camera with one hand, gripping it by use of a strap and holding it up to the face in the now-classic posture was a Sony invention that has since been adopted throughout the industry. The move away from this style of interaction toward products that are shaped like conventional still-frame cameras (while still maintaining the single-hand grip) was another Sony exclusive. The introduction of a tiny LCD screen to replace the optical viewfinder was not a Sony first. And, as we will see, the LCD viewfinder, and the recent move to a smaller upright camera shaped like a small paperback book, also invented elsewhere, have been so thoroughly adopted by Sony that both features have been reinvented.

Looking at the evolution of the video camera, another trend emerges. With each passing year, the cameras become not only smaller and easier to use, the gestures needed to operate the camera have become more fluid and graceful. Like no other Sony product, the video camera has an intimate relationship with the user as it choreographs the movement of hand and eye, encouraging us to view the world through its screen rather than our own eyes. The designs that Shin Miyashita pioneered are so persuasive that virtually anyone can pick up one of his cameras and follow its directions, holding it in precisely the right way because of the way it is designed.

In order to push the video camera through the final barrier that prevents it from achieving true mass-market acceptance, Mr. Miyashita is focusing on new designs that will make the product even more natural to hold and operate. The goal,

Noon

CCD-TR55, 1989

CCD-TR1, 1980

CCD-M8, 1985

SONY VIDEO CAMERA
1980 – 1999

CCD-V8, 1985

Sunrise

he says, is "to balance simplicity with complexity, maintain a proper weight/size ratio and achieve a perfect relationship between the hand and eye." The result, he hopes, will be a video camera that doesn't feel like a video camera.

Rather than update the video camera of today, which is already a mature product and not easy to change, Mr. Miyashita wants to cultivate

Achieving the perfect relationship of hand to eye will soon yield a video camera that doesn't look or feel like a video camera.

a new generation of users by giving the camera a totally new shape. Using memory chips as a storage medium, the camera can be any shape. And using an LCD, it need not be held close to the face to be used effectively. "The next challenge is to make the video camera a casual experience," he says, "as natural to use as a remote control."

The digital still camera evolved from the video camera, using the same charge-couple device as the camcorder and many of the same electronics. But there were three important differences. First, the still camera captures one image at a time.

Therefore, it does not require massive amounts of data storage, such as a DV or 8mm tape, that you find in a video camera. Instead, the still-frame digital can store images on a magnetic disk or in memory inside the camera. By eliminating magnetic tape, and the motor/tape head assembly it requires, a digital camera can be much smaller than a handycam. And because its electronics are simpler, they are cheaper to manufacture, own and use. But the third difference between the digital camera and the camcorder is the most important of all. Unlike the camcorder, which was so new at its inception that Sony designers were free to invent the best possible size and shape, the digital still camera had to acknowledge the decades of experience that users have had with traditional film cameras. Even though digital cameras will one day replace the 35mm camera that we know today, their design must be thoroughly analog.

The first mass-market success in the digital camera realm was the Digital Mavica, introduced in 1997. Its main feature was convenience. All you had to do was slip a standard 1.4-megabyte floppy disk into the Digital Mavica (which includes a floppy drive within its rather bulky housing), snap twenty or

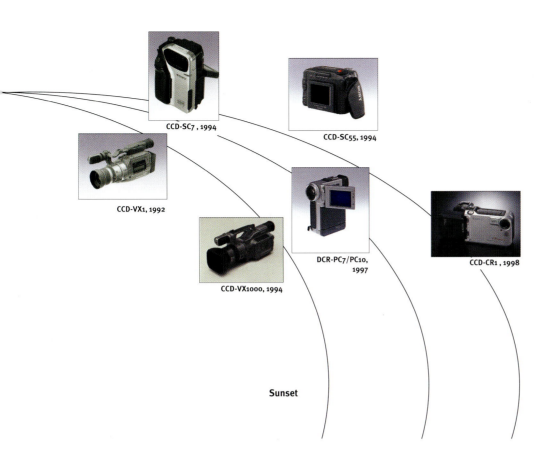

CCD-SC7 , 1994

CCD-SC55, 1994

CCD-VX1, 1992

DCR-PC7/PC10, 1997

CCD-CR1 , 1998

CCD-VX1000, 1994

Sunset

more pictures, pop out the disk and view or print the images using an ordinary PC. With its total ease of use, and ready adoption of the floppy disk medium, which millions of consumers already used, the Digital Mavica proved that digital imaging was easy and fun.

The weight and size of the Digital Mavica didn't bother users in America, where the product was a bestseller. Yet convincing Japanese consumers to put away their film cameras required a smaller, more expressive design that conveys the essence of this new technology. That product was created the year before Mavica's release when PAV's chief art director Kaoru Sumita designed the Cybershot digital camera in 1996.

One of the finest Sony products of recent years, the Cybershot design rests on an understanding of the inherent limitations of traditional camera design. First among these is the fact that traditional cameras must have a fixed lens at the center of the product with the film plane behind—which the digital camera did not need, since the CCD that captures the image is a tiny silicon chip that sits behind the lens. Another limitation of traditional film cameras is their fixed viewfinder, which forces the user to hold the product close to the face and control it in a limited way. Overcoming these limitations was the first task for Mr. Sumita and the key to his achievement.

Digital Mavica. Design: Shin Miyashita (DC/Tokyo), 1997.

"Rather than force the user to hold Cybershot near the eye, like a conventional camera, which constricts the user's movements, I wanted to make the camera small enough and the LCD screen large and flexible enough so that the product could be held at arm's length for greater mobility," he explains. By making the viewing screen large enough to see at a distance, the user could experience great freedom as they hold the camera at their side and point it up, hold it high overhead and point it down and move it around—while always keeping their eye on the screen, snapping pictures at just the right moment." While returning freedom of movement to the user, Sumita choreographed that movement through the specifics of his design, encouraging anyone who picks up the Cybershot to engage in a series of T'ai Chi–like movements as they explore the camera's capabilities and take their first digital snapshot. Once discovered, this totally new way of taking pictures becomes so fluid and natural that conventional cameras seem like dinosaurs by comparison. But for Mr. Sumita, that was only the beginning.

A lifelong practitioner of functional yet friendly design, creating objects that have eye appeal as well as meaning, Mr. Sumita thinks about the people who

In ancient times (before 1980) all video cameras converted light into electronic signals by means of a pickup tube, a large power-hungry device that gave off intense heat after just a few minutes' use. Well aware of the tube's limitations, Sony researchers in the early 1970s began work on a new type of semiconductor called the CCD (Charge Couple Device) that was much smaller and more sensitive than the pickup tube, used very little power and thus gave off no heat, because the CCD was essentially a chip. In January 1980, Sony introduced a color CCD video camera for use in commercial aircraft. That same year, Sony research director Kazuo Iwama proposed that Sony aggressively push development of the CCD with an eye toward creating a portable video camera, weighing less than four pounds, that would use Sony's new 8mm tape to take "video home movies." Until that time, cameras had to be connected to a twenty-pound Betamax in order to record images. Known as Project 80, Iwama worked feverishly with Sony designers and engineers to miniaturize the components that surrounded the CCD. Iwama spearheaded a five-fold increase in the density of the CCD itself and came up with a chip capable of reproducing 250,000 pixels. The resulting product was Sony's first single-unit 8mm video camcorder, the CCD-V8, which set a new standard for picture quality. Today, the CCD is one of Sony's most important technologies. But Iwama himself did not live to see the flowers that resulted from the seeds he had planted. In recognition of Iwama's devotion to Sony and the CCD, Norio Ohga, who became company president the day Iwama died, honored his friend by placing one of the first Sony CCDs on Iwama's tombstone, saying: "Iwama-san, we have finally succeeded in the mass production of the CCDs you promoted." When Sony employees visited Iwama's grave on the seventh anniversary of his death, the chip was still there (see above)—as if Iwama were holding it himself.

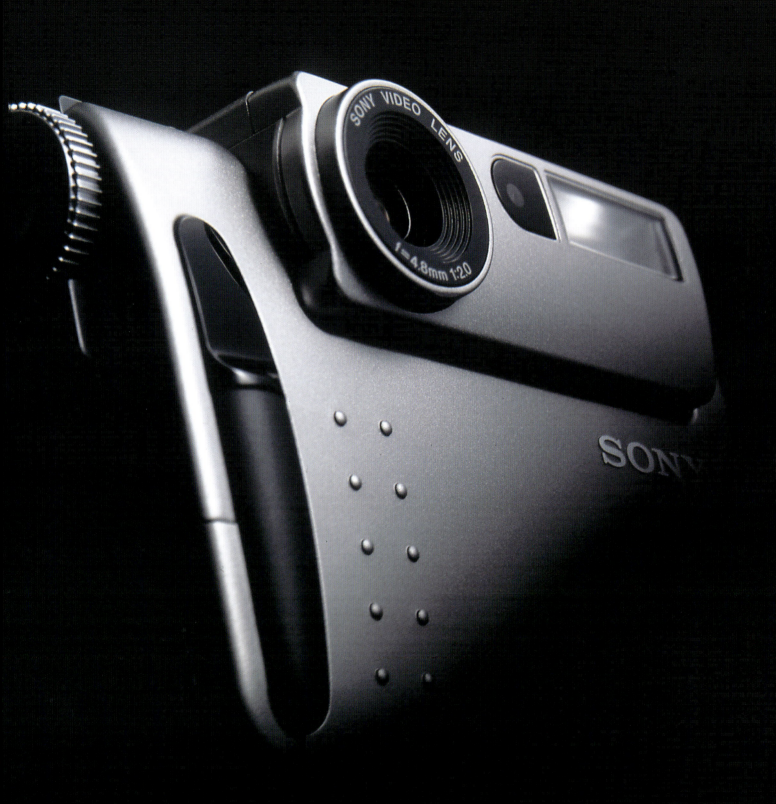

will use his products. "Users live complicated lives and often don't have time to learn new products or technologies," he says. "So it's my responsibility to make products that are as simple and transparent as possible. It's also my job to create a design that goes beyond its immediate function. Once you master the product and learn how it works, I want the user to discover the 'secrets' that are contained in the shape, the 'story' that the product tells in the way that surfaces greet one another and in details that encourage the fingers to remain long after the picture has been taken. Basically, I want to make holding the camera a pleasure, a natural extension of your hand, so that people will feel comfortable and want to hold it all the time. "

The gentle seduction that Mr. Sumita's design encourages between hand and object allows Cybershot to function not only as a camera, but as a personal accessory—something you want to hold simply for the pleasure of holding it.

The design also encourages the user to "play" in ways that most high-tech products do not. The rotating lens at the top, for example, is perfectly shaped and positioned for the user to turn it in an almost absent-minded way—the way we hold a ballpoint pen and intuitively click the end with our thumb. This unconscious "play" was built into the design from the outset, and nearly caused Mr. Sumita to make an embarrassing mistake. So important was the rotating lens element on top that he initially placed the Sony logo in this area, just to the right of the lens. Yet doing that, and rotating the lens backward, toward the user, allowed the precious logo to be turned upside down—an unthinkable (but as we will see later, not impossible) thing to do when designing a Sony product. "When I noticed that, I quickly put the logo farther down on the body," says Mr. Sumita with obvious relief.

The design we see today is the fourth iteration in a month-long exploration. By Sumita's own admission, his first concepts were a bit timid and too similar to existing film cameras to be seen as a digital product. Concept number one resembled a compact 110 film camera with a pivoting LCD on the back. Concept number two was even more conceptional. Only with the third iteration did he discover the essential form—a thin upright slab, the same size and weight as a bar of soap, with a pivoting LCD on the back and a pivoting lens element on the front. The surviving concept model

**Cybershot.
Design:
Kaoru Sumita
(DC/Tokyo),
October–
December,
1995.**

and Illustrator drawings (see below) show how ideas from one concept metastasize from different forms to others. In one way or another, all of the best elements of Mr. Sumita's first three concepts found their way into the final design.

Achieving this balance of form and meaning was the result of close collaboration with Sony engineers who did not always bow to Mr. Sumita's wishes. For example, the processor inside the product was so power-hungry that the battery did not last for more than an hour. The lens was also a problem. "I wanted the best possible lens, both to make better pictures, and to enhance the perceived value of the product and give it a visual boost." These limitations have been remedied in the recently completed Cybershot Pro. But what needs no improvement is the design itself.

It is rare for such a young technology to yield such a mature, world-wise design. But Mr. Sumita has made a speciality of crafting icon statements. Going back to 1963, when he joined Sony, he surveyed the staggering achievements that Sony designers had already won with the transistor radio, married those forms and ideas with the new Black and Silver design language then being touted by Design Center chief (now chairman) Norio Ohga and worked his own peculiar kind of magic on his first signature product, the Citation television set, a thirteen-inch model that inspired a number of consumer models over the next few years. Later, Mr. Sumita created the first ProFeel (1974), giving it a dreamlike modernist expression with its black and silver skin, smoked glass front

and metallic tripod stand. As the first in a long line of monitorlike televisions, Mr. Sumita's ProFeel cast a very long shadow, influencing the design of Sony's current Wega TV. After ProFeel, Mr. Sumita then transferred to PAV, where he designed the first icon statement in the Walkman family, the Walkman 2 (based in part on a concept by Sony designer Shuhei Taniguchi), the first portable cassette player to feature controls on the surface of

The story that Mr. Sumita builds into each product does not reveal itself easily. It must be unlocked and deciphered. Like a fine wine, it must be savored slowly to be truly understood.

the product, not at the side. More than two dozen Walkman designs by others at Sony stemmed from Mr. Sumita's Walkman 2. Mr. Sumita himself added to the mix by designing an additional thirty models, helping to elevate the Walkman from a great product to a worldwide phenomenon. He

then transferred to the video camera division, where he applied his skills to consumer cameras (notably the PC7/PC10) and downsized professional products (such as the new CCD-VX1000) for the advanced amateur.

Given this vast experience, it was only natural that Mr. Sumita would be asked to shine his light on the first Cybershot. No object is allowed to escape his grasp without having a story woven into its form and detailing. The story that Sumita builds into each product does not reveal itself easily. It must be deciphered. Like a fine wine, each design must be savored and enjoyed slowly in order to be truly understood. The keys to this kind of product narrative are more tactile than visual. The essence of Sumita's approach cannot be appreciated from photographs alone. Only by picking up a Sumita creation, turning it over in your hands, feeling the simultaneous sensation of weight (through the use of aluminum and magnesium rather than plastic) and lightness, the simultaneous expression of cold solidity in the material with warm shapes and tactile details, do you begin to understand that designers such as Mr. Sumita do not merely clothe technology, but breath life into products and make them divine.

The most interesting question about Cybershot is: How can Mr. Sumita, or anyone, transcend it? As the clock advances, the next design will occupy a midafternoon position, meaning that it will need a bolder expression or a more professional, elite presence—both of which will be difficult since the present design already reflects both moods in equal measure.

In these Illustrator renderings, Mr. Sumita explored three conventional approaches before choosing the Cybershot design that reached the marketplace. The final design is shown at lower right.

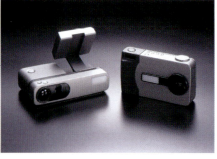
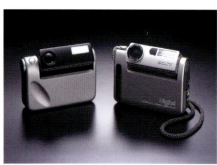

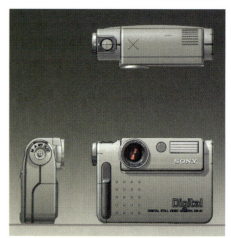

The task of designing the high-end Cybershot model fell to Takashi Ikenaga in the Design Center's Broadcast and Professional group in Atsugi, an hour south of Tokyo. The issue for the new design was simple: Would the new product, called Cybershot Pro, have the look and feel of a high-end camera or the unique shape and functionality that Mr. Sumita had given the original Cybershot? The question was important, because unlike the earlier model, Cybershot Pro had to accommodate the many preconceptions that professional photographers and advanced amateurs have with their equipment.

Any camera that emphasizes performance is designed around the largest and most critical element: the lens. The design and placement of the viewfinder, the integrated handle that encloses the light meter, battery and media bay, the external displays and surface controls all must support the holding and positioning of the lens. Mr. Ikenaga followed this dictum by giving the Cybershot Pro a clean, organic form that melds with the user's hands. Because there is no film to load, the mass behind the lens to the left has been shifted to the right. The soft, rounded form on the left accentuates the barrel-shaped lens, giving the camera a tough, machinelike feel. While gripping the camera with the right hand, the thumb and index finger fall naturally into place. Looking down, we see both an optical viewfinder and an LCD screen on the back. This apparent redundancy acknowledges the fact that professionals often use cameras in a conventional way, holding them to their face while taking a pic-

ture. More aggressive is the decision to make the product Memory Stick ready. This new form of digital media (decribed on pages 188–93) uses memory chips to store images for transfer to a VAIO computer or other Memory Stick device, such as a handheld viewer, desktop picture frame or Memory Stick cellular phone. For all but the most demanding situtions, such as studio photography for large-format output, Mr. Ikenaga's design not only surpasses the needs of most professional photographers, it seduces them with a form that is both reassuring and bold in its combination of old and new.

Acceptance of digital imaging by professionals is critical to its eventual success. As Cybershot Pro infiltrates the picture-taking industry, digital convergence will take a giant step forward.

Cybershot Pro with Memory Stick/PC card media. Design: Takashi Ikenaga (DC/Atsugi), 1998.

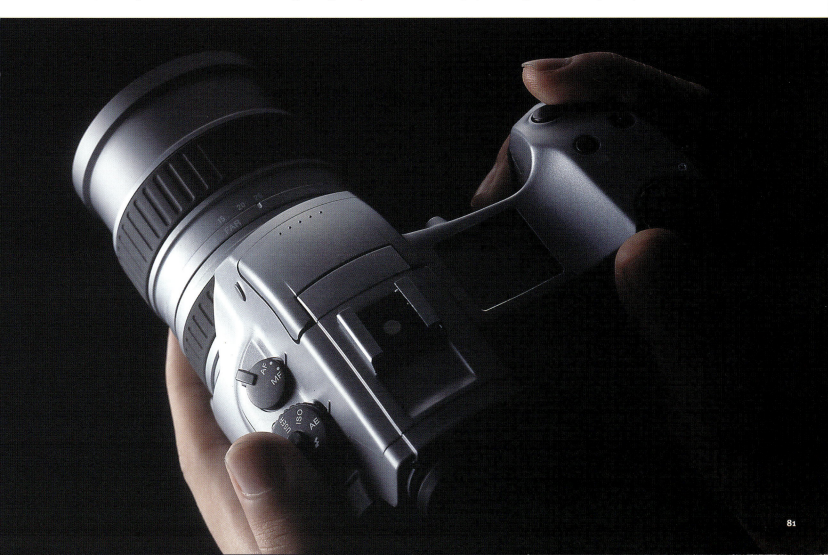

MD Cybershot

Coming off the success of the first Cybershot, Mr. Sumita's next project was to save a troubled marriage that the engineers at PAV had allowed to occur. In an attempt to update the Mavica concept, engineers had replaced the floppy drive with a MiniDisc drive—a significant improvement considering that a two-inch-wide MiniDisc can store nearly fifty times more data than a four-inch-wide floppy. And because the Minidisc is digital, it can store pictures as well as voice or music, allowing the new product, called MD Cybershot, to record images with voice notes, music or any kind of sounds, accept computer data fed through a small port on the side of the camera and also function as an MD Walkman.

Unlike the first Cybershot, which had a splendid design but only average performance, MD Cybershot would be a "no-compromise product"—or so the engineers hoped. But like all projects that are conceived by engineers and reach the designer only after the mechanism and feature set have been fixed, MD Cybershot had problems the moment it fell into Mr. Sumita's lap.

"When I saw what the engineers had done, I said to myself, 'It's the Mavica all over again.' Because of the size of the drive on the back, there was no way to make the product small enough to fit in one hand without straining, and because of the drive's position relative to the rest of the components, it was difficult to give the product a natural shape. From its first little heartbeat, it was clear

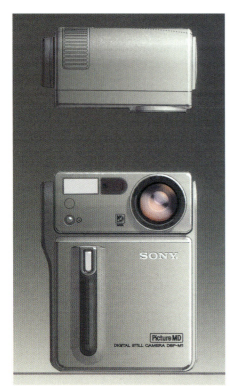

that MD Cybershot would grow up to be a box." The challenge for Mr. Sumita was to at least make it an interesting box with as many interactive elements as possible.

"I made several proposals for changing the design so that the lens and CCD could rotate or pivot like the first Cybershot. But every time I showed the engineers my drawings, they cried. Because this new camera had twice as many cables up top as the earlier one, the thought of

bending and stretching them while pivoting the lens frightened the engineers." As an alterative, Mr. Sumita suggested that the camera have a pivoting screen instead.

Like he had with the orignal Cybershot, Mr. Sumita explored a range of shapes: vertical designs with a pivoting lens up top, vertical designs with a fixed lens and horizontal designs with rotating, fixed and removable lenses. Controls had to be organized in a rational way and

From the outset, Mr. Sumita's design for MD Cybershot was hindered by the length and width of the MiniDisc drive inside the camera. The pivoting lens concept (lower right) was rejected by Sony engineers as too unreliable.

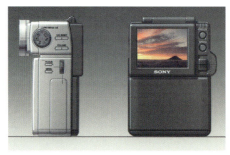

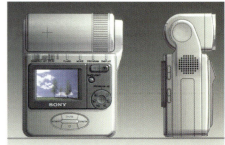

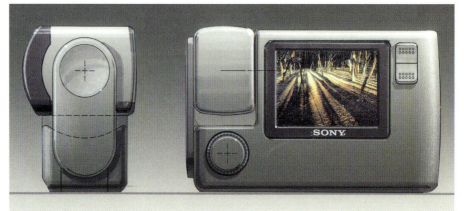

sized according to their relative importance. Space for the Sony logo had to be found on both the front and the back. And certain features from the earlier Cybershot (such as the raised vertical rubber strip on the front that aids in gripping the product) had to be carried forward to give the MD version a family resemblance.

Because of MD Cybershot's size and weight, Mr. Sumita wanted to design a grip into the product. Thus we see a small protruding area on the back of his finished concept positioned exactly where the user's thumb will fall (a detail that was eliminated in the final product). Otherwise, Sumita's final design concept was approved and wended its way to production without serious modification. "My only regret is that I didn't push a little harder to modify the basic layout early on," he concedes.

Yet he did make a few changes. Since the MD camera would be even more power-hungry than the first Cybershot, Sumita removed the battery that the engineers had suggested and installed a new long-life battery used in the PC7/PC10 video camera. MiniDisc controls (forward, stop, fast forward and reverse) were moved from the back, where the user could accidentally touch them, and put on top.

The resulting product is cool and professional in appearance, a more elite early-afternoon expression than the first Cybershot. The MD version is simple and elegant across the front and back, yet complex on the sides, where most of the detailed controls reside, thus giving the product a competent, capable persona. Unlike the cool silver grey of the first Cybershot, the MD model has a slight gold cast, which heightens the perception of value. And its proud upright stance tells you that it's a Sony product without your ever needing to ask.

In Mr. Sumita's view, the long-term future of these cameras is bright, even if their near-term fate is a bit cloudy. The storage media in all digital cameras is changing from tape to disc to memory chips. And functions are beginning to merge. Video cameras now exist that offer single-shot capability, and soon digital cameras will be able to capture motion as well. Harnessing all of these possibilities in the next product will be more difficult than even a man of Sumita's vast experience may suspect. For, as Byron wrote, "nothing is more intimidating than having to top your own success." This makes every project that Mr. Sumita tackles more difficult than the last.

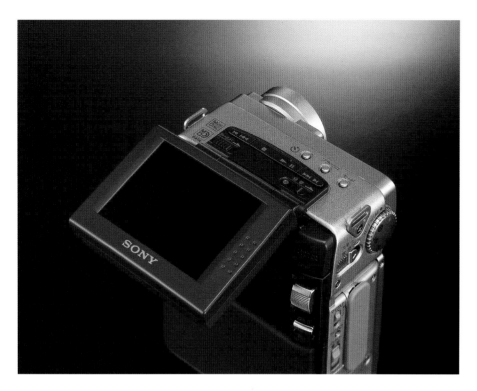

Kaoru Sumita's design for MD Cybershot divides functionality into three areas: a pivoting LCD on the back, imaging controls on the side and MiniDisc controls on top. Below: A detail from the final design concept (left) next to the product itself (right).

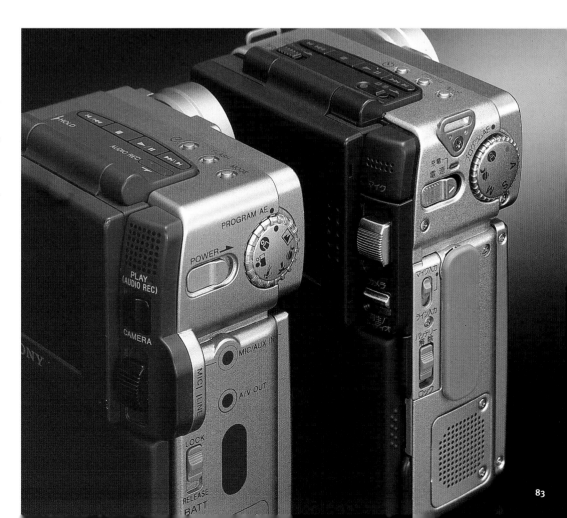

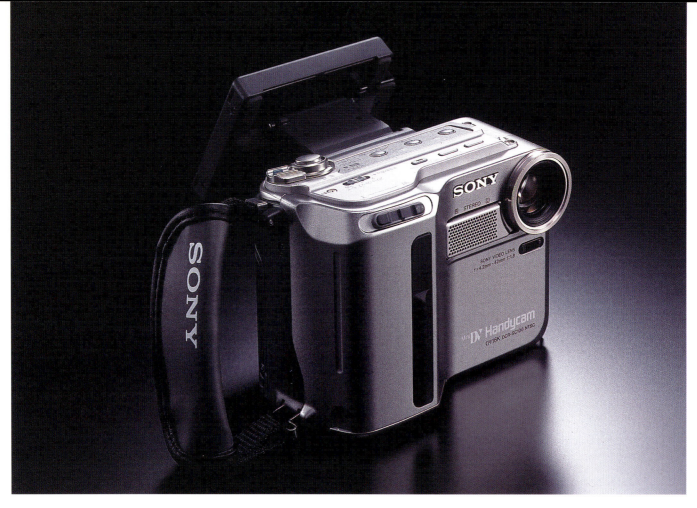

HandyCam CCD-SC100. Design: Shin Miyashita (DC/Tokyo), 1996.

Prior to the release of HandyCam CCD-SC55, designed by Mie Sekita, and the current model known as SC100, designed by PAV's creative producer Shin Miyashita, all video cameras had old-style analog viewfinders that forced the user to place the camera up to their face and aim through a narrow window. "For the semiprofessional, this solution seemed appropriate," says Mr. Miyashita. "But for women, who make up a growing percent-age of video camera buyers, the old viewfinder was a problem. For several reasons, women prefer not to place a cold metal object up to their face." When small color LCDs became available, it was a simple matter to dispense with the viewfinder and install a pivoting screen on the back of the camera. "When we did that, our camcorder sales to women quickly increased."

Shaped like a conventional 35mm camera rather than a camcorder, the CCD-SC100 offers a simple, unintimidating package designed specifically for the amateur photographer. As an entry-level product, every detail is geared toward easy operation. Therefore, with the exception of the shutter release button located at the top of the handgrip, exactly where you would find it on a conventional camera, all major controls are positioned on top of the product with plenty of space

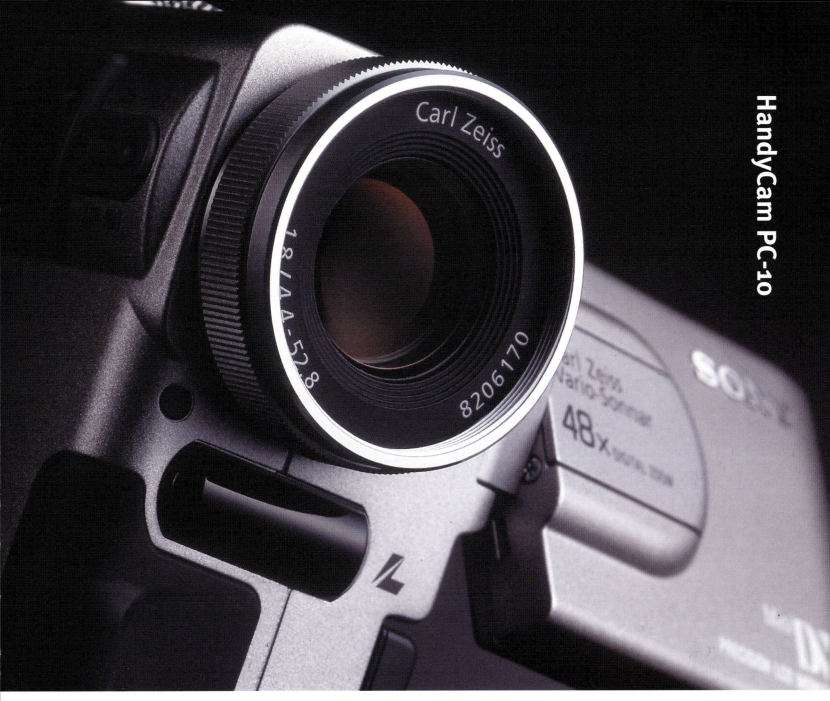

between each button to avoid confusion—an important detail on a product that is less than four inches long.

Until recently, the design of components and subassemblies inside video cameras preceded the design of the final product by months (and sometimes years). "But, at some point, market forces dictated that cameras shrink drastically in size. When that happened, the designer had to enter the process and create the design first," says Mr. Sumita. "Otherwise, the engineer would not know how large or small to make their components."

This design-driven approach at Sony PAV differs from that of many other high-tech companies, where products such as camcorders are still developed by engineers and given to designers for a last-minute cosmetic treatment. The classic example is the small upright video camera introduced by the Japanese Victor Corporation in 1995. Shaped like a mass-market paperback book, the Victor product had an angular vacuum-formed appearance with minimal refinement. Even so, the Victor design became a runaway success, far outstripping Victor's ability to produce it. Because the Victor design had so much unrealized potential, Sony PAV made a decision in 1996 to borrow the basic elements, add several new features and release their version of the concept that same year, calling it the DCR-PC7.

HandyCam DCR-PC10. Design: Kaoru Sumita (DC/Tokyo), 1997.

Kaoru Sumita's design for the DCR-PC10 improved upon an existing design to such a degree that he made it his own.

Look in any direction within the Design Center, and you will find someone who can recite the words of company founder Masaru Ibuka: "The Sony spirit is all about bravely setting out to do what has never been done before." Of course, no one would argue that innovation is a bad thing. Yet the moment you enforce a culture of innovation, the law of unintended consequences often comes into play.

Simply put: In striving to create the "best" product in every category, Sony designers often assume that the "best" does not already exist simply because they have not yet invented it. Yet sometimes the best ideas do begin elsewhere. And it is the designer's responsibility to recognize that fact and build upon the work of those outside the firm in the same way they rely on the work of Sony designers who preceded them.

Such was the case with the DCR-PC7 and its successors, the PC10 and PC1. While examining this design, the similarity to the earlier JVC model quickly comes to mind, then just as quickly disappears. For unlike the thousands of copycat products that litter the marketplace, PC7/PC10's obvious superiority allows it to occupy a category all to itself. For example, rather than striving for the absolute minimum size (reducing the wall thicknesses and making the controls and details too small to use), the PC7/ PC10 is of optimum size.

Since as many women will use the product as men, the design fits even the smallest hand. Slip your hand under the strap on the right, and the camera has an almost glovelike fit, with all essential controls a short finger distance away.

The camera's rock-solid feel is enhanced by padded surfaces on the lower body, which make holding the product a joy. The winglike LCD on the left side has soft-touch controls *behind* the screen (for playback, pause, forward, reverse and stop), not below the LCD, where they can be accidentally touched, even when the LCD is stored away. With so many details crowded into so little space, the careful designer arranges each button according to a predetermined hierarchy to ensure flawless one-handed operation.

On the PC7/PC10, all necessary buttons can be accessed when the hand is inserted through the strap. As a result, the camera's design *controls* our responses from the moment we pick it up. Its superb response makes us feel more competent. Rather than fumble with the product, we trust it implicitly. And little wonder: for the PC7/PC10 was designed by none other than Kaoru Sumita, who

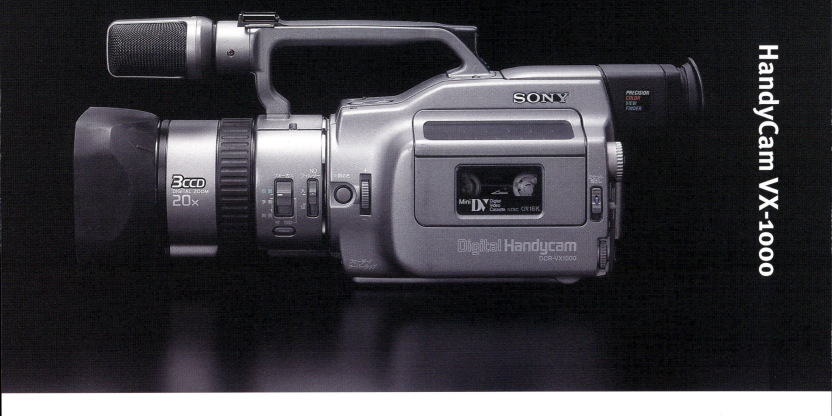

gave birth to the original Cybershot, the ProFeel television, the Walkman 2 and more modern icons than any other Sony designer.

Always pursuing the next level of expression, Mr. Sumita has recently downsized the PC10 even further, collaborated with PAV's engineers to make it simpler, lighter and less expensive, gave it a monochromatic silver-on-gray finish with a less tactile feel than the PC10 and christened it the PC1—the smallest full-featured digital video camera Sony has ever made. The PC1 may be a marvel of engineering, yet from a design point of view, nothing will top the PC10. The nearest contender

would be Mr. Sumita's most potent and long-lasting video design, the CCD-VX1000, completed in 1994. With its bold forms and baroque detailing, the VX1000 may be the most dynamic example of video design of all time. The soft forms make the camera seem large when seen in photographs. Patterned after the professional video cameras designed at Sony's Atsugi facility, the VX1000 could function as a broadcasting tool in a pinch. Yet it was designed for the serious amateur. The VX1000 is one of the few Sony products that contains all aspects of the firm's genetic history. With innovative technology and serious details that are

forgiving to the first-time user, the product is all about performance, yet is still fun to use. Like all Sony video cameras, its superb function and potent symbolism draw our hands to it, invite us to hold the product in the proper way and choreograph our movements as we frame the viewfinder and capture a few precious moments. As other manufacturers' video cameras are replaced every year, the four-year-old VX1000 endures because of its form and detailing are perfect. It can be changed, but it cannot be improved. For this segment of the market, the summit has been achieved.

The honesty and expressive power of the CCD-VX1000 convey a sense of quality on every level. Design: Kaoru Sumita (DC/Tokyo), 1994

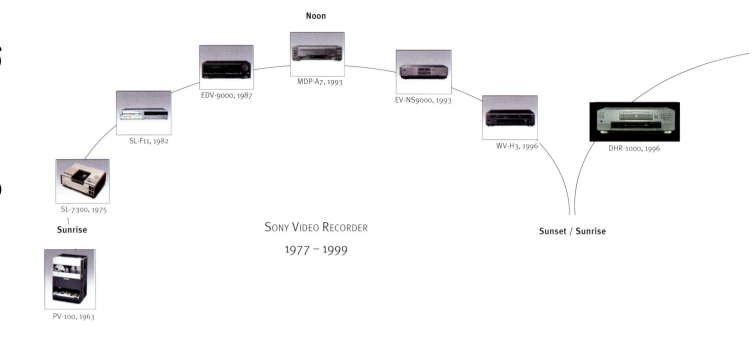

Noon

MDP-A7, 1993

EDV-9000, 1987

EV-NS9000, 1993

SL-F11, 1982

WV-H3, 1996

DHR-1000, 1996

SL-7300, 1975

Sunrise

SONY VIDEO RECORDER

1977 – 1999

Sunset / Sunrise

PV-100, 1963

Translating advanced technology into a form that average consumers and advanced amateurs can use is no easy task. The challenge is to balance a wide range of features with formal simplicity that makes the product easy to learn. The DHR-1000 Digital Video Editor and Time-Shifting Video Recorder achieve this balance through a combination of elegant aesthetics and rigorous user interface design. The product, designed by Takuya Niitsu, radiates the kind of elegance and mystery found in Mr. Niitsu's top-of-the-line DVD player, the DVP-S7000 (see page 94).

Clothed in two tones of grey with a black display, the main unit echoes the aesthetics that Mr. Sumita and Mr. Miyashita have given to Sony's high-end consumer video camera. The chamber that holds the digital tape cassette is given special importance with detailing that makes it appear as solid as a bank vault— an appropriate receptacle for the user's precious video memories. "This part of the design came to me instantly," Mr. Niitsu recalls. But the more important and time-consuming part of the product, released in 1996, is the editing palette, which Mr. Niitsu designed in consultation with engineers and designers at Sony's Broadcast and Professional Group. Slim and unadorned, the palette for the DHR-1000 slides under the main unit for easy storage. Unlike Niitsu's DVD player, which encourages a personal and symbolic relationship between user and product, this design encourages personal interaction with the editing palette and a more distant relationship with the recorder unit.

The DHR-1000 Digital Video Editor and Time-Shifting Video Recorder guarantees professional results when used with a Wega televison or VAIO computer. Design: Takuya Niitsu (DC/Tokyo), 1996.

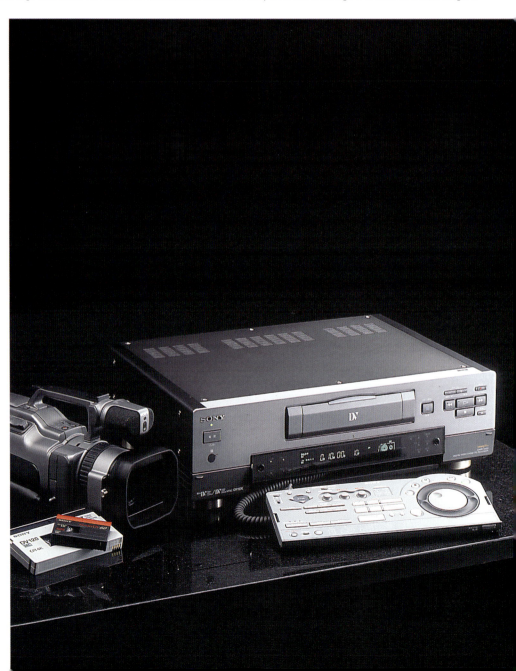

copied by the competition. Yet a strange fact remains: By Niitsu's own admission, he "hates" to use video cameras in his personal life and would never consider owning or using the DHR-1000. How is it possible? "When I cannot relate to a product personally, I apply my experience and give it my signature. That is enough."

The collaboration between Mr. Niitsu's consumer sensibilities and the more functional orientation of the designers at Sony's Broadcast and Professional Group underscore the brilliant work that these unseen individuals give to products that make broadcast television possible.

Since the mid-1960s, Sony has developed a wide range of high-end video cameras and industrial-strength video tape recorders for use in the field and in studio situations, video editing sys-

Crafting this dual relationship took the designer just one week to achieve.

"When I get an image and begin to work out the details, a week can become a very long time," Niitsu explains. The arrangement of controls, finger-sized scooped areas around the jog-shuttle mechanism at the right, beckon the hand. The contrast of shape, color and texture draws the eye in the right direction. And all controls are correctly sized from right to left, with the largest controls being the most important or most often used. Proof of the success of Niitsu's design was that it was instantly

tems, digital reel-to-reel tape recorders and audio auditing consoles used by artists and musical producers around the world. The impetus behind these video and sound products is their superlative engineering. Unlike consumer products, professional equipment must be designed and assembled with almost military precision. Since product failure can be costly, the Design Center's Broadcast and Professional Group devotes enormous time and energy to creating top-quality cameras, recorders and editing equipment that are extremely rugged and reliable enough to operate around the clock.

The process of designing professional equipment is totally different from the rest of the Design Center's work. Unlike consumer products, which are rarely developed in response to surveys or focus groups, professional and broadcast equipment is always designed and engineered with the customer in mind. The design cycle for consumer products is measured in months. The design cycle in the professional realm is mea-

sured in years. Yet technology in professional products changes just as quickly as in the consumer arena. And buyers are few in number and much more demanding. Therefore, work never begins on a new professional camera, editing console or audio/video recording suite without first interviewing potential customers to find out what they like (and don't like) about their current equipment.

Over the years, these detailed interviews with network cameramen and audio technicians at TV and music studios have yielded a number of improvements in technology and design. Chief among these is modular design. Since microprocessor technology now determines the performance of most professional audio and video products, it is essential that circuitboards and other components be removable, allowing a camera or video recorder to remain state-of-the-art through regular upgrades.

Because broadcast equipment rarely sits idle and is always put to the maximum test, the form

of the product and placement of controls are purely functional. "In a sense, our designers do not really design the control placements. They listen to the professionals who use our products, watch them in action, develop a rapport with the tasks and situations that our products must endure and create the product from the customer's point of view," says Katsumi Yamatogi, a creative producer in the B&P group. "For us, aesthetics are of secondary importance. Even so, the look and feel of our products has influenced the design of Sony's consumer products." Examples include Kaoru Sumita's CCD-VX1000 video camera, Takuya Niitsu's DHR-1000 digital video editor/recorder and the Cybershot Pro, a digital still-frame camera designed for both professionals and advanced amateurs by the B&P veteran Takashi Ikenaga. The design of these products owes much to the work of men such as Hiroki Oka, whose design for the top-of-the-line BVP-900 digital video camera (above) took years to develop. With the advent of digital television,

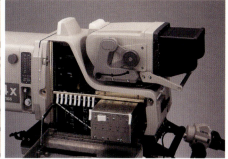

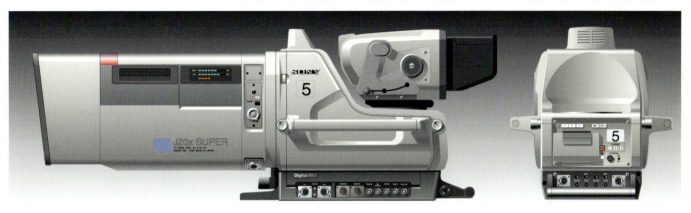

the need for new equipment has spurred a revolution in the design of such cameras. Improvements include a lower viewfinder, which maintains the proper sight line so cameramen do not have to stretch to use it, and electrical components designed as modular subassemblies for easy upgrade.

The environment for professional equipment is another concern. "Editing consoles, in particular, should be designed with the entire room in mind," says Mr. Yamatogi. An example is the ES-7 Editstation, a nonlinear video editing system designed by Tetsu Sumii, Toshiyuki Hisatsune and Osamu Sakurai that offers the efficiency and

ease of use required for one-person operation. Its full-featured graphical user interface (below right) has all of the functions demanded by the experienced user, yet is simple enough for a beginner to use with comfort. The ES-7's hardware component (below left), features seamless analog (tape-based) and digital (disc-based) editing in a single system. The entire product, from the computer server and tape deck to the curved desktop, built-in controls and dual displays, is designed as a single unit for correct ergonomics.

"When designing professional equipment," says Mr. Hisatsune, "we consult with the client and in many cases design the room in which the

product will be used to ensure the best performance."

Recording professional-quality video in the field requires a careful balance between studio camera technology and consumer camera size and design. In field equipment such as the BVP-950 Betacam Digital Camera, you find many of the same features as its larger brother, the BVP-900, in a smaller package. Yet there are limits to miniaturization. At present, it is possible to downsize this much technology into a product that is only the size of a suitcase. Therefore, the camera has been designed to be used on the shoulder; the BVP-950 has a contoured and

Above:
BVP-900
digital video
camera.
Design: Hiroki
Oka (DC/Atsu-gi), 1996.
Below:
The ES-7 Edit-station
is a non-linear video
editing
system, which
offers the
efficiency and
ease of use
required for
one-person
operation. Its
graphical user
interface
combines
professional
functionality
with con-sumer-level
ease of use.
Design:
Tetsu Sumii,
Toshiyuki
Hisatsune and
Osamu Saku-rai (DC/Atsu-gi), 1996.

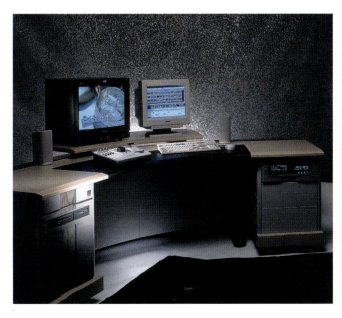

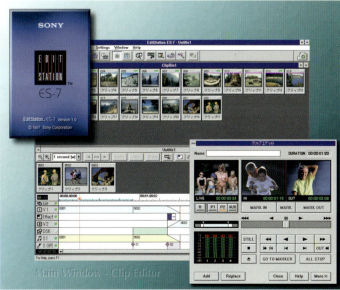

Top: The BVP-950 Betacam Digital Camera offers studio performance in a design suitable for use in the field. Design: Hiroki Oka (DC/Atsugi), 1996. This page, right: The DNW-A220 Portable Betacam SX Digital Editor has been revised to meet the needs of professionals. Design: Osamu Sasago (DC/Atsugi), 1997. Below: An Adobe Illustrator rendering of the HDC-75 Video Camera. Design: Hiroki Oka (DC/Atsugi), 1996.

padded lower section that fits snugly on the shoulder. The work of Hiroki Oka, the camera was designed after extensive surveys among video artists to determine the features and functions that work best in the field. Once the video is captured, it must often be edited in the field before it is relayed to the local TV station or network. The DNW-A220 Betacam Digital Portable Editor has two VTRs mounted side-by-side in a remarkably portable unit. Modular design allows the two units to be used singly or in tandem, allowing a journalist to do editing in the field after conducting an interview. The design, by Osamu Sasago of the Broadcast & Professional Group at DC/Atsugi, has been continually revised in response to comments from professional video journalists, yielding a product that meets the most exacting standards. Symmetrical placement of controls—wheels and buttons on the right-hand unit are the mirror image of controls on the left—provide an intuitive man/machine interface.

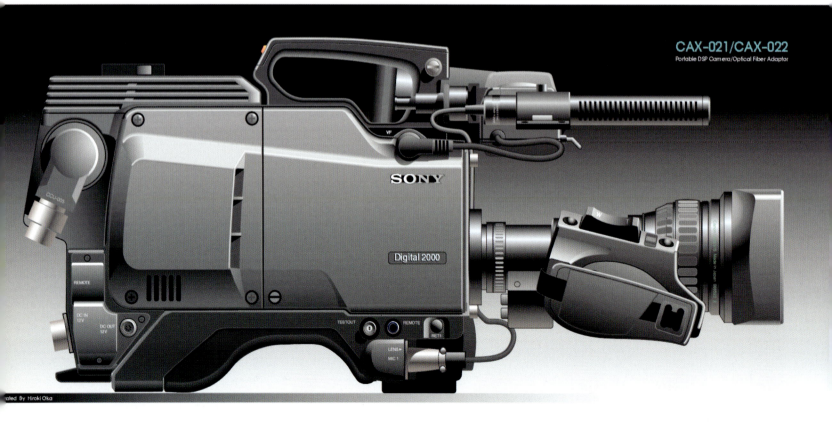

CAX-021/CAX-022
Portable DSP Camera/Optical Fiber Adaptor

ated By Hiroki Oka

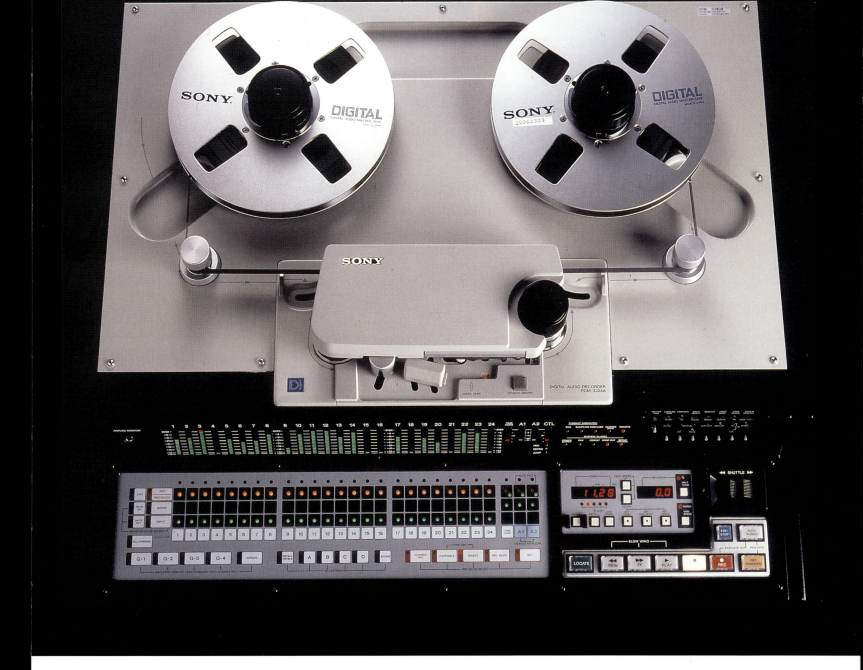

Even though consumer audio products have embraced compact disc and MiniDisc technology, many professionals still prefer the venerable reel-to-reel tape deck, which records using the most exacting digital circuitry and control mechanisms that human minds can imagine. Since computer-driven audio recording is now in the ascendency, reel-to-reel tape machines have reached sunset. As a result, their design is as pure and expressive as a strictly functional object can be. Even those who have no feeling for or understanding of these fearsome machines cannot help but be impressed by their strength and precision. It is almost poignant to think that these gentle giants will soon belong to the past. But that is the nature of legacy technology. It exists only until the next miracle arrives to replace it.

The DVP-S7000 Digital Video Disc Player resolves the potential confusion between DVD and compact disc by projecting a distinctive image that is familiar yet decidedly different from a CD player. The drop-down front door, which "bows" to the user, is a key design feature. Design: Takuya Niitsu (DC/Tokyo), 1997. Opposite page: The spare, understated PBD-V30 Digital Video Discman has a classic sunrise look and feel. It offers a glimpse of things to come. Design: Shinichi Ogasawara. (DC/Tokyo), 1998.

The opposite approach in design and symbolism can be found in the DVP-S7000 high-end DVD player, designed in 1997 by Takuya Niitsu, which takes the aesthetics of the case to new heights by offering the kind of gesture that no electronic product has ever attempted. Once you turn the DVD player on, it bows before you as the front door that covers the DVD mechanism drops down allowing the disk to be inserted. The combination of concentric rectangles on the front, with tiny bull-nose buttons left and right, reveal an almost Zen-like approach to aesthetics that has been a hallmark of Mr. Niitsu's design for the past twenty years. Symbolism, elegance, ceremony, style, a sense of tradition *and* modernity are all essential when crafting a high-end audio product.

"Designing simplicity is very difficult," he says. "I try to create an image that will fix itself on the user's mind. I want someone to glance at the product for only a second, look away, and be able to draw the product's main elements. The basic elements must be different from conventional product design to establish a mood of intrigue or mystery. The echoing shapes in the center of the product remind us of dropping a pebble into a still pond and watching the tiny waves on the surface radiate outward."

The sense of calm and centrality that Mr. Niitsu establishes with this simple device is so elegant that its underlying rigor passes almost unnoticed.

As the last in a long line of audio/video players, Mr. Niitsu's design exhibits the characteristics of a sunset expression in its extreme approach to design, yet also portends the future in the same way that the new Wega wide-screen television indicates a beginning as well as an end—a counterproposal or antidote to the traditional Sony approach to audio design.

"In the past, our engineers and planners added value to products by increasing the number of features. Always more and more features. But I prefer to excite the user and create value by communicating on a symbolic and emotional level, giving us a pure object that delivers superb performance."

Inspired by seeing a Sony-designed radio as a boy, Mr. Niitsu dreamt of becoming an industrial designer and considers it a miracle that he actually achieved his goal of designing the kind of icons that inspired him so many years ago. His heartfelt approach reveals itself not only in the look and function of the DVP-S7000, but in the way it moves our emotions. Because of its origins in compact disc technology, it is not unusual for the digital video disc to follow a similar trajectory as it enters

the market and attains widespread acceptance. If we look back at the origins of the compact disc and MiniDisc players, we see that portable versions appeared within two years of the first tabletop model. And, from a design standpoint, that first portable was essentially the same: square, bulky and visually uninteresting. Like the D-50 Discman (page 50) and the MZ-2P MiniDisc Walkman (page 52), the PBD-V30 DVD Discman is an engineering-driven product with a design that is limited to simple surfaces adorning a plain boxy exterior. The resemblance between this first portable DVD player and the first MiniDisc Walkman is particularly telling. They are almost the same shape. Both are treated as tabletop units, with a sturdy flat bottom and controls on top, not the sides. Both have a jog-shuttle control to aid in scanning the disc. Both have a tiny glass element: an LCD on the first MD Walkman and a tiny window on the DVD Discman to reveal the spinning disc inside. And both are just small enough to carry around. The only difference is color. To establish a visual link with Mr. Niitsu's DVP-S7000 player, the PBD-V30's designer, Shinichi Ogasawara, gave it a champagne gold finish.

As the next portable DVD design achieves a midmorning expression, it will be interesting to

Ritual

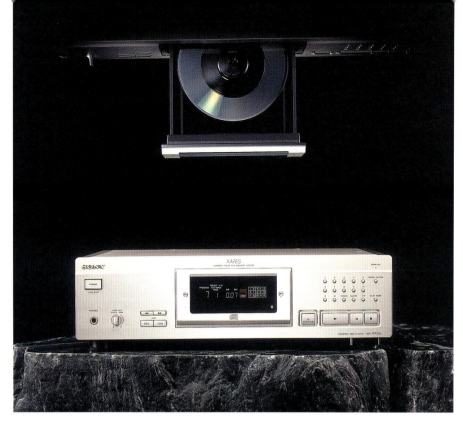

Above: CDP-XA7ES Compact Disc Player. Design: Shigemitsu Kizawa (DC/Tokyo), 1994.

Below: CDP-X5000 Compact Disc Player. Design: Shigemitsu Kizawa (DC/Tokyo), 1996.

see how closely it adheres to the design of the earlier MiniDisc and compact Discman. When we consider how far the MiniDisc Walkman in particular has evolved since its first appearance in 1994, the future of this new disc-based product is incredibly bright. Since DVD platters are the same size as compact discs, there is no technological reason why future DVD Discmans cannot be as small and cunning as today's compact Discman. So we should not be surprised to see an icon version of the

product within a year or two that approximates the size of the disc itself.

Human beings use the objects in their environments in specific and prescribed ways. The classic example in Japanese society is the tea ceremony, which is less about the brewing and drinking of tea than it is about a tradition, procedure and ritual that symbolizes something much larger than ourselves. The feelings we receive when engaging in rituals are as satisfying as they are complex. And as objects and cultures change, new devices and technologies call for new rituals.

For decades, the act of placing a turntable's tone arm on a spinning record, hearing that slight pop as the needle drops into the first track on the album and waiting for the music to begin was a ceremony that everyone above a certain age can remember. Today, the objects are different, but the rituals are very much the same. When using a remote control to manipulate the on-screen display on a television, when we watch a beam of light form the letters VAIO on our computer screen during startup or when we

drop a compact disc into the tray of a CD player and watch the tray slide into the machine, we feel a sense of power that only technology can provide. Enhancing these rituals is a basic function of the Design Center.

When creating a new product in the most traditional and hierarchical of all consumer technologies—high-end audiophile equipment—designers must think about the complex and symbolic relationship between the user and the product before they draw the first line. No designer is more sensitive to this relationship than Shigemitsu Kizawa, who has spent more than thirty years designing all manner of consumer electronics in the DC (television) and HAV groups. Renowned for his expert handling of high-end amplifiers, disc players and speakers, Mr. Kizawa takes a deliberative approach to their design. Before making a move, he forms the image in his mind, imagines the cabinet design or speaker enclosure as though it were a building, then makes his drawing like an architect, precisely rendering his next CD player or pre-amp from the top, front and side, then from a raised three-quarter perspective. "The circuitboard design inside audiophile equipment is known in advance; therefore, I can concentrate on the form, proportions and surface," he says, "as well as elements that move or interact with the user." The sliding mechanism that functions atop his CDP-X5000 compact disc player glides fore and aft with such precision that we cannot help but admire (or even worship) the action. The stillness and solidity of this design give Mr. Kizawa's products a sense of monumentality that have nothing to do with their size or surroundings. The components and materials in these products are of the no-expense-spared variety with extra weight built into the case to minimize vibrations. Ponderous-ness is avoided by giving the product a beautiful gold finish, which is common to all of Sony's high-end audio in Japan (the U.S. version, in black, looks like a bank vault by comparison).

This singular approach contrasts sharply with the design of Takuya Niitsu, who says that his SS-AL5 loudspeaker should function in at least three ways: "as a musical instrument, like an oboe or guitar; as furniture, which means it should be visually appealing; and on a symbolic level, seen in the slight curvature that exists around the speaker element. Since sound is generated inside the box, I imagined that the speaker had pressure on the inside building up, distorting the sides of the box in an interesting way and forcing itself out." Even

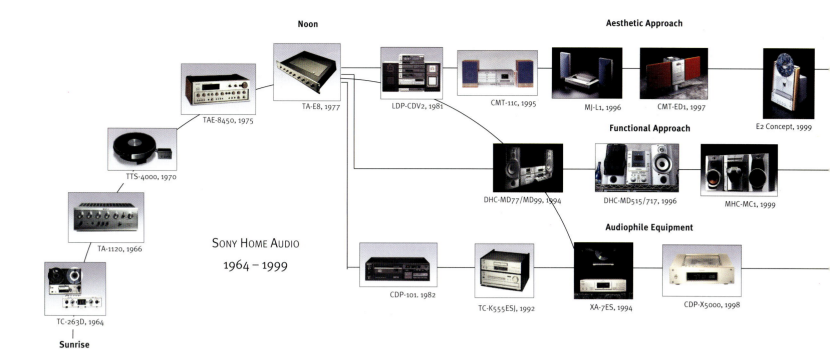

Noon

Aesthetic Approach

TAE-8450, 1975

TA-E8, 1977

LDP-CDV2, 1981

CMT-11c, 1995

MJ-L1, 1996

CMT-ED1, 1997

E2 Concept, 1999

TTS-4000, 1970

Functional Approach

DHC-MD77/MD99, 1994

DHC-MD515/717, 1996

MHC-MC1, 1999

TA-1120, 1966

SONY HOME AUDIO
1964 – 1999

Audiophile Equipment

CDP-101. 1982

TC-K555ESJ, 1992

XA-7ES, 1994

CDP-X5000, 1998

TC-263D, 1964

Sunrise

when the speaker is at rest, this graceful gesture activates what would otherwise be a passive object and visually suggests the physical and sonic purpose to which it is put. Visual interest is enhanced at the sides and back of the speaker by allowing the radius of curve to decay and invert, creating a negative radius that was difficult to engineer but is critical to the overall design.

Meanwhile, half a world away in Park Ridge, New Jersey, the German-trained designer Knut Fenner has taken speaker design in a new symbolic direction using a different vocabulary of forms. Standing tall on a spindly thin hollow metal stand reminiscent of a Giacometti sculpture, Mr. Fenner's design has a sprightly energy that is appealing yet not intrusive. The same is true with the monumental SS-R10 Full Condenser Speakers designed by Shigemitsu Kizawa for the high-end audiophile market. "The ideal design does not attempt to steal the show from the music," he says. "The design should be beautiful but not ornate. It should be derived from the most economical means. To have longevity, a design must be functional. But it must also be tasteful."

In an effort to find the perfect balance between technology and expression, Mr. Kizawa interviewed dozens of music enthusiasts and used their advice to compose the ultimate home speaker system. The principal components are two giant electrostatic

Above left: The SS-R10 Audiophile Speaker System, designed by Shigemitsu Kizawa (DC/Tokyo). Below left: The SS-AL5 bookshelf speaker, designed by Takuya Niitsu (DC/Tokyo). Right: the SS-DD50 Remote Speaker, designed by Knut Fenner (DC/Park Ridge).

panels, which produce sound that is as close to lifelike as manufactured products are ever likely to achieve. The leaning gesture of each design distinguishes the left speaker (model SS-R10-L) from the right (SS-R10-R). Due to their high cost, some users purchase them one at a time.

Espresso

This page: The CMT-ED1 Micro-Component System represents a new form of home audio, with sophisticated use of forms and materials. Design: Kazuo Isono (DC/London), 1996. Opposite page (top to bottom); Takuya Niitsu's clock concept; his initial and refined mock-ups for the flat component system; the MJ-L1 Flat Component System with detail of jog-dial control. Design: Takuya Niitsu (DC/Tokyo), 1996.

At the opposite end of the spectrum, the tabletop audio system now exists in such profusion and in so many different designs that the entire category has become muddled. Seeking an exit from this situation, Sony designer Kazuo Isono, working at DC/London, developed a new vocabulary of forms, giving the squat boxy elements that are common to all mini-stereos a sense of lightness by raising components on a four-inch-high pylon and attaching flat panel speakers that give his design, called Espresso, a clean appearance.

The key to Isono's approach is its refreshing understatement. "I wanted to create a sophisticated design that stands away from the over-designed mini-component systems that now clutter the market, including those made by Sony," says Mr. Isono. "Occasionally, a product category can become so popular, with so many players offering products that are just slightly different, that competition leads to a situation in which the lowest price wins. When that happens, it's time to re-create the product and establish a new playing field. That's what I tried to do with Espresso."

For a mid-priced system, Mr. Isono gave inordinant attention to details, such as the thick glass CD cover on top of the central unit, which has an almost jewel-like quality. A hidden switch under the glass allows the player to be activated by lifting the cover, dropping a disc in place and lowering the glass, which signals the unit to begin playing the disc. Close collaboration between Mr. Isono and engineers in the GA group is responsible for this detail, as well as the angle-adjustable speakers and cable management hardware on the back, which hide the speaker and antenna wires, making the product attractive from all sides. The brushed aluminum panels and brightly colored speaker fabric give Espresso a dramatic look that has redefined this kind of audio product. "I don't think of the design as symbolic, " says Mr. Isono. "It's a wake-up call." Hence the name, Espresso. It shows that Sony can reinvent even the most established product and make it seem new.

In contrast to Kazuo Isono stands Takuya Niitsu. The acknowledged master of product symbolism, Mr. Niitsu does not merely apply design to an existing product, he creates a concept as a

> *"Emotion and symbolism are as important as function when designing a consumer product. Indeed, symbolism is part of the product's function."* —Takuya Niitsu

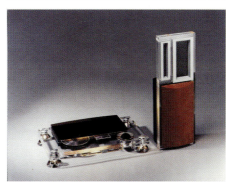

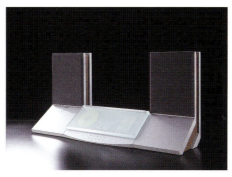

meaningful object. He first designs it without regard to practical considerations, then encourages Sony's engineers to make it work. Many hours of Mr. Niitsu's day are spent in deep thought or the deepest form of thought—otherwise known as play. Next to his work table, Mr. Niitsu's drawers are full of drawings and photographs of fanciful concepts that will never find their way into Sony's product line. One of these explorations was a simple table clock consisting of a disc-shaped pedestal with two tiny metal balls that indicate the hours and minutes and roll around the center of the disc by means of a magnetic mechanism inside. The circumference of the disk represents the solar system with the large and small ball symbolizing the planets Jupiter and Saturn, both in correct alignment with the center.

When not making toys, Mr. Niitsu crusades against banality in other interesting ways. For example, in 1992 Sony asked him to create concepts for an upcoming European exhibition, to which Niitsu responded by designing a new breed of home audio system—a low-slung glass and magnesium confection

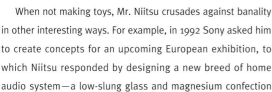

with pedestal-shaped electrostatic speakers. Sadly, the exhibition was cancelled. But Mr. Niitsu completed his design. Soon an engineer noticed the concept and began work on a low-profile circuitboard and CD-transport system. When they encountered problems, Mr. Niitsu offered an elegant wedge-shaped design that gave the engineers more room to maneuver.

Months later, a slim mechanism emerged from the engineers' workshop that followed Niitsu's original concept. Aspects of the first vision

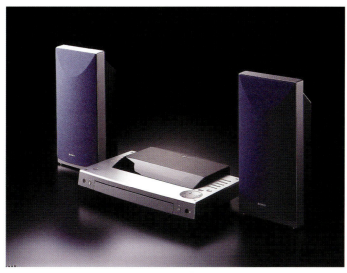

and the wedge-shaped design then coalesced into a low slab-like unit with an angled glass top that rests on a plinth, allowing the design to hover in the mind's eye. To maintain purity, Niitsu used low-profile controls rather than standard knobs, the principal control being round and concave with a jog-shuttle mechanism, a detail that functions as a Sony signature. "I constantly reminded myself to simplify, simplify," says Mr. Niitsu. "The challenge is always the same: to add as little as possible at the beginning and remove as much as possible at the end."

Not everyone at Sony is capable of designing on as symbolic a level as Takuya Niitsu. Nor is every product as successful as Kazuo Isono's Espresso stereo system. One example among many "near misses" in recent years is this odd-looking object, known formally as the SRS-N100 Active Speaker System, but known affectionately among designers at the PAV Group as "old bug eyes." The work of PAV group manager, Kazuo Ichikawa, the product was intended to serve as a one-piece amplifier and speaker system for a Walkman, Discman or portable MD player. With a heavy-duty subwoofer, the unit offered solid sound in the lower register and widely spaced tweeters up top for proper stereo imaging. Given the huge penetration of Walkman products in the marketplace (suggesting an equally large potential for the SRS-N100), considerable engineering work was devoted to the product. A special biocellulose and mica substrate was installed to make the product vibration- and echo-free. A specially designed bass reflex speaker was tucked into the bottom. And oxygen-free copper speaker cords were strung inside the two carbon-fiber satellite arms. But when the product was launched, it bombed. Even though it bore the Sony label, the design was so unorthodox that few consumers recognized it as a Sony product. According to Ichikawa, "there is a fine line between a product that is different and one that is *too* different. This one crossed the line. Once it was on the market, its unconventional appearance turned users off. Nothing could convince them to try it." After selling only a few thousand units, the N100 was withdrawn from sale and now enjoys a curious status as a collector's item. Its main appeal—as one of Mr. Ichikawa's few product failures—is something of a compliment.

The Boombox Redefined

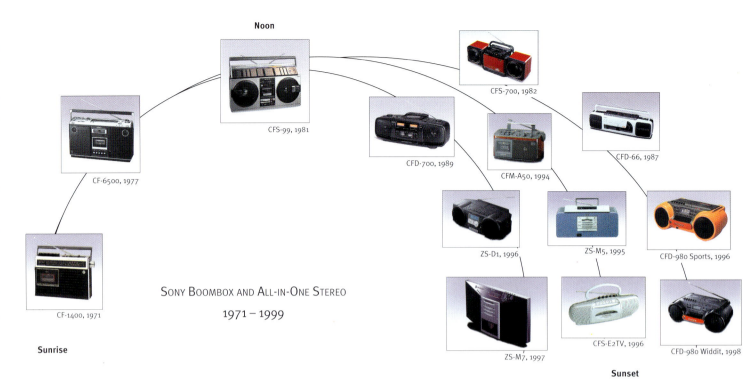

Noon

CFS-99, 1981

CFS-700, 1982

CF-6500, 1977

CFD-700, 1989

CFM-A50, 1994

CFD-66, 1987

CF-1400, 1971

SONY BOOMBOX AND ALL-IN-ONE STEREO

1971 – 1999

ZS-D1, 1996

ZS-M5, 1995

CFD-980 Sports, 1996

Sunrise

CFS-E2TV, 1996

CFD-980 Widdit, 1998

ZS-M7, 1997

Sunset

This page and opposite: The ZS-M7 Personal Stereo System. Design: Atsushi Kawase (DC/Tokyo), 1997.

Considering Sony's penchant for combining two separate products into new forms, it was inevitable that the radio and cassette tape player would one day join hands at the altar. The blissful event occurred in the spring of 1971, when Sony model CF-1400 combined an AM/FM tuner, cassette player and speaker in a distinctive black and silver case. Within a year, a follow-up model with stereo speakers appeared, signaling the birth of the boombox. Over the next decade, size and power of these portable systems reached its logical endpoint with the icon design, the suitcase-sized CFS-99, which split the product line into three now-familiar families: sophisticated versions with sleek black shapes; domesticated models with rounded forms and faux woodgrain; and Sports models that seemed loud even when the volume was turned down. Three classic boomboxes stand out from the rest: the bright red CFS-700 with its low profile and independently rotating speakers (designed by Shinichi Ogasawara in 1982); the bright yellow CFD-980 Sports model (designed by Takayuki Kobayashi in 1996) and the thin, elegant ZS-M7, designed in 1997 by Atsushi Kawase.

Now an Art Director in the Design Center's Interaction Design Department, Mr. Kawase says

his inspiration was "to give the product the slimmest possible profile by maximizing the advantage of our new flat audio mechanism and adding a vertically mounted CD player."

After a round of brainstorming and sketches, Mr. Kawase decided that the typical curvy baroque-looking boombox was no longer the most interesting shape. Kawase wanted to redefine the boombox and give it an element of mys-

tery by allowing the unit to offer itself to the user in both a tangible and a symbolic way. This was accomplished by designing the CD cradle to drop down and pivot outward—entering the user's space as it "hands" the disk over. A similar mechanism is used in Kawase's mid-priced ZS-M5 boombox, which has a more conventional boxy exterior.

His early foam sketches for the ZS-M7 explored a range of architectural shapes, from a tiny curved amphitheater to a mini-office tower with support structures left and right. The graceful planes on the front of the design, the utter symmetry and almost glacial stillness of the design mirrors Mr. Kawase's own personality.

Even the placement of controls indicates a high order of intelligence. The buttons placed along the top of the product (opposite page, below) reveals Mr. Kawase's practical side. Rather than disturb his graceful outline, he could have hidden the controls elsewhere on the product. But placing all of the buttons in one area make the product more user-friendly and (not incidentally) cheaper to manufacture. "I could have been a purist and made the M7 look like a Bang & Olufsen product," observes Kawase, "but hiding the buttons for aesthetic reasons is false. So I kept them in plain view."

The Art and Science of Interaction

Above: The RM-IA9K Remote Commander has a touch screen with a two-dimensional user interface that allows you to control today's complex digital audio systems from across the room. Such devices offer mobility and an interesting form of interaction but no tactile feedback. Design: Shiho Nakajima (DC/Tokyo), 1996. Below: The hardware interface on the WV-D10000 Digital Video/S-VHS Recording Deck offers less mobility, limited interaction but a better tactile experience. Design: Yozo Matsuzaka (DC/Tokyo), 1996.

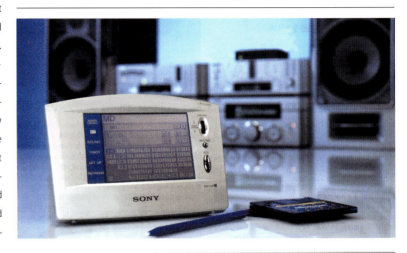

In time, this early human fashioned a bowl from soft clay, allowed it to harden and drank from it, attached a handle to create a cup and pinched the rim at one point to make a spout and create a pitcher. This may have been the first example of human interface design—the creation of an object or process that allows a function to be performed, a signal to be communicated, or information to be conveyed between a human being and the outside world. For many people today, the hunger for information, entertainment and the world beyond our physical grasp is as profound as that first human's need for water. To satisfy this need, hardware and software specialists spend much of their time designing products and interfaces that simplify the interaction between our hands, eyes and ears and the machines that convey the music, images and information we desire.

As the digital era evolves, the need to master 2-D and 3-D interface design grows with each passing day. Though you may not realize it, the most ubiquitous form of literature today is not the novel, not the Bible and not the telephone book. It is the owner's manual that accompanies the millions of consumer appliances and high-tech products that are sold every day. That first encounter with a touch-sensitive display or row of buttons found on a typical new product is a special moment, a time for discovery. It can also be an unsettling experience for users who are unfamiliar with the vagaries of digital technology. When faced with an unfamiliar new product, those who rarely pick up a book will quickly reach for the owner's manual, if only to figure out how to turn the machine on.

For the designer, creating an effective product interface represents an enormous challenge. Nearly every product the Design Center releases to the general public—from hardware and software, to Web design, packaging and logos—involves some form of interaction. Since all manufacturers use the same technology, the key difference between products lies in the quality of the interaction. This makes the user interface a key part of any product's design.

The most intimate form of interaction occurs in three dimensions. Every time we pick up a Walkman, wrap a pair of Street Style headphones around our ears, point a remote commander at a Wega TV or tap the keyboard on a VAIO computer, we experience its three-dimensional interface, we climb a learning curve that allows us to use the product and eventually *own* it in a very

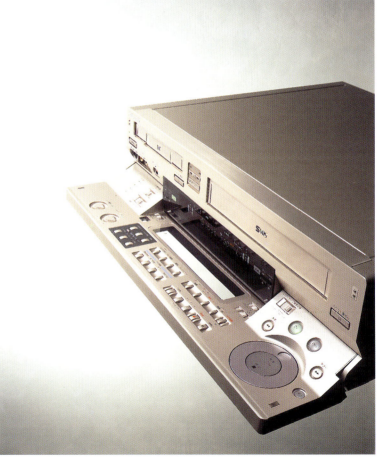

personal way. At their best, such designs have the right form and tactile response, allowing us to feel as though the product were created for us alone. The same experience occurs In a more distanced way every time we manipulate an on-screen interface like the one at the top of this page. Even more distanced is our relationship with an Internet site, a product package or the various signs and symbols that Sony creates, the most important being the Sony logo itself. At every level, the quality of the interaction is a designed event. Rather than allow users to form the wrong impression, the Design Center examines every Sony product, graphic, Web site or package, analyzing its style, readability, ergonomics and function to make improvements that will enhance its ease of use and thus make our experience with the product a little better. One of Sony's central missions, first expressed by Masaru Ibuka in 1946, is to "bring untold benefits to millions." What better way to benefit mankind than to design products that are easy to use?

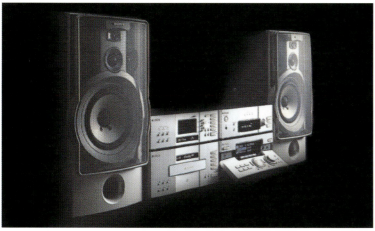

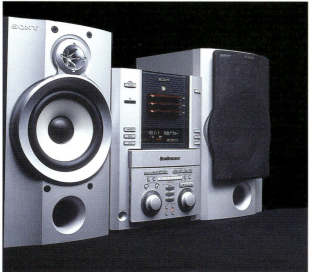

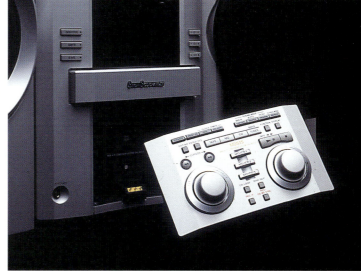

For years, the Design Center has been working to make complex technology simple. Consider the typical stereo system. With rows of buttons and a digital readout, the design is often too complex for the average user, offers too many options and does not reach out to the user in a friendly way.

The solution to this problem began to take shape in 1996, when DC/Tokyo designer Yoshimichi Matsuoka put only analog controls on his digital DHC-MD99 stereo system and designed the controls on a drop-down panel that slides out toward the user—a small but important gesture that extended the stereo into the user's space, shortening the distance between hand and product. Next, Mr. Matsuoka's colleague Tetsuro Miyazaki gave greater emphasis to analog controls on his DHC-MD515 MiniDisc changer by giving it two large control knobs (one for each hand) and placing them on a detachable panel that can be used as a remote control. "I've always liked products that have a big knob," says the designer. "Since we all have two hands, it makes sense to give the control panel two large rotary controls. It feels natural."

According to DC/ Park Ridge designer Soichi Tanaka, "analog controls function better than buttons, because our hands have been turning knobs for decades. We like the resistance that a button provides, as well as the subtlety that analog products have and digital products often lack. With an analog control, we experience on and off and everything in between. With digital buttons, it's either on or off with nothing in between."

The challenge is to give digital technology the warmth that analog controls provide. When designing the follow-up to the MD515 audio component system, Mr. Tanaka advanced Mr. Matsuoka's idea by giving his detachable panel a single large knob (see page 104). "There are buttons to serve as supple-mentary control," he notes, "but you can forget about them most of the time and use the knob for most of the interaction."

Mr. Tanaka's fascination with rotary controls began in the early 1990s, when he designed a twisting mechanism, known as the "jog dial," for a low-end video tape player (see page 141). The interaction was as simple as it was elegant: By twisting the knob to the right or left (a little) the tape would move in that direction (a little); twist it more and the tape moved faster.

The intuitive quality of the jog-shuttle metaphor allowed the knob to quickly jump from the VCR to a handheld remote without any loss of function and worked even better on a port-able cell phone (see pages 142–43). But in the world of digi-tal audio, Mr. Tanaka's knob has a powerful enemy, the button. Since

(see page 104)
(see page 141)
(see pages 142–43)

Above (left): The DHC-MD99 Mini-Disc Component System has a drop-down control panel with analog controls that extends itself into the user's space. Design: Yoshimichi Matsuoka (DC/London), 1995. Above (right): The DHC-MD919 continues this theme with three analog controls centered on the drop-down panel. Design: Tetsuro Miyazaki (DC/Tokyo), 1996. Below: The DHC-MD515 MD/CD changer component system has a detachable analog control panel with two large rotary controls, one for each hand (see below). Design: Tetsuro Miyazaki (DC/Tokyo), 1997.

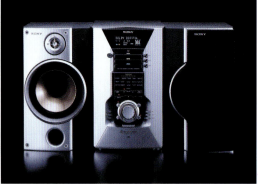

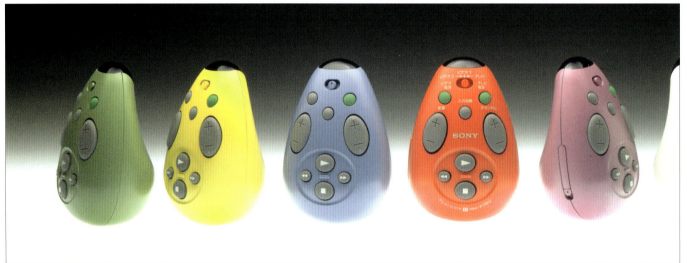

Top row (left to right): Jog-Dial VCR Remote Control. Design: Soichi Tanaka (DC/Tokyo), 1992; Mini Hi-Fi Component System with removable jog-dial control panel. Design: Soichi Tanaka (DC/Tokyo), 1996. Second row: RM-S78T Remote Controller. Design: Akira Yamazaki (DC/Tokyo), 1995. Below center: Concept for a DTV screen interface using a jog-dial metaphor.

knobs are analog, living in a world with many shades of gray, they are lovely to use yet imprecise compared to the button, which is either on or off. Since people are analog, the knob seems totally natural to us. Yet in the black and white world of digital technology, buttons have a clear advantage. The button's on and off action mirrors the ones and zeroes of the digital world. The button and its cousin, the rocker panel and other low-profile devices, are cheaper and occupy less space than a rotary knob, which means a designer can crowd more buttons on a given surface than knobs. Since manufacturers prefer buttons, the interfaces that these buttons control are button-friendly, which makes them rigid point-and-click experiences.

Knowledgeable designers find it easy to make a beautiful object with buttons. In 1995, Akira Yamazaki of DC/Tokyo turned out a lovely line of pear-shaped remote controls that are studded with finger-shaped buttons that won numerous design awards. Designing for function is another matter. In 1995, DC/Park Ridge design manager Rich Gioscia created the RM-V11 and RM-V21 Universal Remote Commander that is a marvel of functional simplicity. Studded with backlit finger-shaped buttons designed in a logical array, the RM-V11/V21 is

large enough to read properly and has all the right visual cues for operating a TV, VCR or other AV product. Mr. Gioscia came up with the basic shape in a moment of inspiration and labored hard to work out the right button placement and perfect the interaction, thus changing the way millions of people interact with their TV. No one has created a

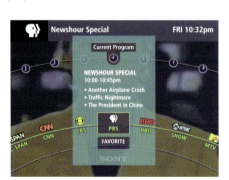

more capable and intuitive remote using a conventional design. Because the components that his remote must talk to respond only to button-style interaction, Mr. Gioscia could not design the RM-V11/V21 without using all of those buttons. Yet this style of interaction is changing fast.

With digital technology, it is possible to transfer controls from a hardware buttons to a software-driven display, allowing a simple handheld con-

troller with a trackball, a four-way rocker button or jog dial to negotiate a range of functions with ease. One concept for digital television developed at DC/New York and DC/Park Ridge uses a jog dial controller and a corresponding dial metaphor on the screen—which gives the user a natural form of interaction while keeping our eyes always on the screen. By transferring most control options from the hand to the screen, a jog-dial controller would give the us a more pleasant tactile experience with greater flexibility. New interface designs could be added by updating software.

Another style of DTV controller might have a multifunctional touch-sensitive LCD that can be used as a keyboard (for Web browsing or e-mail) as well as a conventional TV remote. A built-in video camera would allow teleconferencing. And a memory module, called Memory Stick (see pages 188–93), containing our personal preferences, program selections and bookmarked Web pages, could be inserted, allowing the system to know each member of the household in an instant. Rather than force users to learn the machine's language, digital design will soon bend the machine to our will, giving us the experience we truly want.

Above (center and right): The design for the RM-V11 and RM-V21 Universal Remote Commander leaves no room for user error. Controls are strategically positioned for quick finger access. The user simply points and clicks. Design: Rich Gioscia (DC/Park Ridge), 1994–95. Above (left): The RM-S78T Remote Controller offers a more interesting shape, but a less intuitive button array. Design: Akira Yamazaki (DC/Tokyo), 1995. Below (left and right): The beautifully resolved RM-V22 and RM-V40 Remote Commnder represent the logical endpoint for button-style remote controllers. Design : Knut Fenner (DC/Park Ridge), 1996. As good as it is, the style of interaction we see here will soon give way to controllers with fewer buttons and more control options on the screen.

Top and below left: The RM-X2S car audio controller packs a bewildering array of functions into a single unit that responds to the slightest touch. Design: Shigeyuki Kakizaki (DC/Tokyo), 1996. Below right: RM-X66 controller offers a more subtle tactile experience. Design: Shigeyuki Kakizaki (DC/Tokyo), 1996.

Since most humans have sensitive and nimble fingers, we can often feel things that our eyes cannot see. Using touch alone, it is possible to control complex mechanisms that would be difficult to control using standard hand/eye coordination. For this reason, touch control can be one of the most effective ways for humans to interact with a complex machine. Nowhere does simple finger movement translate into more complex interaction than on the automotive controllers designed by Shigeyuki Kakizaki and his team at the Design Center's Personal & Mobile Communications group in Tokyo. When you look at a high-end car stereo, which offers AM/FM, MiniDisc playback and a 6-CD changer with a vivid (and complicated) display, you quickly realize that it is difficult and dangerous to access functions on the stereo and drive a car at the same time. For this reason, Mr. Kakizaki devised an ingenious wand-shaped controller that combines jog-shuttle interaction with buttons whose location on the wand help the user to understand their function and importance. Indeed, once you learn the style of interaction, it's possible to operate a complex car stereo—adjusting the volume, starting a disk, skipping from one track (or disc) to another, tuning in a new radio station or allowing the product to search for a station—without taking

your eyes off the road. Mr. Kakizaki calls this "blind interaction."

"Because there are so many possible functions, every part of the controller has a distinct shape, texture or feature, such as a slight ridge, that the finger can recognize," says the designer. The precision of this device may seem off-putting at first. But, as you use the product, you discover that the design contains layers of functionality that allow you to climb a learning curve and eventually master the control. "Most people will start with the on/off switch and volume control at

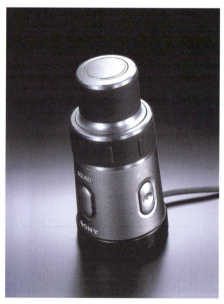

the end of the wand and work their way toward the base, accessing more and more functionality as they go," he says. "Since driving often involves repetitive interactions, it's important to have something to 'fiddle' with in an absent-minded way. The RM-X2S controller provides that." A smoother style of interaction is possible with the RM-X66 controller, which offers the same functionality using components with the tactile quality of an audiophile stereo system. The user interaction it offers is the best you will ever find in an automotive product.

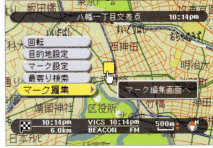

In 1985, the Design Center started a separate Human Interface design group to support the needs of Sony's display company by generating character-based displays for televisions and early computer products. As the importance of interactive displays increased over time, the HI Group has broadened its responsibility year by year and assumed the same level of proficiency as Sony's Industrial and Graphic Design teams. Under Kazumasa Okumura, an MIT-trained interaction designer, the HI group has tackled a range of interesting and difficult projects, the most taxing of all being the CD-ROM and satellite-based mobile directional finder known as the Information-Navi System.

Drive down any street in Tokyo, and the first question that most people ask is: Where am I? Conventional maps are difficult to find. Most streets in Tokyo have no street signs. Many streets have no name. And there is no set rule for building addresses. For decades, Japanese drivers have coped with this situation by simply memorizing the directions to various destinations or asking directions from strangers. In recent years, a satellite-based infrastructure has evolved using the GPS system, small receivers and CD-ROM-based information banks that allow the user to input their location and destination on

the map and follow detailed graphic and audio instructions to reach their destination. This system, often viewed as a toy or gadget in the U.S., is so necessary in Japan that many automobiles in major cities such as Tokyo have some form of electronic wayfinder.

The Sony Info-Navi System, with an interface designed by Mayu Irimajiri and Ippei Tambata, addresses the problem of delivering information to a driver, who controls a moving car while inputting and receiving information on the screen. By combining overhead maps and simple graphic representations that approximate a 3-D view of the terrain ahead, the Irimajiri/Tambata design provides constant Internet access and just enough information to accomplish the task at hand with a sense of richness and style.

Whereas conventional systems offer a 2-D overhead view, the Sony design gives a three-dimensional view of the road ahead that constantly updates itself, a small overhead map in the corner of the screen that constantly shifts as we drive, a pop-up cursor bar or simple written directions, with longitude, latitude, actual time, expected arrival time and compass headings always present on the screen. Map information is contained on a CD-ROM; and the car's location is determined by GPS satellite and constantly updated using sensors attached

to the tires. You can rotate the map on the screen just as you would a paper map, set markers for origin and destination, indicate points of interest to return to later, note upcoming traffic jams and download restaurant and other information from the Internet via a cell-phone linkup. You simply point to where you want to go using the cursor. The system then calculates your present location and maps out the best route considering the time of day, anticipated traffic conditions and graphical representations of passing road signs. The elegant interface makes excellent use of transparent imagery. The home screen is always just one click away (and always present as a transparent image). And the various alert sounds (chirps, beeps, rings and police siren sounds) are a sheer delight.

This technology-driven product would be useless without the icons, visual organization, on-screen buttons and 3-D graphics that a good user interface designer can provide. Incredibly, the system you see here was designed *after* the basic hardware and software had been created. The next challenge for the HI Group will be to create an Info-Navi system in which the interface is designed along with the hardware. One day, says Mr. Okumura, "such systems will use voice command, audio feedback and touch controls" with less reliance on visual information.

A breakthrough in user interface design, the Info-Navi System incorporates CD- and Internet-based input with clever information layering, allowing a driver to use the system and drive a car at the same time. Collaboration with Sony engineers via the Internet allowed the design to be completed in less than four months. Design: Ippei Tambata and Mayu Irimajiri (DC/Tokyo), 1996–97.

PerfecTV

In Japan, the convergence of television and digital content delivery began in 1996 with the arrival of PerfecTV, a digital satellite broadcasting system that beams nearly 200 channels of programming into Japanese homes every day. When you consider that before PerfecTV the average Japanese home was fortunate to have ten TV channels, the arrival of a system that offered hundreds of daily program choices—from free general interest channels, pay-per-view channels and informational services, to home shopping and education—was a major event for viewers and a challenge for those who had to create the Electronic Program Guide (or EPG) that allows us to find and select all those programs.

The traditional way of finding programs, in the newspaper, soon became useless as the columns of tiny characters grew smaller and smaller in response to the growing number of channels, causing a headache for anyone who tried to use it. But creating a real-time EPG was also limited by the size of the TV screen and the patience of the average viewer. To make an EPG work, it was essential to design a system that would make sense of the great number of choices and make the available information accessible to the user. Because Sony manufactures the Digital Satellite System (DSS) dishes and set-top boxes and receives the PerfecTV signal, the company had to build an EPG into the system in order to encourage viewers to subscribe.

The PerfecTV user interface, designed by Yukiko Okura at DC/Tokyo, builds upon an on-screen design patented by GemStar, which aligns the basic information in a familiar way: with programs contained in a series of horizontal bands across the screen with times and days of the week across the top of the screen and channels running vertically along the left side and a cursor that allowed you to jump from one increment to the next in one of four directions (north, south, east or west). The GemStar format is based on the listings and format found in *TV Guide*, which makes it instantly understandable. Since GemStar extracts a royalty from every product that uses this design, Sony is developing its own interface for future products that will be even more intuitive.

Before she could begin her design, Ms. Okura first had to understand the problem by constructing a chart containing a single day's programming with the smallest kanji characters possible. On paper, the chart measured 40 inches square. Translating it to the TV screen resulted in a chart that measured nearly 20 feet square—which made it impossible to scroll through. This quandary set Ms. Okura's mind to work. Fortunately, Sony's U.S. design team had already completed the first DSS programming guide. After studying their effort, Ms. Okura devised a visual framework for limiting the number of choices on the Japanese systems to a few broadly understood categories (news, current events, sports, movies, drama, etc.),

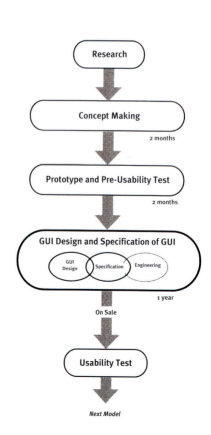

which limited the number of choices at any particular time to only those programs that fall into the viewers preferences, and devised a new visual metaphor to make channel and program selection more intuitive. The metaphor consists of a cylinder that presents a combination of elements (day, time of day, subject matter) that the user can adjust to determine which programs are available at any particular time.

Set the PerfecTV interface to a particular day and time, and the screen information changes dynamically as you change the category of viewing from news to, say, sports. Keep the same category in place but change the day or time, and the listings change again, instantly updating the channel and program information to reflect the settings that have been requested. Working with software designer Tetsuya Kohno and TV hardware specialist Yuji Morimiya, Ms. Okura began the project in the spring of 1995, and concluded her work during the summer a few months prior to the official launching of the service.

Once the final design had been determined and approved, limitations in system memory curbed the number of colors and visual textures used on the screen, but did not limit the use of transparent screens, which allows viewers to see programming through the EPG. This detail has become another signature Sony feature.

After the design was complete, Sony management was so pleased with the result, they asked Ms. Okura to work with engineers to continue the development, a rare instance in which a designer works directly with programmers and engineers.

The number of special-purpose screens designed for the digital TV system range from pay-per-view request/confirmation, promotions (sent to the viewer using PUSH technology), to (in the near future) a special button that will enable sports watchers to switch the camera's view from the players on the field to the dugout, or perhaps even the locker room.

The next-generation electronic programming guide, which incorporates aspects of Ms. Okura's PerfecTV with Sony's new Zooming User Interface (see pages 162–65) promises to make tomorrow's digital television interface even more responsive than today's.

Inset: The research phase for PerfecTV began in the spring of 1995. The finished product shipped in July 1996. Design: Yukiko Okura, Tetsuya Kohno and Yuji Morimiya (DC/Tokyo). Opposite page: The electronic program guide uses a cylinder metaphor to help users select from more than 200 channels without having to search through a multi-layered interface.

Research → Concept Making (2 months) → Prototype and Pre-Usability Test (2 months) → GUI Design and Specification of GUI (GUI Design, Specification, Engineering) (1 year) → On Sale → Usability Test → *Next Model*

Highlights from Yukiko Okura's PerfecTV interface: Top row (left): Ms. Okura's concept for the PerfecTV cylinder metaphor. Top row (middle and bottom): Electronic programming guide selections. Second row (middle): Selecting favorite programming genre. Second row (right): Pay-per-view preview. Third row (middle): Setting the PerfecTV dish antenna. Third row (left): Selecting programming in multiple languages. Third row (right): Your pay-per-view purchase has been accepted.

Compared to the intimacy between users and physical products and the more distanced relationship we have with 2-D screen interfaces, the World Wide Web represents a more distanced, but no less powerful form of interaction. The distance is necessary, because of the Web's size and complexity. With Internet traffic doubling every hundred days, the Web's audience is both huge and diverse. Because it involves so many people with differing levels of expertise, Web interaction has evolved into a highly structured point-and-click environment that leaves little room for error.

During the early 1990s, as the Web evolved from a communications medium for scientists and scholars into a global business and cultural phenomenon, Sony became one of the first major corporations to launch a fully animated interactive Web site. The first Sony site, designed in 1994, was a basic corporate tool offering information

about Sony's various businesses by clicking on one of several balls that were vertically arrayed across the screen. Because it did not make good use of HTML (the language used to build Web sites), the first Sony site was slow and rather limited in scope. Evolving from a basic HTML page to an index site with few visuals to the current eye-popping marketing and promotional experience, Sony.com has climbed one of the steepest learning curves of any corporate Web site. Over the years, designers of the site have included Ellen Tave Glassman (DC/Park Ridge), Anne Kim (DC/New York), Kim Mingo (DC/San Francisco), and interaction design manager Andy Proehl (DC/San Francisco). Outside consultants have included Frankfurt Balkind and, most recently, partners at Belk Mignogna Associates.

Different from 3-D interaction with a product or 2-D interaction with a screen interface, Web inter-

action must be simple, fast and visually arresting. The reason, says Proehl, is that "Web surfers are always one click away from leaving your site. To keep all those eyeballs in the Sony site, we need a simple design with lots of graphics that allows users to scan their options on the home page, make a choice, reach the next layer instantly and make each layer of the site as intuitive and entertaining as possible. The main challenge has always been to give the home page a strong Sony image while also representing the diverse interests of our operating companies." As traffic on Sony.com mushroomed in 1995–96, the design challenge grew as the various operating companies within Sony each struggled for as much exposure as possible. Rather than clutter the site with more information than a 640-by-480–pixel space can handle, corporate peace was achieved by evolving the site from an information-only experi-

ence to one that emphasizes marketing and business activities, giving the home page a row of buttons (each with a GIF animation) for Sony Music, Sony Pictures, the Station, Sony Electronics and PlayStation, with additional buttons at the bottom of the screen for Sony Online (which features corporate and product information) and another button for Sony World, which links to Sony sites in Japan, Asia and Europe. The challenge in corporate Web design is to balance many conflicting desires: to make the site visually alluring, yet easy to understand and download; to provide lots of information and choices, yet also make the site easy to navigate; and to give each area of the site its own ambience, while maintaining a consistent look and style of interaction. Simplicity is achieved by designing the home page on a grid with relatively few options and changing the background at regular intervals. At Sony.com, you rarely see the

same home page background for more than a week. Visual richness with maximum interactivity is achieved through a deft use of imagery, animated graphics contained within "click zones" that act as buttons, and multiple choices arrayed into simple lists, which reduces visual clutter and encourages the user to scan quickly, make a choice and move to the next layer of content. Preference is given to simple bold colors and white type against a black background, overlapping transparent imagery and an asymmetrical grid for maximum visual interest with keyword searches for accessing oceans of text (product specs, music and film info, merchandise, corporate speeches). Banners at the top of pages within the site reinforce the name and identity of various Sony-owned companies, such as Columbia Tri-Star or product franchises such as PlayStation. The various operating companies each design and man-

age their own sites. Yet the opening page is resolute in its simplicity. All we see is the standard Sony logo (which replaces the old Sony Online moniker), four or five buttons across the middle of the screen designating Sony's four main lines of business (music, movies/TV, electronics and PlayStation), a fifth button devoted to PlayStation online games and a large background graphic showing a recent Sony product or film. By simplifying the overall design and de-emphasizing the Sony Online logo on the opening page, the site now reads as simply Sony.

"As a communications medium and sales tool, Sony.com is one of our most important assets," says Proehl. "Leveraging that asset means constantly improving the quality of interaction within the site, keeping the Sony logo pure and recognizeable and developing new approaches to make the experience always seem fresh."

Andy Proehl of DC/San Francisco manages the design effort for the Sony.com home page. The evolution of the home page between November 1995 (opposite page, top left) and March 1997 (this page, top right) reveals an ever-increasing sophistication as the Web evolved into a mainstream medium. The current home page design (bottom row) consists of the Sony logo in the upper left corner; a promotional background image; five GIF-animated buttons that allow the user to click to music, movies and TV, electronics, PlayStation or on-line games; a keyword search window and additional buttons for Sony Online and Sony's Japan Web site. The Sony Japan home page (this page, lower right) was designed as a proposal for the Sony Corporation of America's home page. SCA didn't like it; Tokyo did.

ImageStation

Exploiting the Web's commercial potential is taking new forms every day. One avenue involves the convergence of different technologies, such as digital imaging and computing, to serve an old function in a new and interesting way. For decades, people who take snapshots have endured the cumbersome process of buying photographic film, loading it in their camera, taking pictures, waiting while the film is developed and receiving prints or slides that must be archived and duplicated to send to family and friends. With the emergence of digital imagery and the Web, picture taking, archiving and distribution are now much easier.

In a joint venture, Sony and Picture Vision (who work with Kodak and America Online) have created an on-line digital imaging service called ImageStation. Sony provides the consumer hardware—such as digital cameras (Mavica, Cybershot), video displays, Web TV and VAIO computers. Picture Vision provides infrastructure for sharing, storing and sending duplicated images, providing access twenty-four hours a day. First you log onto the ImageStation site, establish your account and password, upload images from your digital camera, or send conventional photographic film in a mailer. ImageStation scans and stores the images automatically, allowing the user to view them, download them to their computer,

order products with the image printed on it or send them electronically to family and friends.

The primary interaction takes place in the dock (where you upload and manage your images or retrieve pictures sent to the site on photographic film), the gallery (where you archive and view your electronic "photo album") and the shop (where you send images to others and order prints or personalized gifts such as T-shirts, coffee mugs, puzzles and cookies printed with your favorite photo).

Designed by Ellen Glassman, Jan-Christoph Zoels and Susie Sohn at DC/Park Ridge, the ImageStation site employs color and inventive type treatments to draw in users who may be unfamiliar with the Web. Text is large and simple.

Visual clutter is eliminated. And a reassuring tone is set from the very first screen. The ImageStation logo, designed by Ms. Glassman, borrows from the earlier PlayStation logo by allowing the letter I to cast a shadow that forms an S. The relationship of the I and the S extends throughout the site, with sections titled "I See!" (where you peruse your album), "I Store!" (where you archive new images) and "I Share!" (where you transfer images to others electronically). Using an access code, friends can log into your photo album using a Sony television with Web TV or a VAIO computer, view the photo archive in the Gallery and download images or order products in the Shop without having their own separate account.

The interface is smooth and intuitive with images displayed as thumbnails, which enlarge with a mouse click. You can attach ImageStation pictures to an e-mail message, or create a postcard within the site, which shows you how the finished message will look before sending it.

Designed to support Sony's digital imaging products, the ImageStation site could expand to include single-use digital cameras, which Sony could offer for sale, receive back through the site and recycle again and again.

Now that digital design has merged with virtual reality, designers find themselves liberated from the purely physical restraints of the past.

ImageStation Web site interface and logo. Design: Ellen Glassman, Susie Sohn and Jan-Christoph Zoels (DC/Park Ridge), 1998.

Community Place

The very fabric of computer and network technology that supports digital media is spurring further expansion in interactive Human Interface design. To Sony, the term "interactive design" is not limited to the computer. Rather, it means the engineering of an entire flow of events surrounding the user, including environments both real and imaginary. To demonstrate this concept, Web designers Tatsushi Nashida, Naoto Ozaki, Junichi Nagahara and Hidenori Karasawa at DC/Tokyo have created Community Place, a virtual reality site that Web surfers can enter and meet other visitors to chat and exchange information. A unique interface for Virtual Reality Markup Language 2.0 (developed in collaboration with Silicon Graphics and World Maker), and Sony's multi-user extensions, which add sound and video data to scene objects to provide full motion, Community Place allows the user to select a "body double" that appears on the screen and mirrors the user's feelings and intentions. Each user sees themselves and others as cartoonlike figures. These avatars exist in a virtual 3-D space—such as a circus park (seen below) with a ferris wheel and carousel or a grimy New York City street—with on-screen controls that allow users to move around, change position and communicate with others using a dialog box at the side of the screen.

This combination of digital interaction and fluid motion offers an interesting combination of digital and analog experience—the illusion of intimacy without real participation. The design of this virtual environment was inspired by arcade-type video games. Its form and features derives from a template that Nashida and Karasawa created in 1996 that specifies the range of characteristics and motions of each character on the screen—with considerable "headroom" built into the system, allowing it to "grow" as the user gains proficiency.

Future applications for such virtual spaces could include virtual shopping malls—in which robotlike sales clerks can explain merchandise and conduct sales with virtual visitors. Another possible application is 3-D groupware. For example, engineers could share a VTML version of a 3-D CAD file and have a discussion inside their "working machine."

Community Place, designed by Tatsushi Nashida, Hidenori Karasawa, Naoto Ozaki and Junichi Nagahara (DC/Tokyo) in 1995–96, is a Web-based information community where users can chat, share information and join in many different activities and groups. The potential of this form of on-line interaction is staggering.

Another form of interaction occurs between the packaging designer and the customer. In many countries, packaging is treated as a form of marketing — something the consumer would throw away. But in Japan, product presentation has been elevated almost to an art form, with layers of symbolism and meaning injected into even the simplest product container. Walk into any grocery store in Japan and you will be astonished by the attention to detail and presentation: even fish is laid out onto shaved ice in a precise pattern; every piece of fruit is scrupulously cleaned and positioned for maximum visual appeal; and the packaged goods are extraordinarily detailed and always contain some form of humor, emotion or surprise. The reason for this, says Sony designer Hiroshi Nakaizumi, is both cultural and practical. "The function of packaging in Japan is to present the product inside as a kind of gift from the manufacturer to the buyer. For this reason, a lot of attention is given to the wrapping of a product so that the silent ceremony of unwrapping and the first moment of recognition and enjoyment will be as strong as possible. In most of the world, packaging is designed as a sales tool, a means of protecting the product and a way to deliver product information. Once you open the package, you throw the box away. But in Japan, opening the product for the first time is a celebration. Therefore, it's important that the package not only represent the product and make a good first impression, but also provide that symbolic celebration with a sense of style and class." Humor, friendliness, honesty, lively color and inventive shapes are all part of the Sony approach. Depending on the time, the product and the intended audience, the package may be slick and bright with lavish use of heavy-metal inks and elaborate coatings or it may be plain or understated using eco-friendly materials.

If one person symbolizes Sony's Japanese packaging philosophy, that person is Yuko Wada. Ms. Wada was Sony's first female industrial designer when she joined the firm in 1981, transferred to the graphic design group in 1983 (then known as PP, short for Product Presentation) and today packages herself with the same care and attention that she gives to Sony's products.

For Ms. Wada, the philosophy behind packaging has an almost spiritual root. At the same time, every product is an adventure, allowing her to become a child again. "Whether one works in

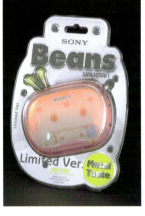

Rosaline Yin, a Shanghai-born graphic designer at DC/Park Ridge is an expert in the complex art of combining imagery, letterforms and icons into a six-sided package using the computer-based tool Adobe Illustrator. When you look at one of her dense, eye-catching creations, it's difficult to see the layers of work that go into making it. This box for the Street Street Style Discman contains six scanned high-resolution images (opposite page) and a blizzard of words in seven different typefaces with a multitude of colors with broad letter spacing in some places, narrow in others and a variety of other treatments. The Photoshop images (shown opposite) begin as simple photographs on which Ms. Yin adds layers of color and visual texture to give them greater impact. For example, the rain treatment on the background image is so realistic, it makes the finished box look distinctly wet. Type, images and other elements are aligned to the nearest 1/1000th of an inch. Trademarks are downloaded from an in-house digital archive. The final Illustrator file that goes to the printer comprises more than 100 megabytes of data.

the industrial sphere, in graphic design, packaging or visual identity, the only limiting factor in a designer's work is their attitude," she says. "If you are not excited by your project, your design will not convey any emotion. And your work will fail in its primary mission: to communicate its spirit to the user."

Overseeing a dozen junior designers, Ms. Wada limits her personal design work to the most difficult projects. "For me, design is like sports. The more overwhelming the opponent, the more fun it is to find a way to win." Headphone packaging presents the supreme challenge. As a silent salesman, a headphone bubble pack must protect the product, show it from all angles, provide reams of product information, appear fresh and inventive, and convey the underlying value of the product while respecting strict cost and environmental constraints. Ease of assembly at the factory, strong visual appeal, the proper balance of security in the store and ease of removal once the user takes the product home all must be weighed against the price of the product.

Among the hundreds of packages Ms. Wada has designed or overseen in the past dozen years, her favorite is the Walkman box containing the unit and headphones that doubles as an attache case. "It costs more than a standard box, but adds value by encouraging the user not to throw it away."

The ceremonial nature of package design is also important. "The gift aspect of packaging, particularly in Japan, allows us to explore a range of expressions"—from elaborate schemes

such as the 50th Anniversary Walkman, which wrapped the product in many layers with intriguing colors and textures, to fun ideas such as headphones wrapped in a round plastic snowball for Christmas, to simple color-coordinated package-and-product combinations. All seem appropriate given the particular product and audience." Like the products themselves, Sony packaging does not follow an identifiable design language. Yet take away the Sony logo, and you still know its origin. Professional-looking prod-

ucts are often wrapped in dark colors, shiny surfaces or thin closely-spaced lines, which project a sense of precision. Low-priced units have more vivid colors.

During the 1970s, in response to the Arab oil boycott and increased concern for the environment, Ms. Wada's graphic designers quickly replaced molded virgin plastic with eco-friendly recycled plastics and paper—a shift that addressed societal concerns while at the same

time reducing costs. But today, with cost reduction no longer the primary concern, the designers concentrate on symbolism. Her Walkman packaging, done in primary colors with child-like drawings of snakes, gorillas and bats is a classic example. "Snakes and bats are usually not our favorite animals," she explains. "But when we listen to music on a Walkman, it puts us in a more positive frame of mind and allows us to see the world in a gentler way. As a result, the bat, snake and gorilla are no longer symbols of terror. We look at them as friends . . . suggesting that the Walkman and music itself music can tame the savage beast." Is there another packaging designer anywhere who applies such profound philosophical thinking to the design of a box?

As the visual survey on the previous pages indicates, the one constant in Sony's packaging design is change. "No single style can represent the incredible breadth of what Sony has to offer," says Wada. "We think of graphic design and packaging as clothing, which we change every day. But changing a particular package doesn't mean that we change our image. We recognize that packaging is a language and that all language is ultimately ephemeral. But what that language communicates to the user remains constant. To maintain consistency, there are specific rules when using the Sony logo. Otherwise, we remain free to express ourselves. People always expect something new from Sony. They always want something that is different, but not *too* different." The challenge, to be always new yet make the package instantly recognizable, is never-ending.

Compare this yellow strategy, which Hiroshi Nakaizumi and Miya Suwa (DC/Tokyo) proposed in 1991 for packaging Sony video media, around the world, to the red strategy that Nakaizumi and Suwa designed in 1992 after Norio Ohga entered the discussion. Since color preference differs from one country to the next, Sony marketers in the U.S. discovered that American users preferred blue to red. In 1994, Mr. Nakaizumi and Suzanne Morris created a blue strategy for the U.S. market.

Tape cassette and MiniDisc media packaging presents an entirely new set of challenges and a different kind of interaction than product packaging. Since all blank media are similar in the customer's mind, the key issues are brand identity, product description and a recognizable color. Immense efforts have been made to develop the right design and color for the packaging of Sony's media products. With competition increasing in the late 1980s, Hiroshi Nakaizumi and Miya Suwa of DC/Tokyo decided to give all video media a unified look. After weeks of research and testing, they decided that the best color for the global market was a bright lemon yellow. Concepts for each tape product were generated. And it was "all systems go," until president Norio Ohga called Nakaizumi and Suwa's choice "surprising"—pointing out that Sony's lemon yellow concepts

were too close to the "Kodak yellow" used on film boxes known throughout the world. To avoid comparisons, Mr. Ohga suggested that Sony adopt a dark, bold red instead. "No one could see the connection between our lemon yellow and Kodak's reddish yellow," says Mr. Nakaizumi. "But Mr. Ohga felt that Sony should pay a certain respect to Kodak, which had pioneered the idea of a global color strategy, by not imitating their color choice or developing anything that was even remotely similar." Within a week, Mr. Nakaizumi and Ms. Suwa presented a red strategy, which was quickly accepted and has since been used in Japan and all international markets in the 8mm video tape category. It was assumed that Sony marketers in the U.S. would adopt the red strategy as well. But U.S. executives couldn't afford to guess about color, since they wanted to

apply a unified color strategy to all consumer media, including computer diskettes and batteries. User testing indicated that Americans preferred blue to red. But Mr. Ohga objected. "He wanted Sony to have a single global color," says Mr. Nakaizumi. "He envisioned walking into any store in the world and picking out Sony media from its competitors because of its red package." But the U.S. marketers demurred. Since Mr. Ohga was planning to leave the president's office to become global chairman, he left the decision to his successor, Nobuyuki Idei, who accepted the local approach. "Fortunately, the blue strategy has been a huge success in the States," says Nakaizumi.

In the audio cassette arena, the key to sales is differentiation—taking a generic product and designing variations for every conceivable audi-

ence and market segment. Various grades of tape need their own color, with yellow shades signifying low-priced lines, rich or dark colors the upper-priced segment, and silver denoting the premium line. "Blank media is a huge business, and cus-

tomers often make judgments at a glance," says Suzanne Morris, a packaging and graphic designer at DC/Park Ridge. "It's important, therefore, to make the strongest impression possible that is consistent with the Sony way." The need for constant innovation in cassette packaging inspired Morris and her colleague

Rosaline Yin to create a unique image for Sony's premium CD-IT cassette in 1996 by designing a three-dimensional hologram of a compact disc that slices through the Sony product name and "wiggles" as you hold the cassette case in your hand. The design, inspired by Sony marketing executive Tom Fukuda, called for a specially printed card wrapped in clear plastic film containing the Sony logo and product graphics, set behind a plastic lens with tiny surface ridges, which create the 3-D visual effect. The current 3-D design for CD-IT, designed by Manabu Sakamoto, depicts the CD slicing through the package.

Of course, all products can use a bit of celebrity endorsement. But for Sony to reach the right audience for their new GIG line of cassette tapes (see page 120), which have a "street culture lifestyle" theme, they did not hire a pop star or film actor. They asked the Japanese cartoon artist Toons Imai to create animated characters called GIG Boy and GIG Girl to appear on GIG packaging and advertising. Conceived in March 1997, GB and GG have appeared on hundreds of thousands of cassette packages and are known throughout Japan. The trouble is, they don't say much. So we asked Mr. Imai to fill us in.

Who are GB and GG? Brother and sister? "No, they are definitely not related. They might know one another, because the Tokyo they inhabit is quite small. I don't know their names. But if you go to any street in Tokyo, you might meet them."

What do GB and GG do all day? "They rollerblade or skateboard, go to clubs at night and enjoy the morning. walking the streets of Tokyo when no one is around. They like wearing comfortable, well-designed clothing that reflects their identity. And since they listen to music on the go, they create their own tapes. They love music. GIG Boy prefers Hip-Hop,

First and second rows (left): CDix, G-Up and CD-IT Cassette packaging have more than 400 color and pattern variations. Design: Makiko Kawai, Kenichi Hirose, and Kouki Yamaguchi (DC/Tokyo) and Manabu Sakamoto (DC/Park Ridge), 1997–98. Second row (right): This CD-IT cassette package uses a holographic image of a compact disc that "wiggles" as you rotate the case. Design: Suzanne Morris and Rosaline Yin (DC/Park Ridge), 1996. Third row and bottom: The current CD-IT package uses a specially designed plastic lens mounted inside the case to achieve the holographic effect. Design: Manabu Sakamoto (DC/Park Ridge), 1998.

GIG Boy • GIG Girl

Above: GIG Boy and GIG Girl, conceived and drawn by Toons Imai (Tokyo), 1996. Below left: Eau du Pop cassette packaging. Design: Yuka Takeda and Yuko Suzuki (DC/Tokyo), 1994. Middle right: GIG Boy and GIG Girl cassette packaging with slide case mechanism. Design: Kazushi Kirihara (DC/Tokyo), 1998. Below center and right: Message cassette notecards. Design: Satomi Moriya, 1996.

and GIG Girl prefers British Rock. They know that music connects them to the world."

Are GB and GG real? "They are real to me. I want to wear the clothes that GB wears." Eventually, GIG Boy and GIG Girl will fade from the scene, but Mr. Imai promises they will not exploit their newfound fame. "They will not become politicians," he says.

Seeking new forms of expression and defining new markets take Sony graphic designers in unusual directions. These include a line of

Karaoke tapes, a line called Eau du Pop (which packages tapes like fine soaps for older women) and a note card line for young people that features a card with a sentimental phrase and a cassette tape with similar packaging that the buyer uses to record favorite music or a voice message for their friend or loved one. The delicate design and heartfelt sentiments on these packages, the work of designer Satomi Moriya, is so unlike Sony's corporate design it's hard to believe they were designed just a few feet away from those

designing GIG Boy/GIG Girl or the umpteenth variation on the ever-popular G-Up line.

"When I focus on a project, I live in my own world," says Ms. Moriya, who wears a frilly white lace blouse with tough-looking black jeans. "My age allows me to understand young people and identify niche markets that Sony's global strategy does not always recognize."

Fitting these niche expressions into Sony's Sunrise/Sunset strategy is not always easy. If we look at the evolution of MiniDisc packaging, for

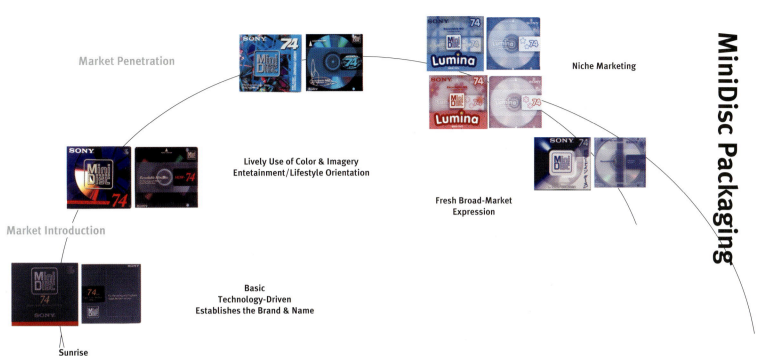

Market Domination

Noon

Market Expansion

Market Penetration

Niche Marketing

Lively Use of Color & Imagery
Entertainment/Lifestyle Orientation

Fresh Broad-Market
Expression

Market Introduction

Basic
Technology-Driven
Establishes the Brand & Name

Sunrise

example, we see that niche design cannot appear until after the high-noon/mass-market-icon design has been achieved. In a world confused by too many incompatible media formats, introducing a new format can be tricky. Therefore, the sunrise MiniDisc media package (designed in 1992) had to be simple, competent and "safe"—which means not too colorful or expressive. All we see on the first package is the Sony logo at the bottom, the MiniDisc logo displayed prominently at the top and, because it is a recording medium, an indication of the time limit on the disc. We see no visual indication that the box contains a disc. And the package itself is simple and gray with a red stripe at the bottom; the disc inside is equally plain and solid with a sober industrial look. (Since the first MiniDisc player did not have a window that allowed you to see the disc inside, there was no reason to decorate the disc.) Once the new media is established in the buyer's mind, we see a midmorning expression (in 1994) that is quite different from the sunrise design. Now, the Sony logo is at the top with the MiniDisc logo centered against a vibrant computer-generated background that emphasizes the round disc inside the package. The time on the disc is more prominent. And the disc inside the package has a round translucent window that allows us to see the platter inside (perfectly aligned for the new breed of MD Walkman that had a tiny window that allowed you to peek at the disc inside).

The third MD package is the high noon/icon design (1996), which dominates the market and establishes a level of expression that is so strong it can feed many later designs. Outside, the graphics are iridescent and alive; the Sony logo remains at the top left; the centered MiniDisc logo is framed for greater legibility and the disc time is moved to the top right—giving all three elements equal importance. As the market for MiniDisc media grows, this high noon design will endure for at least a year (a long time in the world of media design). Yet eventually niche versions will appear. The most interesting of these is Satomi Moriya's Lumina series, designed for teenage girls.

"Since the MiniDisc is a new medium and relatively inexpensive, it should appeal to young people, especially young girls, who are drawn to the small 2-3/4-inch disc." But packaging the product for this audience demanded a unique approach. Using the same logo/brand name/ time elements as the high noon package, Ms. Moriya added the Lumina sub-brand in large soft letters and set everything against a light pink or blue background. "The sensibility of this product is very specific," says the designer. "Young girls become intensely brand-loyal once they feel that their taste is reflected back on them. And taking a youthful approach does not limit the product. It appeals to the young person in everyone."

Sony has many affiliates in a wide range of fields that provide information services and market products other than those made by Sony. The Design Center often devises logos and collateral material for these affiliates to bring their visual identity in line with Sony's image while giving each affiliate a sense of individuality. For the thirtieth anniversary of Sony Plaza, Miya Suwa and Makiko Kawai designed various items, such as bags, stickers and boxes (shown above), to enhance name recognition and exude a pleasant feeling. Thinner packaging materials were used to conserve materials.

The Sony logo has evolved through six incarnations from its first appearance in 1955 to today. The current expression is so powerful it has lasted more than twenty years, an eternity in today's corporate environment. Opposite page: Some of the more than 500 Sony product logos and trade names.

The Sony Corporate Identity System centers on the most well designed and recognized corporate mark in the world: the four-letter Sony logotype, first used in 1955 as the brand name of the company's first radio. In those days, the Sony name was displayed in an attenuated italicized sans serif typeface set within a vertical rectangle—giving the logo a 1950s look. Three years later, the company known as Tokyo Tsushin Kogyo Corporation (a real tongue-twister even for Japanese), decided it had to change its name. As cofounder Akio Morita recalls: "Our company name didn't have a chance of being recognized unless we came up with something ingenious. We also thought that whatever new name we came up with should do double-duty; that is, it should be both our company name and our brand name. That way, we would not have to pay double the advertising cost to make both well known." By making Sony's corporate identity and brand one and the same, Morita could make efficient use of Sony's advertising budget to build both corporate and brand awareness at the same time—a brilliant choice that has since been successfully implemented by many other companies. "Ibuka and I took a long time deciding on a name. We agreed we didn't want a symbol, and therefore [the name] should be short. We wanted a new name that could be recognized anywhere in the world, one that could be pronounced the same in any language."

By that time, designers in the company's radio division had already changed the Sony brand logo from italicized sans serif to a horizontally scaled bold serif typeface (similar to Clarendon) horizontally scaled by 118 percent with copious letter spacing to allow the word to read well on a small product or from a distance. Simple and easy to understand, easy to pronounce and readable in any language in any country of the world, the word *Sony* derives from the Latin word *sonus*, meaning sound, and the English word *sonny*, which the Japanese read as a term of endearment. While the name reflects Sony's origins as a manufacturer of audio equipment, the firm's rapid expansion into video, computers, communications equipment, recording media, batteries, music, movies, cinema and all manner of high-tech hardware has not diluted the name. The secret behind this durability is the consistency with which the name is applied and displayed and the relentless way in which Sony's marketing group displays and reinforces those four letters in every advertisement on every product, package, poster and building in the Sony universe.

Over the years, the logo has been strengthened, attenuated, and had its letter spacing adjusted four separate times, the final adjustment coming in 1973, when former Design

	1955
SONY	1957
Tokyo Tsushin Kogyo Corporation changes its name to Sony Corporation	1958
SONY	1961
SONY	1962
SONY	1969
SONY	1973

Center director Yasuo Kuroki established the current logo. Since that time, several attempts have been made to adjust or change the logo, including several in-house competitions with the attendant head-scratching and chin-pinching. But none of these new logos proved to be as strong or as recognizable as the original.

As a housemark, trademark, trade name, company name or endorsement brand, the Sony logo is always shown clearly, conspicuously and independent of other elements in the design of a product, packaging scheme, letterhead or building. Strict rules apply for the use of the Sony name, both in-house and in advertising. For example, the logo should always exist in an "iso-lation zone"—surrounded by ample blank space in order to display the logo as an independent element. And corporate colors are strictly enforced: only Sony Blue 90 (a special bluish purple mixed according to a secret formula), Sony Light Gray 90, (Pantone Cool Gray 5C), Sony Dark Gray 90 (Pantone Cool Gray 10C), black, white and silver (Pantone 877C) can be used on products, stationery, packaging, vehicles or buildings. To enforce these guidelines, Sony's Brand Management Office oversees logo usage on a company-wide basis, while individual designers make logo decisions on individual products. Occasionally, mistakes occur. A case in point was the three-story-high billboard that loomed over New York's Times Square for more than a decade. Recorded in countless photographs, the tall narrow billboard featured the four-letter logo vertically—an obvious mistake.

Over the years, the word Sony has evolved from the brand for a single radio in 1955, to a company-wide brand in the early 1960s, to a world-wide endorsement brand encompassing a bewildering array of products and services today. Yet examine any Sony product from the past few years, and you will see the familiar four-letter logo in the most prominent area and another more descriptive logo or appellation nearby. In the old days, the Sony logo predominated. Yet, increasingly, it is the more specific brand—such as Walkman, Discman, Pressman, Trinitron or Widdit—that carries the meaning. And these sub-brand logos no longer just sit there waiting for eyeballs to come to them. They explode off the surface, dance for us and graphically collide with the surrounding surface in a way that captures our attention. Their aggressiveness is matched only by their precise placement on the product and by the individuality that Sony designers give to each brand. Though instructional graphics on all Sony products are done in a uniform Helvetica typeface, the more than four hundred logos in the current Sony product inventory run the gamut from simple condensed typefaces to wacky, colorful hand-drawn scripts that take product imagery to a whole new level.

Discman ESP

Beta

WALKMAN

Mini Disc

Plasmatron

Sports

DD QUARTZ

Ruvi

Black Trinitron

W I R E L E S S

Whoopee

PRESSMAN

Betamax

my first Sony

widht

Cyber-shot
Digital Still Camera

The S-Mark

According to legend, Sony cofounder Akio Morita was touring an electronics show in 1967 with a group of dignitaries. Scanning the various products, Morita's eyes fixed on a particularly beautiful television, causing him to gesture to his guests: "This is a Sony design. See how fine it is?" Yet on closer inspection, the TV turned out to be a Toshiba product. Embarrassed by the incident, Morita quickly ordered Sony's Corporate Identity Group to design a graphical symbol that could be fixed to all Sony products, making them easy to identify. Thus began the S-mark: Designed by Sony's logo god Masaaki Omura, the symbol is composed of seven rows of ascending dots that line up vertically on the left and form an "S" on the right. Used to differentiate Sony's products from look-alike competitors, the S-mark has strengthened and enhanced the familiarity of Sony's image in electronics. With the logotype, the S-mark is the central element in Sony's Visual Identity System, often used with the slogan "It's a Sony" on product packaging, advertising, promotional materials and countless decals and is stuck onto the products themselves. Unlike the Sony logo, the S-mark can be removed once the user takes the product home. Used successfully for more than thirty years, the S-mark suddenly disappeared during the summer of 1998, in response to a terse memorandum issued from the Corporate Identity Group. known within Sony as Keiei Kaigi. When the Design Center asked for an explanation, they were met with silence.

Purple Power

Soichi Tanaka's 1990 PlayStation concept was cancelled after negotiations between Sony and Nintendo to develop the machine broke down. This gave Teiyu Goto the opportunity to step in and design the second version himself. Opposite: More than a product, PlayStation has become a worldwide phenomenon, with hardware and game sales responsible for nearly twenty-five percent of Sony's worldwide profits in 1997. Design: Teiyu Goto (DC/Tokyo).

designer of all?" Indeed, there are so many answers to the question "What makes good design?" that no one person can be expected to embody all of the necessary qualities and deliver on every level all the time. With hundreds of graduates pouring out of design schools around the world every year, it is not difficult to find a designer who can give a product an eye-catching form, invest that form with personality and meaning, make it functional, easy to manufacture and easy to use and write a story for the product using the grammar of design that will turn the product into a metaphor or symbol that will change society. Yet, when working on the highest level, the practice of design is more than an aesthetic activity. It is more than giving function to a product, interacting with the user, communicating with society or giving a product lasting significance. Even creating an icon—the most important thing that a working designer can do—is of only passing significance.

Far more valuable, and much more rare, is to find a designer who thinks strategically and can create a product that could evolve into a stand-alone business and change the industry as a whole. While Sony insiders prefer not to talk about it, there *is* such a person within the Design Center. Last year, just one of his designs generated nearly 25 percent of Sony Corporation's worldwide profits. As a result, his vision is now helping to guide Sony from the analog past to the digital future.

His name is Teiyu Goto. A forty-two-year-old dynamo, his business card reads "Chief Art Director, Interaction Design Department, Creative Center, Sony Corporation." Yet the description is misleading, for his projects span a broad range—from televisions, computers, video game machines and logo development to sunrise technologies that will dominate the next century. He has already shaped products that have touched millions and is designing a future that will touch us once again. Yet he would prefer that you not even know his name. A graduate of the Kanazawa School of Art and Design, Teiyu Goto joined Sony in 1977 and began work in the Design Center's General Audio group—a typical assignment for a first-year designer. For the next nine years, Mr. Goto worked on a number of projects. In 1982 he was trans-

ferred to the Design Center's Park Ridge studio, where he crafted the American version of the XBR television in 1986 (an important design that influenced a number of succeeding models). On his way back to Japan, Mr. Goto took with him a new personal computer that had just reached the U.S. market, but had not yet appeared in Japan, the Macintosh Plus. Fascinated by its graphical user interface and industrial design, Mr. Goto was the first Sony designer to own one. Today, nearly every Sony designer uses the Mac (even though Sony makes its own Intel-based computers designed by Mr. Goto). What did he see in the Macintosh? "It was very new and spoke to me in a way that no product ever had. Its form was quite

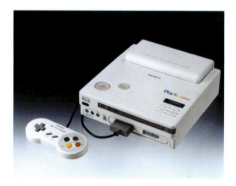

good, and the entire product was user friendly. But what really impressed me was that the hardware was designed to drive software sales. The Mac's designers had clearly done something special, and I wanted to do the same thing for Sony."

After six years in the television group, Mr. Goto began to work on projects for Sony's New Business Group in 1986. "Everyone knew that I was a big fan of video games. So when I heard discussion of Sony developing its own game machine, I wanted to be included."

But Mr. Goto was not alone. Down the corridor, in the General Audio group, another rising young star at the Design Center, Soichi Tanaka, was already involved. The project began in 1988, when Sony president Norio Ohga began negotiating with Nintendo to develop a new video game machine called PlayStation. Sony wanted the machine to use compact disc technology, which Sony controlled. But Nintendo preferred to use its proprietary game cartridge technology. Sony's

proposal, designed by Soichi Tanaka with a logo designed by Masaaki Omura, could accommodate either a game cartridge or a CD-ROM, which appeared to satisfy both Nintendo's and Sony's demands. But as Mr. Tanaka completed his design, Nintendo pulled out of the joint venture and went its own way, forcing Sony to scrap the project. Three years later, with Nintendo riding high and Sony wishing that they had gone forward with their own game machine, the New Products Group revived plans to develop the PlayStation. But rather than wait for Soichi Tanaka to step forward, Mr. Goto went to work.

"After watching the Nintendo product take off in the market, I knew that the video game business would soon become huge," says Mr. Goto. "Therefore, Sony had to be involved. But from a design perspective, the PlayStation represented a special opportunity, since the product would be the first of its kind. For that reason, I had the opportunity to create a totally new icon."

At the time, all that Sony engineers knew was that PlayStation would have a half-sized computer-type circuitboard and a CD-ROM drive. "The product would be used mainly by children," says the designer, "so the machine had to be simple, compact with sophisticated details that a child could appreciate but that would also appeal to adults. And it had to be extremely durable. If a child picked it up and threw it against a wall, the product would have to survive." To achieve the optimum size the product envelope was determined by the size of the circuitboard and the combined height of the power supply and the CD-ROM drive. Otherwise, Mr. Goto was free to create his own unique shape. When conceiving a new product, many designers look at the world and borrow images or ideas from their environment for use in their work. Instead, Mr. Goto looks within himself and extracts images that have never been seen before. "The PlayStation had to be an original," he says. "So I had to create something totally new."

In the game industry at that time, the only CD-based machine on the market was made by the

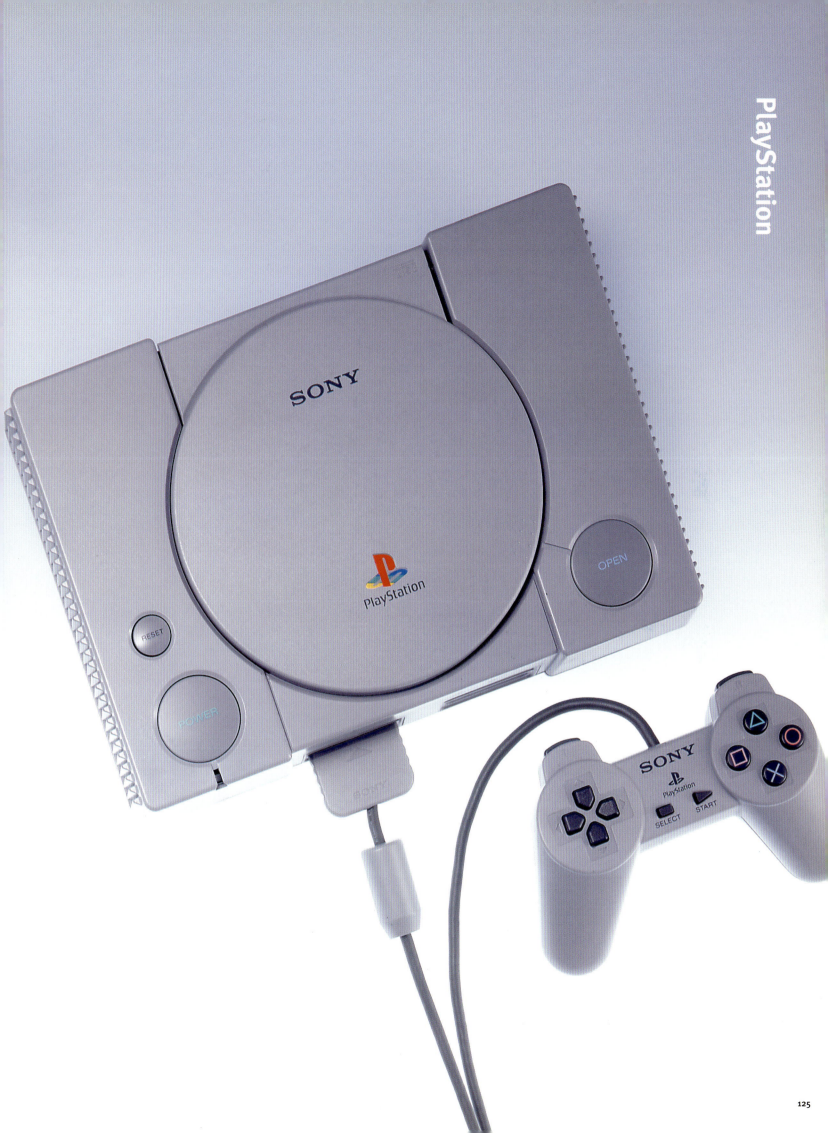

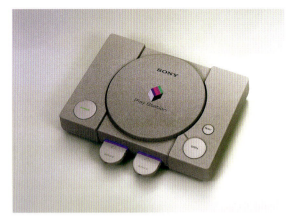

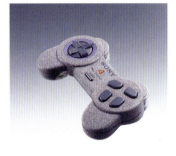
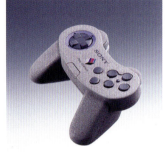
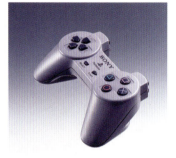
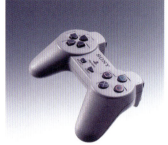

Above: Four of Teiyu Goto's concepts for the PlayStation controller. More than two dozen such concepts were generated in pursuit of the final design. Opposite page: Manabu Sakamoto's logo development for the PlayStation marque. The final logo is one of the most recognized symbols in the world.

startup firm 3DO. Everyone else was using game cartridges, like Nintendo. But Sony learned that another game maker, Sega, would soon release a CD-based system that would offer the same 32-bit performance as Sony's PlayStation. Therefore, Mr. Goto felt that the most important element to the success of the PlayStation would be its design. "Normally, if a product looks good and has the Sony name, people will buy the product. But if the design is truly exciting, you create the opportunity for *a lot of people* to buy the product. Therefore, the PlayStation design was of critical importance."

Because he was involved in every phase, from the first planning meeting to the finished products being released from the factory, Mr. Goto spent nearly a year designing the PlayStation and shepherding it to market. "The image of the product was key to its success. As a high-performance 3-D graphics machine, it was not a toy, and should not look like one," he says. "Users would be sitting in front of this product for hours. So its appearance had to be interesting from all angles. Also, Sony would be making this product by the millions, so it had to be easy to tool and manufacture."

The first run of PlayStation—300,000 units made during the fall of 1994 for Christmas delivery—was so huge that Mr. Goto had to give PlayStation the simplest possible enclosure, a drafted box with a five-sided top that fits on the bottom with only three screws.

As the design took shape, the color of the prod-

uct became an important issue. Everyone agreed that the product should not be black. But choosing the correct color wasn't easy. When the My First Sony line was released with its bright primary colors, Mr. Goto was determined not to take PlayStation in that direction. "Since kids would be using the product, it could not be too light in color, otherwise the surface would look dirty. So I chose a medium shade. Since the product would be used near the television, I wanted it to echo the Trinitron, which is housed in gray plastic with a slightly blue cast. For PlayStation, I did the same, but added violet to the plastic instead of blue." Since the product shell would be made of injection-molded ABS, which gradually turns yellow when exposed to sunlight, the violet-gray color used for PlayStation would counteract this tendency and retain its color for years to come.

Rather than conceive the product as a toy, Mr. Goto saw it as a fantasy machine. On top, the CD-ROM drive cover provides the main visual element with Power, Open and Reset buttons acting as radiating moons at the four-, six- and nine-o'clock positions. On the sides, oversized vents tell us that the product is designed for extended use.

"Temperatures inside the machine reach nearly 100 degrees, so the engineers wanted to put vents on the front as well," says the designer. "But I refused. The engineers wanted a simple perf pattern on the sides. But I preferred a slotted vent, which required us to use side-pull tooling"—a

more expensive process which results in plastic parts that pull away from the mold in two directions when they are made at the factory. "The side-pull vents are more graphically interesting and give the product a high-quality image."

"A circle set inside a rectangle with tightly spaced parallel lines at the side makes a visual statement that is so strong," says Mr. Goto, "you can glance at it, look away and draw the basic shape using a pencil and paper." Reducing a design to a few simple elements gives PlayStation the same iconic quality that Mr. Goto's favorite non-Sony product—the 1984 Apple Macintosh—possesses. Its design will be difficult to surpass.

Buttons and other points of user interaction are oversized so that fast-moving game players can press them from any angle. Details such as the tiny channel that runs between the Open button and the CD drive cover, and the channel that runs from the Power button over the front edge of the product (containing an LED) visually suggest the function of each control long after repeated pounding has worn away the painted graphics on top. Ports on the front of the product can be used for memory expansion or controller connections. To ensure that children will insert the connectors correctly, ribs on top of the connector are matched by similar ribs on the PlayStation case. "More time was spent with engineers on the connector issue than any other aspect of the design," says Mr. Goto. Smaller

corner radii near the surfaces that you hold or touch give the product a sense of precision. The same quality and attention to detail extends to the PlayStation controller.

With so many competing game machines on the market, and with Mr. Goto having no experience designing game products, one can only wonder about the inspiration it took to create the PlayStation controller, whose design has since become the standard throughout the video game industry. "In the beginning, I received negative comments on my controller design. Everyone else in the industry was designing flat controllers, because they are easier to manufacture," says the designer. "Since PlayStation was Sony's first game machine, many people thought that I should follow the competition and give users something that they would recognize. But I could never copy an existing design, especially if I considered it deficient." As an extension of the main unit, the PlayStation controller had to look and feel unique. Its shape and tactile quality had to encourage the user to pick it up and never let go. More difficult, the placement of controls had to be appropriate for both small children and adults. It had to look "new" but also be recognizable and intuitive. "As a 3-D graphics product, PlayStation needed a 'next-generation' controller with a complex three-dimensional form that would make it extremely usable," says Mr. Goto. "When I researched existing controllers, I noticed that the 3DO design had very large buttons for adults. Others had tiny controls for small children. So I steered a course toward the middle, because I wanted the product to work for everyone." The fat conically shaped grip on the controller allows large hands to grasp toward the top of the handle and child-sized hands to hold it

toward the bottom. During the conceptual shape, dozens of foam mockups were generated between February and December 1992. Yet, as often happens, the first controller most resembles the final design.

"Even though I returned to my first concept for the final design, exploring many other shapes makes the final design much stronger than if I had designed only the one concept and stopped at that point. Only by exploring all of the options do I begin to see the purity of my original expression. That first design gave me a direction. Designing and discard-

ing the other two dozen mockups gave me the details that make the final product so effective."

First impressions are often the best when designing something new. Since Sony had no experience in the game market, creating a suitable logo was difficult. Dozens of names were proposed and rejected before a Sony marketing executive suggested the word PlayStation. Even though the name had already been trademarked by rival Yamaha, Mr. Idei liked it so much that he agreed to

acquire it for an undisclosed sum rather than search for an alternative. Once the name was established, the task of developing the logo was given to DC graphic designer Manabu Sakamoto, who in a flurry of activity created more than fifty graphic variations on the letters P and S during a two-week period in October–November 1993.

"I tried every imaginable permutation," the designer recalls. "Eventually, I stood the letter P on end and treated the S like a shadow." Thrilled by the result, Mr. Sakamoto drew three variations, received Mr. Goto's blessing and won final approval from Mr. Idei. For consistency, the P would always appear in red, and the S would always appear in three colors.

Once PlayStation reached the market in December 1994, the first 300,000 units quickly sold out, and Sony has had trouble keeping up with demand ever since. With its first product, Sony has become the sales leader in the billion-dollar video game market. And, as Mr. Goto had predicted, the similarity between Sony, Sega and Nintendo technology suggests that one reason for PlayStation's success was its design. The image that it projects starts a fire in the mind that inspires not only the user but also software developers who have created a global PlayStation culture through the design of innovative 3-D games. According to *Business Week* magazine, the combined sales of PlayStation hardware, software and software licensing accounted for nearly one-quarter of Sony's 1997 profits.

With the success of PlayStation, Teiyu Goto evolved from a work-a-day designer to something of a a demi-god, granting more interviews in 1994–95 than all previous Sony designers had in

the firm's fifty-year history. Yet by this time, Mr. Goto was already working on a project that would make PlayStation seem small by comparison.

For years, Sony management had tried (and failed) to break into the personal computer market. During the 1980s, as American PC makers set the rules in an industry that would soon rival the personal electronics business in size and importance, Sony's Japanese orientation was a disadvantage. Computer operating systems designed to use Latin characters had difficulty translating kanji. As a result many businesses in Japan were slow to computerize. In Europe and America, corporate demand fueled developments in hardware and software that drove prices down and resulted in forty percent of all American homes having a PC. Corporate demand in Japan was small, causing Sony to fall behind in the PC market, just as they had fallen behind in video games.

Yet the PlayStation experience told them that, with a concerted effort, it was not only possible to catch up, but to leapfrog ahead. By the time Sony entered the market, PC clonemakers had already turned the product into a commodity that is difficult to manufacture and sell at a profit. Even so, Mr. Goto believed that Sony had to enter the PC market quickly, even if it meant losing money in the short term. With the Internet changing the landscape of entertainment and communications and many of Sony's own consumer electronics looking more like computers themselves, it was vital that Sony release a line of desktop and portable computers that would put the company on the map and allow them to spearhead the move toward digital convergence.

Before the release of the PlayStation, Sony's New Business Group asked Teiyu Goto to design a new personal computer around a standard motherboard, power supply and chassis that would be supplied by Intel. "To make a difference, the computer would need a unique name and concept and a Sony-like design and an interface on the screen that would make it different from the typical Windows computer," says Mr. Goto. "Because it's a Sony, the computer would have to offer the best video and audio. And because it would function with Sony video cameras, digital still cameras and other products, the computer's inputs and outputs would be state of the art." Combining those two concepts, Mr. Goto made several suggestions to the New Business Group, including the word VAIO, short for "video audio input output." Like

the Macintosh, the VAIO name was short and distinctive and could easily become a brand name. "But the name alone wasn't enough," says the designer. "It also needed a story or legend that would give the name importance. Like the Walkman, I wanted VAIO to become a name that would last for a hundred years." According to insiders, Mr. Goto imagined VAIO not as a new product, but as something ancient that he only recently discovered. "Goto-san wrote a scenario," says one colleague, "in which he was roaming the desert in some distant land, far from civilization. After wandering for days, Goto-san encountered a disturbance in the ground, began to dig, uncovered an artifact that bore a faint inscription and traced the letters with his finger in the sand— V...A...I...O...."

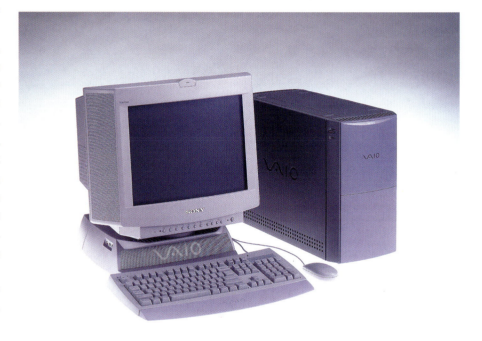

Translating his imaginary sand inscription into a logo, Mr. Goto drew the V and A as a continuous wavy line followed by a separate I and O. When a Sony marketing manager saw the logo, he pointed out that the V and A looked like an analog sine wave, while the I and O resembled the numbers one and zero on which computer binary language is based. "Overnight, VAIO evolved from a made-up word into a brand name for Sony's global strategy describing the shift from analog to digital technology," says Mr. Goto. As Sony's product line evolves from many stand-alone analog devices to a family of digital appliances that function together in a seamless manner, the VAIO computer would serve as the linchpin, a key connection point. Thus the meaning behind the VAIO name has grown even

larger over time and altered its meaning from "video audio input output" to "video audio integrated operation."

The VAIO logo resulted from a collaboration between Mr. Goto (who drew the basic shapes) and Manabu Sakamoto (who elongated the V and A and refined the top of the I so that it pointed toward the O). "That final gesture was necessary because the first two letters were physically linked and the final two letters are widely spaced," says Mr. Sakamoto. "We needed to pull them together visually." Once the VAIO logo had been set, everyone on the team (engineers, designers, software writers and marketers) wore it on their shirt or jacket as an emblem to remind them of who they were and what they were doing. "VAIO was not the same as traditional Sony. It was a little different. But that dif-

ference was critical to the success of the project"— and, as it turned out, critical to the next chapter in Sony's evolution. Before that could happen, though, Mr. Goto's computer needed a physical expression. "The key to VAIO is that as computers evolve, they will become humanized," he says. "We will always be people. And machines will always be machines. But as we work more closely with machines in the future, the connection between the human (analog) and the computer (digital) will be all-important. That is VAIO World. It's an organic thing with humans and nature on one side and the digital realm on the other. The point where analog and digital meet is the product and its interface."

The genesis of the VAIO desktop computer evolved from the PlayStation. "We wanted the mini-

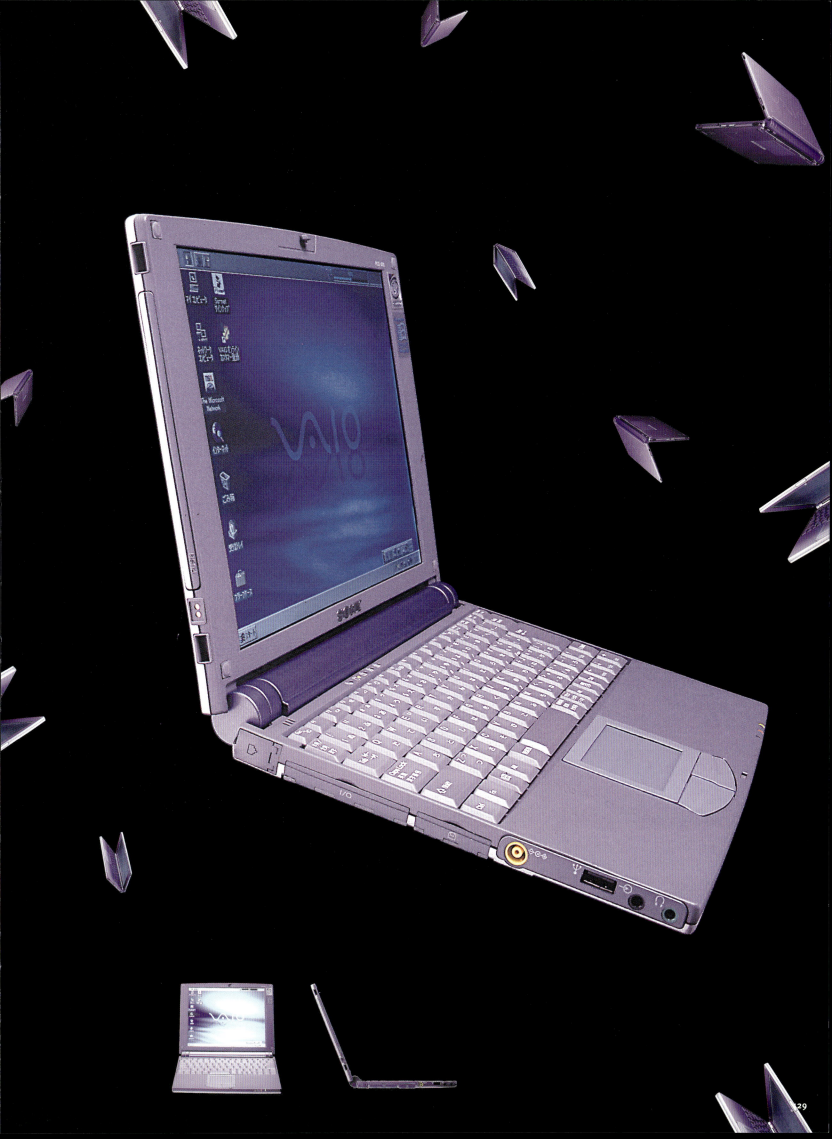

VAIO, short for "video audio integrated operation," is the name given to Sony's personal computer family. The logo is composed of two elements: the letters V and A drawn like an analog sine wave; followed by the letters I and O, which represent the digital notation one and zero. Thus the logo symbolizes the merging of analog and digital technology. The logo comes to life during the VAIO computer's video startup sequence: first, as a beam of light that draws an elegant curve across the sky, then as an impression on the surface of a purple planet, which dissolves into VAIO Space. Storyboard Design: Manabu Sakamoto (DC/Park Ridge), 1996.

tower to be a home-use computer, not an office machine. We expected people to use it near their Sony television or PlayStation. And we envisioned a scenario in which VAIO would become the center of the audio/video experience. On a visual level, I wanted VAIO to harmonize with the rest of Sony's audio/video family." Thus form and color were of critical importance. "Black is too heavy for a home product, so we chose a medium gray. But we also needed an accent color." Mr. Goto had wanted to make PlayStation a two-toned product, but its low price made that impossible. "When I couldn't apply an accent color to PlayStation, I was determined to give VAIO a second color. The gray-violet accent color softens the product in an important way," giving it a quality that is elegant/fun and not elegant/heavy. Why violet? "Because I like it," he says. But what began as a casual choice of color has filtered throughout the Sony design world, turning up in places that Mr. Goto never intended. As the VAIO concept evolves from a brand of personal computers to a global strategy for digital convergence, the color known as "Goto purple" signifies VAIO connectivity the same way that bright yellow identifies the Sports Walkman.

Once the industrial design for the VAIO computer was approved, Mr. Goto wanted to influence the design of the user interface as well. Because VAIO is an Intel-based computer using the Microsoft Windows operating system, a Sony-designed interface would be limited to the startup process and opening screen. "I was impressed by how the original Macintosh starts up with the little smiling face," he recalls. "I wanted VAIO to have the same feeling, but go much further, using color video instead of a simple bit-mapped picture." Relating this idea to graphic designer Manabu Sakamoto, a description of the startup process was written, which reads: "(1) We begin with a dark space. A beam of light comes up; (2) It begins to draw an elegant curve, which forms a pattern like the aurora borealis. The camera moves up and zooms out slowly; (3) We see the surface of a planet. We see the beam of light emerging from the VAIO logo carved into the violet ground. The camera continues to move up, allowing us to look down over the entire scene; (4) The camera moves up and looks straight down at the aurora's light as the drawing is finished; (5) We see the VAIO logo from the top; (6) The screen stops; (7) The light disappears. We see

the logo carved on the ground; (8) The screen view shrinks as VAIO Space comes into view."

To understand how VAIO Space works, imagine that you're in a room looking at three walls and a ceiling that is open to the sky. Moving the mouse and clicking on a wall or the sky moves that part of the screen into view. The main view shows the Video Wall in the center, the AV Wall on the left, the Application Wall on the right and icons above and below. The Video Wall acts as a movie screen that displays video clips that come with the PC, clips that you can download from the Net or clips recorded on your Sony video camera. Above the Video Wall: the icon on the left accesses the Sony World Wide Web site; the icon above the Wall to the right accesses Sony Online support. Below the Wall (from left to right) the icons activate: My Space (a personal working environment with files and fold-

ers); Welcome (to tour the system); Settings (for system preferences); Help; Windows (for accessing the Windows operating system); and Exit (to shut down the computer). As you move the cursor on a Wall or the Sky, it changes to a green arrow. To display a Wall or the Sky, a simple click allows that part of the screen to move into view.

The AV Wall to the left contains VAIO's audio and video software. Here you can listen to your favorite music CDs, voice recordings and synthesized music files, view video files, and, with the integrated telephone application, use VAIO as a speakerphone, fax or answering machine. To the right of the Video Wall is the Application Wall, which organizes and launches the computer's software, arrayed in four groups: Work Center (containing financial management, word processing and productivity applications); Reference Library (encyclopedias, dictionaries and multimedia reference

tools); Game Arcade; and Kid's Land.

Even before Mr. Goto designed his first desktop machine, he envisioned the VAIO experience on a laptop computer. For years, Mr. Goto had used an Apple PowerBook Duo, a subnotebook computer that is smaller than a standard laptop. Its length and width were perfect for a portable machine. Yet it had one flaw; it was too thick and too heavy to carry easily in the hand. Thus it was not truly personal. "The Duo had not achieved the optimum size," says Mr. Goto. Achieving that quality for his next product, the VAIO PCG-505, would force Mr. Goto to rearrange the computer's internal components, altering the product's image and personality in a way that transformed the laptop computer from a machine to a personal accessory.

Following previous laptops, the 505 has a clamshell design with the display positioned above the keyboard, an integrated wrist rest and other details that owe a debt to the first Apple Powerbook designed in 1989–90. Yet Mr. Goto changed these details in such fundamental ways that he revived what had become a dull product and made it playful again. "During the planning stage, I had a clear idea of what I wanted," he says. "I wanted the 505 to be small, but not too small, and as thin as possible, without becoming so thin that the product would seem fragile." In earlier laptop designs, the flat panel display and battery were stacked one atop the other when the unit is closed, resulting in a rather bulky enclosure.

"The challenge," says Mr. Goto, "was to move the battery so that the closed product could be much thinner. The logical answer was to locate the battery at the back, along the hinge that connects the display. With the battery behind the hinge, we could also use that area as a handle." As a replaceable accessory, like a scuba tank on the back of a deep sea diver, the battery pack is designed to snap on and off easily. A two-cylinder battery pack doubles the work time to nearly five hours and serves as an integrated stand, tilting the keyboard to the proper angle for typing. Typically, the back of a computer is reserved for input/output ports. But the 505's backside battery forced Mr. Goto to arrange his ports on the side of the base. "Placing the ports on the side makes them easier to access."

Like the PlayStation, the 505 came forth as a complete expression, with every detail that we see

VAIO Space, the application launcher for VAIO computers introduced to the North American market in the summer of 1996, emphasizes spatial relationships that allow easy implementation of various functions, such as MPEG playback and 3-D graphics. Design: Hiroaki Nakano (DC/San Francisco) and Kim Mingo (DC/New York), 1995–96.

SONY Galileo

in the final product appearing in Mr. Goto's first (and only) hard model. "The evolution of a design takes place in my mind and on my drawing board," he says. "Once we reach the mockup stage, the design is complete." The same degree of finish can be seen in the one-millimeter descending corner radius around the top cover, which softens the product, and a half-millimeter corner radius around the keyboard and wrist rest, where the hand needs greater precision. This consistency of detail extends to the 505's external floppy disk, CD-ROM drive and I/O ports array, which plugs into a single port in the 505's base and gives the user the same I/O ports as a desktop computer. Every accessory uses the same design language and has the same depth and precision as the computer itself.

"Since I first imagined drawing the VAIO logo in the sand, I wanted it to be debossed on the 505's magnesium top cover," says Mr. Goto. But having the letters "sink into" the surface would consume precious space. "Thinness was the life of this product. And users consider every millimeter of thickness to be important. So adding to that thickness by debossing the logo was not possible." Marketing also did not want the debossed VAIO logo to conflict with the raised Sony logo. Therefore, the VAIO logo was painted and not debossed.

Many times when looking at Sony products, we see the designer create an expression that approaches absolute perfection, then pull back when that perfection conflicts with a practical consideration. One aspect of the 505 design falls into this category, and is immediately apparent: Both the brand name and Sony logo on the top cover appear to be upside-down. Look at any laptop computer. Put it in front of you with the cover closed, and you can always read the product logo on top. Yet put the 505 in front of you, and the logo is upside down. The reason? "As a product meant to be used, I designed the logo so that *other people* could see it when the product is in use. Therefore the logo reads correctly with the top cover is *up*." This defiance of common practice underscores Teiyu Goto's desire to build the VAIO brand, make it a singular experience and extend that feeling to every facet of VAIO World, including peripheral devices such as the MDS-PC1 MiniDisc Deck and its supporting software called Digital Media Park. Designed by Eiji Shintani (DC/Tokyo), the MDS-

PC1 allows a VAIO computer to record, archive and create custom playlists on MiniDisc. The beauty of the hardware, with its deeply scooped area where the disc is inserted and retrieved and its industrial details, maintains a visual link with the VAIO World when the unit is turned on and the translucent controls emit a soft purple glow.

To maximize the potential of the MD-PC1, Makoto Imamura and Makoto Niijima of DC/Tokyo created Digital Media Park, a bundled VAIO application that features audio and video playback as well as an AV archive. This unique Windows-compatible software reveals the full potential of PC-based audio and video by enabling users to enjoy different types and combinations of media in many different formats. Like the VAIO itself and the VAIO Space software that it contains, Digital Media Park adds value to distinguish Sony's offerings from the PCs sold by other companies. Key to that differentiation is to give Sony software a look and feel that is unique and original but not too different from the Windows metaphor that millions of users now use.

"The fusion of audio/visual and information technology will transform the way we use personal computers," says Design Center general manager John Inaba. "If you imagine using Digital Media Park not on a PC, but on a PC-like television or entertainment product, we believe that the steps we take with this kind of software will pay rich dividends for users of digital TV and PC/TV fusion products in the years to come." Awarded the Grand Prize for Outstanding Design in 1997 by Design Center management and staff, Digital Media Park was praised for its exceptional ease of use and the tone of the graphics, which is very much in keeping with the VAIO image. This means it is futuristic yet friendly. It makes a strong quality statement with close attention to details, such as the size and weight of the on-screen typography and the virtual buttons on the floating control panel. Digital Media Park allows the VAIO computer to operate a wide variety of compact disc, MiniDisc, Digital Video Disk players and CD changers as well as compatible Digital Video recorders without forcing the user to ever

Above: The MDS-PC1 uses the VAIO computer to archive and customize a MiniDisc collection. Design: Eiji Shintani (DC/Tokyo). 1997. Below: Digital Media Park, a bundled application for VAIO desktop computers, archives audio or video collections and compiles custom playlists when used with a CD or MiniDisc changer. Design: Makoto Imamura and Makoto Niijima (DC/Tokyo), 1997.

touch the hardware (except to load the disks or tape). Digital data contained on the DVD or digital video tape can be read by the Media Park software, archived with graphical icons, arranged into custom playlists and played back through the computer.

Because Digital Media Park uses a Windows-style interface, anyone who has used a PC will master it with ease. Yet Windows-style interaction does not have the fluid, analog quality that many users prefer. To overcome this limitation, Sony designers have developed new styles of interaction that force the computer to accommodate the user rather than the other way around. The most recent example of this trend is the new sub-notebook computer, code-named Tama.

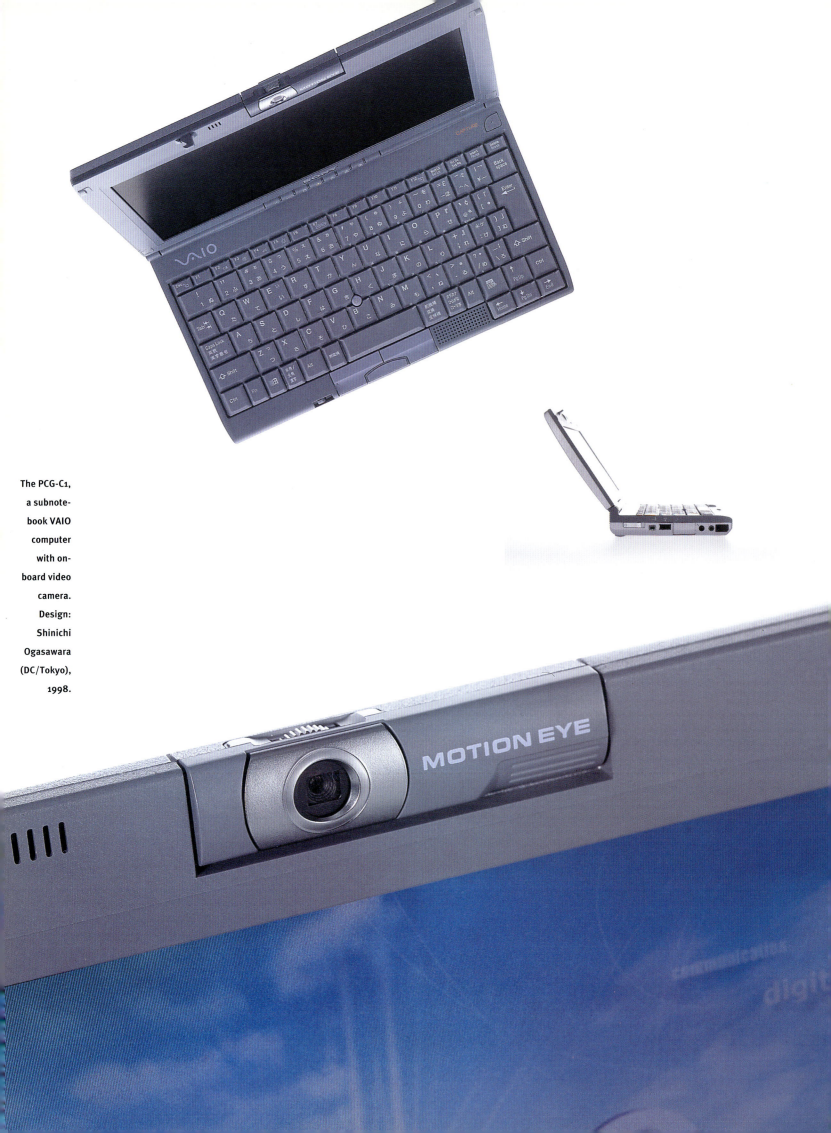

The PCG-C1, a subnotebook VAIO computer with on-board video camera. Design: Shinichi Ogasawara (DC/Tokyo), 1998.

MOTION EYE

Building on the ideas that Mr. Goto hatched with the VAIO desktop and 505 computer, Shinichi Ogasawara and the Sony human interface design team in Tokyo and New York have taken Purple Power to a whole new level by integrating video and audio with computing in a breathtakingly small "mini-subnotebook" called the PCG-C1. As you gaze at the design, code-named Tama, it looks conventional until you notice the tiny rotating video camera lens on top of the display staring back at you. This lens not only records your presence, it also recognizes your gestures, notes your facial expressions and reads digital codes that we will learn about in a moment.

The combination of personal computing with video is nothing new. But integrating these two capabilities in a four-pound, six-by-nine-inch enclosure is amazing to say the least. And bundling this camera/computer with the right software opens up a world of possibilities that give even the most experienced user reason to pause. For example, rather than dream about video-conferencing from your laptop or resort to a cumbersome desktop solution, simply connect Tama to a telephone line, and another Tama-equipped user will see you on the other end. Attaching video clips with your next e-mail is no problem. And when you're finished working, simply turn on one of Tama's "edutainment" programs, and you will see your minutes of downtime turn into hours.

To demonstrate Tama's convergence potential, DC/Tokyo's Junichi Nagahara, Tota Hasegawa and Makoto Niijima, and DC/New York's Eduardo Sciammarella collaborated on a series of audio/video programs called SonicFlow, CyberCode Finder and Smart Capture, which introduce us to the world of video/computer interaction.

Smart Capture is the most straightforward application. Turn it on, and you instantly see yourself as the Tama video camera sees you. After you comb your hair and attach Tama's internal model to a standard telephone line, you can send e-mail with video clips or teleference with another Tama user with a simple point and click motion.

SonicFlow, based on Eduardo Sciammarella's interactive music concept called AIDJ (see pages 166–69), allows the user to interact with Tama's video camera and on-board audio circuitry by playing and manipulating prerecorded music and other sounds using simple hand motions. The rea-

son for doing this is clear. SonicFlow grabs you and does not let go, drawing you into a style of interaction that will change the way you think about and use a personal computer.

The SonicFlow interface is divided into a blue control panel on the left side of the screen (designed by Nagahara) and a larger free-form space on the right (designed by Sciammarella).

"Nagahara wanted to link video with music in an interactive way," says Mr. Sciammarella, "so he wrote a motion-sensing algorithm that picks up the movement of your head or hand and transfers that motion to various icons on the screen, which control sounds and images generated by the computer."

The icons on the right-hand side of the screen represent sound sources that can be moved up, down or side to side on the screen using simple hand gestures that are recorded by the PCG-C1's video camera. Icons grow increasingly larger (and the sounds louder) as they approach the bottom of the screen (or the top, if the user wishes). Multiple icons provide multiple sound sources, which can be manipulated individually via hand motion or as a group by "shooting" white bubbles at the icons. Every bubble that hits an icon affects the sound. Meanwhile, Tama's video camera mingles the user's hand and head motion with a pre-recorded video playing on a small area in the upper left-hand corner of the screen. "The result is not exactly a tool, like PhotoShop," says Sciammarella, "and not a game, like Play-Station. It's something in between. It lets you work and play at the same time."

As the computer-generated sounds follow your gesture, you begin to see how the combination of computing, graphical displays, sound and motion-sensing video will eventually result in computers that allow precise control (such as placing a cursor in a complex document) using simple hand motion. This explains why Tama does not have a trackpad below the keyboard, like its big brother the VAIO 505. Once you learn to control the screen with hand motion, you won't need the trackpad. And once you learn to control the cursor using SonicFlow, you can enter video commands using CyberCode Finder, which executes instructions in response to digital icons printed on a piece of paper that you hold in front of the display. Simply hold the printed digital icon in front of Tama's lens, and the computer does the rest. Soon, the computer will learn to recognize a digital badge that you wear on your shirt. The final step will be a Tama computer that recognizes your face and responds to your gesture as well as your voice, turning the computer into a truly personal assistant, fulfilling Teiyu Goto's prediction when he designed the VAIO concept—that "the machine will become more human in the way it reacts."

Top to bottom: SonicFlow, a bundled application designed by Junichi Nagahara and Tota Hasegawa (DC/Tokyo) and Eduardo Sciammarella (DC/New York), allows Tama users to control sounds and images on their computer using simple hand gestures. Minimalist is one of Sonic-Flow's many built-in songs. The Ambient Demo introduces us to SonicFlow's unique interface. Smart Capture is a simple teleconferencing utility. CyberCode Finder allows the computer to execute commands using digital icons read by the computer. Design: Makoto Niijima (DC/Tokyo).

Staying Ahead of an Ever-Changing World

than today's. "Expanding the individual's horizons is a significant part of what we do," says DC/Tokyo senior general manager John Inaba. "The key is to never be satisfied with what we have and to always push beyond what we currently know." But doing this often requires some fancy footwork, since the Design Center cannot think of the end-user as their only customer. Because of the way Sony Electronics is structured, the Design Center's "client" is one of SEL's operating companies —such as the General Audio division, Personal Audio/Video, the Display Company (which makes televisions), the Information Technology Group (which manufactures computers), the Personal & Mobile Communications Company (telephones, car stereos and navigational devices) or the Broadcast & Professional Group. Developing a new product sometimes begins within the Design Center or can also start as a request from one of the operating companies. Several times a year, Sony designers offer new concepts and product ideas at "line up" meetings held at the Tokyo Design Center. If accepted by DC management, the ideas are then presented as simple foam models or sketches to the product planning group within the appropriate operating company, who analyze the designs, determine whether they fit into an existing product category or define a new one. The product planners establish a potential price point by comparing the concept to similar products in the marketplace, assess how well similar products are selling and report this information back to the designer, who incorporates the data into a new round of concepts that are more detailed than the first. If confidence remains strong, business models are generated, followed by a third round of realistic, production-ready concepts and one or more working prototypes to prove that the concept is feasible and can be manufactured in volume. Eventually, the designs are presented to top management, the final arbiter being Mr. Idei himself.

"What makes Sony unique among high-tech firms is that the designer often starts the process," says DC/Park Ridge veteran Rich Gioscia. "We don't wait for marketing or product planning to give us an assignment. We're proactive." Because Sony designers view themselves as the ultimate consumer, "we often notice emerging trends and shifts in technology that will shape our next round of products. Putting this information together, we can often make educated guesses that result in products that remain ahead of the curve and, thus, pull the market in our direction."

Until recently, no market research, focus groups or user studies were ever conducted at the Design Center to find out what customers were thinking or what they wanted. Indeed,

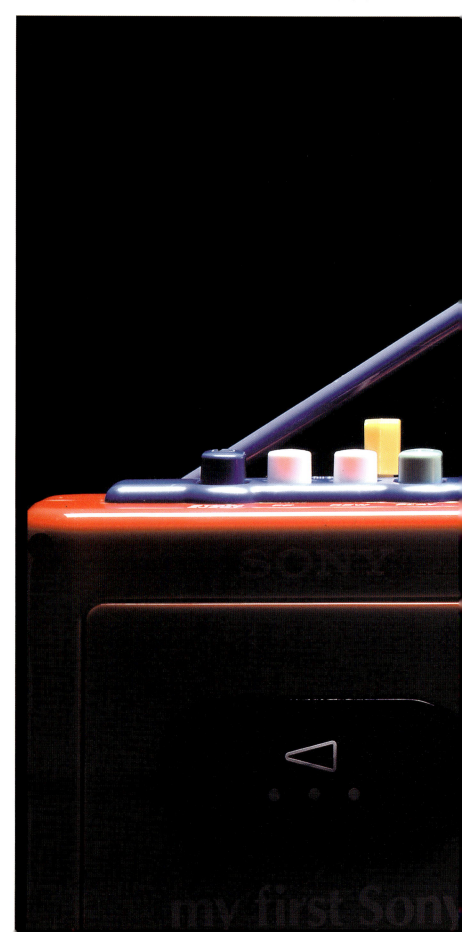

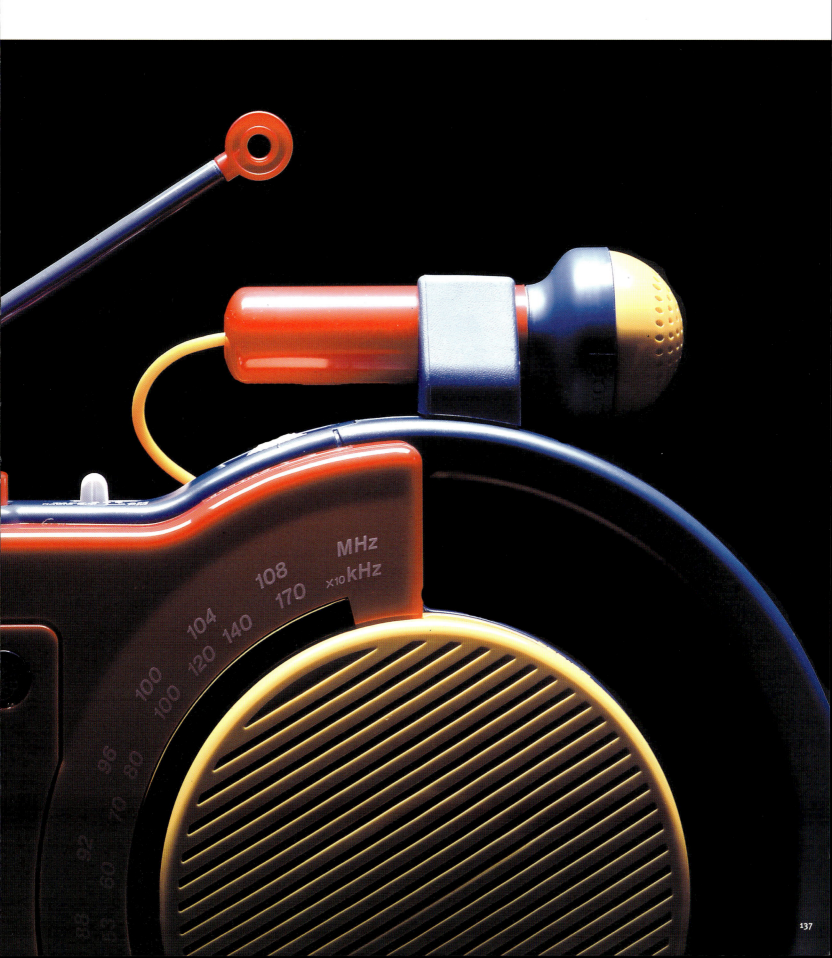

the product development and decision-making structure within the company, particularly in Tokyo, discouraged it. One of Sony's bedrock principles—"to always lead and never follow"—suggested that market research was not only worthless, it was a *bad* idea. For research, by its very nature, is backward-looking. "Even if we had the ability to know what was happening at the moment and could design products using that information," says Rich Gioscia, "the resulting product would probably seem old by the time it was released." The pace of change is so fast today, the only way to stay even with that change is to constantly leap ahead and hope that the world follows your direction.

"You would think that a company like Sony would always be in touch with its customer base," says Eduardo Sciammarella, who now works in the Human Interface Group at DC/Tokyo. "But, over the years, our biggest product successes were not due to any systematic effort. It happened because a particular designer or engineer or product planner had a vision for a product such as the Walkman, the HandyCam, or PlayStation, rallied others within the company to support it and pushed the product through the system. This success has taught Sony management to support individual initiative within the company. But the process was risky, because until recently, there was no formal mechanism for testing new product ideas. Occasionally, a designer will work on instinct and develop a product like the Walkman, which defines a generation. But you also get failure. And by relying on instinct rather than market research or trend analysis, it's hard to know which product ideas have the best chance for success."

To increase the success rate and propel Sony into new lines of business, Masayoshi Tsuchiya has spearheaded a process for identifying societal change and designing products for new types of users by recalling the experience gained from earlier ventures—one of the most successful being the line of children's products called My First Sony.

In retrospect, it was an obvious idea: redesign the Sony Walkman, boombox, Watchman, walkie-talkie and radio into products that would appeal to young children (as well as their parents). The brainchild of designers Ichiro Hino and Akihiko Amanuma, working at DC/Park Ridge in the 1980s, the original My First Sony line was just what one would expect a group of middle-aged Japanese men to produce. The shapes were inventive, with oversized handles and contrasting colors that had never been seen in a Sony product before. But they missed the mark, says Rich Gioscia, "because not enough children were consulted during the development. The designs reflected what an adult thought that a child would want." For the second series of My First Sony, Gioscia and Sony designer Peter Wyatt led a team that began not with concepts or color studies, but by imagining how the products would be used by four- to eight-year-olds in the home. They sketched various scenarios showing a revised My First Sony line in real-world situations, expanded the line by adding an electronic sketchpad that connects to a color TV, and gave the new designs a more vibrant look and feel with bolder, more saturated colors and geometric elements that made the products jump off the shelf, but did not require a complete retooling.

The research that informed My First Sony did not include statistical analysis, focus groups, high-

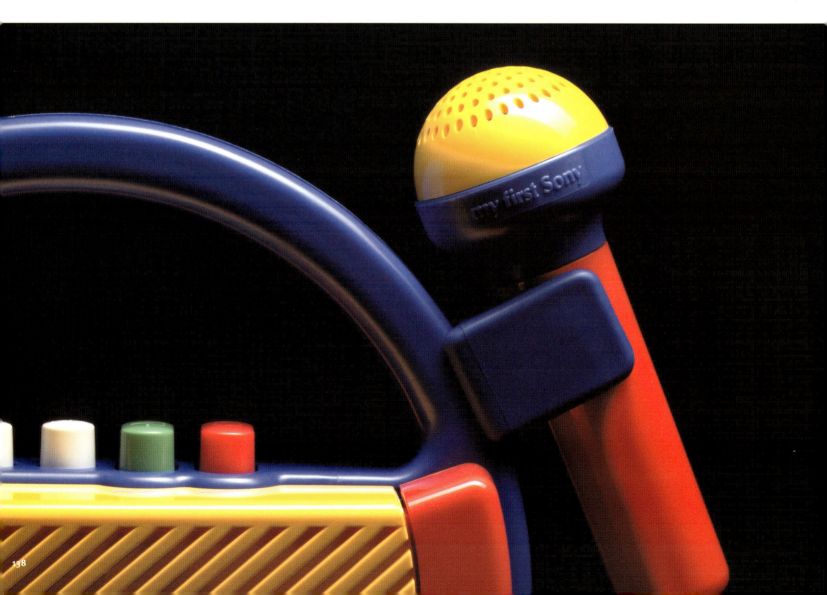

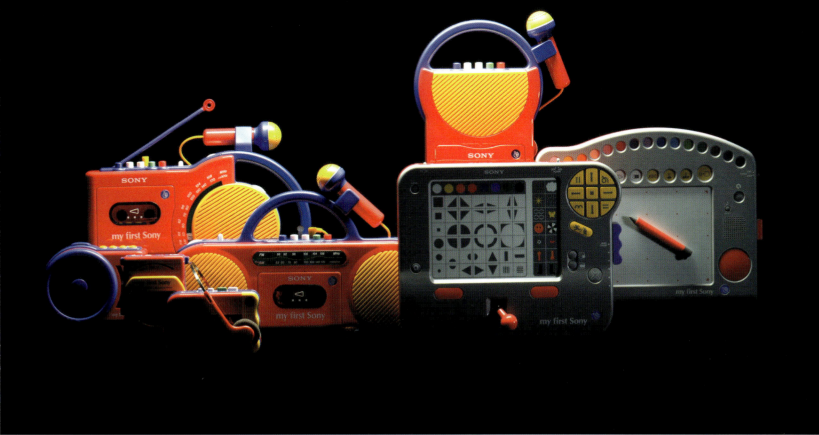

priced consultants making observations through one-way mirrors or diagrams showing MFS's position within Sony's corporate-wide branding strategy. "We wanted to open up the process, but still keep the design within Sony's tradition," says Rich Gioscia. "Unlike most Sony products, which are designed by a lone individual for an imaginary user, My First Sony was a team effort that targeted real children. The earlier MFS designs had a spirit that was close to the target. But being close is not good enough anymore. With every manufacturer offering the same technology, the most valuable aspect of the product—design and personality—must be exactly right."

A good example is the MFS Sketchpad, which makes a serious effort to be functional with a design whose shape and detailing seem almost effortless. Because the Sketchpad would be used near a television, presumably a Sony product, which are uniformly gray in color, the Sketchpad is also gray—the only product in the MFS line to take this conservative approach. With a flat bottom and sides and a curved gesture like an artist's pallette on top, the Sketchpad has a touch-sensitive surface and oversized pen, and more than twenty function keys to access individual colors, line weights and

textures. "As an interactive device, not just an entertainment product, it was essential that SketchPad be clear so that a kid could hook it up and use it without adult assistance," says Mr. Gioscia.

The success of My First Sony was profound, says Mr. Gioscia, "because it allowed us to understand our customers in a more detailed way. My First Sony showed us that by being more customer-focused and understanding new lifestyles, we could remain consistent with our philosophy to always lead and never follow while designing products that stay ahead of an ever-changing society."

For years, product developers at high-tech firms have been ambivalent about market research, focus group testing and trend forecasts. With society and technology changing faster then ever, many believe that trend research is merely a way of recording data that will soon become history. By the time a firm like Sony can identify a societal shift and react to it by developing a new product, the phenomenon will have already passed, leaving their product behind the curve. Focus groups are equally problematic, because there is no commonly accepted means of testing buyer preferences. Put a test subject in a room with a two-way

mirror, and the subject will often respond in a false way, hoping to "please" the test giver by saying that they like (and would probably buy) a product—even if they don't like it at all. Often, focus groups can only tell you about products they use today, reflecting decisions they made in the past. Offering them products that put those decisions in doubt is difficult enough. Asking people to tell you what decisions they will make in the future is even more difficult. For this reason, designers must rely on a certain amount of intuition when crafting a new product. But they are not totally unarmed.

At Sony, an elaborate method for identifying user groups and writing life-and use-scenarios has been developed for designing products and developing new brands. By dividing their audience into five distinct groups, the Design Center can focus products on individuals and niches rather than take a "one style fits all" approach, which often results in one style that fits no one very well.

The most familiar user groups are:

• The Arbiters of Style. Sometimes referred to as "Urban Connoisseurs" or "Label Junkies," this group responds to original expression, respects products that have design integrity and possess a higher level of "taste" than the other groups.

Having traveled the world and been exposed to many cultures and lifestyles, they are materialistic, collectors of both ideas and things, have "insider knowledge," and are very selective, often purchasing products before the mass audience weighs in. They avoid wearing obvious clothing, preferring unique styles, primitive art, things that are handmade, as well as technology that complements their design sensibilities. The materials they prefer are natural, translucent with molded and organic shapes, sophisticated black or near-black, ambiguous shades of brown or fresh white. Soichi Tanaka's Yosemite telephone concept (page 145) was targeted to this group. Though small in number compared to the other groups, Arbiters of Style

interface and love features such as jog shuttle, which make mundane tasks easier and fun. Their material preference includes smoked glass, metal, soft leather and pampered, golden tones. Now in their 30s to 50s, they have also embraced Digital Convergence and will represent a significant market well into the next century.

• The Homelander. The polar opposite to the Virtual Professional, the Homelander is domestic, family-loving, practical and a "follower" who takes pride in work and has a respect for nature. For these people, technology must be family-friendly and "humanized." They prefer the look and function of old technology, which feeds their love of nostalgia. They enjoy plants and gardening, soft

before, this segment wants technology that is easy to learn and use. More interested in communications (cell phones) and mobile products (radio with speaker, not Walkman with headphones), the Off Their Rockers group has money to spend for products that widen their world. They prefer soft simple shapes and details, extra-large controls, product graphics and readouts, old-style buttons (rather than jog-shuttle) with analog functionality and practical materials (plastic) and colors that are not nostalgic (such as white). The key word is simplicity: if a Rocker cannot understand something at a glance, they soon lose interest. Many of today's Sony radios and small audio systems are designed for this segment and a concerted effort is now under way to target them in the future.

In addition to these groups, a new segment has emerged that cannot be ignored. They are:

• Reactors. They are born in the streets, or wish they were. They used to watch MTV but don't anymore. They are subversive, rebellious, suspicious of power and authority, have no taste in the conventional sense and favor honest contradiction (inside/outside, beautiful/ugly, fake/real, treasure/junk) to bland consistency. The Reactor does not intellectualize technology; to be meaningful and real, it must attack our senses.

Image boards help designers to visualize the livestyles, market segments and user scenarios that designers use to target their products.

purchase as many high-tech and personal electronics as the larger Virtual Professional and Homelander segments combined. Mostly in their late 20s to early 40s, they are now embracing Digital Convergence technology.

• The Virtual Professional. A pampered, high-maintenance, hard-charging individual, the Virtual Professional may be a businessperson, executive, entrepreneur or ambitious salary employee driven by career goals, which means they are often disconnected from "real life," family and friends. Instead, their connection is to technology, which they use to insulate themselves. The Virtual Professional lives in the gray area between simplification and acquisition. They are "early adopters" who buy the first new gadget, have no trouble learning a new graphical

well-worn furniture and educational toys for children and reject "the latest" of anything (except this month's issue of *Martha Stewart Living*). Their choice of materials includes unbleached canvas, simple plastic and terra cotta with occasional bright primary colors for their children. Their age group extends from late 20s to late 50s. As "followers," their preferences are subject to influence and change. Though the designer didn't know it at the time, My First Sony was ideal for the Homelander and his or her child. Yet Digital Convergence will mean little to the Homelander until it appears on their television.

• Active senior citizens who are "Off Their Rockers." The wealthiest of all groups, senior citizens represent a gold mine for product developers. More secure and physically active than ever

Quickly bored by the present, the Reactor wants technology to be changeable, adaptable, mutable, futuristic, weaponlike. They are the Street Elite, always in the know, independent, self-reliant and tend to work freelance so that they can rollerblade or snowboard, listen to music or play video games at night and on the weekend. They don't work overtime. Ranging in age from mid-teens to mid-20s, the Reactor enjoys compact podlike design that is retro-futuristic—think of the iMac—with texturized/synthetic surfaces and color preferences that include gray/white as well as bright blue, neon yellow, and red. Sony's Street Style headphones, Street Style Discman, Widdit products and the Playstation are designed for Reactors, as are the Freq and Psyc product lines (see pages 154–59). As new societal groups

emerge, Sony designers must decide whether a group is large enough to target a product that takes eight to twelve months to develop.

No electronic product is more sensitive to societal change than the telephone. Everyone uses the product. But we do not all use a telephone in the same way. People who don't understand high technology, do not use a Walkman and avoid personal computers and the Internet still use the telephone every day. And the way they use that phone is very important to the people who design them. But the way many companies design their phones, you would never know it.

At Sony, understanding the specifics of telephone usage tells designers a lot about a person's lifestyle, habits and tastes. This is important information to know, because the telephone will soon join the PC and the TV as a gateway to the Internet and become a key element in Digital Convergence. For many people, the telephone may become the most important tool of all, because the telephone is ubiquitous. It's portable. Its functionality and range of uses is constantly growing. And unlike the Digital TV or the PC, it has a simple user interface that everyone understands.

Perfecting the design of the portable telephone has been one of the Design Center's most important challenges and has resulted in not merely a "better" telephone, but one that is fundamentally superior to all phones that came before. The design process began with a close examination of the way people use cellular telephones, how they carry them, look up and dial numbers and hold the product while talking. As cell phone circuitry shrinks, allowing the product to fit in the palm of your hand, the telephone still had to be large enough to accommodate the typical human face and needed a keypad and LCD large enough for adult fingers to punch in phone numbers or look up numbers stored in the telephone's memory.

The Design Center can solve this kind of problem by examining the solutions that earlier Sony designers have achieved in other product lines and using that insight in a totally new context. The design of the CM-R111 cellular telephone—(and its offspring, the CM-RX100, CMD-Z1, CMD-Z100 and CMD-Z200) came about in this way by combining advanced cell phone technology with a drop-down boom microphone and a unique control mechanism developed for the video cassette recorder.

The origins of the design date back to the mid-1980s, when the DC/Tokyo designer Soichi

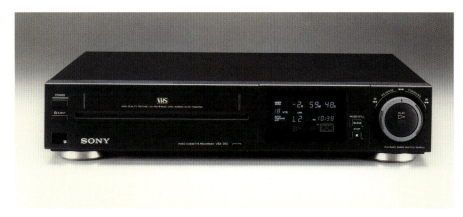

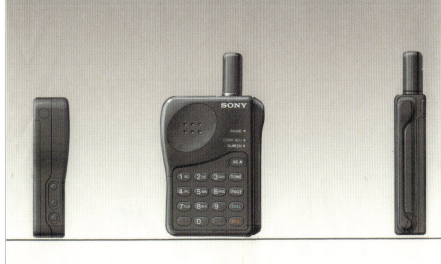

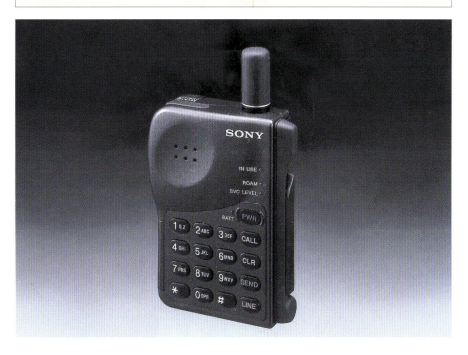

Soichi Tanaka's jog-dial control on the VSX-350 video recorder (top and below left) soon migrated to a handheld remote (below, middle left), and then to a series of telephones designed for the Japanese market, such as the TH-241, (middle and far right). Design: Ichiro Hino (DC/London). Bottom row: For the CM-R111, the jog wheel was moved to the corner of the product for easy access. Design: Ichiro Hino (DC/London), 1993.

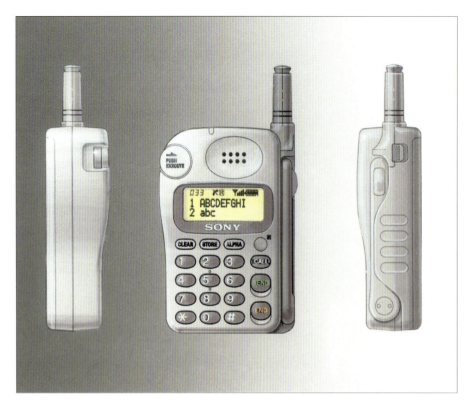

Tanaka began to work on entry-level video cassette recorders. By that time, that VCR had become a mature product with a standard mechanism and a rather plain black box exterior. "The design of the VCR had not progressed much beyond its original form because of intense price competition," Mr. Tanaka recalls. "Keeping prices low meant that we could not add much design to the product. As a result, it didn't look or function as well as it could." For example, controlling the direction and motion of the tape required the user to press separate forward, reverse, pause and stop buttons, which made operating the VCR a less-than-fluid experience. "In a perfect world, such products would have a single control that operated all aspects of the product," says Mr. Tanaka. Since the tape inside the VCR turned in a circular direction, Mr. Tanaka

wanted to mimic that action with the design of his control. "If we turn the knob clockwise, the tape should move forward," he says. "If we turn the knob a little farther, the tape should move faster. Turn the knob counter-clockwise, and the tape should reverse, slowly or quickly, depending on how far you turn the knob."

This unique control—called the jog dial—first appeared on the Sony VSX-350 video cassette recorder, allowing the user to shuttle the tape back and forth with little hesitation. Soon implemented on all Sony VCRs, the jog dial control eventually migrated from the front of the VCR to a handheld control, then jumped from the video world to the portable telephone when Ichiro Hino (the father of the Sports Walkman) used this mechanism on a series of analog cell phones that he designed for the Japanese mar-

ket, such as the TH-241 (illustrated on page 141).

At the same time, Mr. Hino was designing the first in a new class of analog cell phones for the Japanese and European market called the CM-R111. By miniaturizing its internal circuitry, the R111 had the precise length and width to fit snugly in the user's palm. Yet the distance from the earpiece to the bottom of the product was much shorter than the distance between the ear and mouth of the average adult. To solve this problem, Mr. Hino designed a tiny drop-down boom-shaped microphone for the R111 that also functioned as an on/off switch. Flip the microphone down, and the phone came on automatically. Flip it up, and the phone entered standby mode. By positioning the earpad to the left and the extended boom mike to the right, Mr. Hino achieved the maximum ear-to-mouth distance, allowing the tiny phone to function well on all but the largest adult face. The soft bulge at the top cradles the ear during extended use. Mr Hino then accentuated the R111's asymmetrical form by drawing a curved line that visually separates the keypad from the earpad.

A huge advance over previous cell phone designs, the R111's only flaw was its tiny keypad. But Mr. Hino had a solution. Just before leaving DC/Tokyo to head up the DC/London office in 1993, he made a preliminary drawing for a telephone, called the CM-RX100, which was slightly taller than the R111 and had two new elements—a tiny jog dial in the upper left-hand corner and an LCD on the front that displayed names, telephone numbers and other information. This new design allowed users to enter frequently dialed names and numbers with the keypad only once, store the keyed information in the telephone's memory and scroll through it using the jog-dial control. Like flipping through a Rolodex, it was easy to locate a previously dialed name and number. Once the desired name and number appeared, it could be dialed by pressing the jog wheel with the thumb.

"I wanted the user to operate the RX100 with one hand," says Mr. Hino, "because people often use a telephone while doing something else. By placing the jog-shuttle control in the upper left corner of the product, the user would instinctively hold the phone in their left hand and operate the jog wheel with their thumb, keeping their right hand free to make a note, carry a briefcase or drive a car." Adding the LCD made the telephone slightly taller, allowing the earpiece to be moved

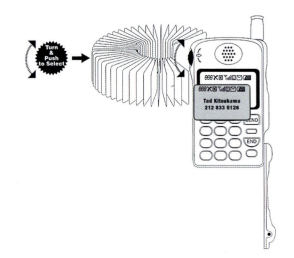

to the center of the product and yet still have the same ear-to-mouth distance as the earlier model.

In 1995, the Hino design was carried forward by Yutaka Hasegawa at DC/San Francisco, who refined the overall shape, enclosed the jog wheel inside the product (leaving only the edge of the wheel visible), enlarged the LCD, simplified the product's assembly by combining the antenna and boom mike into a single assembly and gave it the same wave form as the Hino design, which emphasizes the jog-shuttle gesture and maintains the asmymetrical shape that identifies all Sony mobile phones.

This new design, first seen on the CM-Z1, the CM-Z100 and currently used on the analog/digital CM-Z200, offers the most natural form of interaction ever designed in a portable phone—so good, in fact, that Mr. Hasegawa sees little opportunity for improvement. "Once the jog-shuttle gesture is fully absorbed by users," he suggests, "it may be possible to design a telephone without a keypad." With the Z200's optional charging station/speaker phone attachment connected to a VAIO computer, it is possible to transfer phone numbers and other data to the telephone's memory without using its keypad. Once the names and numbers are installed,

the user can easily scroll through the list using the jog dial and LCD and dial the correct number with a single click. For this technique to succeed, however, the interface on the screen will have to be simple and easy to read.

One idea being considered borrows the cylinder metaphor from Yukiko Okura's PerfecTV interface (see pages 108–9). As you scroll through your list of numbers, the number first appears in a foreshortened view at the top of the screen, pops up in full as it passes across the center (where the number can be automatically dialed), and drops away in foreshortened view at the bottom. The entertainment value of this approach reminds us that for a tool to be truly useful, it must also be fun.

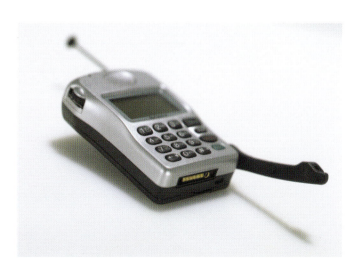

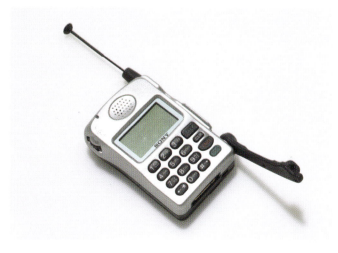

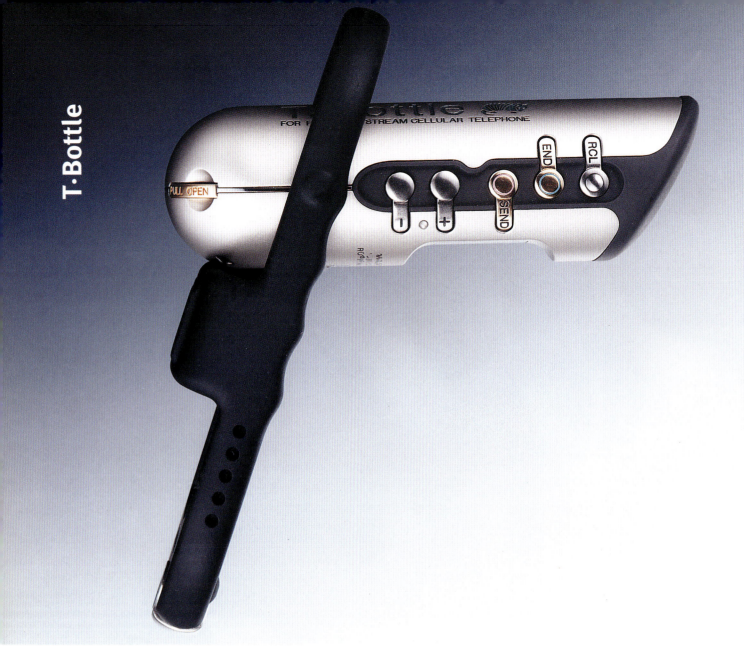

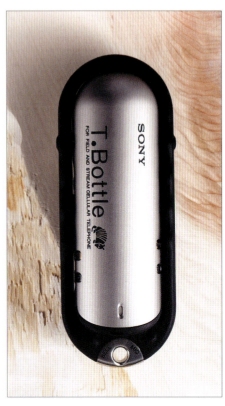

T•Bottle, a lifestyle telephone concept wrapped in a rugged aluminum tube. Design: Soichi Tanaka (DC/Tokyo), 1996.

To enliven the telephone as an object, the Design Center has funded lifestyle studies that take the familiar handheld receiver in an entirely new direction. The finest of these concepts is by Soichi Tanaka, who created a pair of cell phones using a unique blend of form materials and detailing. Cunningly small and rugged to the core, Tanaka's concepts, code-named T•Bottle and Yosemite, show how different a telephone can look, feel and perform if the design addresses the user's lifestyle. With its cylindrical metallic shape wrapped in a thick elastomer-covered bumper, T•Bottle looks like a heavy-duty drink container until your pivot the bumper downward and break the bottle in half, exposing an earpiece, keypad and LCD inside the cylinder, surface mounted controls on the outside and a mouthpiece located inside the bumper. Put the opened T•Bottle to your face, and it's a full-featured cell phone. Its rugged design is suited to outdoorsmen and construction workers, but would appeal to anyone.

Even more inticing is Tanaka's Yosemite concept. Inspired by the much-loved Outback series (1986–87), its rounded, compact form, armored construction and soft-feel paint make it immediately appealing. Fold out the circular earpiece, and you discover a circular LCD with a multi-function mechanism accessed by turning the knurled ring around the display, memory chip voice recorder controls, a jog-shuttle dialing mechanism and a square solar cell that protects the keypad. Every detail, from the sealed surface controls, to the finger-hugging surface on the back, are beautifully executed. Such concepts are created not only as exercises for the designer, but as ways to persuade Sony management that society is always changing and that products should stay ahead of that change.

For years, the Design Center's corporate identity specialist David Phillips has proposed that Sony create new brands that would target newly emerging markets and stand on their own,

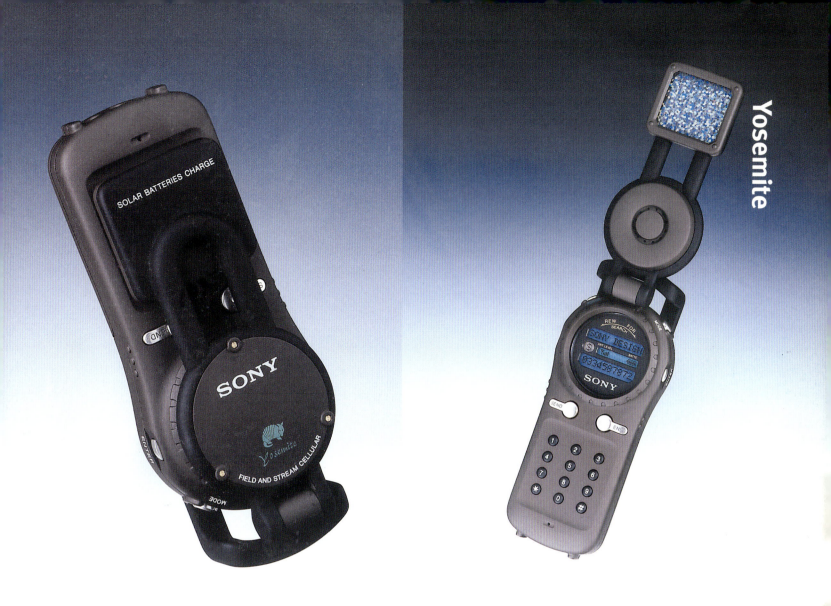

deemphasizing the Sony logo so that it functions as an endorsement brand.

"Sony already has an outstanding name and image," says Phillips. "But using that name too much can dilute its power. Rather than blanket the world with the Sony logo, we need to leverage its equity by creating new brands that open up new markets." In 1993, Phillips drafted a proposal to Design Center director Kei Totsuka that outlined the many ways that Sony could benefit by creating a separate brand under which the Design Center could craft a new line of products for a targeted audience. "Our designers can do almost anything in three dimensions," says Phillips. "But their most inventive work often conflicts with the Sony name or appeals to audiences, such as youth culture, for whom the word Sony is not all that meaningful."

Creating new brands and clothing those brands in entirely new designs would bolster Sony's image by showing that there is a Sony product for everyone. And creating new brands will allow Sony to focus on more specific customer trends and desires. "Today's market is so diverse and competitive that Sony must create new categories in which there is no competition," wrote Phillips in his 1993 proposal. "Sub-brand products will not interfere with the traditional Sony image." Like Mr. Tanaka's telephones, "they will look and work dramatically different from traditional Sony products, as well as the competition's products." In 1993, Sony management was cool to Philips's proposal. Developments within DC/Tokyo in 1994 and 1995, however, slowly turned that situation around. As PAV's lifestyle and sports designs evolved away from Sony's traditional image, causing many of those works to be buried because they "didn't fit with the Sony image," Mr. Phillips won permission to adapt one of these sports-oriented PAV confections and put his proposal to the test with a product line called Freq. To understand how that came about, let's first take a close look at the aesthetics and culture of lifestyle design.

Yosemite, a lifestyle telephone concept with built-in memory chip voice recorder, integrated solar cell and soft-feel finish. Design: Soichi Tanaka (DC/Tokyo), 1996.

Defining the Edge

It wasn't so long ago that sports was what kids did in their spare time. Today, however, sports has become big business. The direct and indirect sports economy generated by firms such as Nike, for example, is larger than that of many nations. And the various sports and lifestyle product lines of Sony—including boomboxes, radios, cassette, CD and MD Walkman units, headphones and related equipment—generate sales in the millions of dollars every month.

The reason is that sports are no longer limited to leisure time and have little to do with activity. It's an attitude, and a demographic group devoted to mobility, conspicuous consumption, and constant self-regeneration. The products that define the sports and lifestyle phenomenon succeed on multiple levels, are fundamentally different from the rest of Sony's product line and light years away from the banal necessities of everyday life. As a group, lifestyle designs give us a clear message that is both optimistic and democratic. The script is simple: Anyone smart enough or cool enough to carry a Beans Walkman in their pocket, wrap some Street Style headphones around their head or suspend a Sports Radio from their neck can surmount the obstacles of birth and environment, cast off the style of their parents and create their own personal identity through the products' collage of shape, color, texture, logotype and graphics.

Sony practices this form of brand architecture with particular effectiveness, building layer upon layer of exquisitely crafted motifs. At the Design Center, hundreds of hours are spent creating an effect that hits the user where they least expect it: in the heart as well as the mind and body. As sports and lifestyle activities continue to occupy center stage in our global culture, the equipment that supports these activities range from the simple to the voluptuous, from functional folk art to technological laboratory-based equipment and from tactile fantasies to runway-inspired works of creative abandon. Such designs captivate us like no other products can. They express the self-accessorization of our lives. They evoke qualities that allow faceless warriors to fantasize about competing on the world stage. Though they are the most personal of all Sony products, they also reflect the professionalization of electronics by suggesting that products possess abilities far in advance of our own. Just as weekend athletes often invest in gear once reserved for gold-medal

winners, electronics mavens look to sports and lifestyle products for a psychic advantage.

Unlike all other Sony products, sports and lifestyle designs have an identity all their own, yet they achieve completion only when someone is using the product. The first Sports Walkman and Sports Radio, designed in the early 1980s, were conceived as high-tech prosthetic devices, artificial appendages that allowed the user to greet the world as a champion. Yet today's sports and lifestyle designs, such as the now-ubiquitous Street Style Headphones and Street Style Discman, are very different. They are not attached to us. Rather they are integrated with our bodies. They fit like a glove, allowing us to enjoy them without noticing their presence as we control their every function in an almost involuntary way.

The details on a Street Style Discman are so carefully drawn they fuse with the body, encouraging a sense of total mastery over the product. Such changes mean that we now enjoy a new type of relationship with our equipment. Perfectly designed sports and lifestyle gear offer more than a pleasant experience; they provide a psychic involvement with something more powerful than any of us could hope to be.

The nexus between personal electronics and the worlds of music, sports, fashion and industrial culture no longer evolve along parallel tracks. They converge, borrowing from one another in a fluid exchange that is purely contemporary and cuts to the heart of modern life by reminding us that identity is always in flux and can be reinvented by replacing yesterday's design with something new. Modern culture is all about change. And the faster that transformation can happen, the better. Just as we resculpt our bodies in athletic clubs, adorn ourselves with fashionable clothing and order up surgical changes as casually as we would order a meal—we expect our electronic products to follow suit, always expressing something that is individual, fresh and new. In this way, the design of personal electronics inspires our cultural imagination by nourishing our physical need for objects that are constantly changing. Indeed, the very identity of modern electronics hinges on their ever-changing look, feel and function, the stories they convey as we use them over time and the way they empower us, triggering our imaginations to dream in ways that were not possible before.

The siamese connection between sports

design and music has spawned many different subcultures that borrow from one another, creating ever smaller, more specific user groups and demographic segments.

Sports aesthetics, lifestyle design and music are synonymous with youth culture, made all the more unavoidable by MTV with its heterogeneous mix of styles, brands and lifestyles. MTV offers a compelling lesson on the fluid nature of contemporary identity that the Design Center has not failed to appreciate. At Sony, the quest for new expression never ends, and defining the edge is as necessary as oxygen is to flame.

You might think that giving a product visual expression would be "fun." But you would be wrong. Given the tight schedules, limited budgets and the almost suffocating weight of the past, investing an inanimate object with the right personality at a place like Sony is difficult. Before striking out in a new direction, the designer must consider the company's aesthetic standards, the size of the product (small designs are given freer rein than large ones) and the kind of product (such as TVs, which look grotesque if they depart too far from the norm). Color, materials, cost, environmental factors, manufacturing limitations and other factors also limit the designer's options. But the biggest limitation is a question that has killed more good designs at Sony than any other: "Is it Sony-like?"

"Being 'Sony-like' is not a visual style," says Hiroshi Nakaizumi, "it's a state of mind." To be "Sony-like," a design must have the basic Sony attributes that set the tone for every Sony product —innovation, simplicity, ease of operation, functional form, originality and a quality that enhances the user's lifestyle. "If you attend product meetings in Tokyo, you hear the term 'Sony-like' all the time," says Nakaizumi. "But nobody ever defines the term. People who have been with the company for years think they know what it means. But the meaning changes depending on who is talking. Newcomers, of course, don't have a clue."

Occasionally, a designer comes along who does understand. One of these rare birds is Ed Boyd, who joined DC/Park Ridge in 1995. Renowned for his PAV concepts, Boyd's SRS-PC71 Active Speaker System, designed in 1997, is a uniquely expressive product. "Since the desktop computer is a serious product, it should not have an active personality," says the designer. "Yet peripheral products that live away from the CPU and display do not have to follow the VAIO language. Instead, they can express what they do on their own terms" By combining speaker units of two different diameters at right angles to each other, I have reduced the width to an absolute minimum. I have, thus, achieved a rich bass sound from a very compact product. This dynamic style is well suited to the aggressively styled computer monitors of recent years."

With its quirky animalistic form—a headlike

This page and opposite: H2O concepts for Discman, Walkman, pendant radio and boombox. Design: Ed Boyd (DC/Tokyo), 1995–96.

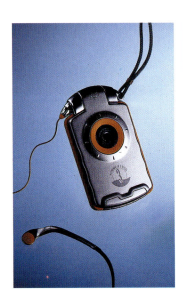

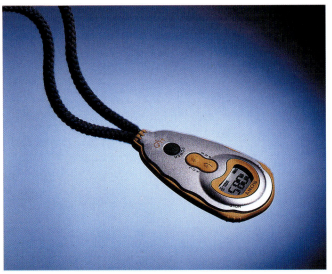

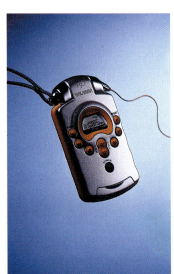

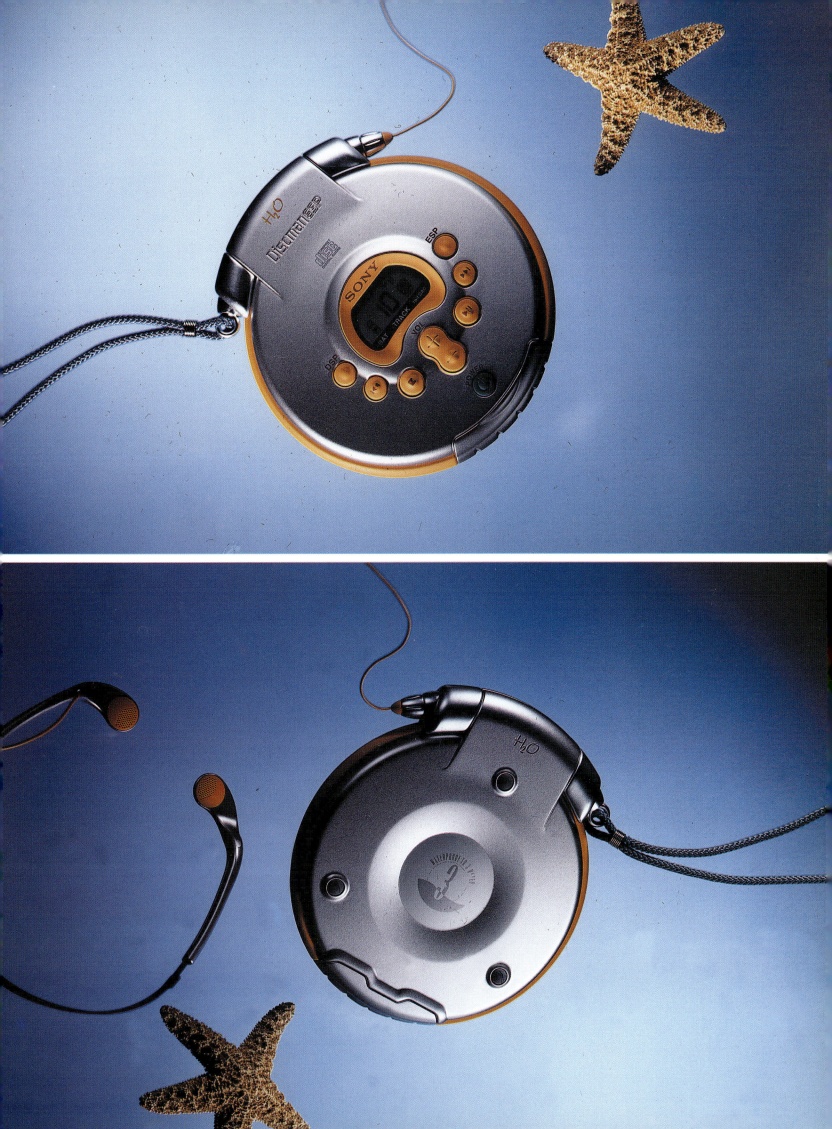

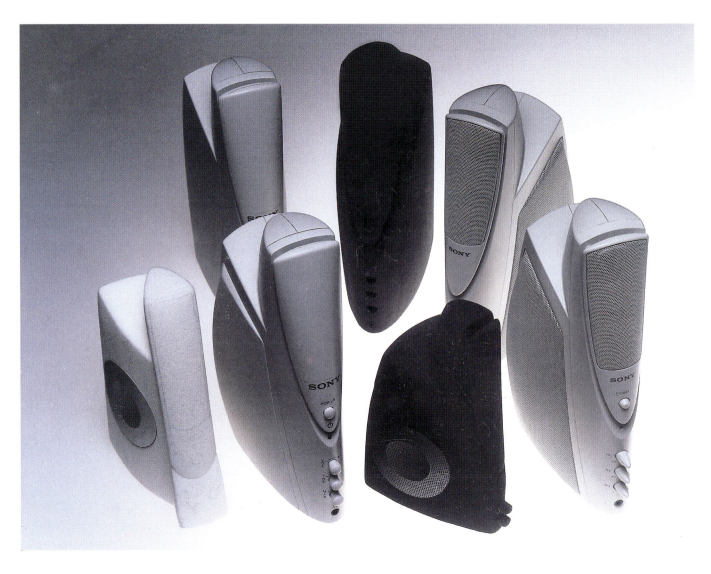

Top: Foam
concepts
for the
SRS-PC71
Active
Speaker
System.
Inset:
Wire-frame
drawing.
Design:
Ed Boyd
(DC/Tokyo),
1996.

tweeter and mid-range speaker with an extended chin (or is it a bird's bill?) set on a short narrow-shouldered body, Boyd's speaker resembles a very strange little man—or a pelican with its wings folded close to its body. Its beautiful flowing lines, contrasting textures, crisp corner treatments and perfect balance of elements make Boyd's design as "Sony-like" as any product can be.

Even so, most of Mr. Boyd's designs for Sony never reached production, including his splendid Walkman concepts, code-named H2O, which Boyd designed in Tokyo for the PAV group in 1995–96. An update on the venerable Sports Walkman with a strongly aquatic flavor, the H2O designs for Discman, portable radio, cassette Walkman and boombox—with their bold orange and brushed metallic surfaces, baroque curves, humorous imagery (note the diving bell reference on the front of the Walkman on page 150), and limpid details —are among the most interesting and exuberant work that any Sony designer has done in the portable arena. The obvious question—why Sony

didn't manufacture these concepts—remains unanswered.

Yet one Ed Boyd design that bears traces of H2O did make it into the world. The Sports Walkman Necklace Radio, designed in 1994, features a perfectly sculpted teardrop-shaped receiver, with a black analog dial wrapped in yellow and blue plastic, with a breakaway neck strap that also serves as a headphone cable and

radio antenna. Headphones plug into the neck-lace instead of the radio.

Of course, nothing in Ed Boyd's work is exactly as it seems. Here, the radio is not a radio. It's a talisman that functions like a piece of modern jewelry. The power that radiates from this small object is so great it can be blown up to any size and still retain its essential character. Conversely, if you reduce the product to just a few pixels on a computer screen, its icon quality remains intact. Few Sony designs have this ability. Strange that it should turn up in one of the oldest and least expensive product categories the company makes. The Sports Radio is not digital. It's not a conver-gence product. And the sound it produces is not even that good. But its design is pure gold, evi-dence of a special individual working at a special time in his life.

Another young master now at the top of his game is Tetsu Kataoka, the man who gave shape to the current Sports Walkman in 1996 and broke new ground the following year with a series of

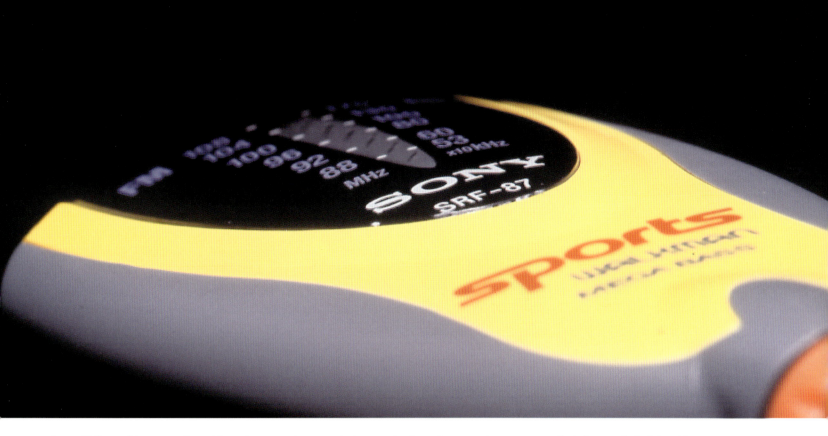

Sports Walkman, Discman, radio and boombox concepts that were not really Sports at all. "The original inspiration was Sports," says the designer, "but as I designed them, I found myself appealing to a younger audience who weren't interested in the old Sports cliches. The user I was trying to reach belonged to a new tribe. They love skateboards and snowboards. They live everywhere . . . from Tokyo to Berlin . . . some in the streets, some on the slopes and some in between. They span all socioeconomic groups, include boys, girls and everything in between, speak their own language and have a style to match. As a result, they relate to each other in ways that outsiders didn't understand."

While working at DC/Park Ridge, Mr. Kataoka became an avid snowboarder and befriended many in this new generation. As he listened to their speech patterns, watched their behavior and made note of their attitudes and preferences, he thought he understood them. But as his SPO Street concepts show, he didn't really understand them at all.

Conventional to the core, Mr. Kataoka's designs hit all the right buttons. They were cheap, had no inappropriate details (such as waterproofing) that smelled of the old Sports line, and had interesting details, such as a leather wallet-style Walkman case with a heavy chain that attached to the belt. The work was good, but as Kataoka himself admits, the designs missed the target by a mile.

"It was clear that this new generation would soon become an important consumer group that Sony could not ignore. And it was also clear that traditional Sony imagery wouldn't reach them. To succeed, we had to develop something new . . . a totally new brand and design . . . that didn't look or feel like Sony."

Above and below: The Sports Necklace Radio offers classic analog controls and a unique breakaway neckstrap that also serves as a headphone cable and antenna. Design: Ed Boyd (DC/Tokyo), 1995.

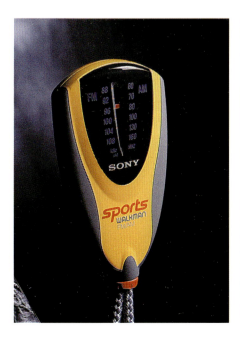

Defining New Lifestyles

BOOMBOX

WHITE SPEAKER

HOLDING

BOOMBOX

CD BOOMBOX

The SPO Street concepts alerted the Design Center to a new emerging market, known as Generation Y. They soon inspired a new approach to Sports Walkman design that gave birth to the line known as Freq. Design: Tetsu Kataoka (DC/Park Ridge), 1996.

ANALOG RADIO
WITH LARGE HEARD PHONE

PORTABLE RADIO

PAGER CASE WITH WALLET

pager
radio page

Many Sony insiders disagreed. With the most recognized brand name in the world, they asked, why develop a new one? But Kataoka's opinion struck a chord with DC's corporate identity supervisor, David Phillips, who first proposed developing an alternate brand for Sony way back in 1993—and was turned down. His argument was simple. For years, Sony had succeeded by producing a few generic products, then generating many different models that distinguish themselves primarily by technological features and price. This strategy worked as long as Sony was first to market, gave consumers the best technology and had the lowest price. But in Phillips's view, all consumer electronics technology was becoming commodified. The historic lead that Sony enjoyed over Matsushita, Sharp and Toshiba was eroding. "Soon, it may no longer be possible to distinguish Sony from the rest of the crowd," says Phillips. "The only tools left are our name, package design and image creation. Yet a profound market shift, from mass to microsegmented markets, was occurring, turning traditional market thinking upside-down. This shift is dramatically affecting the way companies conceive, design, manufacture and promote their products. And branding is critical."

In 1996, Phillips conducted a corporate identity analysis by interviewing dozens of Sony executives and asking them to describe the company's image and identity. His findings were disturbing. Despite Sony's reputation as a visionary company, many key executives could not define that vision. And there was profound confusion about the branding of Sony's own products. "In the past, Sony had been successful with sub-brands that distinguish specific performance characteristics," says Phillips. "Sports, Street Style and My First Sony all did a fine job of defining their purpose through both name and design." But design can be easily copied, making it hard to create lasting distinction. "Sony cannot own the color yellow, so the Sports concept will eventually lose its edge. Today's market is so diverse and competitive that Sony must create new categories where there is no competition. New brands allow Sony to focus on specific consumer trends without disturbing the traditional Sony image or diluting the strength of

our corporate brand. With a new brand, we can create a totally new design." This time, Sony management agreed. But the designer whose concepts had inspired this decision, Tetsu Kataoka, didn't think he could design, much less name, the product that Sony wanted to create. "We wanted the new brand to be inspired by sports like skateboarding and snowboarding," says Kataoka. "We wanted to reach the teen and pre-teen audience in the traditional way—but on an emotional level," which the Sony brand—with its broad product line and global presence—did not. "As a Sony designer, I could not reach this new audience. I didn't know them. I wasn't close to them. So Dave Phillips and I had to find a consultant who was."

For years, the snowboarding market had been growing at a geometric rate, due in part to small firms that had found ways to segment the market and design snowboards for specific niche groups. Leading this trend was the Burlington, Vermont, design firm Jaeger DePaolo Kemp, which had created snowboard graphics for Burton that rocketed that company to market leadership and won JDK kudos from designers. Dave Phillips liked JDK's graphic style, respected their depth of knowledge and subscribed to many of the ideas in JDK's company manifesto, which partner Michael Jaeger calls "The Consciousness of Chaos."

Speaking at a recent forum sponsored by Harvard's Design Management Institute, Mr. Jaeger outlined his approach by noting that the digital revolution has transformed youth culture. "Young people thirst for information and change and have instant access to everything," he says. "Years ago, kids in the U.S., Japan and Germany followed different trends, but now they all know what's cool and what isn't. This means that youth culture is now a global phenomenon." Because of the Web, traditional sources of information no longer communicate as they once did. "The young consumer is profoundly suspicious of conventional media and repulsed by advertising and hype. They know when they're being 'sold to' and are turned off by it. To survive, we must build a new relationship, a new brand that cuts through that skepticism." In Jaeger's view, the old social paradigms—which used advertising, public relations and a hierarchical, Bauhaus-inspired design philosophy to further the corporation's need

Developing the correct name and logotype took JDK in some interesting directions (above). The process culminated in an expressive, if somewhat blobby, script that looked like it had been made by an eight-year-old using jello instead of ink.

for organization and control—had been rejected by today's youth. Sounding like a new-age prophet, Jaeger told hushed the audience at DMI that "the Web has changed everything. Now that kids share information, ethnic identities and regional differences, the whole advertising-driven media apparatus, as well as the design that serves it, is crumbling." In its place, designers should respect the multiplicity of voices by establishing new relationships with users, the corporation and themselves. "For brand identification to work, it must establish a core meaning while catering to the consumer's need for change. Using meaningful visual impressions, we can establish that meaning by building an empathetic relationship between the brand and the audience. As old institutions lose their influence and new ones take their place, the designer can bridge the old and the new by viewing design more broadly, integrating all aspects of a design's presentation, forming new relationships, creating a symbolic web with other functions and disciplines. Those who do not respect the symbolic web of creative viewpoints will have limited success in today's design."

Linking JDK's philosophy with the theory known as "experiential marketing" authored by Professor Bernt Schmidt at Columbia University, Dave Phillips says that "traditional branding misses opportunities to connect with consumers on an emotional level. To succeed, we need to address the whole of our experience: how we feel, think, act and react."

Working together, the Design Center and JDK needed to come up with a meaningful new name that would appeal to this young, skeptical and highly diverse audience. The brand could not be monolithic. It had to have a cultural dimension, both inside and outside the company. It had to have a "story" or narrative that could engage its audience, create an emotional relationship with and invite them to build their own individual expression.

The first task was to come up with the right name. During Phase One, JDK drafted a list of nearly two hundred potential names (see partial list at right) that related to various qualities the target audience preferred, narrowed the list to five names, consulted with Sony on selecting the final name—Freq (pronounced Freek)—and

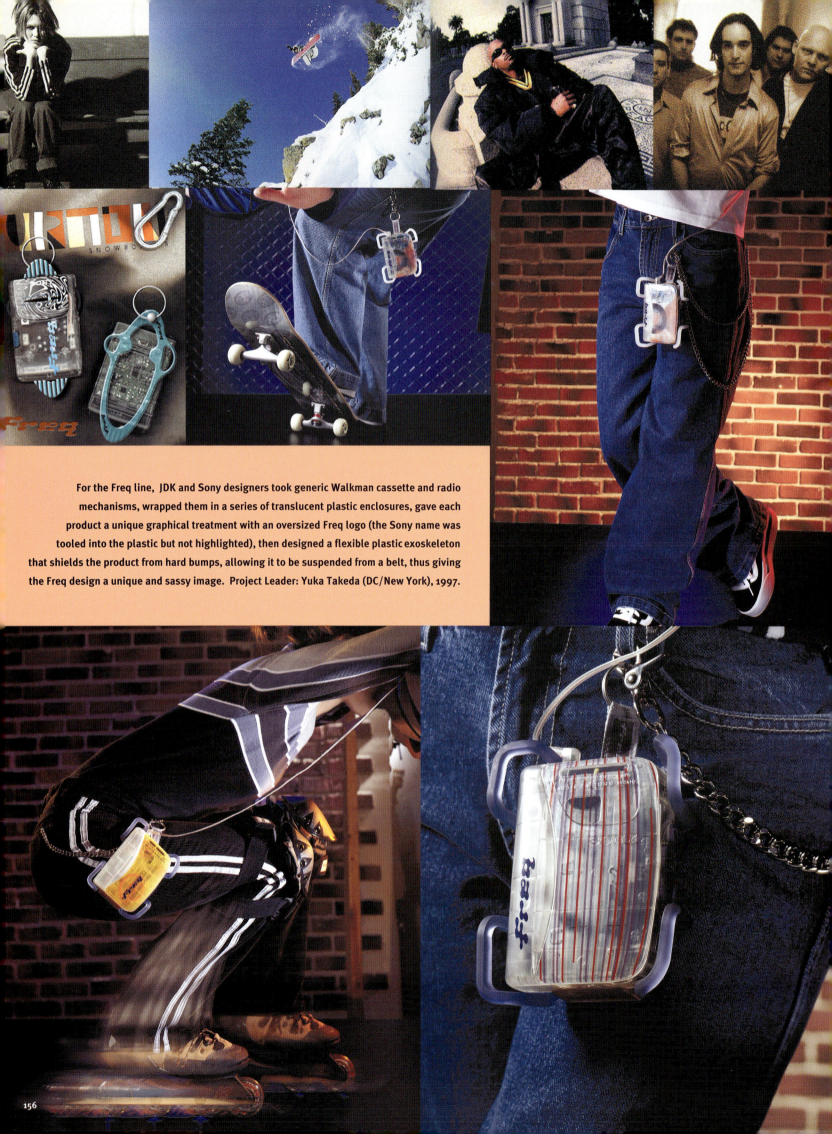

For the Freq line, JDK and Sony designers took generic Walkman cassette and radio mechanisms, wrapped them in a series of translucent plastic enclosures, gave each product a unique graphical treatment with an oversized Freq logo (the Sony name was tooled into the plastic but not highlighted), then designed a flexible plastic exoskeleton that shields the product from hard bumps, allowing it to be suspended from a belt, thus giving the Freq design a unique and sassy image. Project Leader: Yuka Takeda (DC/New York), 1997.

proposed a series of graphical concepts that included a rounded treatment that resembled the controls on a stereo, wiggly, sports and technoid treatments, and a blobby italicized typeface that looked as though it has been formed by a very hip eight-year-old using Jello. All agreed the last logo was best, at which point Sony shot a clever video showing a series of random blobby shapes that coalesced to form the new logo. The name was good because it means different things to different people. "If you think of the word frequency, it has a positive, techy connotation," says Dave Phillips. "It also sounds like freak, which many Freq users are or want to be. It ends in a hard consonant, which makes it easy to say and easy to understand. Catch phrases like 'What's your frequency?' practically rolled off the tongue. Everything was falling into place. Sounding like a proud father, Phillips predicted that "the brand name would be more important to Freq's success than the design." The prediction turned out to be wrong. But in Freq's early days, any claim was possible.

Once the name and logo were accepted, applying Freq to the products was straightforward. As a low-priced line—comprising two Walkman models with side-mounted controls, two analog radios

and headphones—the Design Center was forced to use existing mechanisms and plastic molding. "We wanted to use the Freq logo alone and eliminate the Sony name altogether," says project leader Yuka Takeda," but the Sony name had already been cut into the Walkman tooling, and eliminating it would have been very expensive. If you look carefully, you still see the Sony name." To compensate, JDK came up with lavish graphical treatments, using brightly colored and translucent plastics to hide the famous logo and disguise any resemblance to Sony's existing products.

Meanwhile, back in Tokyo, Kazuo Ichikawa and Tetsu Kataoka created a soft plastic exoskeleton, called a "bumper," to protect the Walkman and enhance its visual identity and added hardware that allowed users to suspend the product from a backpack or belt. "Skateboarders are a clip-on society," says Mr. Kataoka. "They don't hold onto things when they ride, so a contoured Sports-style grip was unnecessary. In fact, it would have been a turn-off." Three differing graphical treatments for the Walkman emphasized the need for choice, which extended down to the radio line as well. Because they are small and thus easy to tool, Freq radios were more expressive, featuring an inte-

grated bumper molded to a translucent plastic card with the printed circuitboard inside, with a look and feel that came straight from JDK's Burton style vocabulary.

In the Sunrise/Sunset scheme of things, Freq was beyond perpetual sunset, proof that the final light of day is always the best. The hardnosed ten- and twelve-year-olds who made up JDK's focus groups lusted after the new Freq designs. And as the Freq lifestyle took shape, the imagemakers at JDK and Sony envisioned an entire Freq culture that extended well beyond personal electronics. Meanwhile, Sony management in Tokyo began to think about new lifestyle categories for middle-aged Americans and senior citizens.

In a position paper titled "The Birthing of a Brand," JDK announced that Freq was no longer just a name on a Walkman, it was "the frequency of mobilized individuality." According to the designers, this new Freq organism had both a mind and a soul. Its left brain was steeped in nontraditional thought. Its right brain was focused on building a platform that could communicate its "consciousness of chaos" message to the Freq tribe. Its heart resonated with meaning that was

After the success of the first Freq line, dozens of second-generation concepts for Discman (top row) Walkman (middle row), radio products (bottom row, center) and headphones were created in 1998 with granitelike and spiral patterns, highway stripes on asphalt, new bumper designs and a touch-sensitive surface that left a telltale impression after the user handled the product.

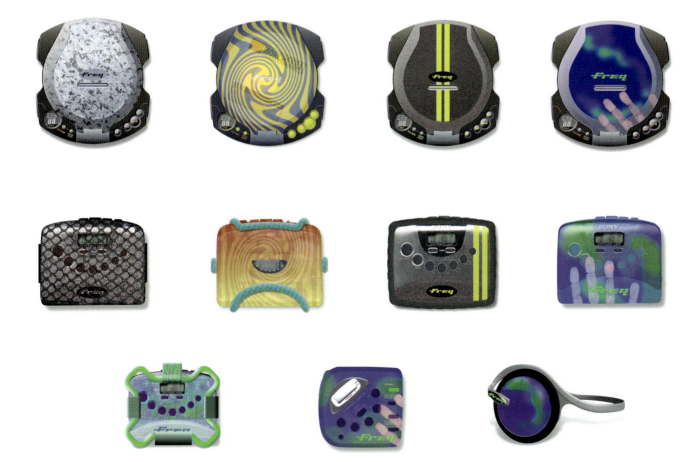

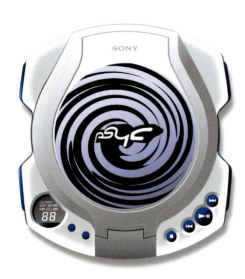

The Psyc product line carries forward a number of elements from the second-generation Freq family. Brightly colored, translucent plastics with psychedelic swirls and geometric buttons are wrapped in a variety of soft plastic exoskeletons that serve as bumpers and allow a keyring to be attached. Design: Tokyo PAV and Park Ridge Design Center, 1998.

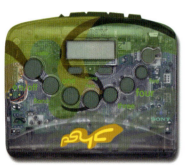

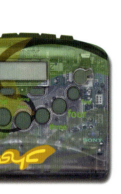

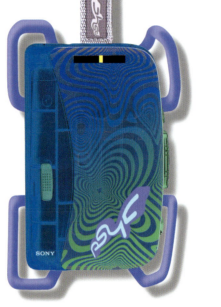

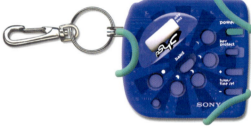

never specified. And its fear was its "corporate grandparents," meaning Sony. The key elements to birthing a brand were to "develop and communicate a manifesto, thus creating a groundswell of support for the movement. A personality for a brand is conceived, based on something which makes it real to the audience, and which communicates inherent values to that market. The manifesto, or point of view, acts as the platform for the brand, from which the brand can grow." The Freq rallying cry—"Listen to Yourself"—would establish a basic starting point for the brand's personality. One Freq positioning statement noted that "Freq is an invitation to individualism . . . powerfully raw, sexually real and honestly conveyed. We are all unique. We are all tapped into our own frequency. Yet it's our collective individuality that inspires."

Considering the target audience, JDK suggested that nontraditional avenues would serve the Freq concept better than advertising. "Using nontraditional means, the brand would not be created overnight," says Michael Jager, "it would acquire meaning over time and represent values that would resonate with the target audience." The recommended means for injecting Freq into the culture were described as: "1. alpha seeding; 2. cryptic Web advertising on selected sites; 3. wheat paste posters, sticker sand postcards and a [Web-based] Freq 'zine."

Freq products would include a new line of Freq-style Walkman, Discman, an AM/FM headset, boombox, and Freq-ified Street Style headphones . . . a Freq personal computer, pager or personal digital assistant . . . sweaters, jackets, caps, ankle wallets . . . a Freq version of PlayStation . . . packaged cassette and MiniDisc media . . . Freq-oriented music collections . . . flashlights, pens, keyrings . . . followed by Freq books and comics . . . product placement on "Dawson's Creek" . . . a Freq web site . . . a Freq TV game show, and finally Freq cover stories in *Rolling Stone*, and later *Time* magazine.

According to the imagemakers at JDK and the Design Center, the Freq concept knew no bounds. But Sony marketing wasn't so sure. Stepping back from all the excitement, they noticed that the Freq name was not as exclusive as JDK had hoped. Even though Sony had registered the name, it was showing up in all kinds of places, like the Web, which Sony couldn't control. "The name was great in 1997," says the Design Center's Rich Gioscia, "but by 1999, we feared that it might lose its punch." Among the many risks of launching a new

brand, the biggest is to choose a name that doesn't stay ahead of the curve long enough to establish the brand in the marketplace. "Even though the

campaign and the designs had been a success, a consensus grew inside Sony that Freq was not the best name we could find," says Gioscia. "Since

the Freq idea catered to youth culture, and young people thrive on change . . . morphing from one identity to another . . . it was possible, even desirable, to change the name."

This time, JDK fired off a series of potential names, such as "Vurb" and "Noize," but none had the resonance of Freq. So Rich Gioscia conducted his own research, scribbled half a dozen candidates in his little black notebook and came up with the new name—"Psyc" (pronounced "Sike")—all by himself. Sharing many of the qualities of the Freq name, Psyc had multiple meanings. A shortened form of the word psychology, it also suggests the word 'psychedelic,' and in kid parlance translates as a verb meaning to challenge someone (i.e., to "psych someone out"). The new word had the same short, cursive sound as Freq. The letterforms had interesting ascenders and descenders that graphic designers could exploit when creating a logo. No one had trademarked or registered the name for personal electronics. And the word also functioned as an acronym: "Products Signifying Youth Culture."

Interested by the new name, JDK came up with a series of logo treatments that linked the four letters together in various ways. The most interesting was a digital treatment (left, top example) that expressed the word in a random series of dots that looked good on a product as well as a T-shirt. Yet all agreed that the best treatment for all usages was the logo that JDK called Super Cruiser (left, fourth from top), which has a bold three-dimensional look and served double duty by aiding in pronunciation by emphasizing the 's' and de-emphasizing the 'p.' "A new name aimed at youth culture should have an insider quality," says Gioscia. "But it should also be easy to pronounce."

As this book goes to press, the Psyc product line is being implemented using the same design elements as the Freq family—colored and translucent plastics, wavy free-form graphics and the new logo used to obscure the Sony name that is molded into the plastic.

It remains to be seen whether Psyc will evolve into a movement like Freq or be replaced by yet another name in a year or two. According to Kei Totsuka, who oversaw the early stages of Freq, "the name was never as important as the designs and the products. Freq and Psyc show us that it is possible to create a narrative to support the products. But a story or brand name should never be the primary reason for launching a new product."

Defining and Designing the Digital Future

"THE TROUBLE WITH THE FUTURE," WROTE THE FRENCH POET PAUL VALÉRY, "IS THAT THE FUTURE IS NOT WHAT IT USED TO BE." NOT TOO LONG AGO, WE SEEMED TO BE EVOLVING gently toward the future. But today the pace of change is accelerating exponentially, and the future seems to be racing toward us at an ever-quickening rate. As computers merge with the other products and technologies that give meaning to our daily lives, physical distance seems to be collapsing, and time itself is being compressed, measured not by the human heart but by the ever-quickening beat of the microprocessor.

Looking back a few years, it's easy to see the steps that have led us to the convergence of the analog world with the digital, of home entertainment with computers and of the intellectual side of our being with the physical and the emotional. This convergence, many years in the making, arrived in full force during the summer of 1994, when Hughes Electronics' DirectTV system beamed 200 channels of digital television into American homes and became the fastest-selling piece of electronic equipment ever in its first year. Yet digital television's success was soon eclipsed by the launch of the Web browser called Netscape Navigator. Within a few months, more than six million copies of Navigator had been downloaded to consumers on the Web, transforming the way consumers and businesses viewed the Web as an economic, communications and cultural environment.

Today, the rapid penetration of digital television and the remarkable popularity of the Web are pointing the way to a new era of digital convergence that is affecting the design of every consumer electronics product and changing the lives of those who use them. With digital broadcasting, digital telephony, digital music, movies and games, digital video and photography and digital newspapers and magazines, an almost infinite array of information and entertainment choices will soon be at our fingertips.

To address the challenge of navigating this vast multimedia stream, Sony Research Laboratories teamed up with DC/New York in 1996 to establish the Zooming User Interface Project. Their goal: to develop a next-generation user interface that would replace the current Windows metaphor with a new form of interaction that would work equally well across the many digital platforms that will soon be found in the home, from digital television, AV equipment to camcorders, to digital telephones and personal computers.

Inspired by the PAD++ research project conducted at New York University and the University of New Mexico, the Sony ZUI project has created what many observers in the PC and consumer electronics industry have been waiting for: an extensible, customizeable, Java-compatible, hardware-independent electronic user interface that can work well on a screen of any size, from a 48-inch television to a handheld PDA.

Before describing what this means, consider that the most widely used digital interface—Microsoft Windows—is based on ideas that are more than twenty years old. Conventional 2-D graphical interfaces such as Microsoft Windows and the Macintosh OS, which borrowed liberally from work done at Xerox PARC in the late 1970s, were designed for the manipulation of text, images and numerical data in a business setting—not today's quickly evolving multimedia environment. Office metaphors such as the desktop with files and folders, as well as abstract metaphors such as windows and icons, are too static and limited when manipulating streams of digital information, imagery and video in a dynamic environment. As a result, putting a Windows-style interface on a digital television would be ridiculous. By the same token, multiple devices placed throughout the home, each designed for a particular purpose, cannot rely on a single windowing interface. The necessity of reading the title of a file to distinguish it from others around it limits the usefulness of conventional graphical user interfaces, particularly on very large or very small screens.

The many different computing devices that will soon invade our homes will need to relate to the user through an interface that is appropriate for all display sizes. And nearly all of these devices will be linked in some way to the World Wide Web. For this reason, Sony Research Laboratories devoted the first phase of their Zooming User Interface research to the challenge of navigating the Web—learning lessons that would later be applied to digital set-top boxes (available in 1999), a variety of AV applications and devices, as well as Sony's Digital Satellite System (known as PerfecTV in Japan, DirecTV in the US and Sky TV in Europe).

"We began our work by talking about new ways to navigate content," says ZUI design manager Andy Proehl. "The prime example at that time was Web browsing. Therefore, we decided that by creating our own browser we could explore various navigational concepts and use that experience in designs for digital television and related technologies."

> *"The digital revolution will shake our entire business platform so that brand image, production power and even the best technology will no longer be enough. We must recognize that in the future most of our products will become part of a larger digital network. From now on, Sony's work is to build bridges between computers, communications and entertainment . . . not mere boxes."*
>
> —Nobuyuki Idei

Opposite page: three views of a prototype on-line magazine titled *Muz*, which features a 3-D zooming interface designed by Sony's ZUI team in DC/New York and the design firm IO 360. Instead of reading the magazine by scrolling up or down or side to side, the reader "zooms" into the screen in a continuous fluid motion, revealing new layers of content as the image expands. Should you ever become lost or confused, you can retrace your steps by simply "zooming out."

In order to bring Sony quality to this new form of software and overcome the natural skepticism for software that exists in a hardware-driven company, the designers—Andy Proehl, Kim Mingo, Eduardo Sciammarella, Anne Kim, Tom Grauman and Franklin Servan-Schreiber—had to make their new user interface as innovative, consistent and consumer-friendly as possible.

"As the first zooming application to channel the full range of digital media directly into the home, the zooming feature had to be spectacular," says Tom Grauman.

Working with engineers at Sony R&D in New York, they wrote the program in Java in order to port their work to a variety of platforms. "Developing the core technology early and deciding to write the code in Java was a crucial step," says Proehl, "because it now makes it possible to deliver zooming to virtually any digital product." The result, called WaveCatcher, could be the most important user interface design since the development of the Windows-style GUI.

Upon booting up, there are no menu bars on the screen, no windows, no file management or application icons. Instead, the screen contains a seamless, flowing world of entertainment and information laid out in a seemingly infinite space. A simple point-and-click motion causes the image on the screen to move toward us in a zooming motion, transporting us to our destination like a high-tech video game. As we plow deeper and deeper into the screen, through an imaginary space that has no apparent end, we pass dozens of information sites, where we can stop to explore in depth. Using mere finger pressure, we can accelerate our descent, slow down, turn left, right, up or down, pull back (causing the screen space to move away) or stop at any point to browse information within that immediate area. And as we explore this cyber environment, our journey forms an elegant Spiral that serves as a map, allowing us to return to any part of the journey with a simple click.

As the first application using Sony's Zooming User Interface, WaveCatcher is also the first multiscale interface technology to display and store Web-based information. The term *multiscale* is important, for only on a scalable interface can large amounts of information be displayed on both large and small screens. Technical barriers, such as processor speed, fixed storage and memory, no longer inhibit the development of zooming graphical interfaces for the consumer market. The only barriers are the monopoly position of existing soft-

ware, such as Microsoft Windows, and today's restrictive interface design and navigation conventions, which force users to think of cyberspace as a two-dimensional experience, with movement limited to "back," "forward" and "home" and screen-sized height (known as the x axis) and width (the y axis) but no apparent depth (the z axis).

Sony's Zooming User Interface is the first to break through this z-axis barrier, giving the user continuous access to information without being bound by windows. As such, zooming represents a revolution in user-interface design and interaction—equal in importance to the windowing designs of the late 1970s and the first Web browsers of the early 1990s.

According to ZUI design manager Proehl, the use of the Java programming language is an essential part of Sony's strategy. "When we began the project, Java was still in its infancy," he recalls. "But our engineers had faith in the Java concept, because it allows applications to work across all platforms, allowing software to be written once and later run on virtually any digital device." When programming in Java, a digital TV, personal computer, digital cell phone or digital camera are all equal. With Java, proprietary standards enforced by Microsoft and Intel begin to crumble, releasing a tidal wave of digital information, entertainment and potential as it connects the traditional PC into a multitude of computing devices networked to each other in the home. Finally, Sony's Zooming User Interface and Java share a common philosophy. Just as Java was designed to run programs across a wide range of digital platforms, zooming has been designed to work well on displays of virtually any size, from wall to wallet. The ability to read well on screens both large and small is a crucial advantage, since Windows interfaces on a small screen and can rarely display all the information that a typical computing device can provide. By making the best use of screen real estate, zooming gives the user direct and enjoyable access to vast amounts of information without resorting to complex symbolic systems, intricate metaphors or the mind-numbing task of scrolling a screen up or down or side to side.

WaveCatcher was chosen by Sony R&D as the first ZUI-based application, because it is designed to operate in the infinity of cyberspace (where zooming action can easily take flight) and because Web browsers are the most general (and therefore the most challenging) applications now being developed.

As the capabilities of the PC and audio/video devices converge, zooming will provide a totally new experience by allowing us to zoom through cyberspace, digital TV, our personal data or AV collections, picking up information by pressing a simple multipurpose button and using that data in many different ways.

The Zooming User Interface combines the free-form space and passive quality of television with the active quality of gathering, creating, storing and sending associated with the PC—giving us a form of interaction that is direct, intuitive and enjoyable on every level. Unlike today's Netscape- or Microsoft-style browsers, zooming proved ideal for searching the Web. "A zooming interface makes surfing the Web, or viewing any digital content, an immersive experience," says Proehl.

When you switch on your living room TV or PC and fire up the zooming engine, there is no desktop, icons or menu bars, only content arrayed in three-dimensional space. Depending on the application, the content might contain Web sites, your personal documents and files, information on a CD-ROM or a digital TV electronic programming guide.

To explore the content on screen, you position your cursor using the mouse, click and watch the screen objects move toward you, filling the screen as they approach. The fluid motion is reminiscent not of a typical Windows-style computer, but of a high-powered video game. As the screen view changes and the objects on the screen move closer, your can click on an approaching object and thus activate its content, revealing pages and images that then fill the screen.

Screen objects can contain any kind or amount of information. Unleashing the text, images, video or sound in a screen object doesn't require an application to open it. The information opens automatically. Once opened, pages and images can be moved, resized or cropped using the mouse. At the bottom of the screen, you find the MediaBin, which helps you transfer objects from the screen to your hard disc or memory buffer. Next to the MediaBin is the Navigation Ring, which functions like a jog-dial and makes it easy to zoom in or out or pan across the screen and zoom in that direction. Next to the Navigation Ring is a list of Views, which let you jump quickly from one place to another.

These navigation tools allow you to manipulate media space directly, without an iconic layer of abstraction. Since the Zooming User Interface uses the entire screen, interface elements remain until

To illustrate how zooming unleashes content from the confining structure of the page, the ZUI design team at DC/New York, led by design manager Andy Proehl, created a computer-based demonstration that shows how an on-line edition of the *New York Times* might look with a zooming interface. One version offered a hub-and-spoke structure as you zoom into the screen (top); another arranged contents in a descending spiral (above); and a third version offered information in a more free-form manner (below). "The goal of the *New York Times* demo was to give the user an immersive, analog feeling that breaks away from the page metaphor," says Proehl. "The effect is somewhere between a PC and a TV. You zoom into the screen to see more content and zoom out when you feel you want to go somewhere else." All three approaches shown in the *New York Times* demo allow users to explore complex information in a more intuitive and entertaining way than in a conventional windowing interface. "When we read a newspaper, we zoom with our eyes all the time without realizing it," says ZUI design director Kei Totsuka. "But reading on paper is a 2-D experience. With a zooming interface, it becomes a 3-D experience," one that renders the conventional page metaphor obsolete.

an object comes into focus, resulting in a minimalist user-interface design.

The difference between Zooming and Windows is obvious. The biggest failure of a windowing environment is the inability to display pages in context of each other. "When using a Windows-based environment, we look at information one page at a time in a *linear* fashion," says Proehl. "Yet Zooming displays information in a *relational* manner—which is much closer to the way the human mind works. It's free form, like people, not rigid like a machine."

By arranging content in a relational manner, WaveCatcher records a Web browsing session by providing users with a continuous visual trace of all pages visited during the session, known as a spiral. The process of spinning a Web spiral is simple. When a new page appears, older pages recede behind it in a circular pattern. Spirals can be saved, edited, printed and detached to start new Spirals.

Zooming also allows huge amounts of visual information to be accessed on a relatively small screen by transforming a Web Spiral into two alternate shapes: a Tree or a Grid. The Web Tree arranges a group of Web pages with branches diagramming links. A Web Grid displays pages and sites in a compact series of columns and rows. The user can change the Spiral, Tree, or Grid to display

pages, bookmarks, titles or links. It's also easy to sort a group by date, title or address. By transforming the Web from a page-based experience to a session-based paradigm, WaveCatcher's Web Spiral presents pages as a time-based series. The Spiral grows as new pages appear in front of old ones. Yet the Spiral always occupies a finite amount of screen space—allowing access to a few, or to hundreds, of interconnected pages.

Next time you switch on your TV, imagine how a WaveCatcher interface would transform your viewing experience, with video content, photographs, magazines and links to your favorite sources for music and news arranged in a fluid Zooming environment. Unlike, today's Windows-based interfaces or the PerfecTV interface shown elsewhere in this book, the Zooming User Interface favors a continuous inflow of data, allowing you to continually explore or receive data using PUSH technology—setting the stage for a new kind of consumer media technology that exists somewhere between conventional television and a personal computer search engine that operates continuously.

Given the narrow bandwidth of conventional telephone lines and the lengthy download times that sometimes result, this personal data gatherer can be programmed to download content at night, when networks are less crowded and data transfer rates are higher—allowing interactive magazines

filled with multimedia information and entertainment to be downloaded overnight.

To demonstrate this potential, the ZUI design team created a prototype on-line music magazine called *Muz*, which contains text, still images, video and music in a Zooming environment (see page 160 and 165). Once the magazine appears on the screen, you zoom in, the content moves closer, and as you activate one part of the screen, the content contained there reveals itself automatically. The density of information and the unique combination of images, sounds and words will take your breath away. Even more stunning is the interaction, which combines the precision of a PC with the "gotta have it" quality of PlayStation. *It's fun.*

The Zooming User Interface follows the classic principles of software design:

- The underlying code is *efficient*, ensuring quick response using microprocessors of moderate speed (150MHz Pentium) with modest amounts of free RAM (6 to 8 MB);
- The software is *forgiving* (if a user gets into trouble, the interface allows him to recover);
- It is *flexible* (it can perform its intended function without any change in a variety of situations and be used in various systems with little or no modification). Flexibility in modern systems is difficult to design and execute; and
- The interface has *conceptual integrity* (it uses a limited number of design forms in a uniform manner. Design forms include the way data is organized and displayed, mechanisms for component communication and the way components inform users of an error condition).

Other in-house demos explore the use of the Zooming metaphor in an on-line shopping catalog, an on-line photo archive and an on-line version of the *New York Times* (see page 163), which turns the familiar 2-D newspaper into an exciting multidimensional experience. Because the Zooming effort has been secret until now, the *Times* editors have not yet seen what twenty-first-century design and technology could do for the Old Gray Lady.

Since most of the content on the Web and in dedicated servers will be static information—waiting

to be downloaded, rather than live real-time content like today's broadcast television—the Zooming experience allows this "dead" information to spring to life. Unlike current Web data, which seems flat and lifeless, the ZUI animates the experience, encouraging us to use the system simply because it is fun.

True to Sony's design philosophy, the Zooming interface adds entertainment to a serious navigational tool—giving users the best of both worlds.

As a strategic multiplatform vision, the Zooming User Interface is Sony's answer to the growing demand for digital information—whether it comes from the Web, via satellite, though DTV cable or home-based networks. Zooming gives the user direct and continuous access to vast storesof multimedia information, bypassing the restrictions caused by conventional interfaces, especially on small- and medium- sized screens.

The design concepts behind the Zooming Project are a much larger strategy and effort within Sony to change the way we organize and enjoy information provided by Digital TV, the Web, AV products and a variety of display technologies, such as handheld electronic books. By the time you read this, Sony's ZUI team will be putting the finishing touches on a range of products that will allow television viewers and music fans to enjoy the experience of zooming right away. These include an electronic programming guide for use in satellite and cable TV, interactive advertising both on Digital TV and the Web, on-line magazines and recorded programs.

"The detail and beauty of Zooming is totally Sony," says designer Sciammarella. "The attention to aesthetics that you see in the beautiful finish of a Sony television runs throughout the ZUI design, from the overall concept to the most subtle interaction. The symbolism, the directness of our approach and the innovation inherent in our design all hark back to the company's original mission statement . . . to make each product do what has never been done before."

With the Microsoft vision dominating user interface design, it is both odd and fitting that a firm like Sony, known for innovative hardware but a relative newcomer to software, would be the one to invent such a revolutionary approach.

Rather than replace one monopoly standard with another, the Zooming User Interface, coded in Java and suitable for all screen sizes and applications, answers Nobuyuki Idei's call for "an open architecture that will enable the seamless integration of PC and AV products."

"Zooming represents a fundamental shift in the way we relate to electronics," says Sony's Tom Grauman. To illustrate, he demos a "reverse zoom" technique that starts with a classic Windows screen. Then, as the screen view pulls back farther and farther—shrinking the Windows screen, and with it the entire Microsoft universe, to a single pixel—new worlds of interaction come into view. "This is just a demo and more symbol than reality for the moment," says Grauman. "But the Window on your screen will eventually be subsumed into a vastly larger digital space. And that day is coming sooner than you think."

Below: The potential for on-line magazines using the zooming metaphor is unlimited. Here we see a detail from the *Muz* magazine prototype developed by the ZUI team at DC/New York and the design firm IO 360. To access this screen, the user simply zooms in that direction. On the bottom of page 160, we see the graphic containing the Sullen Girl in the lower right corner of the screen. By zooming into that graphic, the text and images expand to fill the screen, as we see on this page. Zooming into any element of this screen reveals yet another layer of content.

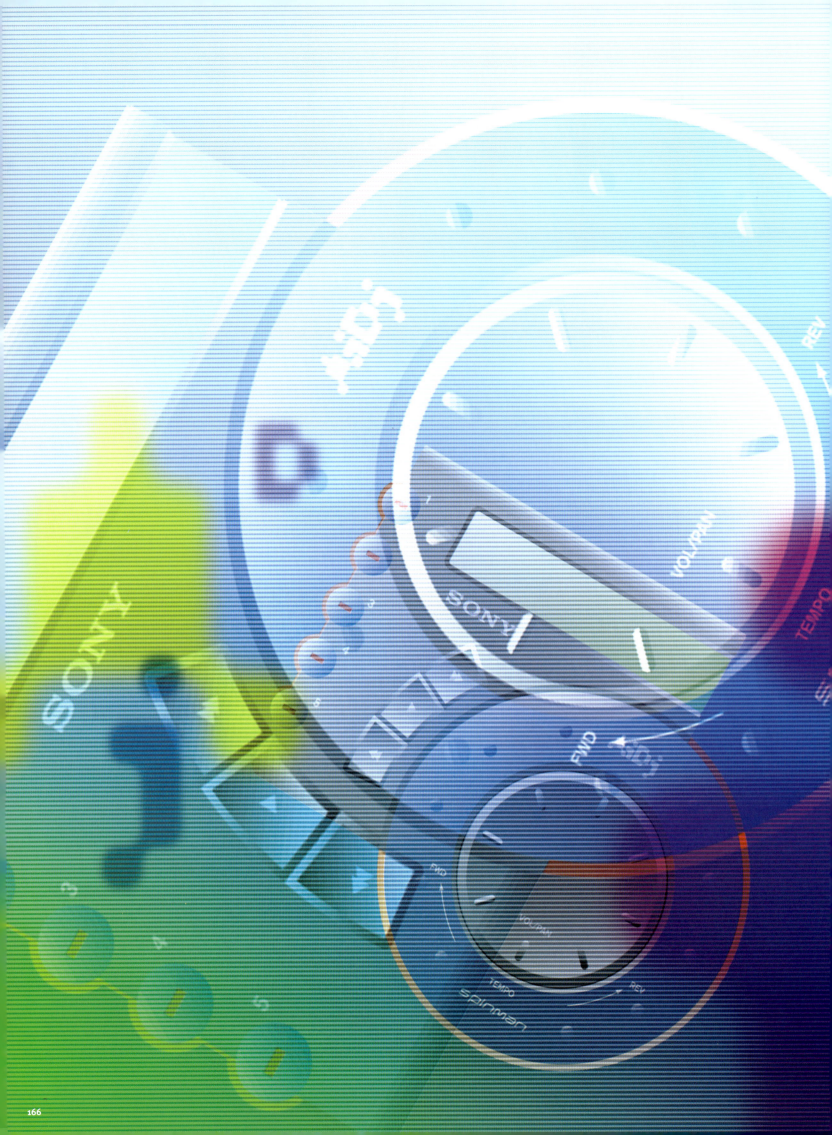

Like all classic Sony designs, the concept called AIDJ (Artificial Intelligence Disc Jockey) began as a beautiful idea that was quickly translated to story boards and developed into a highly visual jaw-dropping computer demo. The work of user interface designer Eduardo Sciammarella at Design Center/New York, AIDJ "explores different modes for controlling electronic music, showing how digital media and visual computer-generated controls will change the way we create and relate to music in the future." A true "creation product," AIDJ allows the user to mix and remix prerecorded sounds into new compositions. As such, it is more than a recording, playback and mixing tool. It paves the way for a new breed of electronic instruments—fusing the vast library of stored sounds with the fast-and-dirty DJ culture of urban music.

"As a designer, I like to explore the interaction between hardware and software, between the physical 3-D product and its 2-D interface," says Sciammarella. "Therefore, I designed foam mock-ups of AIDJ's hardware components, then addressed what we see and do with the screen." These include: SpinMan, a handheld multitrack MiniDisc controller/recorder/playback unit with a large LCD screen; CD SpinMan, which uses recordable compact discs instead of MD; and SpinBox, a boombox device with both MD and CD, a larger screen and built-in speakers. "Once I had these hardware images in mind, I could visualize the interface more clearly."

It starts with prerecorded sounds or tracks, which appear on the AIDJ screen as album covers that can be manipulated in several interesting ways. "The way you access the tracks is straightforward. You load the branded AIDJ media into the SpinMan or SpinBox, decide how many tracks your musical piece will contain, divide the screen into a grid and position your album covers into the grid," says the designer. "Some icons may contain songs, background elements, voices or other sounds. The fun begins when you mix elements from the multitrack MD and interact with the icons on the screen, increasing or fading volume, balance and other aspects of the sound with your fingertips." With practice, it's possible to "play" an AIDJ device like a musical instrument. "There are many possible futures for electronic music," says Sciammarella. "I want the AIDJ concept to be one of them." It's not a real product yet. But it has potential. Let's tour the system and see if you agree.

MD SpinMan
A handheld, battery-operated multitrack MiniDisc player/recorder/controller, MD SpinMan interfaces with a touch screen on a desktop or portable computer, has both a jog-dial and conventional button controls, allowing the user to mix sounds from up to 12 separate sources, including prerecorded and user-programmable MiniDiscs. Can also be used with a larger separate screen.

CD SpinMan
Like MD SpinMan, the CD version uses CD media and can record mixes and compositions using its recordable CD drive. Because of the larger size needed for such a mechanism, CD SpinMan echoes MD SpinMan's round shape in a product suitable for laptop (rather than handheld) use.

SpinBox
A powerful boombox for MD and CD mixing and recording, SpinBox has a large professional-sized screen and a unique speaker design with louvers that allow sound to be directed toward the audience (during live performance) or toward the creator (while composing). Appropriate for its audience, SpinBox looks like a professional tool.

Blank Media
Users can record their own source sounds and store mixes generated on an AIDJ machine using off-the-shelf multitrack MD media or recordable compact discs.

Pre-Mixed and Branded AIDJ Media
The system can also accommodate prerecorded sounds, both professional and amateur, allowing AIDJ users to tap into a limitless library of source material or swap tracks with their friends. Whole songs or song elements could be recorded on multitrack MD for mixing into finished compositions on SpinMan or SpinBox.

Music Mix Opening Screen

The most basic AIDJ program is called Music Mix, which is stored in SpinMan's memory and can be called up to begin the mixing/composing/recording session. The user begins by loading sound sources from a MiniDisc or CD onto individual tracks in the SpinMan or SpinBox machine. These sound elements then appear as icons that resemble album covers on the AIDJ display. They line up in a neat row and serve as visual indications of the sounds they contain.

Music Mix Screen Layout

With the sounds loaded onto tracks and the icons lined up, we notice that each sound is encircled by two tiny rotating balls, which represent music speed, or tempo. At first, all sound source icons are of the same size (and thus the same volume), and all the orbiting balls are rotating around their sounds at the same tempo.

Music Mixing and Manipulation

As you push the sound sources around the screen with your fingers, the icons increase (or decrease) in size (and thus volume) in relation to their position on the screen. The speed of the orbiting balls around each sound source can also be controlled. By programming the SpinMan, for example, we can nudge icons to the bottom of the screen to increase the volume of individual tracks, adjust the tempo and move the balls to the left or right to achieve the proper stereo imaging, thus creating a unique musical mix that we can play with and manipulate to our heart's content.

From Manipulation to Composition to Recording

Sound sources can be controlled manually or in an automatic or random fashion. They can be turned on and off, faded or increased and manipulated using the zooming metaphor, browsing and exploring sounds that never appear on the prerecorded tracks. Sound collage possibilities quickly turn music manipulation into original composition. The remix becomes an original piece of music. And the screen representation can serve as the cover art. Once the desired mix is achieved, the user can create a "loop" that stores the sound mix in memory, allowing it to be replayed and recorded in real time using controls at the top of the screen. The resulting digital soundtrack has no loss of fidelity and is as unique as the user wants to make it.

Sound Seek

Another method for mixing and creating sounds is a program called Sound Seek. Faster and more immediate than Music Mix, Sound Seek allows many different sound sources to be archived in the system and represented on the screen as colored dots that are spaced and sized for easy finger access. The prerecorded sounds function like clip art on a personal computer. The number of dots on the screen is limited by the number of prerecorded sound sources loaded into SpinMan's memory. Each sound becomes "active" the moment you touch that dot on the screen and decays the moment you lift your finger.

Seeking Subtlety

The brilliance of this idea becomes apparent the moment you touch the screen. First-time users will be sorry they have only ten fingers. But after a few minutes of playing, you soon learn that the beauty and potential of Sound Seek is best achieved by adopting the "less is more" approach. Blending and variety of sound become more important than sheer volume. Using the "sound dropper" technique, you can also touch the screen in a way that radiates an effect on all the sounds on your screeen, like a pebble dropped into a pond. The radiating waves affect the sounds in a unique and interesting way. Sound Seek is more than a musical collage; it's the first glimpse at an entirely new kind of musical instrument— as subtle as a piano and as wide-ranging as an orchestra. If Sony ever decides to release this software commercially, it will be a runaway success among electronic musicians.

MD Mix

Creating an album cover for your new creation is accomplished by downloading graphics that come with your prerecorded sound sources with a simple drag-and-drop motion and mixing them in the same intuitive way that you mix sounds.

MD Mix Interface

Individual graphics from your sound sources appear as colored panels, which the user can combine manually or allow the machine to mix in an automatic fashion. The resulting graphic is as unique as the sounds they represent.

Presentation Design: TANK

One of the most intriguing Design Center concepts in recent years is a worldwide system for delivering electronic music on demand, known in the industry as EMD or eMusic. Long before the invention of recording devices, our music experience was defined by, but limited to, live performances: one-time events shared between audience member and artist. The introduction of recording devices, such as the gramophone in 1889, changed that forever. The advent of radio in

A concept for a MiniDisc Walkman with a built-in LCD introduces the Design Center's eMusic demo program, completed in April 1998. Executive Producer: Keiichi Totsuka. Project Leader: Rich Gioscia. Design Team: Yumie Sonoda, Jan-Christoph Zoels and Eduardo Sciammarella. Design Consultants: John Maeda and Antenna Design. Presentation Design: Funny Garbage.

1910 gave birth to the music industry, creating diverse musical styles and expanded listening audiences. Long-playing records, introduced in 1948, allowed us to bring music into our homes. New subcultures and lifestyles emerged. Music became part of our lives. In 1964, audiocassettes allowed us to record from our LPs and radio, controlling the music we wanted to hear (and didn't want to hear). Music became more personal, and with the Sony Walkman in 1979, became portable as well, allowing you to take your music with you. In 1983, the compact disc introduced high-quality digital sound in a simple,

nearly indestructible format. And random access, offered by the CD player in 1985 and later by the CD changer, provided us with even more control over our listening experience. Cultural and technological milestones, such as MTV (1981), personal computers and the Internet (1983) expanded our perceptions of music as entertainment and altered our lifestyles more quickly than we could have imagined. eMusic is designed to build on these innovations in ways that will transform the way we experience music and entertainment. But achieving this goal requires a series of steps, the first being a persuasive and coherent vision that shows how an actual eMusic system might look and perform. In 1998, DC/Park Ridge, New York and San Francisco collaborated on a computer-based demonstration program that showed nine variations on the eMusic concept. Using their vision and visualization skills, the Design Center created these "views of the future" so that engineers, product planners, content providers and senior management could see what is just over the horizon and take advantage of potential technologies in the early stages of development.

The design process began with a series of brainstorming sessions among Design Center members as well as outside consultants Antenna Design in New York and John Maeda in Boston. They identified the range of potential users for a broad-based eMusic system; decided what these users would want from such a system; explored the simplest means for delivering these products and services; and, ultimately, created both 3-D concepts and 2-D user interface designs that have Sony Style.

Currently, there are a number of on-line music stores—including Cdnow, Music Boulevard, Amazon.com and Tower Records—which replicate the results that mail-order companies such as Columbia House and BMG have already accomplished using traditional means of distribution.

But such on-line services pale in comparison to the Design Center's concept for eMusic, which includes home networking, wireless data transmission and downloading from the Internet. Internet transfer can be accomplished using a technique called streaming, in which music that is of less than CD quality is downloaded and played in real time; or higher quality music can be downloaded at night, as the user sleeps, when Internet traffic is lighter and transfer rates are higher, allowing high-fidelity files to be gathered for later playback. Since many companies will probably offer their own version of eMusic, each with the same range of services, success will belong to the system that delivers the richest overall experience and offers ease of use that far exceeds anything we know today. With a cultural dimension that communicates on both an emotional and a spiritual level, this kind of design builds brand awareness by attaching itself to the user's heart and mind and not merely his or her pocketbook.

Recent trends in the music industry indicate that a growing percentage of listeners want to personalize their music, recording mixes of the songs that they want to listen to and formatting their CD collections to satisfy their own particular tastes. Most people also prefer to sample music before they buy it. Gone are the days when people will buy CDs that contain only a fraction of the music they truly want to own.

This profound shift in musical taste and buying habits means that the system most likely to succeed will be the one that provides customers real-time sampling as well as the ability to download individual songs rather than entire albums, so that users can create their own customized compilations. The goal for eMusic is to elicit discussion on the development of a next-generation music distribution system, address the needs of potential music purchasers alienated by today's retail environment, promote artists more effectively and bring more value to the music consumer by delivering a higher level of convenience, catalog availability, personalization and mobility.

The benefits to the user will be: a much richer, more personal user experience; true convenience, immense diversity; the ability to sample before purchase; easy searching; and user profiling that would allow the system to provide regular updates using PUSH technology.

The market for this kind of service already exists. According to Jupiter Communications, a New York–based research firm, the on-line music business will grow to $1.7 billion by the year 2002, representing 7.5 percent of the entire music market. The most desirable segment of this market—the 25- to 34-year-old age group—has grown most quickly and now represents 30 percent of the on-line population. Thirty-two new music Web sites are listed on the Yahoo search engine every day, or about 930 new sites each month. And by the year 2000, 67 million households will be on-line. Considering these numbers, the potential for a new product like eMusic stretches far beyond music delivery. Books, news, movies, education and other forms of digital media can follow the same model, offering listeners, viewers, readers, students and shoppers

eMusic will revolutionize the way we perceive and experience music and entertainment.

virtually anything, anytime, anywhere. The eMusic demo recognizes that new forms of music delivery will be needed that can give listeners maximum choice and the ability to customize their musical selections with greater ease of use at moderate cost. eMusic also takes the concept of convergence a giant step forward by eliminating the separate component structure of linking a 200-CD changer to a computer. To become a seamless experience, the Design Center predicts that eMusic will ultimately be delivered via either cable modem or a dedicated T1 or ISDN connection.

The key to eMusic's success will not depend on technology, hardware or infrastructure alone. Indeed, the most critical element will be the 2-D software interface—the point at which consumers either embrace the system or turn away. The Design Center's task is to make them stay tuned. The scenarios presented on the following pages are mere seeds of ideas now being pondered at the Design Center. As project leader Keiichi Totsuka says, "This might be just a designer's dream. But dreams can be realized." This one should be.

Net Receiver

 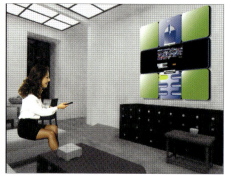 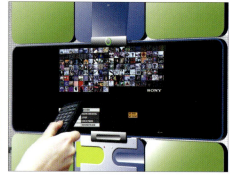

Media: Mini-Disc, Compact Disc (stored in 200-CD changer) and flash memory. Connection: Cable modem; ISDN or T1 line. Interface: GUI. Playback location: Home.

Net Receiver. A visual media browser, Net Receiver simplifies interaction with CDs stored on a 200-CD changer by offering random access to the user's collection, visual and text data about each title and artist, as well as liner notes, cover art and concert information (automatically downloaded from the Web). Our prototypical user, Debbie, says, "I want to browse my collection . . . to know more about an artist, liner notes, cover art, concert information, inspiration . . . I want to sing along." On the wall, we see a simple sound system with a CD changer, MD recorder, four flat panel speakers and a display that lights up at the click of Debbie's handheld controller. On the screen, we see a graphical user interface that displays Debbie's music collection, grouped into categories (jazz, pop, classical, reggae, etc.), and provides access to broadcast or streamed entertainment via the Internet. When Debbie clicks on a category, all discs in that category illuminate. She samples music from each CD by clicking on the cover graphic. She clicks again, and the screen fills with the album's cover art and song lyrics with instant Net access to updated concert information and a discography for ordering other discs by the same artist. If Debbie wants to record to a MiniDisc, it's just a click away. Several Net Receiver devices throughout the house can be connected via a HomeNetwork.

eMD Walkman. Here we see Priscilla, age 16, in her bedroom, saying, "I want to make quick recordings easily. glance over my contents quickly . . . I want to read liner notes." On her bedside table we see a toaster-sized appliance with a pop-up touch-sensitive screen that functions like a mini Net Receiver and connects via the Home Network. As

Priscilla scans her music collection on the screen, she decides to go rollerblading while listening to music on her eMD Walkman. To make a disc, she touches various album cover icons on the screen of her bedside component and drags each icon to a collection point at the corner of the screen called "Make MD." She then drags icons representing liner notes, cover art and other visual content for each selection to another collection point labeled"Make MD RGB." Using this system, Priscilla can drag (and thus record) entire albums or individual selections in any order. Once she makes her selection, an MD recorder on the wall next to her bed downloads the music and other data from the Home Network (which includes a 200-CD changer and VAIO computer, stored in a cabinet or closet) to a MiniDisc. One minute later, the disc pops out. Priscilla inserts the disc in her eMD Walkman (see page 170). As the music fills her ears, cover art, liner notes and lyrics and other imagery appears on the screen as she roller-blades down the street. The style of interaction in this concept is just a short step away from the CD-changer/VAIO computer/MD recorder combination that you can purchase today. The difference is the design of the interface and the tight integration of various functions into a seamless product, giving the novice user full access to their media without having to operate separate components. This intelligent system anticipates her wishes and executes her commands. If Priscilla had wanted to read an eBook instead of listen to music, she could have downloaded an AudioBook with pictures and other visual data on an MD and played it on the same eMD Walkman.

Media: Mini-Disc, Compact Disc (stored in 200-CD changer) and flash memory. Connection: i.LINK (IEEE 1394). Interface: GUI. Playback: Mobile.

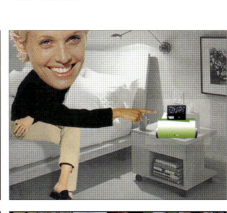

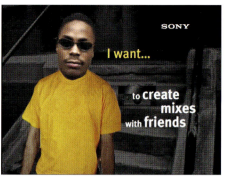

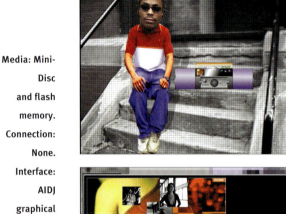

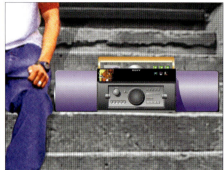

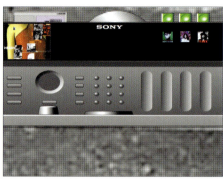

Media: Mini-Disc and flash memory. Connection: None. Interface: AIDJ graphical user interface. Playback location: Street, club, home, anywhere.

AIDJ. Based on Eduardo Sciammarella's AIDJ concept (see pages 168–71), AIDJ embraces the electronic music subculture with a product that offers visually interactive mixing and programming with boombox portability. Sitting outside his NYC apartment, we see Fred, a part-time DJ, aspiring composer and music producer, saying, "I want to interact with and enhance my music . . . create mixes with friends . . . and perform my digital creations." At his feet, we see Fred's boombox with built-in speakers, CD and MD recorders and an intriguing little screen with icons bouncing around

like characters in a video game. Each icon represents a different track in a multitrack musical mix. The pre-recorded tracks (either commercial sounds that Fred purchased or 'raw' sounds that he recorded himself) are loaded into the boombox. As each sound is loaded, an icon representing that sound appears on the AIDJ display. Each icon (and the sound it represents) is a free-floating entity. As an icon moves toward the top of the screen, it grows larger, causing the volume of that track to increase. As an icon moves toward the bottom of the screen, it grows smaller and fainter. As the

icon moves right or left, the sound shifts between left and right channels. With his fingers, Fred manipulates these icons on the AIDJ interface like the keys on a synthesizer, blending the various sounds while creating a unique musical mix that draws listeners from up and down the block. He records his mix for later playback and allows his friends to step in and make their own music mixes.

Tune (not shown). A device for receiving live audio and contextual information via dedicated digital broadcasting, Tune allows our typical user, Eric, to enjoy music while traveling on the subway.

Saying, "I want to access streaming audio on the go . . . and get musical suggestions," Eric pulls a pen-shaped digital receiver from his pocket, dons his headphones and uses the tiny screen to tap into a dedicated broadcast server, calling up music and information on his favorite bands. Reading lyrics as each song plays, Eric samples 30-second selections of new artists and bookmarks his favorite selections for later listening.

Baseball Card. An easy way to sample and share digital music on low-tech paper media using a simple wireless device, Baseball Card is the music medium of choice for Bucky, a street citizen, who says , "I want to belong to a music community . . . I want to share my music . . . I want to collect music links." Bucky always travels with a skateboard at his feet and his Baseball Card reader hanging from his belt. Stopping at a local newsstand, Bucky buys the new edition of *Tunes*, removes one or more "sound cards" bound into the magazine, each containing a few minutes of encoded music. He inserts a card into his Baseball Card reader, music fills his ears, and he rolls away. Later, Bucky meets his skateboard buddy Lance.

They exchange Baseball Cards, slap high fives and roll off together.

Music Flyer (page 176). Another innovative use of print media, Music Flyer offers a targeted system for music promotion. To demonstrate, we meet Robin, a young music professional, club owner and promoter, who says , "I want to sample music . . . encounter new releases and genres, and promote artists playing in my club."

Standing in front of her club after a performance, Robin distributes pre-printed flyers with artist information and encoded magnetic strips

Media: Cards with embedded audio files. Connection: None. Interface: Printed cards. Playback: Anywhere.

Media:
Cards with
embedded
audio files.
Connection:
None.
Interface:
Printed cards.
Playback:
Anywhere.

containing a 30-second music sample and data for accessing additional information and ordering music from the Web. We take the flyer home, use a disc-shaped reader to collect the information from the magnetic strip, upload it to our Net Receiver, sample the music, read the accompanying cover art, liner notes and band information and order the group's latest recording from the Net for download to our system later that night (when Net traffic is lower and data transfer speeds are higher).

eMotivator. A kiosk for acquiring music in remote locations, eMotivator offers instant access

to networked digital music for one-time listening. To demonstrate, we see Beth at her local health club, saying "I want to buy music on-line at the right time and place." On her wrist is a watch-sized eMD recorder/player that uses chips for temporary music storage. Before exercising, Beth samples various tracks at the kiosk, makes her selection, downloads an hour's worth of music to her wrist device using wireless transmission, then proceeds with her workout. Rather than bring her music collection from home, Beth can enjoy all the music she wants, in a convenient pay-per-listen arrangement.

Big Ear. Many listeners want to experience live events at home using digital AV but cannot find information for accessing their favorite broadcasts. To demonstrate, we see Meredith at home, who says, "I want live access to concerts . . . to feel like I'm actually there." Browsing through her monthly magazine listing opera performances from around the world, Beth notices a concert at La Scala. She removes a disc-shaped device from her Big Ear receiver, clicks on a circle in the magazine, which reads encoded data containing the frequency on which the closed-circuit digital

Media: Flash
memory.
Connection: T1.
Interface:
GUI .
Playback
location:
Retail or event
locations.

Media: Live transmission. Connection: Cable modem, ISDN, T1. Interface: Paper/scanner. Playback location: Home.

broadcast will appear, returns the disc to her Big Ear receiver and marvels as the descrambled pictures and sounds stream into her living room. When the concert is over, Beth's Big Ear account is charged a few dollars for the service.

Auto Channel. An intelligent networked car radio, Auto Channel provides wireless download of home audio library, personal profiling of musical tastes and smart agent capability to alert the user to upcoming events. Here we see Roger gesturing to his VW Passat, saying, "I want to access

my music anywhere . . . and go to where my favorite music is playing." Using a remote commander, Roger downloads music from this home-based Net Receiver to Auto Channel. On the dashboard, we see a touch-sensitive screen with cover art and selection information loaded and ready for playback. While driving and listening to music, Roger receives an Internet alert advising that his favorite band Jamiroquai will be playing at a local club and is guided to the club using graphical/text/audible directions from a GPS system.

As Internet commerce grows, systems such as eMusic will soon become ubiquitous. Already, Sony has patented all relevant eMusic technology and concepts and is now working on the promise hinted at in this demo. In addition to music, the eMusic concept can harness the power of the Web to distribute all kinds of digi-data—such as eBooks, eMovies, eNews and eGames—effectively bypassing current channels of sale. In short, the eMusic vision could fundamentally alter Sony's entire business model.

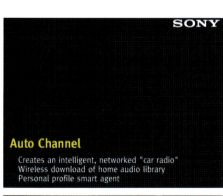

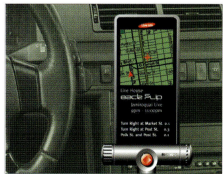

Media: Flash memory, MD. Connection: FM, Wireless telephony. Interface: GUI, Speech recognition. Playback location: Car.

177

Digital Dreams

Look at every leading corporation, and you will find that designers not only provide the vision that engineers, product planners and management need to develop a coherent product line, they make that vision seem inevitable by creating believable concept models that narrow the gap between what can be and what will be.

Because of their sensitive nature, most Sony concepts are rarely shown outside the company and are almost never published. The reason, says DC senior general manager John Inaba, is simple: "Even a ten-year-old idea can have functional and aesthetic features that are useful to us today. At Sony, advanced concepts are treated like fine wine. We can choose to drink them right away. Or we can put some of them away for the future and not push them into the market too soon. The best ideas never go out of style."

The belief in conceptual thinking is so strong at Sony that the closets, shelves and hard discs at the Creative Center and Shibaura Technical Center in Tokyo, the B&P Group in Atsugi, the Park Ridge Design Center and offices in San Francisco, Singapore and London are filled with drawings and models that may one day become products that help to define the digital future. Some represent incremental improvements on existing technology or put a current product to a new and interesting use. Others are so daring they may never achieve product status. But dreaming is what designers do best. And technical feasibility is not always the first priority. According to Mr. Inaba, "the designer must never restrict his or her thinking to what we can achieve with today's technology. Because ideas that were unthinkable a few years ago are now commonplace." A classic example is the 1991 concept by DC/Tokyo designers Haruo Oba and Junichi Nagahara called Noise Art. Taking the idea of personal audio to a new level, the designers envisioned a portable system that creates music in response to the user's state of mind as well as ambient sounds in the immediate environment. Using sensors that read the user's blood pressure, pulse, skin temperature and brain waves, the Noise Art unit converts

Noise Art, a concept for a biofeedback Walkman that creates sound in response to the user's vital signs (such as heart rate and blood pressure) as well as ambient sounds in the user's environment. Design: Junichi Nagahara and Haruo Oba (DC/Tokyo), 1991.

these signals into sound waves using a complex biofeedback mechanism and plays the sounds through a headphone/head sensor unit. As the user's moods shift from moment to moment, the sounds from the unit respond in kind, offering a unique range of sounds for each user as it creates an ambient space in which any journey is possible. When the Noise Art concept was first unveiled in 1992, most observers dismissed it as fantasy. But, today, the design is technically possible. Indeed, aspects of Noise Art's man/machine interaction have already been included in the SonicFlow software bundled with the PCG-C1 subnotebook computer (see. page 134).

The ten concepts that follow share at least one comman goal: to inspire Sony's engineers to develop the technologies and products that the world will need at the dawn of a new century. Before this book is published, some of these ideas, a few conceived less than a year ago, will already be in users' hands. "Our design concepts always try to fulfill specific needs," says Mr. Inaba, "always pushing as far into the future as we can, but tying those visions to a business model that allows the designs to become real."

These concepts, many of them published here for the first time, represent the Design Center's vision of the future. Behold.

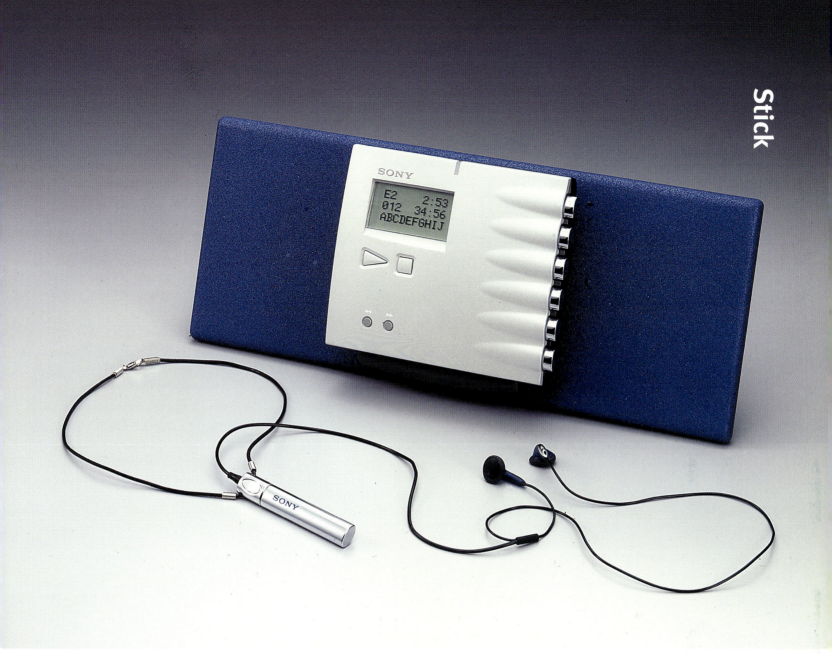

A tabletop CD and MiniDisc player with integrated speakers may not seem like a revolutionary idea. But look closer. Along the right side of the central unit are six circular slots, each containing a four-inch-long metal cylinder packed with memory chips. These sticklike memory units function as digital media. While inserted into the main unit, you can download music from a compact disc or MiniDisc to the Stick, remove the cylinder, attach a tiny device to the end of the Stick (containing a headphone port, a tiny amplifier and battery) and enjoy up to an hour of digital sound. This solid state Walkman-type device has no moving parts and can be re-recorded again and again. With the Stick

system, digital duplication will never be easier. To ensure the longest possible playing time (as well as to appease record producers concerned about unauthorized copying) the Stick system, or its real-world counterpart, will probably use sound compression that is greater than today's Minidisc . . . a minor concession when compared to the huge advantage that such a system will provide to casual music listeners. As the Stick concept neared completion, Sony's engineers began work on a real-word version using a technology called Memory Stick (see pages 188–93), which industry watchers predict will become the next form of digital media, ultimately replacing the disc and tape technology that we know today.

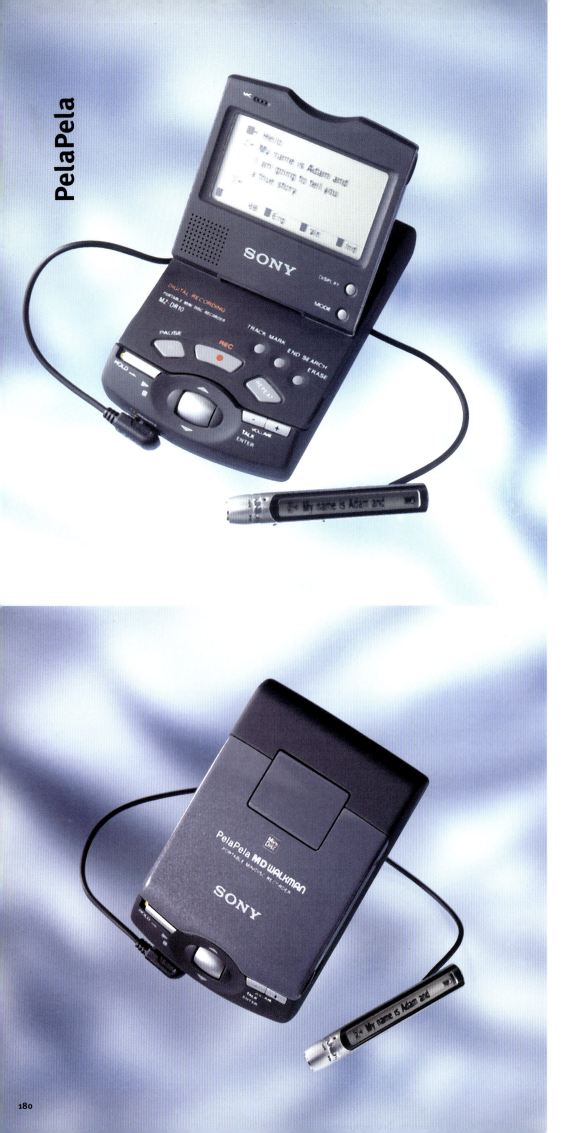

Often the most interesting design concepts do not propose bold new technologies or envision some mythical future to justify their existence. Rather, they take existing technology and put it to a new use that its inventors never considered. This was the case in 1996, when the interaction design specialist Yukiko Okura took a standard portable MiniDisc player in 1996 and mounted it inside a clamshell case with a hinged black and white LCD display and control buttons up front. Instead of playing music, the MiniDisc in this concept, known as PelaPela (which translates from Japanese as "fluent speaker"), contains language instruction and repetition exercises that appear as phrases on the LCD screen, or as spoken text through the unit's built-in speaker or headphones. Designed for maximum functionality, minimal product size and an eye-catching, hand-friendly shape, the PelaPela unit can be used on a tabletop, in the palm or be tucked into a pocket or knapsack when used on a subway or bus (where instruction continues by using a stick-type view screen, based on Sony's existing MiniDisc controller, designed by PAV genius Daisuke Ishii) instead of the larger LCD. Since repetition is essential to effective language learning, PelaPela makes full use of the MiniDisc's random access capability, allowing the user to scroll through common phrases using a built-in rolling-type controller and to replay phrases by selecting the words on the screen and gently pressing the roller (which remains exposed even when the unit is shut). Since MiniDiscs can hold up to 70 megabytes of digital information, the PelaPela concept can maneuver through a book-length language instruction course on a single disc. Other versions of the concept—such as a student model containing college entrance testing materials—could allow this design to serve a wide and diverse audience. A recordable version, which could receive updated information via the Internet, is quite feasible. When the full potential of the concept is realized, a billion-dollar industry could easily result.

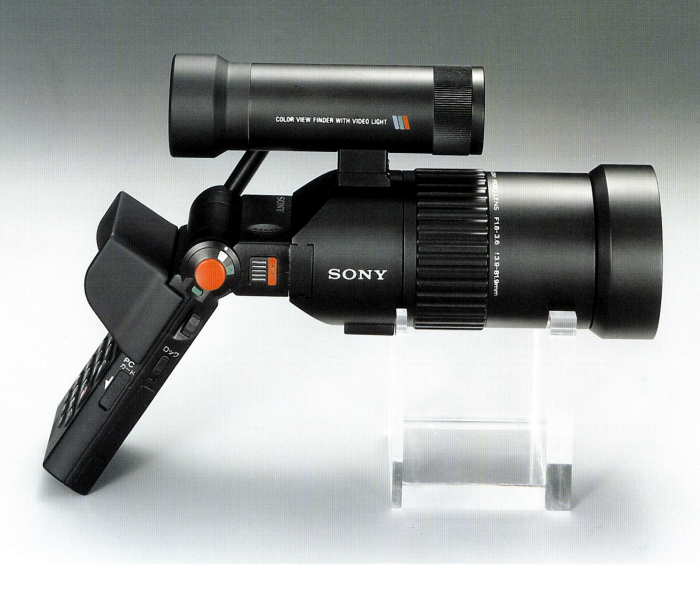

Among the many limitations of video recording are the time length of the media (be it DV tape or disc) and the problem of transmitting the captured images to your intended audience. For network broadcasters with satellite links and mobile video units, this is no problem. But what about the rest of us? As cellular bandwidth increases, digital camera designer Akira Yamazaki envisions a day when a consumer video camera can utilize satellite transmissions to send video images via the Internet to a remote server, allowing both professionals and amateurs much greater flexibility than they currently enjoy. This mixed use of existing and future technology shows what is possible when a designer allows himself or herself to dream.

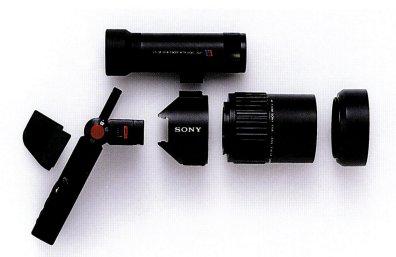

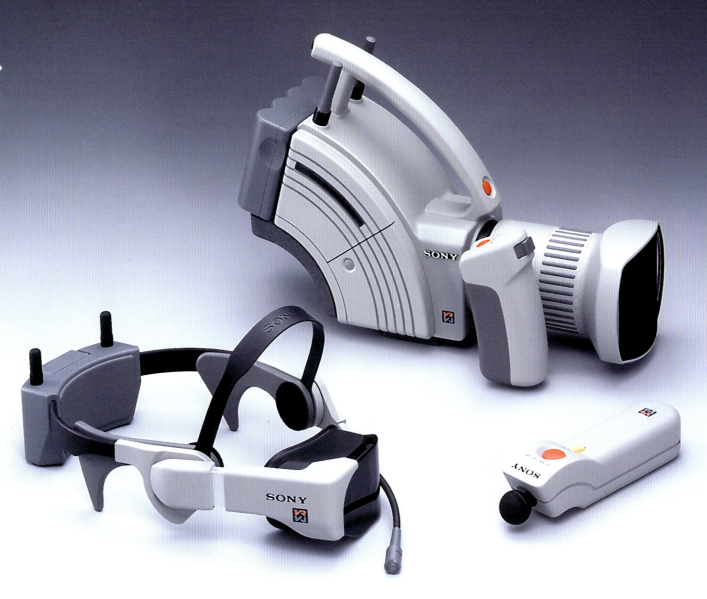

By combining a conventional digital video camera with a modified version of the Glasstron head-mounted display (with only one eyepiece instead of the Glasstron's stereo vision) and a handheld remote control/microphone, the VRVJ (Virtual Reality Video Journalist) concept, designed by Hiroki Oka, Toshiyuki Hisatsune, Osamu Sakurai, Shigeya Yasui and Tetsu Sumii at Sony's Broadcast & Professional Group in Atsugi, Japan, would enable a single journalist working alone to conduct and videotape an interview, control the camera's zoom and angle, record the audio, and monitor the results in real time with the head-mounted display (which also has integrated headphones). By moving the camera's viewfinder to the headpiece, the designer was able to give the camera a more distinctive yet ergonomic shape.

Voice recognition has been a fascination of designers and engineers for decades. Now that desktop PCs have gained this ability, attention has shifted to handheld devices that can convert spoken words into written text and transmit text data via e-mail to anywhere in the world. The Commet concept, by Miwako Yoritate of DC/Tokyo, is a combination cell phone, pager, Web browser and e-mail transmitter/receiver that gives the terms "voice mail" a whole new meaning. Shaped to resemble a conventional cell phone, the unit features a hinged lid that reveals an LCD screen (with integrated ear- and mouthpiece), touch-sensitive icon buttons and ample processing power for storing and manipulating spoken and written text. The technology underlying this concept already exists. All that is needed is the infrastructure to support it. In the quest to unite the telephone and computer, Commet takes a giant step forward, giving the product a degree of simplicity and elegance that allows it to evolve from a machine to a personal accessory.

Pen-Type Input Device

In addition to voice command, physical gesture will also be important in controlling tomorrow's computer-based digital products. Since remote controls of the past have become too complex, the more natural and efficient way to interact with a myriad of choices on a screen is to simply point and click using an "air mouse." This simple, pen-type device, designed by Takao Nakayama, indicates not only what is possible from such a device in the near term, its minute size suggests that such functionality could also fit into an even smaller product, such as a bracelet or ring.

Digital Block

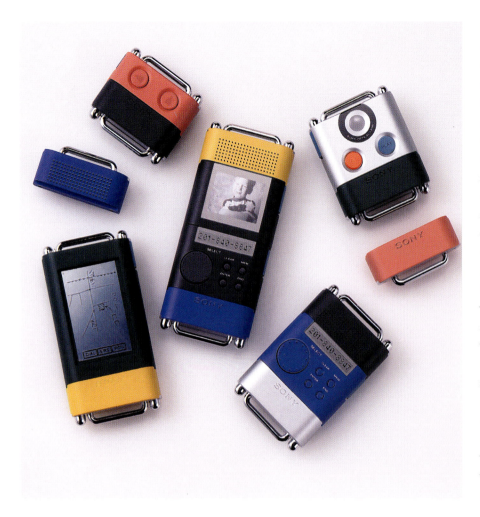

Reviving Shinichi Ogasawara's 1989 Digiblock concept (page 24), Takashi Sogabe of DC/Park Ridge gives us an interesting new family of personal audio/video products called Digital Block. By miniaturizing the technology and dividing components into discrete modules that fit together like Lego toys, the Digital Block concept allows multifunctional products to be assembled using simple and affordable units that consumers can purchase over time. Since components share the same architecture and mounting hardware, they can be combined in many different ways, allowing Digital Block users to always have precisely the product they need. Components include a miniature MD player/recorder, CD player, digital camera, IC voice recorder, battery unit, AM/FM receiver, speaker unit, pager, cellular phone, personal digital assistant and (potentially) a miniature TV receiver. Digital Block components fit together snugly using metal rods that extend through each unit and secure tightly at the ends. Soft shapes, bright contrasting colors and price-conscious materials make this an appealing concept—one that Mr. Sogabe is now using to build a series of working prototypes that may soon become actual products (see below).

Adobe Illustrator rendering showing various Digital Block components and configurations, ranging from simple radio and battery units, pagers, IC voice recorders, cellular telephones and digital cameras to CD/MD/radio combos with batteries and speakers. Design: Takashi Sogabe (DC/Park Ridge), 1998–99.

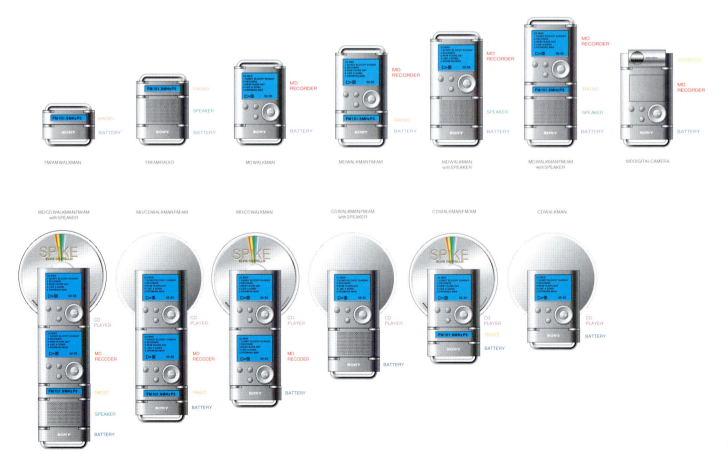

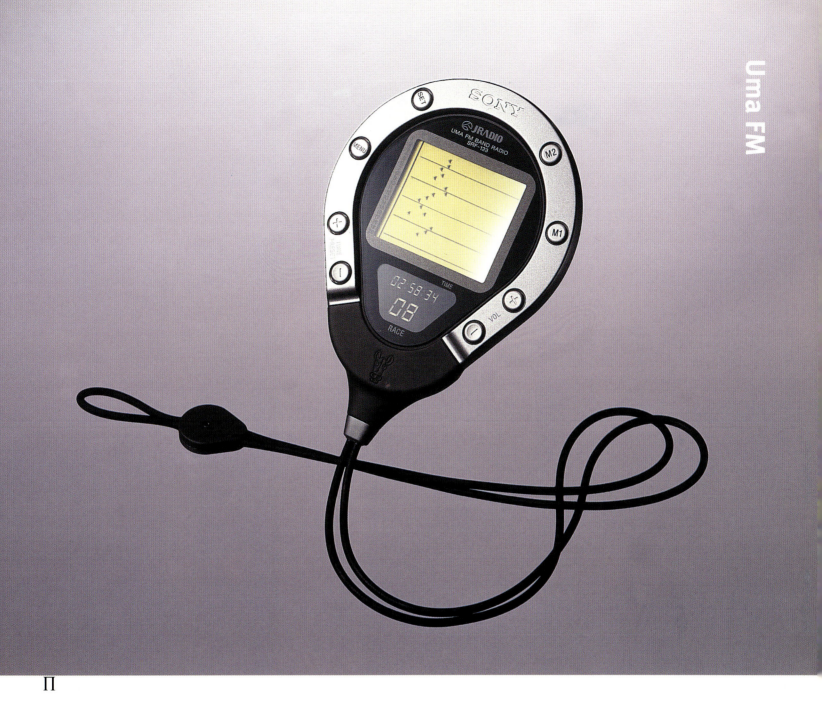

Π

What may be the ultimate niche product, Uma FM is a digital FM radio/information manager designed for horse racing enthusiasts (*Uma* is the Japanese word for horse). Since horse racing is one of the most popular sports in the world, PAV designer Koichi Maeyama imagines a product that racing enthusiasts can take to the track. It combines an FM tuner and digital stopwatch with Game Boy–type interaction (receiving signals from tiny transmitters located in the saddle of each horse, which appear on the Uma FM screen) as the race proceeds. The clever horseshoe form with nail-shaped buttons around the perimeter of the screen is suspended from a looped antenna that doubles as a neck strap. Only at Sony does one see products that invest high technology with the kind of metaphor that provokes humor, offers insight into human behavior, or in this case, both.

We all know that audio systems have grown more complex in recent years. With tabletop units such as the Sony CDP-CX260 200-Disc Mega-Storage CD Changer or tomorrow's pedestal-shaped CD changers (right), we can access dozens (or even hundreds) of compact discs. But keeping track of all that music, locating individual selections and editing our favorite CDs into custom playlists is difficult. One answer is to merge AV hardware with a personal computer using software such as Digital Media Park (see page 133). Another is to combine localized hardware and software with computer access to the World Wide Web, allowing us to browse our music collection and download information and sound clips of our favorite artists from the Internet, creating a seamless media experience.

In 1994, Sony R&D asked the Design Center to think about merging the personal computer with digital AV products. "Once you network audio components with a PC," says DC/San Francisco design manager Andy Proehl, "you create a virtual media environment, calling up selections from many different sources without having to touch the hardware yourself. All sound sources become equal. And once you give the instructions, the system does the work for you." This discovery has informed subsequent investigations, such as Media Rave (a hardware/software music storage/retrieval system) and eMusic.

In 1997 the Media Rave project begat a system known as CD Ease, in which hardware (designed by Rich Gioscia, Knut Fenner and Jan-Christoph Zoels in Park Ridge) and software (designed by Andy Proehl and Kim Mingo in New York and San Francisco) are integrated with a 2-D user interface that makes a large CD collection and the Internet available without touching the hardware. "When we began, we agreed that hardware has become too complex for most users," says Mr. Proehl. "Once you put your CDs into a changer, you've lost physical contact with the music. So the first thing to do was reestablish that physical connection by providing cover art and liner notes on the screen so that users could relate to their music in a traditional manner . . . with their eyes as well as their ears."

The CD Ease interface offers complex functionality in a graphically rich point-and-click environment. Unlike a hardware interface, which gives users all of the buttons all of the time, the

CD Ease software approach gives us "quiet" buttons that remain flat or hidden until the cursor passes over them. Everything on the screen remains muted except the album covers, which are highlighted the moment you select and click.

"We wanted to bring the visual side of music CDs to the screen," says Kim Mingo. "The animated interface with cover art and liner notes restore a key part of the musical experience. This way, the user can refer to their favorite music not as 'Track 7; 3:45,' but as an interesting graphic. Because the system is connected to the Web, up-to-the-minute news items and concert information can be downloaded in response to your musical selections [note the Web-generated Maxwell and Brad announcements at the bottom of the screen, shown opposite] . . . which makes you part of a musical community, not an isolated consumer." Routine functions, such as dubbing, which traditionally involves two or three separate compo-

nents, can now be handled using a single point-and-click interface. "Unlike hardware, which forces us to think in a mechanical way, software gives us content- or task-based interaction, which is a lot more enjoyable," says Mr. Proehl.

For years, Sony Music has been developing Web-based content that controls your home CD player. For example, an audio download from a Sony site can play over your system and call up related music in your collection automatically. "When we put liner notes and graphics into the system, then added Web access, we discovered that anything is possible, because it's all software." As a result, functionality is built into the system. For example, song title data on your CDs are automatically added to the system as you insert a new disc. The convergence of CD Ease's AV capability with the personal computer results in a virtual media environment that is limited only by your musical tastes.

Above: Concepts for a tower-shaped CD Ease changer. Design: Knut Fenner and Jan-Christoph Zoels (DC/Park Ridge). Below: Chart showing the range of choices and functionality available with CD Ease.

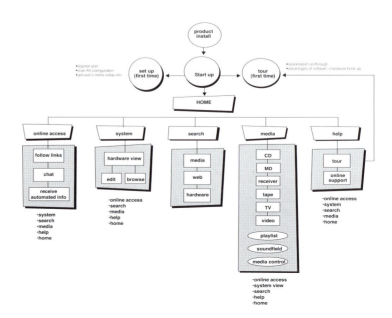

The CD Ease user interface, designed by Andy Proehl and Kim Mingo of DC/San Francisco, is visually rich, multilayered and fully interactive, yet also easy to learn. All elements on the opening screen (top row, left) activate in response to the position of the cursor (top row, right). System View (second row, left) configures the hardware/software interaction with a one-click Preferences button. Data from the user's CD changer is arranged graphically (second row, right). Titles appear when the cursor passes over the CD's cover. A single click reveals the CD's contents (third row, left) with playback controls at the top of the screen. A menu on the right side of the screen (third row, right) accesses the system's basic functions without the user having to return to the opening screen. A discography of artists in the user's collection is available on-line (bottom row, left) allowing the user to sample cuts from other discs by the same artist, view video clips and buy a new CD (or two). Songs from various CDs can be easily compiled into custom playlists (bottom row, right). Drop-down controls at the top of the screen appear as the cursor enters that part of the screen.

If we chart the evolution of consumer electronics, the driving force behind the popularity of each new technology—the phonograph, the reel-to-reel or cassette tape recorder, the video cassette recorder, Walkman, Discman, video camera or personal computer—was not the hardware that delivered the music, images or information. It was the tape or disc media that allowed the hardware to function. Without the audio cassette, the compact disc and MiniDisc (all invented, co-invented or popularized by Sony), it's doubtful that recorded music would enjoy the worldwide success they do today. Where would television be without Beta or VHS tape or camcorders without a DV cassette? Would the first generation of personal computers have succeeded if Sony hadn't invented the 3.5-inch floppy disk? Hardly.

It will be difficult for the next generation of digital consumer electronics to merge with the PC and the networked world without a new form of digital media—a portable means of digital exchange that will allow users to download, store and exchange data between products that are not networked together.

Without an easy and inexpensive way to record, access and share digital information among a broad range of products—from telephones, digital cameras and VAIO laptops to voice recorders and Walkman units—the convergence phenomenon that Sony envisions will never achieve mass-market acceptance. To be accepted, this new media will have to be portable, cheap enough to purchase by the dozen, easy to understand and simple enough to handle any kind of digital data—including images, sound, text or data.

Unlike the standalone products of the past, the success of tomorrow's AV and information technology will be determined not only by their performance or design, but by the way those products connect with and talk to one another. As personal computers, television, audio equipment, cameras and telephones begin to use the same digital data, the need to exchange this information from one device to another will become even more essential than it is today. In short, connectivity will be king.

For years, Sony has researched new forms of media that could link digital cell phones, digital cameras, car navigation systems and digital audio to DTV and personal computers, which are then connected to digital cable systems, satellite, local area networks and the Internet. They put aside current digital recording technology, such as the postage stamp–sized NT cassette, digital video cassette and MiniDisc, because all three require a separate recording and playback device. This means they could not work in the smallest digital products, such as cell phones.

The ideal digital medium should not require a dedicated mechanism. It should access data directly, making the transfer both instantaneous and noise-free. To survive the real world, the media should be as simple as possible and solid state, with no moving parts. It should be physi-

Opposite page: Concept for a Memory Stick Walkman/ Headphone with a handheld controller. Design: Satoshi Suzuki (DC/Tokyo), 1998. Above: The DCR-TRV900 Digital HandyCam uses Memory Stick (inserted via PC card) to record still images.

cally robust, and impervious to dust or motion. And to achieve worldwide acceptance, it would have to be cheap to manufacture, cheap to buy and become less expensive over time.

In the past, Sony researchers have solved similar problems and altered our media landscape in the process. Now they have done it again. On July 30, 1998, Sony launched this new digital medium, called Memory Stick.

Shaped like a piece of chewing gum, Memory Stick measures 0.85 inches (21.5 mm) wide, 1.97 inches (50 mm) long and a mere 0.11 inches (2.8 mm) thick. Weighing just 4 grams, the Stick's bluish purple plastic housing (inspired by the VAIO purple power aesthetic) contains a tiny IC controller and one or more flash memory chips (4MB or 8MB in the first version, 32MB by the time you read this and up to 128 MB in future models). Its minimal width and thickness allow total freedom in the design of future Memory Stick products. The Stick connects to the world via a 10-pin serial interface at one end, which is recessed to prevent fingers from accidentally touching the tiny metal contacts (preventing the electrical charge that runs through your body from zapping your data) and a manual switch to prevent data from being accidentally erased. With an internal clock speed of 20-MHz, an average data read/write speed of 2.5MB per second, the Stick has splendid performance, yet requires a mere 3 volts/45 milliAmps of power.

Inexpensive, portable and able to transfer large amounts of data in the blink of an eye, Memory Stick establishes a new universal standard for exchanging and sharing digital content, offering as yet unimagined worlds of flexibility and convenience. More than a new way of recording, Memory Stick represents a new way of thinking. A new way of sharing and connecting digital content, without barriers. Memory Stick is not just a recording media. It will become the Universal Media.

Sony has designed the Memory Stick format for total compatibility. This means that every type of digital AV and IT product, whether professional, industrial, business or consumer, will support (and be supported by) Memory Stick. From digital cameras and video recorders, digital telephones and TVs, all the way up to the remarkable world of VAIO personal computers and car navigation systems, all will be compatible with this new universal media. Sony has

once again created a new market, and a new Digital Lifestyle based on the concept of sharing: the power to instantly and easily exchange digital data with anyone, at any time, anywhere in the world. Ultra-portable and extremely easy to use, Memory Stick makes digital sharing more convenient than ever before.

An entire universe of Sony AV and IT products will soon become Memory Stick compatible. Every compatible product will recognize its own type of application, such as pictures or navigation software. Specially designed to handle all AV and multimedia file formats, Memory Stick can record, play back, and transfer music, pictures and every other digital content, your way, at home and everywhere you go. And today's Stick will function in perpetuity thanks

to Sony's original serial protocol, which guarantees compatibility with future Memory Stick media, which will be available in progressively higher capacities.

Because Sticks are inexpensive, portable and can transfer data with ease, Sony will include copyright protection technology in future Memory Sticks to protect music, moving and still images, games, digital books and other intellectual property from unauthorized copying and distribution. Therefore, as memory prices continue to fall, future Memory Sticks will soon offer the storage equivalent of today's MiniDisc—making a solid state Memory Stick Walkman, game player or electronic book a virtual certainty.

Sticks intended for audio and video applications, starting with the 32MB version due in

1999, will incorporate digital copyright protection. And higher-capacity Sticks designed for music will use a tighter data compression algorithm than found on today's MiniDisc, resulting in a slight degradation in sonic performance compared to MiniDiscs but more music-per-megabyte. Most consumers will not notice the difference. What they will notice is that unlike a disc or cassette, Memory Stick has no moving parts, and needs no motor, magnetic head or tracking mechanism to record or play back music, giving Memory Stick products a huge advantage in portability and power consumption over today's disc- and tape-based systems.

Memory Stick needs no separate device in order to function; you simply insert the Stick into a slot built into your Memory Stick telephone, voice recorder, camera or other device and access data automatically. On a VAIO PC, the Stick fits into a PC card. With no moving parts to wear out, this tiny wafer can be recorded and played back thousands of times. And its nonvolatile RAM can hold data for decades.

Inspired by a 1995 Design Center concept called Stick (see page 179), the technology inside Memory Stick evolved from an intense competition among various engineering and R&D groups within Sony. One group proposed that the Stick be the same size and shape as a credit card. This design would allow the Stick to use many inexpensive 16MB chips rather than one or two higher-capacity chips, it would also offer enough surface area to apply graphics, enabling Sony to distinguish its Memory Stick from future competitors. But others within Sony argued that a credit card–sized Stick was too large to use in the smallest products, such as cell phones. Rather than limit the design of tomorrow's digital products by using media that is unnecessarily large, this second group proposed a smaller, slimmer Memory Stick that is nearly identical to the design we see today.

As soon as Memory Stick's design and specifications were set, Mr. Idei asked the directors of Sony's ten internal companies—such as the Personal Audio Video and General Audio groups, the Display Company, Personal & Mobile Communications and Broadcast & Professional Equipment—to develop concepts that could evolve into a family of Memory Stick products. To facilitate this effort, Mr. Idei estab-

This page:
An 8MB
Memory
Stick,
shown
actual size,
front and
back.

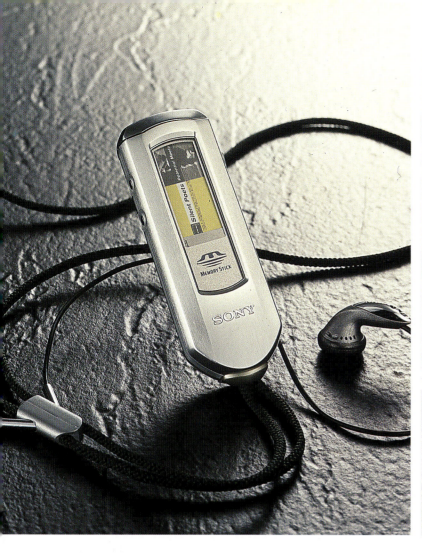

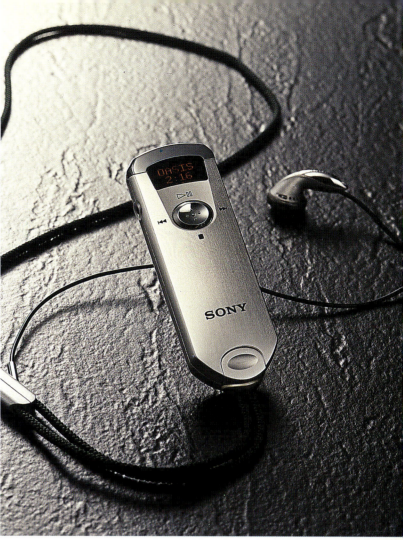

Design Concepts for 1999–2000 Memory Stick products. Above and below left: Memory Stick Walkman, headphones and desktop charger/recording station.
Design: Daisuke Shiono, Personal Audio/Video Group (DC/Tokyo). Below right: Memory Stick Image Viewer. Design: Kiyoshi Ohta (DC/Tokyo).

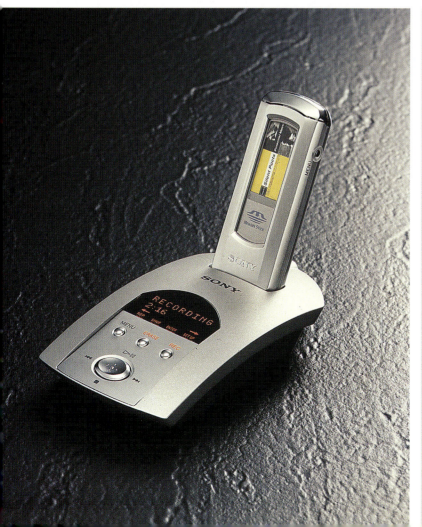

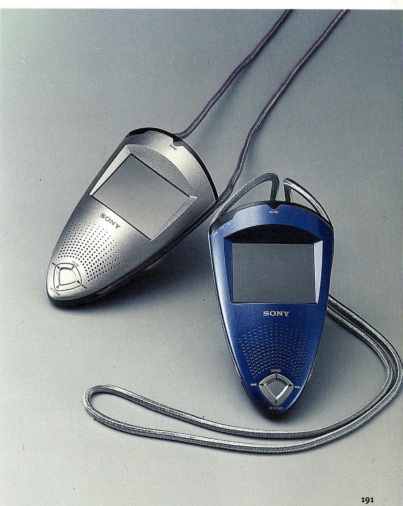

lished Sony's first "virtual corporation," called VAIO Center, coordinated by the Design Center's general manager John Inaba, managed by Mr. Inaba's lieutenant Fujio Noguchi and populated by the heads of Sony's ten internal companies, who served on VAIO Center's board on a rotating basis.

By organizing the VAIO Center within the Design Center, Sony could establish a vision for Memory Stick that would showcase the Stick's potential, persuade competing firms to accept the Stick as a de-facto industry standard, and coordinate Sony's resources—across all product categories—to create a "Memory Stick Universe" of diverse AV and IT products, each with built-in Memory Stick slots.

"Forming a virtual corporation to develop Memory Stick and implement it across the entire company shows that Sony is serious about changing its internal culture," says Fujio Noguchi. "The potential of Memory Stick is so large, because it works with all kinds of consumer electronics, personal computers and professional equipment, allowing it to become a standard like the compact disc. And the Stick is so useful by itself, it is not necessary to create a 'killer application' to recognize its potential." Creative uses for the technology will surely be invented once the Stick reaches consumers. "Someone, somewhere will dream up an application for Memory Stick that we never anticipated," says Mr. Noguchi. "That's the nature of any new medium. But designing that use in advance is not necessary for Memory Stick to gain acceptance and reach critical mass."

The first Memory Stick product to reach the market was the DCR-TRV900 Digital HandyCam (see page 189), released in the fall of 1998, which can record in both interlace format (for TV) and progressing scanning (for computers) and uses the Stick to record still images. The second product is Cybershot Pro (see page 81), which combines professional design and 1.5 million pixel performance with total ease of use. Future products, shown in concept form at COMDEX '98 and detailed road maps inside Sony charting the future for Memory Stick indicate that the Design Center will soon plug this

Memory Stick logo

new media into every corner of Sony's product line. Voice recorders, digital and video cameras, Internet telephones, cellular phones, Memory Stick–compatible televisions and VAIO laptops—even the long-discussed Memory Stick Walkman—are all on the drawing board or nearing completion. One example is a desktop picture frame wrapped around a flat panel LCD and a Memory Stick port on the front. Take a photo with a Memory Stick camera, remove the Stick, insert it in the frame, and up pops the photo to display for as long as you like.

"Once users realize that all Memory Stick products talk the same language (the IEEE 1394 protocol, known within Sony as i.LINK) and can communicate at network speed, the barriers that now prevent individual consumer electron-

Memory Stick represents a new way of thinking. A new way of sharing and connecting digital content, without barriers.

ics from working together will collapse," says Noguchi. "The result," he predicts, "will be a revolution."

The Memory Stick concepts and prototypes shown at Comdex '98 indicate what the future holds in store. By replacing the internal memory in an existing Cybershot camera, for example, the Memory Stick Cybershot allows us to take a snapshot at a birthday party, add voice notes to the image such as the birthday song from the party, remove the Stick from the camera and insert it into a Memory Stick desktop picture frame or handheld viewer (see page 191, lower right), which displays the images and transmits sound through an integrated speaker. Or insert the Stick into a compatible cell phone or desktop Internet phone (opposite page, middle right) and send the pictures and sound to a

friend or relative across town or across the country. That same Memory Stick phone can also store your Web account, password, personal information and preferences for surfing the Web, store downloaded information and archive telephone numbers, allowing you to dial someone by pushing a single button.

A Memory Stick Info-Navi System can store your favorite travel itineraries and guide you to your destination in a flash. A Memory Stick VAIO laptop computer can allow you to make notes all day without needing a hard disc (or the heavy battery needed to power it), making the computer marvelously thin and lightweight. A Memory Stick digital television could allow you to insert the Stick into its remote control. The Stick would contain all of your personal preferences, e-mail address, Web account and favorite programs, all of which would come up on the screen for you to access with a single click (no more hunting for programs or Web addresses).

The arrival of the Memory Stick Walkman (see pages 188 and 191) has been a much-talked-about event within the Design Center. Since Memory Stick requires no motor or playback head or optical pickup, has no moving parts and can operate for days using a conventional battery, a Memory Stick Walkman will offer noise-free digital sound, random access and other features found in an MD Walkman in a small trouble-free product. All that's needed is a 64MB stick to store the music (using data compression similar to the MD format).

In the future, the Memory Stick Universe will encompass every aspect of our personal and professional lives, offering new freedom to share and exchange every type of digital content. Imagine carrying around an entire encyclopedia, your complete medical records, a whole library of electronic books and generations of family albums in your pocket. Now imagine a miniature IC recording media that fits every digital product you own and works perfectly with all of them—playing music, showing videos and recording the many kinds of data you need to run a household or business. Sony is turning these digital dreams into practical, affordable realities.

With the arrival of Memory Stick, "you don't have to imagine anymore," says Mr. Noguchi. "The revolution has already begun."

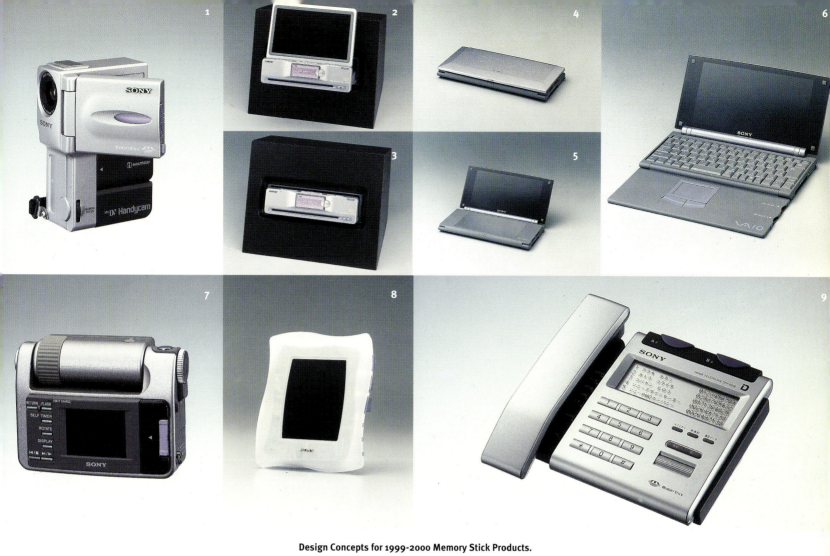

Design Concepts for 1999-2000 Memory Stick Products.

1. Digital Video Camcorder. Design: Personal Audio Video Group, Tokyo, 1998. 2. Info-Navi Car Navigational System. Design: Yasufumi Yamaji, Personal & Mobile Communications Group, Tokyo, 1998. 3. Car Audio System. Design: Yasufumi Yamaji, Personal & Mobile Communications Group, Tokyo, 1998. 4 - 6. SubNotebook Computer: Design: Satoshi Masamitsu, Information Technology Group, Tokyo, 1998. 7. Cybershot Camera. Design: Personal Audio Video Group, Tokyo, 1998. 8. LCD Picture Frame. Design: Haruo Oba, Information Technology Group, Tokyo, 1996. 9. Internet Telephone. Design: Yasuhiro Ishibashi and Atsuo Nagai, Personal & Mobile Communications Group, Tokyo. 10 - 11. Cellular Telephone. Design: Toshiaki Sato, Personal & Mobile Communications Group, Tokyo, 1998.

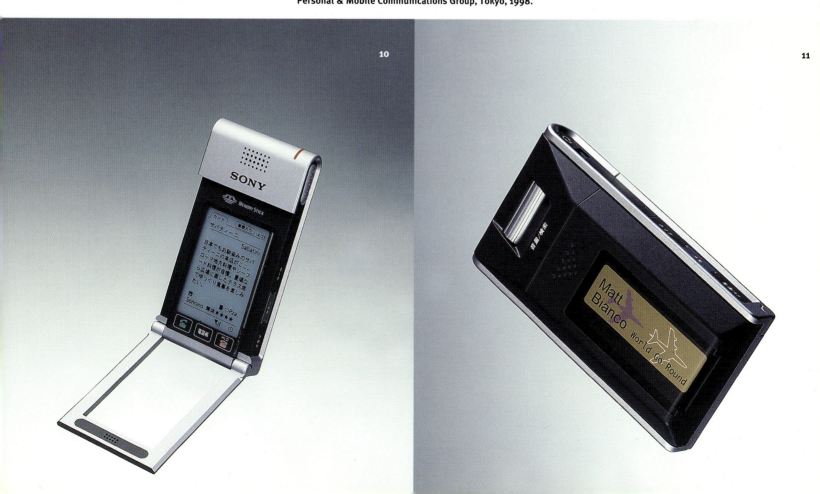

Digital Dreamer

For the past half century, Sony's business has focused on stand-alone electronics products. From the transistor radio to the Walkman, camcorder and Trini-tron, Sony has earned the world's respect by designing and delivering better, more sophisticated and smaller electronics than anyone else. Yet as the final months of the twentieth century draw to a close, the corporation that symbolized the consumer electronics revolution is leaving its past behind and moving into the wired age. Today, Sony is developing products for a world that now communicates using everything from satellites and the Web to home-based networks.

Nobuyuki Idei was chosen to lead Sony into this brave new world. Having joined Sony in 1960, Mr. Idei worked his way to the top of the company by developing a detailed understanding of both the "hard" and the "soft" side of Sony's business. With hands-on experience in video, audio and PC-related businesses, he is also a master of image-making, advertising, marketing and design, including a tour as director and general manager of the Design Center. Like his predecessor, Norio Ohga, who combined solid business savvy with a love of classical music (serving as a world-respected orchestra conductor), Mr. Idei is one of the most cultured and cosmopolitan business leaders imaginable. Sleek as a knife with a gentle smile, fluent in Japanese, English and French, Mr. Idei is known to frequent Tokyo jazz clubs (where he knows many of the singers and musicians by their first names). His grasp of global business, politics and the ever-shifting winds of high technology caused the magazine *Time Digital* to rank him as the second most "cyber-elite" person in the new digital economy in 1998. This makes Mr. Idei ideally suited to regenerate Sony and spearhead its convergence strategy, positioning the company at the point where hardware, software and the Internet will meet and converge.

In the world according to Idei, tomorrow's Sony will not only produce the world's best hardware and software, as it does now, it will also tie all the many strands that make up the global Sony group, supplying all manner of content and services to homes via digital satellite, digital cable and the Internet, to name a few, causing the PC and all kinds of entertainment devices—from TVs and digital cameras to audio systems, game machines, telephones and even radios—to merge with personal computers into a large net-workable family. Of course, computer giants like Compaq, Hewlett-Packard and IBM also believe that PCs and consumer electronics are converging. But Sony is the company that dominates the home living room; it is the only company with the right balance of hardware and software, broad-

"Design is not a matter of styling. It's about the excitement that the product offers and the satisfaction that it generates in the customer."

cast and professional equipment, media products and non-entertainment services, as well as expertise in every corner of the consumer electronics and personal computing industry, as both a hardware manufacturer and a software and content producer. With vast libraries of music and movies, television properties and game titles at their disposal, some of the most sought-after brands in the world and the unique ability to participate in every facet of the new digital economy—from content creation to the end user in the home—Mr. Idei and his management team understand that what we see today is but an interlude between the analog past and an all-digital future.

Despite the attention given to the personal computer, the demand for digital consumer electronics, plus the entertainment and services they deliver, will dwarf the market for personal computers, operating systems and related software.

To ensure that Sony leads the way toward this digital future, Mr. Idei has adopted a three-step strategy that has already begun to take shape. In the future, Sony will unveil a vast array of products and services to customers by linking its holdings in music, film, television, games, publishing and financial services with a new family of consumer electronics that use i.LINK (IEEE 1394) high-speed networking interface and the VAIO (video audio integrated operation) concept. Some of these products will use Memory Stick. Others will use conventional disk media, infrared technology or will connect directly to the Internet. For the millions of analog televisions still in use, the principal link will be a digital TV set-top box, which viewers will need to access DTV. When fed through a cable or satellite system, the set-top box will serve as a gateway through which Sony's music, motion picture and other content and services will enter the home via the Internet, dedicated broadcast or cable systems.

Step two, occurring simultaneously with step one, has been to restructure Sony from the top down and the bottom up. Having devoted the three years to the launching of new digital camcorders, MiniDiscs and other AV products, Mr. Idei has reformed Sony's management process to speed up decision-making and streamline the product development cycle to better compete with nimble rivals in the consumer electronics and PC industries. He reduced the number of board members from thirty-eight to ten, restructured Sony's research and development organization and its headquarters operations, expanded the eight-divisional company structure to ten, split the consumer AV products company into three units, established an Information Technology company and merged two mobile communications units to create the Personal & Mobile

Communications company. He instituted global networks for tighter control of inventories, allowing management to track sales, profits and market demand in real time. The use of common software and sharing of design tools and networks among units in Asia, the U.S. and Europe would also shorten product development time.

While head of the Design Center (from 1990 to 1993), Mr. Idei developed an elaborate and detailed philosophy of design that focuses on the challenges that Sony faces in the near term as well as the distant future. This philosophy reveals itself in statements made during Mr. Idei's frequent visits to the Design Center to video the quarterly Creative Reports, which often end with a lengthy question and answer session.

The central mission at Sony, which Mr. Idei repeats to his designers at every opportunity, is that all products and services must be of the highest quality and offer the best value. At a time when every manufacturer has access to the same technology and offers products of uniform quality at every price point, customers have become so demanding that they will not tolerate a product that does not perform well on every level. For designs to succeed in this hyper-competitive environment, they must appeal to the customers heart as well as their mind. With events occurring at an every-quickening rate and the pace of change accelerating, both products and the people who design them must always look forward. This helps explain the Design Center's Sunrise/ Sunset strategy: no matter what time of day it is, the designer's job is to set the clock forward and anticipate the change that is sure to come.

As a believer in change, Nobuyuki Idei inspires his designers by regularly visiting the Design Center studios to share his observations. The question and answer session that follows often results in some thought-provoking analysis. Here is a sampling:

Linking Design to Each Phase of a Product's Life Cycle. "When products are in the Sunrise phase, it is important to create, to be original, to set the precedent for the rest of the industry, and at Sunset, product variations become more important. Sunrise/Sunset works for products, because it allows us to give design the right level of expression. It also works for the designer, because it allows him/her to set the precedent when the product is first launched and create a completely new category at Sunrise. When we

design an 'original'—such as the first Walkman, the first Discman or the PlayStation—design can have significant impact at Sunrise. And as the technology and features of the product evolve, the designer must always be conscious of the product's Sunrise/Sunset position.

Yet not every designer can create designs at all points of the day. To understand this, imagine that you are in a baseball game. If the team falls behind, you may need to call in a relief pitcher. But it would be a mistake to put a starting pitcher in that position. For designers, it's important to know whether you are playing as a relief pitcher, or standing on the mound as a starter.

When I see a camcorder by itself, I may say it's a good design. But after taking the previous product

"All designers should be motivated to function as an ace pitcher with every product."

design into consideration and observing the market and stream of business, I might say, 'Hey! We are now playing a new game!' The best design isn't only a question of design quality. It must also convey a clear message to a new generation.

When I met with Ryuichi Sakamoto the other day, we looked at one of Sony's recent products, and he told me "That is an inanimate design." If the design had been drastically different, he might have bought it. But since the design was similar to the former model, it didn't excite him. I sometimes have the same feeling. When you play in a new game, you should have the strength to create something fundamentally new that will excite the customer. Basically, all designers should be motivated to function as an ace pitcher with every product."

The Effect of Sony's Changing Business Model

on Design. "During the analog era, the individual product was important, because it often functioned as a stand-alone object. But now that we are in a networked environment, interaction through the screen has become more important for the time being. Yet this is only a temporary condition.

As we look forward, we should develop advanced designs that move beyond the screen-based interface . . . beyond where we are today. When computers no longer rely on screen operation, reliance on a screen interface will wane. This will allow us to return to a more natural form of interaction. True interaction between the user and the product will become important again. So, designers shouldn't define interaction design as on-screen interface. They should move beyond.

Naturally, on-screen interface design will remain an important factor, but you should pursue and realize something beyond that in the new digital era. So the designers' job will be much heavier in the future. Eventually, everything will return to the original. People will enter and leave networked environments almost unconsciously. I don't think operating everything through a screen will be the best solution."

From Virtual Reality to Real Reality. "When we talk about Virtual Reality, the screen lies between you and virtual reality. But in the future, it will be more and more unconscious(transparent). Virtual Reality will become Real Reality, and product design will become very important again. Rather than improve or strengthen 2-D interface design, we should realize something beyond 2-D that is more natural and significant."

Migrating Products to the Net. "Today, general purpose computers are very common. But as device cost drops in the near future, personal computers will be designed to meet specific customer needs. When we remove excess functions, the computer could become a PlayStation, a Walkman or both. In case of computer products, word processing software or spreadsheets could be installed in the hardware. Yet, eventually, those functions should be installed on the network side. This way, you won't have to have sophisticated intelligence in your local environment. Sony should create those kind of application specific products."

Reinventing the Design Center. "Since designers always work within the context of change, we can expect shifts within the Design Center as the

digital revolution takes hold. But precise changes," says Mr. Idei, "depends on what kind of business model Sony intends to develop. It's a difficult problem. Until recently, we didn't have to think about a business model for televisions. But, going forward, we have think in terms of a display system. What consumers will do with that system will become a critical theme. The role of designers is to realize the best success story by business model with product planners and engineers. In the past, we understood what TVs meant; but this is no longer the case.

Look at the Wega TV design. Within a year of its introduction, it has been met with stiff competition and has lost its vividness. If Sony doesn't take proactive steps to clarify what should be the next plan—with designer, product planner and engineer working as a team—competitors will beat us in an instant."

Looking Forward. "No matter how diversified our business becomes, certain qualities—such as emotional satisfaction and pride of possession—will always be important. Those feelings should never change, and the design of Sony's products should always convey them. Design is not a matter of styling. It's about the excitement that the product offers and the satisfaction that it generates in the customer."

Visual Identity versus "Design DNA." "Some people believe that a product's identity should be visible. But there is also an invisible element that our designers call "Design DNA," which appeals to a latent or subconscious desire among all people to have an emotional relationship with their physical environment. If we successfully pursue that theme, that could become Sony's identity, which is difficult to copy because it does not exist on the surface.

True identity is not about design ... it's about satisfaction. Even when you don't use the product, you are happy that you own it. Because you and the product have become one.

I believe that Sony has that spirit as a company. The reason that the Design Center works so closely with the divisional companies [such as TVs, Personal Audio Video, or Information Technology] is to facilitate communication between designers and product planners ... allowing them to share Sony Spirit effectively. Designers cannot exist alone.

Simply put, we all are creators, and Sony is a creative company. Product planners and marketing groups are creators. There are business-model creators. And designers are also creators. It would be a fatal problem for Sony if that spirit is denied. But I see no danger of that happening."

Working Fast. "Speed is critical for a company. You may not realize that fact when you are on the top of the wave (moving fast), and I think Sony's business speed is very fast. That may not be clear from the outside, when people ask: "What's going on at Sony?" The answer is that we're evolving . . . fast. Sometimes I wonder, 'Is it OK running so many businesses this fast?' But I guess that's who we are."

•

Inspired by Mr. Idei's philosophy and driven by the vision and energy of DC/Tokyo senior general manager John Inaba, all 200+ Design Center members are focused on the future, anticipating tomorrow's technologies and social trends as they begin work on a broadly-based digital product line that will encompass all of today's consumer electronics products and connectivity solutions. Though details are sketchy and the company has made no announcements thus far, the media and content in this new digital architecture will no doubt include both conventional hardware media such as compact disc, DVD, MiniDisc, solid state media such as Memory Stick, digital broadcasting and communication via satellite and cable linked to the Internet as well as home networks with high-speed iLINK (IEEE 1394) connectivity between various hardware components.

"For consumer electronics to prosper in the digital age," says Mr. Inaba, "they will need to be networkable, linked to the Internet, and they will need to function in a more natural way. Their forms and interfaces should inspire our emotions. They should entertain us, be pleasing to the hand and eye, and be so easy to use that they free our minds to concentrate on the task at hand."

Like Sony's analog product line in years past, each product in this new digital family will function as a stand-alone device. The personal computer will not exist in the center of this digital world, but will be one product among many. All products will speak the same language. Thus, on a fundamental level, all products will enjoy equal access to the networked world. "They will also form part of a seamless web," says Mr. Inaba, "in which all elements—from the smallest camera or voice recorder to the largest digital TV—will speak the same language and merge into an organism that is greater than the sum of its parts."

The first glimpse of this new product/network architecture appeared in January, 1999, when Sony and Royal Philips Electronics N.V. announced an alliance with Sun Microsystems, Inc., to create a new generation of networked entertainment devices and appliances that will communicate with each other and via the Internet.Under this alliance, Sony, Sun and Philips plan to link two developing software standards to forge a global computer network that stretches from the living room to the corporate computing center. Virtually any kind of electronic device built with the combined standards, including televisions, stereo receivers and video cassette recorders, will interoperate with and be controlled by the network.

This new kind of computing environment will rely on the technology known as Jini (pronounced JEEN-ee), developed by Sun Microsystems. Based on Sun's Java programming language for Internet applications, Jini is based on the concept that devices should work together, allowing anyone to create a personal network anytime, from anywhere. Unlike traditional notions of computer networking, which require a PC with a complex operating system at the center, Jini technology is a "distributed" design, with a transparent collection of devices (such as TVs, audio equipment, digital cameras, voice recorders and computers) and services all cooperating together. Jini technology enables a device to simply connect to this collection or network of services by plugging it in, with no drivers to find and no operating systems to start or restart. In the same way that Java technology enables software to run on any device, Jini software enables any device to participate in a network regardless of the underlying software used in the device or the network protocol used for communicating. Jini technology offers transparent connectivity and brand-independent interoperability, potentially allowing each device on the network to contribute its processing power to the network and participate in the distribution of information to all other attached devices using an i.LINK (IEEE 1394) digital interface.

Under the January 1999 agreement, Jini will be combined with the Home Audio Visual interoperability architecture—known as HAVi—which was developed by a consortium of eight consumer electronics companies. Led by Sony and Philips,

the HAVi consortium includes Grundig A.G., Hitachi, Ltd., Matsushita Electric Industrial Co., Ltd., Sharp Corporation, Thomson multimedia, and Toshiba Corporation.

Once connected as a network, HAVi-compliant electronics appliances will be immediately interoperable, sharing their resources and capabilities to offer increased functionality and greater ease-of-use. Specifically, HAVi appliances will provide the convenience of hot plug-and-play connectivity—meaning that any device in the network can be attached or detached without shutting down or restarting the system—as well as forward compatibility.

Home entertainment networks based on the HAVi specification promise to play an important role in enabling entertainment providers, electronics manufacturers, and consumers to embrace a wide range of new interactive services made possible by the advent of digital technology. Digital content received from digital broadcast, network, and package media can be distributed throughout the home to any appliances on the network. When using the appropriate digital content protection technology, these interoperable digital AV appliances will provide an infrastructure for many new services, such as high-speed Internet access, video-on-demand, and home AV server applications.

This home networking approach is the most likely platform for the post-PC era, because it is logical (plug and play operation is a concept that everyone can understand), scalable (meaning that networks can range from two devices to more than twenty), and highly flexible. For example, using a HAVi network, a user can program a VCR while away from home, or seamlessly route a television program to a computer disk drive or recordable DVD for later playback. Because all components are linked, most of the work is handled by the network, not the user.

It's no surprise that Sony would announce HAVi with Philips, since the two global giants have been partners in various technology ventures since the 1960s. Yet the alliance between Sony and Sun Microsystems, a leading developer of Internet computing equipment, is new and signals the critical role that Silicon Valley technology and culture could play in Sony's future. Even though Sun has no experience in consumer electronics, their expertise in computing, software and digital networking, combined with Sony's and Philips's

leadership in consumer electronics represents an alliance strong enough to take on the other likely contender, the Microsoft Corporation, in a standards battle for the consumer market.

Microsoft, which controls the personal computer market with its industry-standard Windows family of operating systems, has made aggressive moves to create links between the personal computer and consumer electronics world with their Universal Plug and Play standard and Home Application Program Interface, which is supported by several PC manufacturers.

At first glance, the Sony/Sun/Philips initiative and the Microsoft effort appear to be similar. Yet the two technologies have deep philosophical differences. Basically, Microsoft envisions a future

By combining traditional fields of expression in new ways, the Design Center is reinventing how people will choose, receive and experience entertainment itself.

in which the PC dominates the home environment, controlling everything from video delivery to telephone messaging. In contrast, the Sony/Sun/Philips HAVi alliance represents a decentralized approach in which control among various devices is spread throughout a network with no central point.

In a HAVi environment, the consumer can access the network using any compatible appliance or device, regardless of their physical grouping. That appliance could be a personal computer, or a television, an all-in-one infrared remote control device, or systems such as wearable technology that are still in development. For example, in the future, a user wearing a HAVi-compatible electronic badge on his/her jacket could control

various aspects the system by simply being present. As they come home from work, their HAVi security system could "read" their electronic badge and use that information to disengage the alarm, unlock the door and boot up various applications (such as audio or video systems, heating/cooling or telephone message center) as they enter the home. Using HAVi, Sony and its partners are now preparing applications that will allow consumers to control their appliances and access data and media in a more personal way.

Once digital appliances in a home network are linked to one another and then to the Internet, audio/video, telephony and computing will merge in ways that will allow the home network to become the source of all learning, information and entertainment activities. For more than a decade, the personal computer and television have been battling one another for our time and attention, with each slowly attaining the capabilities of the other. Until recently, PCs have been morphing into "infotainment" devices, while televisions have sprouted keyboards and gained Internet capability, causing many consumers to wonder which technology will overtake the other. But this approach is too limited. The reason, says John Inaba, is that "until now, no one has supplied the necessary vision, concepts and products to show the world what convergence really means."

With a HAVi network, you can have the power and functionality of a PC, with the television's ease of use, the entertainment value of a game machine or AV system and the toollike quality of a cell phone or digital camera, linked into a seamless digital structure, offering a window on any world the user can imagine. With i.LINK connectivity, this networked family can capture, respond to and deliver anything that can be seen, heard or understood using digital technology. The key parts of this system will have such a compelling physical presence, it will naturally occupy the center of family life. And in the years to come, such products could have "ubiquitous interfaces," in which 2-D and most 3-D interfaces have a similar look and feel, connecting us to a world of content and services that is always available. With ubiquitous interfaces extending across an entire product line, once you learn one product, you will know them all. Yet individual products will still deliver a unique experience to the user.

According to VAIO Center director Fujio

Entertainment

Browsing, Gathering, Selecting

Satellites Digital Cable

Audio/Video Technology Digital Set-Top Box

Communication

Discman, MD Walkman, Digital TV World Wide Web
Memory Stick Walkman

EPG Web Browser **The Network**

Memory Stick TV Remote

Home Audio Systems

Internet

Memory Stick Walkman

Sony.com

CD Ease Digiblock **New Product** Community Place

Memory Stick
Picture Frame

PlayStation Digital Telephony

eMusic, eMovies
eLiterature

Cybershot, Mavica Memory Stick Cameras
HandyCam

Memory Stick Computers,
Cell Phones and Desktop
Digital Video Edit- VAIO Internet Phone Online investing
ing

Online Commerce

**Personal Com-
puting**

Image Station

Content Creation

Active Engagement

Noguchi, "we do not always look to a product for the same experience. Sometimes, we want to dominate the technology, interact with it and bend it to our will. At other times, we prefer to treat the product in a more passive way. One challenge for the future is to design products with controls and functions that we can use passively, or actively, or somewhere in between, depending on our mood and needs." Yet all of these new products and services will have the four qualities found in every great design. They are:

Innovation. This means erasing the barriers between technology and users, being first to market with new technology, then following up with features that differentiate Sony products from competitors and allow Sony to lead markets as the design of products evolves.

Desirability. Every product, package, graphical image and interface will express Sony's technological leadership, exemplify Sony quality in look, feel and performance with designs that are both alluring and adaptable to many situations.

In the end, the most desirable product is one that both reflects and expresses the user and their environment.

Entertainment. All products, now matter how serious or task-oriented, will have some element of entertainment or play built into their design. This way, the thrill that a user feels when first using a product will never fade. After all, a product that is not fun to use will not be used very often.

Intuitiveness. Every design will be easy to understand and functionally transparent, offering positive feedback to the user and making technology more friendly and accessible while minimizing the need for operating instruction.

If you take the first letter of each of these four virtues, it spells the word IDEI. This may be coincidence. But at Sony, innovation, desirability, entertainment and intuitiveness are more than slogans. They are articles of faith that will help steer the Design Center through its next chapter and help to define the world to come.

Let's call it the Idei Principle.

As the most design-driven company in the world, Sony will rely upon the Design Center to give shape to the future. It will reflect the essence of the company that started the consumer electronics revolution. It will provide a friendly, open hand that Sony extends to millions of users around the world—providing not only the image that observers have of Sony, but also the image that Sony has of itself.

By combining traditional fields of design expression—products, packaging, graphic design, logotype, interaction and on-line products—in new ways, the Design Center is reinventing how people will choose, receive and experience entertainment and information itself. The vision and energy needed to assemble this digital landscape could only come from Sony. As we look forward to a new century that is in some ways uncertain, it is comforting to know that, in terms of technology and media, it will be the very best of times.

**Above:
A diagram
outlining
various
features of
the Sony
Design
Center's
upcoming
projects
offer a
road map
for digital
convergance
well into the
next century.**

As we explore the work of the Sony Design Center, examine its corporate structure, hierarchy and management, analyze its vast product line and critique the strategies that reveal themselves in each new design, it is important to remember that the Design Center is also a family. With more than 200 men and women now working on four continents, practicing a host of disciplines and ranging from first-year designers to 40-year veterans, the Sony design family shares a common vision and philosophy that allows each designer to think and act as an individual. Behind the famous logo and the sleek surface of every Sony product, one can see the designer's personality at work. Without the designers' care and endurance, this book would not have been possible. As a tribute to their effort, we list the designers whose work is featured in this book, highlight their most noteworthy designs and ask each designer to tell us what they would like to design or do in the future.

Akihiko Amanuma

A General Manager at the Design Center's Merchandising & Product Communication Strategy Group in Tokyo, Akihiko Amanuma was born in Tokyo, joined Sony in 1967 and has extensive experience at Design Center studios both in Europe and the U.S. His most important contributions include the TC-D5M Tape Recorder (known as "Densuke") and concepts that resulted in the first generation My First Sony product line (with Ichiro Hino). His desire for the future, he says, is to "design a range of products that exhibit functional beauty with the utmost simplicity. I would also like to design my own future."

Edward L. Boyd

Born in Indianapolis, Indiana, Edward Boyd joined Sony in 1991, and soon became a star at the Design Center's Park Ridge studio, whereupon he was transferred to the Personal Audio Video Group in Tokyo as a Senior Designer. There he designed videoconferencing and MiniDisc concepts in 1994–95, penned the SRF-87 Sports Radio in 1995 and created a series of Walkman, Discman and boombox designs code-named H2O in 1996. That same year, Mr. Boyd left Sony to design personal and sports-related products for Nike. "Looking forward," he says, "my goal is to run my own business, focusing on high-tech products that combine furniture with digital technology in a way that will redefine the home and office environment." Employing lessons learned at Sony, Mr. Boyd says that "tracing a path toward toward the unknown often takes you to the most interesting destination."

Kathryn Cimis

Formerly a graphic designer at the Design Center's Park Ridge studio, Kathryn Cimis joined Sony in 1993. Her many contributions include implementing the "blue strategy" for the packaging of Sony media products and the BYOS Walkman clothing strategy (with Hiroshi Nakaizumi).

Michio Deguchi

Born in Tokyo, Michio Deguchi joined Sony in 1989 and has focused his attention on Personal Audio Video products, such as the design for the MZ-E55 MiniDisc Walkman, the D-808 Discman and the WM-EX655 analog cassette Walkman. Rather than limit his future designs to existing technology, Mr. Deguchi says, "I would like to challenge conventional ways of thinking to create a new form of design that offers something for everyone."

Guy Dyas

Formerly an industrial designer at the Design Center's Park Ridge studio, Guy Dyas was born in Essex, England, and joined Sony in 1991, where he collaborated on a range of concepts and products, including the second-generation My First Sony product line in 1992. Two years later, he left Sony to join Industrial Light and Magic.

Knut Thomas Fenner

Born in Kenzingen, Germany, Knut Fenner studied industrial design in Germany and worked at Human Factors Industrial Design in New York and Siemens Medical in Germany before joining Sony in 1995. Working at the Design Center's Park Ridge studio, Mr. Fenner's best work includes the CMT-EX1 Compact Component System, the SS-DD50 Dolby Digital Surround-Sound Speaker System, the RM-V22 and RM-V40 Remote Commander, a walkie-talkie baby monitor called Baby-Call, and a range of concepts and prototypes, including a handheld telephone concept called TaskFone. His near-term goal is to travel the world and "do wacky things" with design. "Having worked on everything from toothbrushes to digital CAT scanners to wristwatches to stereos, I see everything as a challenge. Using this experience, I want to design products, that have poetry and personal expression."

Christopher Frank

Born in Salinas, Kansas, Christopher Frank began his career as a freelance designer, collaborating with several San Francisco area design firms, including Compass Design, Gingko Design, Studio Red, and Studio X, as well as his own furniture design firm Cipra and Frank, before joining the Design Center's San Francisco studio in 1997. While at Sony, Mr. Frank has conducted strategic investigations "whose intent is not only to create artifacts but to redefine the design process and its objectives. The solutions for projects are defined as strategic stories which are the result of investigating various users and lifestyles, their environment, services, business and technology." Mr. Frank's key designs from the past year include an Internet Display Terminal and a second-generation Wega TV concept called Digiplane. "In the future, I would like to design not only products, but experiences," he says. "Much of technology has complicated our lives. Reacting against this trend, I would like to focus on products that enhance the quality of life, help people to rediscover their senses and enjoy the balance of life."

Hiroshige Fukuhara

Born in Osaka, Hiroshige Fukuhara joined Sony as a graphic and packaging designer in 1997. His most interesting works to date include the unified design for HandyCam cartons, package design for the Beans Walkman and the logo for SmartFile. Having just begun his career, Mr. Fukuhara has no firm goals, saying, "I want to do anything and everything!"

Richard Gioscia

Born in Brooklyn, New York, Richard Gioscia worked as a freelance industrial designer at Mark Design and Lesko Design in New York City before joining Sony in 1986, where he now serves as director of design at the Design Center's Park Ridge studio. His most notable designs include the CFS-2050 stereo radio cassette recorder and CFM-2500 radio cassette recorder (both part of the second-generation My First Sony family), the RM-V11 and RM-V21 Remote Commande, and the KP-53XBR200 and KP-61200 XBR Projection TV. Looking forward, Mr. Gioscia says, "I want to help develop ways for Sony designers to think about products differently, consistently improve our design and development process and evolve new ways to understand and identify potential markets."

Ellen Tave Glassman

Born in Philadelphia, Pennsylvania, graphic specialist Ellen Tave Glassman designed product packaging at Cousins Design in New York City for such clients as General Electric and Gillette before joining Sony in 1988. While at Sony, her most significant contributions have been designing Web-based products such as ImageStation, designing the Home Page for Sony.com during the early 1990s and managing the Park Ridge graphic design department. In the future, she says, "I would like to lead the Graphic Design Group into the era of seamless graphic communication in which the Web, packaging, and traditional print medium work hand in hand to create powerful messages about Sony."

Teiyu Goto

Born in Kyoto, Teiyu Goto joined Sony as an industrial designer in 1977, later worked in the Design Center's General Audio and Display groups in Tokyo (where he designed the KV-29ST1 Kirara Basso TV), the Park Ridge design studio in the mid-1980s (where he designed the American version of the XBR television) and the New Business group in Tokyo during the early 1990s, where he designed his most famous product to date, the PlayStation, followed by the VAIO family of desktop and portable computers, including the subnotebook model PCG-505, which many consider the most influential portable computer of its time. Now serving as Chief Art Director in the Interaction Design Department at Design Center/Tokyo, Mr. Goto hopes to "create products that never lose their originality and which one can feel attached to for years to come."

Tom Grauman

Born in Seattle, Washington, software and user interface designer Tom Grauman worked at Microsoft during the early 1990s as part of the team that developed the animated operating system interface known as Bob, and joined Sony in 1996 to work with the Galileo design team in New York. His most influential work has been

the creation of the Zooming User Interface and demo project such as ZUI web browser called WaveCatcher. Now providing software and support for Keiichi Totsuka's advanced technology team at Design Center/Tokyo, Mr. Grauman is also starting his own Internet-related business in New York. His goal is to "combine new ways of interacting with information in a screen-based environment and leverage those techniques in the networked economy."

Katsuhisa Hakoda

Born in Tokyo, industrial designer Katsuhisa Hakoda joined Sony in 1993 and has designed or collaborated on a wide range of personal products for the General Audio and Personal Audio Video groups, the most notable being the HB-A5300 Graphic Computer for My First Sony, the MZ-R30 Mini-Disc player, and the ICF-B200 Emergency Radio with hand-crank generator. "My next goal," says Mr. Hakoda, "is to widen my expertise by designing car audio products and a new line of cellular telephones."

Tota Hasegawa

Born in Tokyo, user interface designer and programmer Tota Hasegawa joined Sony in 1997 and burst upon the scene with his first project by collaborating with Junichi Nagahara and Eduardo Sciammarella on the design of Sonicflow, a bundled application for the VAIO PCG-C1 subnotebook computer. He currently works on advanced software and user-interface projects at Design Center/Tokyo.

Yutaka Hasegawa

Born in Kanagawa, Japan, Yutaka Hasegawa designed camcorders and home audio equipment for the Victor Corporation of Japan before joining Sony in 1990, where he now serves as a manager at the Design Center's San Francisco studio. His most striking designs include the SDDS Digital Film Reader, the DVS6000 Digital

Switcher, the DME300 Digital Multi Effector and the design for the Z-100 Cellular Telephone and Z-200 Dual Mode Cellular Telephone. In the future, he would like to design entertainment tools for network services.

Haruo Hayashi

Born in Tokyo, Haruo Hayashi joined Sony as an industrial designer in 1982, has worked on a variety of product and projects—most notably the HDC-500 HDVS Camera; the second concept for the MDR-G61 Street Style Headphones and the System G Digital Multi Effects Editor—and is now a general manager at the Design Center's Singapore studio. A master in the design of technology-driven products, Mr. Hayashi's long-term goal is to "create designs that make people happy."

Ichiro Hino

Born in Tokyo, Ichiro Hino joined Sony as an industrial designer in 1981 and soon made his reputation by designing the first Sports Walkman, a breakthrough product that inspired dozens of lifestyle products at Sony (and elsewhere) in the years that followed. While working at the Design Center's Park Ridge studio, Mr. Hino helped to create the first generation My First Sony product line, designing the HB-A5000 Graphic Computer himself. Using the jog dial control mechanism designed by Soichi Tanaka, Mr. Hino crafted the TH-241 Cellular Phone and CM-R111 Cellular Phone (the precursor to the Z100/Z200 Cellular Phone), managed the Design Center's London office in recent years and is now a manager at Design Center/Tokyo. "As a designer," he says, "my goal is to create a simple product that one would instantly recognize and want to buy again and again . . . a simple design that one would never get tired of."

Kenichi Hirose

Born in Kyoto, Kenichi Hirose joined Sony in 1993 and has since provided the wrapping for

innumerable MiniDisc, audio cassette and Digital Video cassette products as a designer in the Visual Communication Design Department at Design Center/Tokyo.

Toshiyuki Hisatsune

Born in Fukuoka, Toshiyuki Hisatsune joined Sony as an industrial designer in 1986 and is now a manager specializing in car audio and high technology products at Design Center/Tokyo. His best-known designs include the DVS-7000 A/V Switcher, the PCM-E7700 Digital Audio Tape Editor and the CLIP-1 Credit Card Radio. His near-term goal, he says, "is to create designs that are fun to use."

Kazuo Ichikawa

Born in Tokyo, Kazuo Ichikawa designed a wide range of personal audio products for the Japanese market before joining Sony in 1986. His most impressive Sony designs include the first concept for the MDR-G61 Street Style Headphones, the SRS-100 Speaker System, and the TR-M1,the first business card–size radio. In recent years, Mr. Ichikawa has been General Manager at the Personal Audio Video Group in Tokyo and now serves as General Manager of the Design Center's London office, where he guides the development of products for the European market. Recognizing the growing importance of human interface design, he would like to integrate industrial design with human interface design, "so that product designers will no longer function as mere stylists and interface designers will broaden their approach to encompass the entire product. Once the boundary that separates industrial design and human interface begins to disappear, a new kind of product will emerge. Once again, form will follow function."

Takashi Ikenaga

Born in Osaka, Takahashi Ikenaga joined Sony as an industrial designer in 1990 and has since

specialized in high technology and professional products. His most memorable contribuions include designs for the MDH-10 Portable MiniDisc-DATA recorder, the UP-D9500 A3 Digital Printer and the DSC-D700 digital camera, known as CyberShot Pro. Mr. Ikenaga is now a Senior Designer at the Design Center's Broadcast & Professional Group in Atsugi, Japan.

Makoto Imamura

Born in Tokyo, Makoto Imamura joined Sony in 1996 and now serves as a designer at Design Center/Tokyo with the goal to "create a design in which hardware and software work together perfectly."

Mitsuru John Inaba

Born in Tokyo, Mitsuru John Inaba joined Sony in 1968 and now serves as Senior General Manager at Design Center/Tokyo.

Mayu Irimajiri

Born in Saitama, Japan, Mayu Irimajiri joined Sony in 1996 and now serves as a designer in the Interaction Design Department at Design Center/Tokyo. Her most important contribution has been the interface design for the Info-Navi System. "In the future," she says, "I would like to design from a woman's perspective, resulting in products that I would also want."

Yasuhiro Ishibashi

Born in Tokyo, Yasuhiro Ishibashi joined Sony in 1990 and has since designed a range of audio products, including the CDX-C9000 Series Car Stereo, the Paldio 311 Cellular Phone and the ICF-R700V Credit Card–Size Radio. Now serving as a Senior Designer at the Personal Audio Video group in Tokyo, Mr. Ishibashi's near-term goal is to focus his attention on the design of portable audio products.

Daisuke Ishii

A designer in the Personal Audio Video group in Tokyo, Daisuke Ishii was born in Tokyo

and joined Sony in 1992. His many designs for the PAV group include the CCD-TRV91 Handycam, the PLM-700S personal video monitor (known as Glasstron), and the ultra-thin MZ-E50 MiniDisc Walkman (with Takahiro Tsuge). Like most designers, Mr. Ishii's goal is "to totally design—from concept to advertizing—a product that everybody would want. Outside of Sony, I would also like to design environments such as museum interiors and tea ceremony rooms, signage, chairs and advertising."

Kazuki Isono

A Senior Designer at the Design Center's Broadcast & Professional group, Kazuki Isono was born in Aichi, Japan, and joined Sony as an industrial designer in 1987. His most unusual creations include the VPL-X2000E LCD projector and the CMT-ED1 Audio Component System (code-named Espresso) stationed at Design Center/London. Now married to Rie Isono (see below) and a new father, Mr. Isono would like to focus his energies on the design of child-care products.

Rie Isono

A former member of Design Center/Tokyo, Rie Isono was born in Tokyo, joined Sony in 1986 and is best remembered for the design of clever, eye-catching portable products such as the TwinPhone for Swatch Telecom, the YPPY Walkman and the first Beans Walkman, which since spawned numerous versions. Her goal as a designer is to create products that have a more subtle psychological impact that "can teach a child the value of design."

Shigeyuki Kazama

A Senior Designer and manager of the Industrial Design Group at the Design Center's Park Ridge studio, Shigeyuki Kazama was born in Tokyo and joined Sony in 1987. Designer of many innovative products, Mr. Kazama's most important contributions include the SS-A5

speaker, in which the form improves sound reproduction as well as serves a cosmetic purpose, and the KV-XBR100, which has a triangular design, allowing the product to fit neatly in the corner of a room. While at Park Ridge, Mr. Kazama's goal is to "become a craftsman again. Rather than focus on budget meetings, I want to just do the work . . . to start from zero and control everything to the end. I also want to as guide product planning as well as R & D for the American market."

Shigeyuki Kakizaki

A Creative Producer at the Design Center's Personal & Mobile Communications group in Tokyo, Shigeyuki Kakizaki was born in Tokyo, joined Sony in 1987 and has since designed or collaborated on a broad range of mobile telephone, car stereo and GPS navigational devices.

Masakazu Kanatani

An Art Director at the Personal Audio Video group in Tokyo, Masakazu Kanatani was born in Wakayama, Japan, designed a wide range of audio products for the consultancy GK Design in Tokyo, joined Sony in 1986 and has since designed a number of signature products, such as the MZ-E35 MiniDisc Walkman, the D-335 Discman and the PRODUCE-200 Word Processor. His goal is to design products that are used on a daily basis.

Hidenori Karasawa

A designer in Human Interface group at Design Center/Tokyo, Hidenori Karasawa was born in Nagano, Japan, joined Sony in 1996 and is currently focusing on "a new style of interface design that changes according to the user's needs."

Tetsu Kataoka

Born in Yamaguchi, Japan, Tetsu Kataoka joined Sony in 1988 and has designed a wide range of personal electronic products, the most influential being an 11-inch television for the European market in 1991, the TR-33

HandyCam in 1993, the WM-FS595 Sports Walkman in 1997 and concepts for a street style Sports Walkman, code-named SPO, that inspired a later series of designs called Freq. Now a Senior Designer in the Personal Audio Video group, Mr. Kataoka would like to focus on new technology and modes of interaction that would allow him to create a "heart touching product."

Makiko Kawai

A package and graphic designer in the Design Center's London office, Makiko Kawai was born in Tokyo and joined Sony in 1993. His most memorable contributions include designs for the YPPY Walkman and GIG audio cassettes. His goal is to expand his range of expertise by designing microcassette products for interiors, tableware, Internet-related hardware. "In general," he says, "I want to create designs that make people happy."

Atsushi Kawase

An Art Director in the Interaction Design Department at Design Center/Tokyo, Atsushi Kawase was born in Osaka and joined Sony in 1982. Responsible for many interesting products over the past seventeen years, including one of the Spirit concepts (1989) on which Sony's current design language is based, Mr. Kawase's favorite design is for a simple flashlight. "It was never manufactured," he says, "but it's the most credited of all my designs." Looking forward, Mr. Kawase would like to create "a design that one can admire ten or twenty years from now . . . a product that one wouldn't easily want to throw away."

Anne Kim

Born in Seoul, Korea, interface designer Anne Kim worked with the graphic designer Jessica Helfand and as an art director at Site Specific in New York before joining Sony as a freelance designer in 1996, where she collaborated on the design of the

Zooming User Interface as part of the Galileo project in New York. Her near-term goal is to continue her studies at the MIT Media Lab and combine her interest in user interface design with software programming.

Kazushi Kirihara

A Senior Designer in the Visual Communication Design Department in Tokyo, Kazushi Kirihara was born in Hiroshima, Japan and joined Sony in 1987. During the past decade, he has created many graphic and package designs for Sony's media products, his favorites being the jacket case for MiniDiscs, 8-millimeter video cassettes, and the CDix audio cassette. Looking forward, his goal is to focus on strategic designs for Sony's expanding family of media products.

Tadamasa Kitsukawa

A manager at the Design Center in New York and Park Ridge, Tadamasa Kitsukawa was born in Hyogo, Japan and joined Sony in 1987. His most impressive contribution has been the creation of Sony's in-house CAD/CAM system called Fresdam (with Mitsuhiro Nakamura). His near-term goal is to create a new line of computer-driven mobile products as well as concepts for a new kind of personal digital assistant.

Shigemitsu Kizawa

A Chief Art Director in the Home Audio & Video department at Design Center/ Tokyo, Shigemitsu Kizawa joined Sony in 1958. Born in Tokyo, he has created a great many audio and video products with special care given to the design of high-end audiophile equipment. His most celebrated contributions include the CDP-X5000 and TA-F5000 CD Player and Amplifier, the LLC-2000M Language Laboratory System and the Sony ES Series (TA-FA7ES,CDP-XA7ES, TC-KA7ES,ST-SA5ES,TA-E90ES and TA-N90ES). "Keeping in mind that the simplest design is best," he says, "I want my next

product to be something that catches the user's eye and is magnanimous."

Takayuki Kobayashi

Born in Kanagawa, Japan, Takajuki Kobayashi joined Sony in 1992 and is now a Senior Designer at Design Center/ Tokyo. His next goal is to design the hardware and interface for a new personal digital assistant.

Tetsuya Kohno

Born in Tokyo, Tetsuya Kohno joined Sony in 1987 and is now a Senior Designer in the Interaction Design Department at Design Center/Tokyo. His most acclaimed contribution has been a collaborative effort on the design of the PerfecTV user interface (with Yukio Okura). His goal is to design the interface for a next-generation personal digital assistant.

Kenichiro Kono

A Creative Producer in the Home Audio & Video group at Design Center/Tokyo, Kenichiro Kono was born in Ehime, Japan and joined Sony in 1974. His most significant contributions include a twentieth anniversary commemorative Trinitron television for Sony America, the first Sony VHS video recorder and the CDP-555ESD compact disc player. Looking forward, Mr. Kono would like to produce designs for a new family of consumer audio/visual products.

Koichi Maeyama

A Senior Designer in the Personal Audio Video group in Tokyo, Koichi Maeyama was born in Saitama, Japan, and designed audio products for Toshiba before joining Sony in 1988. Looking forward, Mr. Maeyama would like to "design the ultimate authentic products with the simplest possible mechanism."

Satoshi Masamitsu

A Creative Producer in the Interaction Design Department at Design Center/Tokyo, Sato-shi Masamitsu was born in Hiro-

shima, Japan, and joined Sony in 1985. Among the dozens of products that he has created during the past fourteen years, his favorites include the D-E700/E800 Discman, the ICD-50 memory chip recorder and the NWS-5000 Series News WorkStation. Looking forward, Mr. Masamitsu would like to create a design "that is not tense but yet has various great factors compiled in it."

Yoshimichi Matsuoka

Born in Kanagawa, Japan, Yoshimichi Matsuoka practiced furniture design and manufacturing in Boston before joining Sony in 1992 to focus on home audio products. His designs include the DHC-MD99 component system, the DHC-MD515 component system, and the DHC-MD9 component system. Now working at Design Center/ London, Mr. Matsuoka is exploring various product genres for Sony. His long-term goal is to create designs for both tableware and furniture.

Yozo Matsuzaka

A Senior Designer in the Home Audio & Video group at Design Center/ Tokyo, Yozo Matsuzaka worked as an industrial designer on information technology products and heavy electric manufacturing before joining Sony in 1986. Born in Tokyo, Mr. Matsuzaka has designed a wide range of home audio and personal audio products such as the DVW-10000 video recorder in 1997 and a series of low-end Walkman products in 1996. Looking forward, Mr. Matsuzaka will focus on next-generation home entertainment products.

Kim Mingo

Born in Long Branch, New Jersey, Kim Mingo worked as a freelance graphic designer for Atlantic Records and freelance display designer for Giorgio Armani in New York before joining Sony as a user interface and Web designer in 1995. While working at Design Center/New York, her most noteworthy con-

tributions include several versions of the Sony.com home page in 1995–96 and the interface for the music software program CD Ease. Now working as a freelance designer, her forthcoming work will include interface designs for digital television, as well as products "that make people think about media and content in a new way."

Shin Miyashita

Born in Tokyo, Shin Miyashita joined Sony in 1975, where he now serves as a Creative Producer in the Personal Audio Video Group. His most exceptional designs include the BVW-200 video camera, the HB-101 Hitbit computer and the SL-F1.TT-F1 Betamax portable video tape recorder. A master at designing products with long life cycles, Mr. Miyashita's next goal is to design digital products that can be continually updated and eventually recycled.

Tetsuro Miyazaki

Born in Hiroshima, Japan, Tetsuro Miyazaki designed audio products for another company before joining Sony in 1991, where he now serves as a Senior Designer in the Home Audio & Video Group at Design Center/Tokyo. His long-term goal is to "design products that evoke the character and richness of Japanese tradition."

Akinari Mohri

An Art Director in the General Audio Group at Design Center/Tokyo, Mr. Mohri was born in Tokyo, joined Sony in 1974 and has been responsible for a wide range of audio and personal electronics products. His best work includes the WM-D6 (Walkman Pro) the ZX-7 Radio Cassette Player and the MDR-F1 Open Air Headphones. He also achieved an interesting expression with the M100MC microcassette recorder. In the future, Mr. Mohri would like to create a new genre of design that, he says, "isn't influenced by trends or limited by a product's cate-

gory and will be loved for a long time."

Yuji Morimiya

An Art Director specializing in televisions and displays at Design Center/Tokyo, Yuji Morimiya was born in Fukuoka, Japan and designed camcorders and video recording decks at the Victor Corporation of Japan before joining Sony in 1986. His most influential designs at Sony include the CCD-TR55 8-millimeter Camcorder, the PZ-2500 Plasmatron and the CDP-R10 compact disc transport. As digital convergence changes the world of video cameras and displays, Mr. Morimiya wants to focus his attention on next-generation digital cameras and wearable viewing systems.

Satomi Moriya

A designer in the Visual Communication Design Department at Design Center/Tokyo, Satomi Moriya was born in Gifu, Japan, and joined Sony in 1994. Her inventive packaging for audio cassette products (as note cards for young girls and as karaoke tapes for older users) and MiniDiscs (with the Lumina line for teenage girls) introduced the idea of niche markets for Sony's mass-market media products. In the future, Miss Moriya wants to "design products with warmth."

Suzanne Morris

Now serving as Graphic Design Supervisor at Design Center/Park Ridge, Suzanne Morris worked at Rie Yoshimura International in New York before joining Sony in 1994. Her most memorable designs include the "blue strategy" for media packaging (with Hiroshi Nakaizumi) and packaging for the Psyc product line.

Junichi Nagahara

Born in Tokyo, Junichi Nagahara joined Sony in 1990 and is a Senior Designer in the Interaction Design Department at Design Center/Tokyo. The creator of several influential con-

cepts, such as Noise Art (with Haruo Oba), and promotional pieces, such as the M-GET TV promotion, Mr. Nagahara's most recent contribution is the interface for the interactive music/video program called Sonicflow (designed with Eduardo Sciammarella and Tota Hasegawa). In the future, Mr. Nagahara says, "I want to produce music software, design sounds, and, most of all, design something that can change the way we think and live today as well as the years to come."

Atsuo Nagai

Born in Tokyo, Atsuro Nagai joined Sony in 1979 and now serves as a Senior Designer. His most impressive works include the HighVision studio camera for Sony's Broadcast & Professional group and the Kirara 2DIN Car Stereo. His goal is to "design a product that reflects the face of the users as well as the beauty inherent in its functionality. For Sony, I would like to design broadcast equipment and computers. For non-Sony products, I would like to design airplanes, trains and other forms of transportation."

Hiroshi Nakaizumi

Born in Akita, Japan, Hiroshi Nakaizumi joined Sony in 1983 and has served as both a graphic designer and manager, spearheading media package designs such as the "Red Strategy" used on video tape packaging in Japan, the "Blue Strategy" used on media packaging in the American market and the "BYOS" clothing strategy for Walkman and Discman products (with Kathryn Cimis) at Sony's Park Ridge studio. He now serves as a manager at Design Center/Tokyo.

Shiho Nakajima

Born in Hyogo, Japan, Shiho Nakajima joined Sony as an industrial designer in 1996. Thus far, his most important contribution has been the design of the RM-IA9K touch-sensitive AV remote comman-

der. His philosophy is simply "to design something that is cheerful."

Mitsuhiro Nakamura

A Creative Producer in the Personal Audio Video Group at Design Center/ Tokyo, Mitsuhiro Nakamura was born in Kagoshima, Japan, and joined Sony in 1983. His most striking designs include the NT-2 Digital Micro Recorder (with Takahiro Tsuge), the PDF-5 Personal MD File and the MDR-G61 Street Style Headphone (with Hiroshi Yasutomi and Ken Yano).

Hiroaki Nakano

An Art Director at the Design Center's San Francisco studio, Hiroaki Nakano was born in Tokyo. Prior to joining Sony in 1986, he worked as a designer at Casio Computer Company. Now specializing in interaction design, his design credits include the startup sequence and interface for VAIO Space, included on every VAIO computer. His near-term goal is to design interfaces for 3-D communication systems.

Rumi Nakano

A Senior Designer at Design Center/Tokyo, Rumi Nakano joined Sony in 1984. Born in Tokyo, she is follows a simple philosophy: "I always strive to do the best work, so that my newest design work is also the interesting." Her goal: "to design a product that is both cute and fun."

Takao Nakayama

Born in Ibaraki, Japan, Takao Nakayama joined Sony in 1987 and now works as a senior designer at Design Center/ Tokyo, where his goal is to "create something that will be close to our daily lives."

Tatsushi Nashida

Born in Nagano, Japan, Tatsushi Nashida joined Sony in 1987 and now serves as a senior designer in the Interaction Design Department at Design Center/Tokyo focusing on Web-based prod-

ucts. His most interesting designs include a CD/MS editor and the browser and contents for Sony's virtual reality chat environment called Community Place. Looking forward, his goal is to design an application "that one can be attached to the more one uses it."

Makoto Niijima

A senior designer at Design Center/Tokyo, Makoto Niijima was born in Saitama, Japan, and joined Sony in 1991. His most distinguished contributions to date include an in-house concept proposal for a Video on Demand system, the XV-J2000 Kanji Video Titler and Cyber-Code Finder, a bundled application that accompanies the PCG-C1 VAIO Subnotebook Computer. In the future, Mr. Niijima would like to create a design "in which computer technology is used as a material rather than just a tool."

Takuya Niitsu

Born in Osaka, Japan, Takuya Niitsu joined Sony in 1980 and now serves as an Art Director in the Information Technology group at Design Center/Tokyo. When asked to list his most influential designs, Mr. Niitsu replied: "My next design, followed by the one after my next designand the one after my second next design." His stated goal is "to create a product that 100,000 people can relate to and a design that 100 million people can relate to."

Fujio Noguchi

Born in Tokyo, Fujio Noguchi designed a wide variety of audio products for Kenwood and office supplies for Canon before joining Sony in 1988. A specialist in both audio and television design, Mr. Noguchi's most memorable contributions include the first-generation PIXY Mini HiFi, the PLACID Audio System, and the KV-PW Series (known as Power Wide). Now a manager at Design Center/Tokyo, Mr. Noguchi is also spearheading the in-house vir-

tual corporation known as VAIO Center, which is plotting Sony's digital convergence strategy. As a designer, his goal is to create "something that gives excitement, fun and inspiration."

Haruo Oba

Born in Shizuoka, Japan, Haruo Oba joined Sony in 1986 and now serves as a senior designer in the Information Technology Department at Design Center/Tokyo. The author of many interesting products and concepts, his most impressive contributions include the Noise Art project (designed by Junichi Nagahara) and the VAIO L Series computer. His next goal is to create a design that "adjusts as well as feeds back to the changing media landscape."

Shinichi Obata

Born in Saitama, Japan, Shinichi Obata joined Sony as an industrial designer in 1985. While working in the Personal Audio Video Group, Mr. Obata designed many products, the most notable being the ICD-R100 integrated chip recorder, the ICF-C233 clock radio and the BC-221D battery checker. Looking forward, Mr. Obata would like to focus on the design of general merchandise.

Shinichi Ogasawara

Born in Hokkaido, Japan, Shinichi Ogasawara joined Sony in 1978 and now serves as an Art Director in the Interaction Design Department at Design Center/ Tokyo. His most best-known contributions include Spirit concepts from 1989, the CDP-101 (the world's first compact disc player), the CCD-TR2 Handycam, the PMC-M2 (the first personal MiniDisc audio system) and the new VAIO PCG-C1 subnotebook computer. In the future, Mr. Ogasawara promises that his next product will be "a design with a motive."

Hajime Ogura

Born in Kyoto, Hajime Ogura joined Sony in 1990 and now serves as a senior designer at Design Center/Tokyo. His more interesting designs include the Watchman personal television and concepts for Memory Stick shown at the 1997 Comdex technology expo. His goal is to design products "that relax our hearts."

Kiyoshi Ohta

Born in Ishikawa, Japan, Kiyoshi Ohta designed personal computers for NEC before joining Sony in 1988 and now serves as a manager in the Display group at Design Center/Tokyo, responsible for the design of Sony televisions, including the new Wega model. Widely experienced in consumer electronics, he has designed such memorable products as the XR-U80 Series Car Audio System, the KL-50HDF8/43HDF8 LCD Projector and the 1998 WEGA Design Project. His near-term goal is to design a wearable personal computer.

Hiroki Oka

A Creative Producer at the Design Center's Broadcast and Professional Group, Hiroki Oka was born in Tokyo and joined Sony in 1979. His most interesting contributions include the BVP-700 Studio Camera, the PCM-3348 48-channel Multi-track Audio Recorder, and the DVR-1000, the world's first D1 format Digital VTR. Though he intends to remain at Sony, Mr. Oka's ultimate goal is to design architecture, interiors and furniture.

Kazumasa Okumura

Born in Tokyo, Kasumasa Okumura joined Sony in 1979 and now serves as a Creative Producer in the Interaction Design Department at Design Center/Tokyo. His most interesting designs to date include interfaces for the CD Liberty audio system, the NEWS UNIX Workstation and the DVBK-2000 - D-2 Digital VTR. As Sony enters the new millennium, Mr. Okumura's near-term goal is to create "a Sony-style Interaction design" for the next generation of digital products and a more natural form of interaction in the years to follow, substituting screen interfaces with voice control or gesture manipulation.

Yukiko Okura

Born in Tokyo, Yukiko Okura joined Sony in 1977 and now serves as an Art Director in the Interaction Design Department at Design Center/Tokyo. Her most outstanding designs include the user interface for the PerfecTV electronic programming guide and the Mini-Disc language learning device known as Pela Pela.

Masaaki Omura

Born in Tokyo, Masaaki Omura joined Sony in 1996 and now serves as a Manager in the Visual Communication Design Department at Design Center/Tokyo. His many logo designs including the logo for So-net (the on-line service in Japan), the logo for Aperios (Sony's operating system for next generation TV set-top boxes and other devices) and the logo for the Tokyo Design Network. His goal is to design new logos as Sony's product line evolves, including the redesign of the Sony logo itself.

Naoto Ozaki

Born in Chiba, Japan, Naoto Ozaki joined Sony in 1974 and now serves as a Senior Designer at Design Center/ Tokyo.

David Phillips

Born in New York City, David Phillips worked at Landor prior to joining Sony in 1993. While working as a corporte identity specialist at Design Center/New York, Mr. Phillips collaborated on the design of the first Sony.com home page and conducted in-house investigations and brand building presentations, one of which led to the development of the Freq product line (design: Jaeger DePaolo Kemp, art direction Yuka Takeda) in 1998. He now works with Jaeger DePaulo Kemp in Burlington, Vermont.

Andy Proehl

Born in Bronxville, New York, Andy Proehl worked at an interactive exhibit designer at Edwin Schlossberg Inc. in New York before joining Sony in 1994 to manage the Galileo project in New York. His most remarkable achievements include the management and co-design of the Zooming User Interface (with Eduardo Sciammarella, Tom Grauman, Franklin-Servan-Schreiber and Anne Kim), the concept CD Ease (with Kim Mingo) and the successful completion of the 1991 NYC Marathon (in 3 hours, 48 minutes). Now serving as Manager of Interaction Design at Design Center/ San Francisco, Mr. Proehl's near-term goal is "to create products, tools and content that will allow consumers to embrace DTV and enjoy the coming digital convergence landscape."

Manabu Sakamoto

A Senior Designer at the Design Center's Park Ridge studio, Manabu Sakamoto was born in Tokyo and joined Sony as a graphic designer in 1990. A specialist in logo development and product packaging, Mr. Sakamoto created the logo and graphic treatment for many Sony products, media products, formats and brands. These include the logo for the DV (Digital Video) Format, the logo for SDDS (Sony Dynamic Digital Sound) and the logo for PlayStation, which has since become one of the most recognized marquees in the world. He has also designed the packaging for dozens of Sony electronic and media products. Having mastered the field of graphic design, Mr. Sakamoto would like to leverage this expertise in the design of consumer products for Sony, giving them a stronger, more focused brand identity.

Osamu Sakurai

A Manager in the Design Center's Broadcast and Professional Group in Atsugi, Osamu Sakurai joined Sony in 1985. His most notable designs include the graphical user interface for the Vision Touch System, the GUI for the ES-7 EditStation and the KV-H161 Personal TV. His goal is to design "an easy-to-use, fun Home Server, the user interface for a home networking system and a video editing system with facilitated operation."

Osamu Sasago

Born in Chiba, Japan, Osamu Sasago designed audio products for Kenwood before joining Sony in 1985 and now serves as a Senior Designer at Design Center/Tokyo. Like many of his colleagues, Mr. Sasago's goal is to infuse design with emotional meaning in order to create "heart-touching products."

Toshiaki Sato

Born in Tokyo, Japan Toshiaki Sato designed electronic home appliances for Toshiba before joining Sony in 1989. Now serving as a Senior Designer at Design Center/Tokyo, Mr. Sato's key designs include the D-211 Discman, a concept design for a multimedia automobile and the SO207 Cellular telephone. His goal is to create a personal electric vehicle.

Eduardo Sciammarella

Born in New York, Eduardo Sciammarella joined Sony in 1994 and spent a brief period at the Design Center's Park Ridge studio, where he created the RingPhone concept (in 1996) and pager concepts that prompted Sony to enter the page market. In 1996, he transferred to Design Center/New York to create the music interaction concept called AIDJ, collaborate on the eMusic concept, co-design the zooming user interface as well as SonicFlow (with Junichi Nagahara) for the PCG-C1 subnotebook computer. Now a Senior Designer at the Creative Development Group at Design Center/Tokyo, Mr. Sciammarella's goal is to "design concepts and strategies for the delivery

of networked-enhanced content and services."

Mie Sekita

Formerly a designer in the Personal Audio Video Group at Design Center/Tokyo, Mie Sekita was born in Tokyo and joined Sony in 1989. Her most interesting designs include the D-777 Discman, the SRF-M900V Pocket Radio and the CCD-SC55 and CCD-SC65 Handycams.

Franklin Servan-Schreiber

A former member of the Sony Research & Development Lab in New York, Franklin Servan-Schreiber managed the first phase in the development of the Zooming User Interface.

Eiji Shintani

A Senior Designer at Design Center/ Tokyo, Eiji Shintani was born in Ishikawa, Japan, and designed car stereo products at Pioneer before joining Sony in 1991.

Daisuke Shiono

Born in Tokyo, Daisuke Shiono joined Sony in 1992 and now works as a designer at Design Center/Tokyo. His goal is to "create a design that gives dreams to children and a design that give dreams to elder citizens."

Takashi Sogabe

Born in Tokyo, Takashi Sogabe joined Sony as an industrial designer in 1983 and is now an Art Director in the Personal Mobile Communications Group at Design Center/Tokyo. His most significant designs include the Ex-1 Walkman, the FX Series Hi8 Handycam (in 1993), the first Cordless Speaker and Headphone Series (in 1989) and the recently completed Digital Block concept. Looking forward, his goal is to "design products in mature markets such as telephones and radios taking into consideration usability and most of all enjoying the process of designing it."

Susie Sohn

Born in Seoul, Korea, Susie Sohn worked at the New York advertising agency Kang and Lee before joining Sony in 1998. Now a Senior Designer specializing in graphic design and pakcaging, Ms. Sohn's any contributions include the design of the Sony card, the graphic treatment on the Psyc digital radio, analog and digital walkman and Psyc packaging. Looking forward, Miss Sohn would like to design "theme oriented websites for people may be interested in education, spirituality and religion, including Christian chat rooms and teen sites having a positive educational and spiritual orientation."

Yumie Sonoda

A Supervisor in the Interaction Design Group at Design Center/San Francisco, Yumie Sonoda was born in Oita, Japan, and joined Sony in 1992. Her most striking designs include concepts for interaction displays shown at SIGGRAPH in 1995 (with John Maeda), concepts for the eMusic project (1998) and the interface for the Internet Display Terminal (1998–99).

Tetsu Sumii

Born in Tokyo, Tetsu Sumii joined Sony in 1994 and now serves as a designer at Design Center/London. His most noteworthy designs include the desk for EditStation 7 and the Banana Sports FM Walkman. His goal as a designer is to "create something that everyone can enjoy, including myself."

Kaoru Sumita

One of the legendary figures in the history of Sony design, Kaoru Sumita was born in Tokyo, joined the Design Center in 1972 and distinguished himself almost immediately with the design of the WM-2 Walkman and the first Profeel television—both now considered among the greatest of all Sony designs. Now serving as Chief Art Director in the Personal Audio Video group, Mr. Sumita has turned his

attention to video and digital still cameras, the most significant being the DSC-F1 Cybershot, which gave the handheld camera a totally new look and feel. Looking forward, Mr. Sumita's goals are simple: "to create good designs."

Miya Suwa

Born in Tokyo, Miya Suwa joined Sony in 1988 and now serves as a Senior Designer in charge of product planning and package design at the Visual Communication Design Department at Design Center/Tokyo.

Satoshi Suzuki

Born in Kanagawa, Japan, Satoshi Suzuki designed toys such as robots before joining Sony in 1991. Now a designer at Design Center/Tokyo, his most interesting designs include the SRS-GS70 Shoulder-Mounted Speaker, the SRS-Z Series Headphone and the MDR-DS5000 Digital Surround Head-phone System. His goal is to "design a product that is not affected by the trend and is loved for a long time."

Yuko Suzuki

Born in Miyagi, Japan, Yuko Suzuki joined Sony in 1982 and now works as a Senior Design in the Visual Communication Design Department at Design Center/Tokyo, where her most noteworthy contributions include the package for the MDR-E238 (the first Walkman), the package for the Groove Series (the first Fontopia earphone) and the carton for the ZS-D1 Personal Audio System. Her goal is to "create a product that people would remember in their hearts."

Noriaki Takagi

Born in Kanagawa, Japan, Noriaki Takagi joined Sony in 1995 and works as a designer at Design Center/Tokyo.

Yuka Takeda

Born in Shizuoka, Japan, Yuka Takeda joined Sony in 1985 and now serves as a Manager at

Design Center/New York. The most impressive of her many designs include the logo and collateral design for Sony Plaza, designs for CDix, X Series, Hip Pop and Eau de Pop cassette packages and strategy and management for the Freq product line. Her long-term goal at Sony is to "bring together the disperate cultures within the company—such as music, motion pictures, PlayStation and design—to develop a new multi-disciplinary approach to product design."

Ippei Tambata

Born in Tokyo, Ippei Tambata joined Sony in 1993 and now serves as a Designer in the Interaction Design Department at Design Center/Tokyo, where his best-known contributions include the interface for the NVX-FW808 Car Navigation System, the DVP-S7000 DVD Player and the XS-AW3 Active Woofer. His goals include "designing something that one can feel attachment to, such as robots."

Soichi Tanaka

Born in Tokyo, Soichi Tanaka joined Sony in 1988, where he now serves as Senior Designer at Design Center/Park Ridge. Credited as the designer of the first jog-dial control, Mr. Tanaka's most impressive designs include the PHS101Y cellular phone concepts. His goal has always been to "enjoy the design process itself regardless of product type or genre."

Shuhei Taniguchi

Born in Hokkaido, Japan, Shuhei Taniguchi joined Sony in 1960 and was part of the design team that developed the Black and Silver design language in the mid-1960s. The author of many influential designs, his most notable contributions include the ICF-5500 Sky Sensor radio, the ICF-SW1 radio and the basic design idea that led to the WM-2 Walkman (designed by Kaoru Sumita). Now a freelance design consultant, Mr. Taniguchi wants to design products for elder citi-

zens and thus create a new "universal design" that can be applied to all products.

Keisuke Tejima

Born in Tokyo, Keisuke Tejima joined Sony in 1972 and now serves as an Art Director at Design Center/Tokyo.

Keiichi Totsuka

Born in Yokohama, Japan, Keiichi Totsuka joined Sony in 1982 and has produced or managed a great many products and design concepts and new media strategies, such as the recently completed eMusic demo. Now working at Design Center/ Tokyo, Mr. Totsuka is leading a team that will forge a closer relationship between consumer electronics, entertainment and the networked world.

John Tree

Born in Edinburgh, Scotland, John Tree worked for the London-based design consultancy firm before joining Sony as an industrial designer in 1996. While working at Design Center/London, Mr. Tree's contributions included the key concepts that inspired the current Wega series television design, the CMD-C1 European GSM Mobile Telephone and concepts for home AV equipment (with the English furniture designer Jasper Morrison). Recently transferred to Design Center/San Francisco, his goals include "designing product interfaces, combining 3-D hardware interface with 2-D screen-based interface, as well as developing new interface metaphors." His long-term goal outside Sony is to design public architecture.

Masayoshi Tsuchiya

Born in Tokyo, Masayoshi Tsuchiya joined Sony in 1974, has served a variety of roles as both designer and manager, and now serves as Vice President at the Design Center's Park Ridge studio. As a designer, his most exceptional contributions include the MZ-

109 (the first "wireless Walk-man" with radio-controlled headphones), TCD-D10 (the first DAT audio tape recorder) and KX-27HV1 Profeel Pro television. His long-term goal is to create "a design with human aspects incorporated. I believe this to be an important factor especially in this digital era."

Takahiro Tsuge

Born in Yamanashi, Japan, Takahiro Tsuge joined Sony in 1989 and now serves as a senior designer at Design Center/ Tokyo. The author of many interesting designs, his most notable contributions include the ICF-C703 Clock Radio, the NT-2 Digital Micro Recorder (with Mitsuhiro Nakamura) and the MZ-E50 MiniDisc Recorder (with Daisuke Ishii). Mr. Tsuge's goal is "to design something that I would want and design that something in a straightforward way."

Miwako Tsukada

Born in Kumamoto, Japan, graphic designer Miwako Tsukada joined Sony in 1993 and has conducted several interesting projects as a member of the Visual Communica-tion Design Department at Design Center/Tokyo. These include repackaging of the Beans Walkman and Whoopee Walkman and package design for the YPPY Walkman.

Jun Uchiyama

Born in Tokyo, Jun Uchiyama joined Sony in 1986 and is now a senior designer at Design Center/Tokyo.

Yoko Uzawa

Born in Chiba, Japan, Yoko Uzawa joined Sony in 1988 and now works as a Senior Graphic Designer in the Visual Commu-nication Design Department at Design Center/Tokyo. Her most notable contributions include package design of the MZ-R2 and MZ-E2 MiniDisc Walkman, for cassette Walkman with snake and crocodile motifs and for the MDR-E888.

Joe Wada

Born in Tokyo, Joe Wada joined Sony in 1986 and has since become an almost legendary presence, responsible for two Spirit concepts in 1989 and such breakthrough products as the DD Quartz Walkman, the MDR-D77 Eggo Headphone, the WM-SX77 Outdoor Walk-man and CDX-99 Car CD Chang-er. Now serving as an Art Direc-tor in the Personal & Mobile Communications group at Design Center/ Tokyo, Mr. Wada's goal is to "design a tool that one would want to use forever."

Yuko Wada

Born in Kumamoto, Japan, Yuko Wada joined Sony in 1981 and now serves as a Creative Producer in the Visual Com-munication Design Department at Design Center/Tokyo, where she oversees the creation and design of product packaging.

Jim Wicks

Born in Champaign, Illinois, Jim Wicks joined Sony in 1987 and now serves as director and stu-dio manager of the Design Cen-ter's San Francisco office. His long-term goal at Sony is to conduct strategic investiga-tions that will identify new mar-kets and leverage design in order to create new business opportunities.

Peter Wyatt-Brandenburg

Born in Chicago, Peter Wyatt-Brandenburg joined Sony in 1990 and collaborated on sev-eral products and strategies at the Design Center's Park Ridge studio, including Drum (part of the second-generation My First Sony line), new concepts for personal computers for Fujitsu while at Ziba Design (Portland, Oregon), and a next-generation notebook computer concept for Hitachi while working at his current employer, Hauser (in Los Angeles, California). In the future, Mr. Wyatt-Branden-burg's goal is to "continually work with cross-functional teams to better understand

where new design and busi-ness opportunities exist."

Katsumi Yamatogi

Born in Okayama, Japan, Katsu-mi Yamatogi joined Sony in 1979 and now serves as a Cre-ative Producer at the Design Center's Broadcast and Profes-sional Group.

Akira Yamazaki

Born in Tokyo, Akira Yamazaki joined Sony in 1984 and now serves as a senior designer at Design Center/ Tokyo.

Yoshinori Yamada

Born in Tokyo, Yoshinori Yama-da joined Sony in 1991 and now serves as designer at Design Center/London. His most inter-esting contributions include the KV-6AD3 6-inch television, the TV and the European version of the WEGA Series Flat TV. His goal is to "do my best in designing products for the Gen-eral Audio group."

Yoshinobu Yamagishi

Born in Fukuoka, Japan, Yoshi-nobu Yamagishi joined Sony in 1991 and now serves as a designer and product planner in the Personal Audio Video Group at Design Center/Tokyo. His most noteworthy designs include the first YPPY Walkman and the MZ-E30 MiniDisc Walk-man (with Masakau Kanatani). His next goal is to "use my design work to create and coor-dinate new businesses."

Kouki Yamaguchi

Born in Osaka, Japan, Kouki Yamaguchi joined Sony in 1992 and now serves as a designer at Design Center/Tokyo.

Shigeya Yasui

Born in Osaka, Japan, Shigeya Yasui joined Sony in 1993 and now serves as a senior designer at Design Center/Tokyo.

Ken Yano

Born in Okayama, Japan, Ken Yano joined Sony in 1992 and has distinguished himself as an industrial designer with prod-

ucts such as the ICF-C113 Clock Radio, the SRF-M90 FM Radio and the MDR-G61 Street-style Headphones (with Hiroshi Yasutomi). His goal is to "design a unique product that Sony or any other compnay has never made, something aston-ishing, fun. A product that would gives dreams to every-one." Mr. Yano now works at Design Center/Tokyo.

Hiroshi Yasutomi

Born in Shizuoka, Japan, Hiroshi Yasutomi joined Sony as an industrial designer in 1994. While working at Design Center/Tokyo, one of his first projects, the MDR-G61 Street Style Headphone (designed with Ken Yano and Mitsuhiro Nakamura), became an interna-tional success and one of the finest Sony designs of recent years. Looking forward, Mr. Yasutomi would like to "pro-pose new user interface designs from a product design-er's point of view."

Rosaline Yin

Born in Shanghai, China, Ros-aline Yin worked at Young & Rubicam in New York before joining Sony Corporation of America as a graphic designer in 1989. In 1993, she trans-ferred to Sony Corporation (Japan) and then to Sony Elec-tronics in 1994, where she now works as a senior designer at the Design Center's Park Ridge studio. Among her many pro-jects, the most well-known include the first-generation CD-It packaging featuring a holo-graphic image, the icon system for Sony Outlet stores in the U.S. and packaging for the cur-rent Street Style Discman.

Miwako Yoritate

Born in Fukushima, Japan, Miwako Yoritate joined Sony in 1982 and now serves as an interface designer in the Inter-action Design Department at Design Center/Tokyo. His most important contributions include the interface design for the D1 and D2 Digital video tape

recorder, the on-screen inter-face for the HD Profeel (16x3) television and the graphical user interface for the SDP-1000 Effects Editor. His goal, says Mr. Yoritate, are to "change the many of the inconveniences of the world, design communica-tion tools that ties family together, and, most of all to design products from an eco-logical perspective."

Yasuo Yuyama

Born in Shizuoka, Japan, Yasuo Yuyama joined Sony in 1991 and now works as a Senior Designer at Design Center/ Tokyo. His many designs include the X series car stereo, the MHC-EX7 Set Stereo and the MZ-R5ST MiniDisc Record-ing Station.

Jan-Christoph Zoels

Born in Berlin, Jan-Christoph Zoels worked as a design con-sultant in Berlin, as Assistant Professor at the Rhode Island School of Design, for IDS in Seoul Korea, for the Jan-van-Eyck-Akademie in Maastricht (The Netherlands) and for his own design consultancy before joining Sony in 1997. Now a Senior Designer at Design Cen-ter/Park Ridge, Mr. Zoels's most noteworthy designs include collaboration on the eMusic project, concepts for Digital TV interfaces/remote controls and second-generation Wega TV. His goals include designing "nondiscriminatory products for mature users focusing on interaction modes that are not technology driven" and creating what he calls "sensual interaction design experiences."

Photo Credits: Masahiko Yoshida/Mono Magazine (Tokyo, Japan): pages 1 (top) and 62, all rights reserved; Takatoshi Sato/*Mono* Magazine (Tokyo, Japan): pages 6 (lower right), 82 (top), 85 (top), 129, and 133 (top left and right), all rights reserved; George Diebold (Montclair, NJ): pages 1 (bottom), 29, 30, 31, 32 (top and bottom), 35, 40, 41, 43, 44 (top), 45, 46, 47 (top), 50, 51 (top), 56, 63, 95, 104 (middle), 105, 136, 137, 138, 139, 146, 147, 148, 149 (top), 152 (top), 153, 178, and 186 (top left and right); Toons Imai (Tokyo, Japan): page 120 © Toons Imai. All other photos courtesy Sony Corporation (Tokyo, Japan), Sony Electronics, Inc. (San Francisco, CA, Park Ridge, NJ, and New York, NY) and/or Sony Corporation of America (New York, NY), all rights reserved. All attempts have been made to identify, credit and obtain permission from photographers whose work is used in this book. Any photographer or rightsholder who feels that previously protected photographic work has been used without permission, please contact the publisher.

Acknowledgments

Producing a work of this kind is the result many individuals—a chain of vision, organization and passion that begins with a conversation and ends with a book. First came the vision of Keiichi Totsuka, a vice president at the Tokyo Design Center, who first suggested the idea for this book in 1998, rallied support within the organization and provided considerable insight into the philosophy of Sony's design. Next came the organization and focus of Hiroshi Nakaizumi, a manager at the Tokyo Design Center, whose unerring judgment and dry humor made the writing and research a pleasure. Without Hiroshi opening doors, translating conversations and helping with the details of fact checking and picture selection, this book would never have been finished. Next came the talent and passion of Manabu Sakamoto, a graphic designer at the Park Ridge Design Center, who guided the completion of the book, executed the cover design and offered perspective on a wide range of issues. I also wish to thank the Design Center's Senior General Manager John Inaba, and Sony president Nobuyuki Idei, for their kindness and support, as well as dozens of designers, managers and support personnel in Tokyo, San Francisco, Park Ridge, New York and London, all of whom made a contribution.

In Tokyo, thanks are due to Akihiko Amanuma, Ichiro Hino, Kaoru Sumita, Shin Myashita, Joe Wada, Kazuo Isono and his dear wife Rie, Kazuo Ichikawa, Tetsu Kataoka, Teiyu Goto, Daisuke Ishii, Masakazu Kanatani, Shigeyuki Kakizaki, Kazushi Kirihara, Shigemitsu Kizawa, Yuko Wada, Satomi Moriya, Yuji Morimiya, Takuya Niitsu, Shigeyuki Kazama, Fujio Noguchi, Yukiko Okura, Mayu Irimajiri, Hiroshi Yasutomi, Ken Yano, Tatsushi Nashida, Shinichi Ogasawara, Kiyoshi Ohta, Atsushi, Kawase, Ippei Tambata, Shuhei Taniguchi and Mariko Watanabe.

In Park Ridge, I wish to thank Masayoshi "Mick" Tsuchiya, Rich Gioscia, Knut Fenner, Rosaline Yin, Ellen Glassman, Jan-Christoph Zoels, Susie Sohn, Soichi Tanaka, Takashi Sogabe, Gina Dekins, Tadamasa Kitsukawa, Suzanne Morris, Ayako Nagano, Yumiko Takagi, Takahiro Tsuge, Barbara Rahelich and Christina Brueck. I also wish to honor the memory of Lori Joseph. Your kindness is sorely missed.

In San Francisco, I wish to express my gratitude to Jim Wicks, Christopher Frank, Yumi Sonoda, Yutaka Hasegawa, Hiro Nakano, and David Mould.

In New York, I wish to thank Andy Proehl, Kim Mingo, Tom Grauman, Eduardo Sciammarella, Anne Kim, Tom Grauman, Yuka Takeda, David Fine, Dave Phillips, Uchiko Katayose and Lia Lee.

In London, my thanks go to John Tree and Makiko Kawai.

At Universe Publishing in New York, special thanks go to Charles Miers, Elizabeth Johnson and Scott Lavelle for their vision, patience and professionalism. At Axis in Tokyo, I wish to thank Hidetoshi Kita and Keiko Sano for their enthusiasm and support. Special thanks also go to Cindy Ho in New York, who inspired the project during its final stage.